The Future History of
Contemporary Chinese Art

The Future History of Contemporary Chinese Art

Peggy Wang

University of Minnesota Press
Minneapolis
London

The University of Minnesota Press gratefully acknowledges support for the publication of this book from Bowdoin College.

An earlier version of chapter 6 was previously published as "Tensile Strength: Threads of Resistance," *positions: asia critique* 28, no. 1 (2020).

Published by the University of Minnesota Press
111 Third Avenue South, Suite 290
Minneapolis, MN 55401–2520
http://www.upress.umn.edu

ISBN 978-1-5179-0915-4 (hc)
ISBN 978-1-5179-0916-1 (pb)

Library of Congress record available at https://lccn.loc.gov/2020022320.

Printed in Canada on acid-free paper

The University of Minnesota is an equal-opportunity educator and employer.

27 26 25 24 23 22 21 20 10 9 8 7 6 5 4 3 2 1

To my family

Contents

Note on Translations and Names

Following Chinese practice, Chinese surnames precede given names except for those individuals whose names are known under alternative orders and spellings.

All translations unless otherwise stated are my own.

Acknowledgments

As a book that upholds the value of artists' voices, works, and primary sources, I am indebted to all of the artists, curators, and critics who welcomed me into their studios and homes over the years. I am grateful to those named in the book and many more for their generosity and willingness to share their time, experiences, and expertise with me. Many are unnamed here, but I would like to give special thanks to Feng Boyi, Carol Yinghua Lu, Song Dong, Yin Xiuzhen, and Fang Lihua for being tremendous sources of guidance since my earliest research trips. I thank Biljana Ciric for opening doors for me in Shanghai; Angela Su from Asia Art Archive and Pi Li from M+ Museum for facilitating my viewing of key objects from the Sigg collection; and Anthony Yung and the staff at Asia Art Archive in Hong Kong for helping me to locate materials during multiple research trips. Thanks are owed to Philip Tinari, Xu Bing, Lydia Chen, and Su Xinping for their help in securing research affiliations in Beijing.

This book benefited from the wisdom and warmth of numerous communities that I have had the good fortune to belong to over the years. At the University of Chicago, Wu Hung and Judith Zeitlin fostered a community sustained by intellectual exchange and good cheer. I thank Bonnie Cheng, Jeehee Hong, Julia Orell, Eleanor Hyun, Seunghye Lee, Nancy Lin, Karl Debreczeny, Stephanie Su, Christina Yu Yu, Yudong Wang, and Wei-Cheng Lin for their camaraderie during my graduate years and since. I owe heartfelt thanks to Wu Hung for his guidance; his dedication to growing this field continues to inspire me. Courses and conversations with Darby English taught me the value of writing with care and precision. His work interrogating representation serves as a model for my own. During my undergraduate years, Heping Liu shepherded me into Chinese art history and remains a constant source of support. I cannot thank these individuals enough.

I express gratitude to the vibrant community of researchers who energize this field. I have been sustained by friendships and thought-provoking conversations with Wenny Teo, Franziska Koch, Meiqin Wang, Birgit Hopfener, Mia

Yu, Orianna Cacchione, Katherine Grube, Nancy P. Lin, Madeleine Eschenburg, Elizabeth Parke, Susan Beningson, and Jane Chin Davidson. My work has benefited enormously from encounters with Julia F. Andrews, Kuiyi Shen, Gao Minglu, Jerome Silbergeld, and John Clark, who paved the way in this field and continue to serve as mentors and exemplars of intellectual engagement. I am particularly indebted to Jane Debevoise, whose encouragement and sage advice motivated me throughout this process.

This manuscript took shape through my experiences in the classroom. Engagements with students in my seminars and lectures raised critical questions, and I wrote much of this manuscript with them in mind. I am grateful to the colleagues and friends I met during my years at Denison University: Joy Sperling, Joanna Grabski, Karl Sandin, Jacqueline Pelasky, Elizabeth Bennett, and Jeehyun Lim. At Bowdoin College, my colleagues in the art history department and Asian studies program have provided me with an academic home. I thank them for their collegiality and cheer. This project would not have been possible without the indispensable support of Linda Docherty and Dana Byrd, mentorship by Belinda Kong, and Shu-chin Tsui, whose invitation to contribute to her projects on contemporary Chinese women's art served as a critical turning point for my work. I have benefited enormously from the steadfast commitment of a stalwart community of writers. I thank Shana Starobin, Alison Riley Miller, Samia Rahimtoola, Margaret Boyle, Ingrid Nelson, Sakura Christmas, Leah Zuo, and Kristen Looney for their friendships and rigorous accountability.

The evolution of this book owes much to readers who gave invaluable feedback on earlier iterations of chapters. I thank Wen-shing Chou, Chinghsin Wu, Tara Kohn, Yuhang Li, Jeehee Hong, and Sohl Lee for their careful reading and perceptive comments. Progress during the final stages of this manuscript was driven by the critical insights and questions raised during workshops at the Asia Art Archive in America and the University of Chicago. I thank the participants and organizers of these events. In particular, I am grateful to Reiko Tomii, who took the time to help push my work to be better. This project was also enhanced by judicious feedback I received during talks, conferences, and panels organized by Christine I. Ho, Catherine Stuer, Chelsea Foxwell, Lily Chumley, Ying-Chen Peng, Franziska Koch, Rui Oliveira Lopes, Anthony Yung, Mike Hearn, Alexandra Munroe, Jason Kuo, Karin Zitzewitz, and Mia Yinxing Liu. Special thanks are owed Namiko Kunimoto for helping me to usher this work to publication. I thank the two anonymous reviewers of this manuscript, whose discerning notes guided my revisions. I am grateful to Pieter Martin for taking on this project and patiently guiding it through to completion.

ACKNOWLEDGMENTS

Many institutions provided resources and funding for my work. The University of Chicago Center for East Asian Studies, the Franke Institute for the Humanities, and a Fulbright-Hays Doctoral Dissertation Research Award funded research and writing of my dissertation. Funding from a Fulbright fellowship enabled follow-up fieldwork, and my home institution of Bowdoin College awarded me with grants for the research and publication of *The Future History of Contemporary Chinese Art*.

Nothing would be possible without the love and support of the Wang and Meisenhelder families. I thank my sons, Trevor and Sylvan, who fill my heart and are forever showing me what is important. And to Brady, my intrepid partner in all things who has been on this journey with me from the very beginning, I owe my deepest gratitude for his unrelenting encouragement and unfailing support.

Introduction
Actors in the World

In December 1992, Zhang Xiaogang (born 1958) visited Tiananmen Square. In a photograph marking the occasion, the artist stands alone as the red gate stretches out behind him (Figure 1). Chairman Mao's famous portrait looms over the artist's right shoulder. This picture can easily fall prey to simplified politicized readings that position Zhang—as a proverbial purveyor of the freedom of expression—against an oppressive state. While undoubtedly seductive, the trope of artist-as-dissident has long overshadowed narratives of contemporary Chinese art. When art is relegated to reactive dissidence against a monolithic government, this flattens the complicated ways in which artists negotiated their relationships with politics. This book centers on what is simultaneously a cause for and consequence of consigning art to such limited contexts: the severely reduced scope of what is seen as relevant and meaningful in the art itself.

The Future History of Contemporary Chinese Art opens up understandings of art that have been overlooked by existing interpretative frameworks. In addition to presenting new interpretations of even the best-known artworks, I confront the limiting assumptions that have precluded these readings from coming forth. This methodological intervention is directed at both reassessing the past and preventing the same constraints from fettering future histories. At the heart of my approach is a focus on artists' enactments of agency through their conceptions of and convictions *for art*. Specifically, I track how artists seized on the capacity to define art as a means of asserting their place in the world.

Situated in this way, the photograph of Zhang reads very differently. His visit to Tiananmen Square came at the tail end of a year of heart-wrenching realizations that made him question long-held assumptions about art and art history. Throughout the 1980s, Zhang and his peers saw themselves as the valid inheritors of Western artists like Vincent van Gogh and Henri Matisse. In their

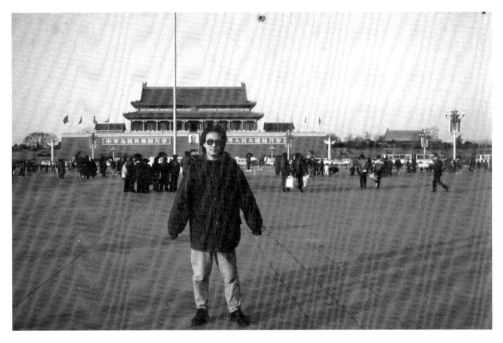

Figure 1. Zhang Xiaogang in Beijing, December 1992. Photograph courtesy of the artist.

letters to each other, they effusively described such figures as kindred spirits. In 1992, Zhang took a three-month trip to Europe that shattered these illusions of kinship. As he visited museum after museum, he saw how the artworks that he had long admired in printed texts suddenly appeared foreign when experienced in person. His encounters with Western contemporary art left him feeling similarly alienated. Writing to a friend, he lamented this painful rift: "These glorious names once encouraged us. I once regarded them as my true friends . . . but I've begun to realize clearly that my real name is always 'China.'"[1] Over the course of these three months abroad, Zhang came to see a world ordered by cultural differences rather than bound by shared lineages and legacies.

Adding to his disillusionment, Zhang also witnessed firsthand how Chinese art fit into this reoriented world: "What is the true contemporary Chinese culture? So far, it remains in the hearts of Chinese people but doesn't have a clear image to be explained and commented on. . . . This difficult task must be taken on by the Chinese people themselves. The Westerners don't care about so-called Chinese culture."[2] Spurred by these realizations, Zhang returned to China with a burning desire to figure out for himself what was distinctly Chinese. Only then, he reasoned, could Chinese artists hope to define rather than be defined;

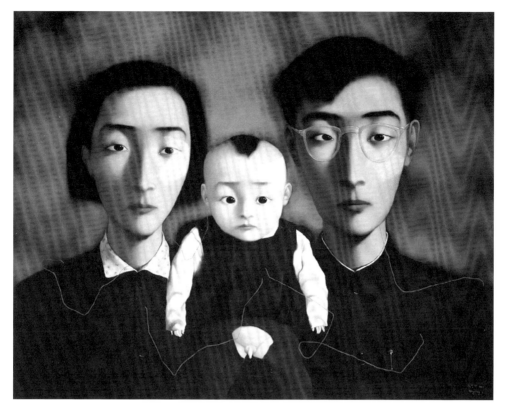

Figure 2. Zhang Xiaogang, *Bloodline—Big Family No. 2*, 1995. Oil on canvas, 180 x 230 cm. Courtesy of the artist.

to position rather than be positioned. He elaborated on this in one of his final letters from Europe: "What exactly real contemporary Chinese culture is, only we know. But we have yet to come up with clear concepts and images to show to the world."[3] Although he didn't have a vision yet of what it would look like, Zhang's mission for art was certain.

Placed within this context, the photograph of Zhang at Tiananmen shows the artist in the midst of a call to arms. His visit to this historic place, his experience of the built environment on-site, and the subsequent images that he produced all channeled this urgent objective to define "contemporary Chinese art" for the world to see. The following year, Zhang began his renowned *Bloodline* series (Figure 2), paintings he would continue to produce through the mid-2000s. Recent interpretations continue to posit these images as bleak renderings. They focus, in particular, on the figures' similar facial features as evidence of the artist's opposition to the state's imposition of "collective norms."[4] In contrast, I locate

the series within the artist's continued experiments with formulating contemporary Chinese art and its own art historical lineage.

Even as Zhang's understandings of specific narratives changed, he continued to view art history as a place for establishing identity and legitimacy. Turning to his art as a platform for exhibiting his findings, Zhang pictured a history for contemporary Chinese art in order to lay claim to its future. Significantly, his ambitions for art extended beyond the temporal to encompass worldly dimensions. As discussed more fully in chapter 2, this book understands Zhang's works as motivated by, and ultimately embodying, such bold declarations as: "We shouldn't try to fit into some imagined 'international standard'; instead, we should participate in constructing the world's new cultural scene. The pre-requisite for participation is a long-term effort by Chinese artists and critics . . . to respect themselves first. I might sound too broad, but I'm confident that full-scale participation is feasible."[5] Zhang's fervor for how these paintings could operate as images for the world galvanized every aspect of his process, conceptualization, and rendering of form and content. By highlighting the connection between artists' self-positioning and the artwork they produced, this book shifts understandings of art away from assumptions of domestic dissidence. In its place, art emerges as a profoundly generative site for artists to address the world and assert their own terms of belonging.

The Future History of Contemporary Chinese Art takes seriously artists' anxieties over the stakes of interpretation. To recover artists' agency, I focus on their role as actors—including political actors—first and foremost through their capacity as artists. By tracing how they channeled their concerns into their art, I show how they sought to author a past; both in order to lay ownership over their future and to carve a place for themselves in the world. By situating artists' strategies front and center, I present how they conceived of and activated the power and efficacy of their art.

My invocation of "future histories" references both artists' convictions *for* art and art historians' responsibilities *to* art. As such, my approach attends to the critical significance of art as the vehicle through which artists invested their future-facing and world-facing claims. This introduction lays out three key aspects for understanding artists as actors in the world: first, the discourses in the 1980s and 1990s in which artists invoked the term "the world" and how they saw themselves as operators within it; second, the historical paradigms around worldly belonging that paved the way for these artists' objectives; and, third, how artists then invested their art with the capacity to theorize and materialize the very relationships that they sought to form.

Worldly Ambitions

Chinese artists' discourses on the world fit into broader calls during the 1980s and 1990s for China to "head towards the world" *(zouxiang shijie)*. Whether sending young people to study abroad or enabling foreign investment, Deng Xiaoping's policy of reform and opening up *(gaige kaifang)* pivoted away from an earlier Maoist worldview that celebrated cooperation among developing countries in Africa, Asia, and Latin America as an anti-imperialist front. By the 1980s, a new strategy turned to emphasizing both self-reliance and extending relations towards capitalist countries.[6] This call rang across a spectrum of fields, from sports to literature and commercial business. Iterations of the slogan explicitly framed this initiative as a stepped move outwards: "break out of Asia, head towards the world."[7] In its literal translation, *zouxiang* means "to walk toward." By capturing a sense of linear directionality within a striding motion, this slogan exemplifies the country's initiative for advancement. It would not simply be a case of getting swept up in global tides and popular currents. It entailed people marshaling their strength in a considered march ahead and out into the world.

Artists' discussions of how Chinese art could participate in this move outward were already rife with anxieties over undue Western influence. Throughout the 1980s, young artists in China engaged in fervent experiments that drew heavily on the flood of Western philosophy and art catalogs that had been banned during the Cultural Revolution (1966–76). These vibrant explorations crested in the mid-1980s in a movement known as the '85 Art New Wave. As art groups sprang up across China, they issued statements and organized events that hailed the "freedom to create" as a means of "propel[ling] human civilization forward."[8] Yet, by the end of the decade, this movement was being retrospectively framed as one of subordination to a "foreign cultural system."[9] Realizing that they had failed to make their own visibility a critical objective, artists turned to their own lives to look for artistic languages that didn't resort back to a Western center.

In the late 1980s, as artists looked back with retrospective lament at the impact of Western art, they looked ahead with anxiety at another order of Western-centrism looming on the horizon. In 1988, Wang Luyan summed this up in a letter to fellow artist Zhu Jinshi, in which he raises the term *shijiexing*. *Shijie* means "world" while the addition of *xing* refers to the essence or nature of a thing, much like appending the suffix "-ness" to a word. In his comments, Wang uses this term to describe entities that presume to encompass the world. And, in the following quote, he specifically calls out art histories and institutions that claim to be *of* the world:

Fundamentally speaking, if from now on art history only takes the West and Europe as the center, then a Chinese artist's possibility of being "successful" will always come from a passive position. . . . Our fate can only be genuinely changed if the world wakes up from its long sleep. Which is to say: We change our position! We choose them, rather than being chosen. We must make the standards for "success," rather than allowing "success" to make standards for us. Only then can we talk about creativity! Otherwise, we can only hurry to struggle within other people's standards, waiting, serving as the seasoning in someone else's banquet. This is what I have come to recognize as so-called worldliness. I will no longer embrace any illusions . . . "worldliness." Can those few famous museums, critics, collectors really represent "worldliness"?![10]

For Wang, it was not enough for Chinese artists to simply be seen as included in the world or even rewarded with recognition. They needed to awaken to the biases cloaked by Western appeals to worldliness. Otherwise, they would forever surrender themselves to a system that deprived them of the freedom to determine their own worth. Even as Wang exposes the problems with believing in either universal standards or blindly adhering to Western values, his ardent call steps away from uncritically adopting the Western use of the word "worldliness" for themselves. Rather than also asking Chinese artists to speak for the world, Wang urges them to actively assert their own terms for being in it.

Concerns over Western-centrism continued to haunt and, accordingly, animate artists and critics to claim their power in the world. By the 1990s, a new version of the earlier slogan appeared nationwide as: "China heads toward the world, and the world heads toward China" (*Zhongguo zouxiang shijie, shijie zouxiang Zhongguo*). As Yunxiang Yan argues, this shift indicates a greater sense of entitlement over globalizing cultural forms as they developed inside China.[11] When applied to contemporary art, this mounting ownership over the conditions and forms of global circulation—particularly within one's borders—led some to focus on building a new infrastructure for exhibition in China while others saw the imperative of writing their own history. In short, this emphasis on bilateralism refocused the generalized goal of being acknowledged on the same international platform to seizing the authority to determine one's identity, contributions, and place in the world.

During the 1990s, as artists in China received first-time invitations to participate in the Venice Biennale (1993), São Paulo Biennial (1994), and Documenta (1997), they were already well aware of the distinction between waiting to be recognized by the West versus taking hold of the power to recognize them-

selves. As anticipated by Wang Luyan's letter, artists' experiences with these international exhibitions led to an explosion of debates over how to challenge the passivity expected of Chinese art. One of the most critical sites for enacting intervention was through art itself. However, even as artists used their art to engage the world on their own terms, recognition of these tactics has remained eclipsed.

One of the reasons for this is the limited parameters placed on understandings of both art and the world in discussions of the global art world.[12] With a focus on the mechanisms, agendas, and historical conditions that have enabled art and artists to circulate, studies of the global art world are anchored in a geospatial understanding of the world. While this cartographic lens is important, the impulse to map leads to the positioning of contemporary Chinese art as passive objects waiting to be *made global*. As Pheng Cheah explains, this emphasis on geographical space "conflates the world with the globe and reduces the world to a spatial object produced by the material processes of global circulation as exemplified by globalization."[13] Cheah describes the repercussions of this spatial categorization of the world on literature, an outcome that also applies aptly to art:

> The fundamental shortcoming of equating the world with a global market is that it assumes that globalization creates the world. This leads to a restricted understanding of the relation between literature and capitalist globalization that places literature in a reactive position. Instead of exploring what literature can contribute to an understanding of the world and its possible role in remaking the world in contemporary globalization, theories of world literature have focused on the implications of global circulation for the study of literature.[14]

As Cheah argues, because "global" abides by a spatial understanding of the world, this limits a work's relationship to the world according to its circulation. Indeed, there are two main threads by which Chinese artists' participation in the "global sphere" has historically been tracked: through diaspora artists and exhibitions abroad. Both have privileged a way of thinking about artists and art in terms of mobility. And, as such, they have limited discussions on the relationship between art and the world to what has been *done* to an artwork.

To open up how art posits different perceptions of the world and even its possibilities for "remaking the world in contemporary globalization," I trace artists' works for their assertions of being and belonging in the world.[15] Rather than tracking what happens to a work after it has been made, this book follows

how the very making of the work—from conceptions of art through experiments in practice—operated as artists' claims on the world. Treating artists' works as arguments for what constitutes art highlights the value of self-definition and self-positioning as declared *through* art. This approach pushes past the passivity assigned to art objects in accordance with global mobility.

Artists' relationships with the world have been similarly circumscribed in histories of contemporary Chinese art. Oftentimes, artists' imaginations of the world are discussed through their renderings of maps, geographical boundaries, or international politics.[16] This focus on literal depictions of the world can inadvertently relegate other works to being seen only in relation to localized contexts and domestic relevance. Additionally, this encourages a way of reading works that remains more interested in pictured sociopolitical content than analyses of artistic forms and aesthetic priorities. This effectively thwarts deeper excavations of artists' efforts to shape the world through their art.

Like its reception by Chinese artists, when the term "global art world" is used in this book, it is understood to be distinctly Western-centric while also ripe for contestation. This recognizes the threats posed by the global art world while also making clear that these concerns propelled artists to exceed the conditions placed on their participation. While tracking how artists sought to contribute to the formation of the global art world, I also use the term "worldly" to draw attention to preexisting and coexisting understandings of the world that privileged the power of art and the agency of artists to position themselves. As we move ahead to think about what the term "global" can and should encompass, it is necessary to reassess its current usages in light of historical paradigms. The following section introduces the larger histories of worldly belonging and world centering that informed how artists and critics approached the question of artistic engagement on a global scale. These, furthermore, contextualize the world-making ambitions with which artists invested their art.

Historical Paradigms of Worldly Belonging

The artists featured in this book were born in the 1950s and 1960s. Their seemingly grandiose statements about art are not surprising given the ambitious scope and scale of artistic efficacy in which they were raised. Historically, art throughout the twentieth century in China has been a means of nation building, enlightening the people, and a way of even leading the charge toward a new world. In the 1980s and 1990s, when artists and critics articulated the stakes of self-definition, some saw their work against the immediate backdrop

of the Cultural Revolution (1966–76). Others, such as art historian Gao Minglu, reached back even further.

Writing in 1986, Gao cites important connections between the '85 Art New Wave and the May Fourth Movement of 1919. He describes the debates and discourse about art in the mid-1980s: "Theoretically, in one very short year [1985], it reenacted the basic content and three phases of the May Fourth Movement's struggle between China and the West, and between ancient and modern. . . . The contents of the movement were divided along the lines of national essence, foreign affairs, and the coming together of China and the West."[17] In drawing upon the historical background of the May Fourth Movement, Gao invokes the looming specter of China's semicolonial status starting from the First Opium War (1839–42). In the waning years of the Qing dynasty (1644–1911), the Chinese empire struggled against unequal treaties and foreign concessions. With the establishment of the Republic of China in 1911, Chinese intellectuals continued to fiercely debate how to modernize the country—now a nation-state—in the shadow of Western imperialism.

In 1919, the May Fourth Movement began as a protest against the terms of the Treaty of Versailles. In particular, students in Beijing called for representatives of China to reject the treaty's granting of the former German concession area of Shandong Province to Japan. But, as indicated in Gao's preceding description, the significance of May Fourth was also in its explosive thrust toward activating agendas for national salvation. Within this, age-old arguments persisted over whether modernization should entail the adoption of Western technology and culture and to what extent. In his essay on the '85 Art New Wave, Gao Minglu references these issues as they played out in art. In particular, he cites the young artists Xu Beihong (1895–1953) and Lin Fengmian (1900–1991), who traveled to Europe and Japan between the 1910s and 1930s to study Western styles. When they returned to China, they selectively advocated different paths forward rooted in distinctions between Westernization and modernization: while Lin sought the emancipating power of expressionism, Xu latched onto the efficacy of academic realism in reaching the public.[18]

These China–West relations are important for understanding the deeply historic debates over Western influences on Chinese art. At the same time, for art historians like Gao Minglu, these two ends of the twentieth century did not just offer parallel situations. They were, in fact, continuous. As he explains it, "The momentous May Fourth Movement prematurely concluded its historical mission and left its onerous historical tasks for later generations to resolve."[19] To Gao, as artists of the 1980s confronted how best to treat Western sources, they were actually dusting off the same questions faced by earlier generations of artists.

In Gao's account, the Mao era acts as a break. With the establishment of the People's Republic of China in 1949, views on Western art were much more cut and dry. Western art was deemed bourgeois, decadent, and self-serving. Socialist realism, which adapted the academic realism that Xu Beihong had championed, formed the basis of the curriculum. As Mao proclaimed that art and literature must serve workers, peasants, and soldiers, the Party-State established new institutions to educate and activate cultural workers. As such, in Gao's schema, it was only after the chaos of the Cultural Revolution and the launch of the movement in the 1980s to reform and open up that artists could return again to address "the modernization of Chinese art" by means of experimental practices.[20]

In yet another narration of historical development, many artists—born in the 1960s—situated their experiences in the 1980s and 1990s against the era of their childhood. While on the surface the Mao and post-Mao time periods seem diametrically opposed, the ways in which the contrasts are drawn illuminate fascinating frames by which the past and present were perceived to be connected. Writing in 1995, for example, artist Zhang Peili (born 1957) explains how—for many of his peers—the geopolitics of the global art world connected back to the Mao era:

> From the 1950s to the 1970s, in the heart of Chinese people there was a kind of centrism *(zhongxin gan)*. From Mao Zedong's famous saying that the East wind prevails over the West wind, they had the confidence to believe that China was a representative of the world's power, and that one day it would defeat the West and change the world. After the 1980s, when they learned that the image of China in the world was not as mighty as they originally thought, this kind of confidence began to collapse. But in recent years, this lost centrism has been ignited again among Chinese artists. Its reason is that in recent years economic circumstances have taken a positive turn, and Chinese artists have repeatedly received opportunities to exhibit their work internationally (for example, at the 45th and 46th Venice Biennale, and the 22nd and 23rd São Paulo Biennial) and so people have bravely predicted that during the twenty-first century, the center of art in the world will follow the economic center and shift to China.[21]

Zhang positions perceptions of the Western-centric global art world as a matter of losing a Chinese-centric world. At the same time, he describes how his

fellow artists are looking to the future to rectify this. In doing so, Zhang sheds light on the enduring hold of these historically entrenched ways of thinking of the world. To his peers, the world was not only spatially and ideologically divided but also ultimately host to a competition to occupy its center.

The repercussions of this perceived power struggle on post-Mao conceptions of the art world are just as important as understanding its consequential effects on how artists saw the power of art. While the Mao era of art production has often been dismissed as mere "propaganda," scholars have recently disputed the characterization of the Cultural Revolution as a period of "cultural stagnation."[22] Pointing to the popular production of billboards, paintings, posters, big character posters, and theatrical performances, scholars have called for a reassessment of how these visual forms have been valued.[23] In fact, artists in the 1990s were already picking up on the flattening and dismissal of this legacy in their work. Chapter 3 follows how Wang Guangyi turned to study artistic techniques and purposes propagated during the Cultural Revolution as a means of visualizing his own art history and asserting its presence in contemporary art.

Hand in hand with the processes and principles governing cultural production were the worldly ambitions undergirding artistic creation at the time. While some saw China during the Cultural Revolution as "isolated," this was notably a retrospective designation assigned in the 1980s. Artist Zheng Shengtian (born 1938), who was in his late twenties when the Cultural Revolution began, remarks about this time: "I think the efforts of members of my generation have not been in vain. Many of us sought to create a new art for a new world."[24] This new world not only glorified China specifically but also referred to a larger socialist world built on popular revolution. China—whose alliance with the Soviet Union was already crumbling by 1960—aligned with Africa and Latin America to lead the Third World against Western capitalism.[25] Zheng's comments—echoed by many other enthusiastic artists at the time—saw art's collaboration with political ideology as a means of contributing to an entirely new world, one with China at its center and guiding the way forward.[26]

These accounts by Gao Minglu, Zhang Peili, and Zheng Shengtian remind us of the existing worldviews that predated—and necessarily informed—encounters with a Western-centric global art world in the 1990s. Scholars have noted the propensity among Chinese artists for thinking in terms of collective "revolutions" and "movements."[27] Within this framework, it is also important to call out how artists have seen themselves as active participants in creating and changing the world.

Microhistories and Meta-Art

To emphasize how artists saw their work functioning as part of a larger project toward worldly belonging, I use two key methodologies: microhistories and meta-art.[28] In order to understand how artists saw themselves in relation to the world, it is necessary to approach the "macroscale" of their ambitions through a microscale approach to their art. This, thus, doesn't see the macroscale and microscale as being at odds, but rather the micro provides new visibility to details of how they saw the world and themselves within it.

"Micro" in this case, emphasizes a zoomed-in view. This methodology follows Carlo Ginzburg's view of "micro" in microhistory as an "analytic approach to history" that draws on "microscopic" dimensions.[29] He writes: "The prefix 'micro' has been often referred, misleadingly, to the size (either literal or metaphorical) of its objects, rather than to the analytic approach, which is at the very center of microhistory as a project."[30] In thinking of "micro" as a matter of magnifying—like adopting a magnifying lens—this allows for what is blown up and made clear in ways that might otherwise not be seen.

This book thus builds on the important work of existing studies dedicated to individual artists, but also departs from monographs and case studies in its explicit connection between the macro and the micro.[31] As Ginzburg notes, this kind of close analysis may pave the way for "much larger (indeed global) hypotheses."[32] The micro allows us to make new connections with a zoomed-out view of the world while, at the same time, the macro is that which alerts us to the need for detailed looking and analysis. Indeed, this kind of microview allows for new interpretations of works and conditions that depart from macroviews that have kept contemporary Chinese art passively positioned within the global art world.

A second critical way in which this book departs from other studies of contemporary Chinese art is in its focus on how artists conceived of art. This dedicated lens on artists' claims over art and art history leads to a particular way of understanding artists' works. I refer to this as "meta-art" in order to draw attention to artists' comments on and claims for art *through* their art.[33] This is not an arbitrary methodological application: artists were intensely occupied with breaking down art and harnessing their own power toward self-definition. Writing in 1989, for example, art critic Yi Ying points to the meta-art consciousness that was already growing out of the preceding decade. While he looks back on the 1980s as a period of Western "imitation," Yi values the self-critique that it yielded: "regardless of whether one opposes New Wave art or stands aloof from this debate, one necessarily ruminates over the question

of what constitutes art."[34] Understanding artists' deep interests in what constitutes art draws attention to how their works functioned as experiments in defining art for themselves. In this way, meta-art is a line of inquiry that artists themselves employed.

At the same time, artists' concerns with art clue us in to the importance of tracing these objectives and initiatives in their works. As such, meta-art also serves as a critical art historical methodology. That is, in addition to tracking how artists enacted these questions in their art, this book also uses meta-art to highlight what has and hasn't been historically asked of contemporary Chinese art. As an art historical approach, this takes into account artistic process and form alongside the intellectual and creative histories and biographies of artists. This builds on existing case-study-based scholarship that has been undergirded by biographical narratives. But it also deviates from these studies in its close observation and analyses of artworks as the primary vehicle through which artists asserted themselves as actors in the world. By doing so at a zoomed-in scale, I treat each artwork as a work in progress that attempts to theorize and materialize its own social and aesthetic conditions. This thus follows how artists were continually refining artistic purpose and, furthermore, setting up their works as concretized theorizations of what artwork is and can do.

Seeing the chapters as "microhistories" encourages connections that may be ignored when regarded as discrete "case studies." Altogether, they also showcase the multiplicity of perspectives and artistic engagements that surround major historical events. For example, each chapter details an artist's specific experiences with the Tiananmen Square massacre and encounters with the global art world. Seeing these major phenomena through the micro privileges nuance over sweeping generalizations.

The first chapter—"Spaces of Self-Recognition"—introduces the range of debates in the 1980s and 1990s concerning how to position contemporary Chinese art in the world. Each of the following five chapters is then dedicated to a single artist: Zhang Xiaogang (born 1958), Wang Guangyi (born 1957), Sui Jianguo (born 1956), Zhang Peili (born 1957), and Lin Tianmiao (born 1961). Chapters 2 and 3 focus on two of the best-known artists in the contemporary Chinese art canon: Zhang Xiaogang and Wang Guangyi. Often held up as darlings of the market, they have been criticized for issuing a politicized and essentialized "Chineseness" to cater to foreign audiences. But, as I argue, blame that has been cast on these particular artists should instead be shouldered by the narrow interpretations that have accompanied their widespread circulation.

A quick glance shows that both Zhang and Wang used their paintings as vehicles for picturing existing images. Zhang drew on family portraits while

Wang's *Great Criticism* series (Figure 3) looked to Cultural Revolution imagery. As pictures of pictures, their works both sought to resurrect particular artistic modes and make them visible in contemporary art. When Zhang found a cache of family photographs in 1993 in his childhood home, he didn't just try to imitate the photographs as commonly believed. Instead, he saw in these found artifacts a specific visual lineage. In the techniques of photo retouching, Zhang saw not only a value standard imposed onto the people, but even more importantly one that had been applied to *pictures* of people. As a deployment of aesthetic codes, these values guided the visual treatment and arrangement of forms. This discovery converged with the artist's search for a "distinctly Chinese" history of picturing in which he could locate himself.

Wang Guangyi's paintings also arrived through a realization that he wanted to create art that emerged out of his own life and convictions. In this case, he utilized political pictures to acknowledge an art history for the people. Both artists turned to their art as a place to not only study picturing but also make claims for how China-specific principles and techniques deserved to be seen as "contemporary art." While both artists set out to define and create "contemporary Chinese art," in no case was a unified art form their goal. Instead, these and other artists sought to participate in an international discourse on their own terms, by creating images that were both contemporary and Chinese.

Chapters 4 and 5 focus on Sui Jianguo and Zhang Peili, respectively, and continue to show how artists broke down what they saw as art's constituent components—in particular, how they questioned and revised their views on representation, delved into how meaning is mediated, and set out to posit their own definitions of art. Many artists spent the decade interrogating understandings of art received through their own academic training and from translated Western sources. Chapter 4, in particular, traces Sui Jianguo's experiments with stone. Alongside his discoveries about material, Sui arrived at new ways of describing cultural reference and collective experience in his claims for the place of sculpture in contemporary art. In his conceptualization of "stone," he saw the dangers of relying on a static reference to Chinese tradition, for example, literary ties to the Chinese classic *Story of the Stone*. Instead, he pegged his references to a continuing cultural quality of endurance in the face of struggle. Like the previous chapters, this tracks an artist's attempts at coming to terms with how to define and claim contemporaneity.

These chapters on sculptors and painters deliberately return to formats that are too often cast aside as conservative and staid in the face of seemingly newer art forms. Rather than exclusively discussing installation and performance, these chapters show the need to see "experimental art" as experiments *in art* and

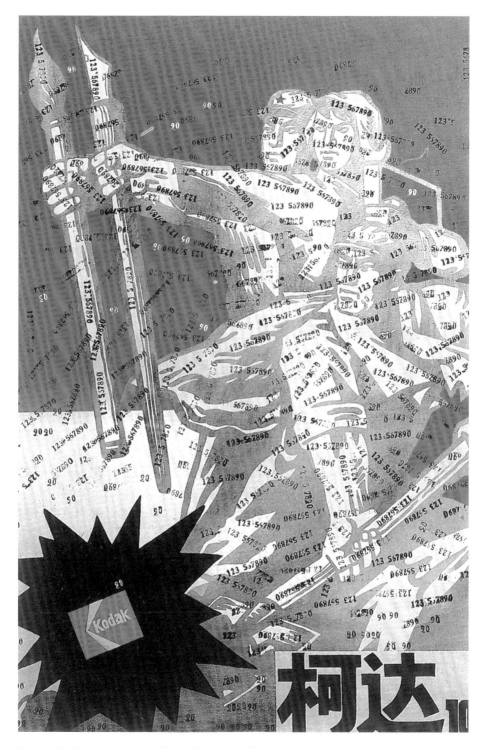

Figure 3. Wang Guangyi, *Great Criticism: Kodak*, 1990. Oil on canvas, 150 x 100 cm. Courtesy of Wang Guangyi Studio.

not just the adoption of particular mediums and formats. To this end, chapter 4 introduces how artists and critics engaged in a discourse about sculpture at the time. In particular, by the mid-1990s, there was considerable pushback against just assuming installation was more advanced. Significantly, this too emerged out of the perceived need for Chinese artists to establish their own standards.

Rather than joining in the chorus of claims over defining "contemporary Chinese art," the subject of chapter 5—Zhang Peili—has always remained critical of these kinds of proclamations. Even as his peers promoted cultural agendas for defining art, Zhang pushed back against the impulse to define at all. This chapter begins and ends with one of his best-known works in which a newscaster reads the definition of "water" into the camera. This work has often been seen as an exercise in revealing the absurdity of state news and its operators. The political machinery of state-run television is easy to critique for all its orchestrated programming. However, art historians and critics have rarely paid attention to the fact that what is being read is a dictionary definition. By drawing attention to this aspect of his work, I show how his art moves beyond serving as explicit acts of resistance. Instead, I focus on how he uses his art as a place to investigate the nature of resistance through his interrogation of the impulse to define.

Chapters 2 through 5 concentrate on art produced during the volatile and vibrant years from the late 1980s through the mid-1990s. Chapter 6 follows Lin Tianmiao's work through the 2000s. Lin's career path differs from the previously discussed artists. She was not an active participant in the '85 Art New Wave and only attended art classes for a year at Capital Normal University. She lived in New York City in the late 1980s and early 1990s before establishing herself as an artist in Beijing. These differences help show the broad applicability of meta-art inquiries, particularly when directed at the imposition of the category of gender on top of culture. Rather than just telling a biographical, gendered story, I foreground Lin's turn to art as a place from which she challenged dominant narratives that have been told about her artwork. By tracing Lin's uses of visual, material, and audio components in her work, this chapter reveals how the artist set out to actively intervene in how her work has been understood. By analyzing how her works make her voice visible and material, this joins the artist's exhortation to viewers to confront her art *as art*.

Historiographical Possibilities

The selection of these particular artists may be surprising given how much attention they have all received. Already the subjects of multiple monographs and exhibitions, these figures seem to be known quantities. Of course, there

is plenty of room for scholars to cover less studied artists and works, and it's important that this labor is done. But, I argue, it is also precisely the time for scholars to ask less studied questions of well-known artists and works. That these artists are renowned is precisely what makes them ideal sites for investigating how artists have been treated. In addition to showing what new readings can be put forth, this interrogation shines a light on why certain approaches have and haven't been given priority. By drawing attention to the ready acceptance of certain histories and approaches, this book shines a light on the assumptions that have stood in the way of new possibilities in interpretation. By reconsidering existing histories and offering up new interpretative frameworks, this book calls attention to the historiographical and methodological interventions necessary for redirecting the future history of contemporary Chinese art.

In recent scholarly and curatorial efforts to position histories of contemporary Chinese art in the world, there have been efforts to expand contexts horizontally to see the ripples and connections between art across space, and not just time.[35] This book joins in with this question of how to connect China's art history with the world. In doing so, it wades into issues art historians and curators are currently grappling with, such as, how do we map engagements between art from different parts of the world, and embedded within different art histories? Reiko Tomii explains the stakes of such a project through the necessity of locating "more contact points to link local and global and hence more possibilities for decentering and exploding the hitherto Eurocentric and closed narrative."[36]

Some scholars have charged accounts of contemporary Chinese art with upholding essentialist-nationalist narratives. Paul Gladston, for example, argues against what he sees as an "exceptionalist view of Chinese cultural identity" and instead foregrounds the ways in which discourses on art in China have come from mixing with "non-Chinese cultural influences."[37] For Gladston, scholars have failed to take into account a deep history of philosophical exchanges and other influences from abroad.

I argue that of equal, if not greater, concern is the restriction of contemporary Chinese art to a story of domestic development. When placed in a spatial schema for determining global relevance, it seems that works made by artists in China can only ever be read as addressing circumstances in China. This leads to a peculiar divorce between a work's image and its objecthood. A work is often discussed in terms of its "image" or subject matter as relevant only to the immediate environment in which it was created. It is only designated as "global" if the art as object is exhibited abroad.

By understanding engagements with the world outside of physical mobility, this book shows how artists used their work to intervene in multiple, converging historical conditions. Tracking artists' conceptions of art reveals how they sought to use their work to construct lineages and recalibrate frames of interpretation. By tracing how artists rethought their ideas about art, this approach not only opens up new meanings of artworks but also sheds light on the stakes of self-definition at this time. By taking their world-facing intentions seriously, this analysis pushes beyond the geospatial determinations for a work's relevance and instead locates how artists embedded their works with the capacity to assess and assert their own relationships with the world.[38] Their consciousness toward art history, furthermore, clarifies how they invested their art with the capacity to reorient future histories by staking claims on their past.

Addressing the Art of Art History

This attention to art answers a long-awaited call by artists to treat their art *as art,* and, in turn, to treat them *as artists.* In December 1993, the *New York Times Magazine* published one of the earliest expositions of contemporary Chinese art to the English-speaking public. Titled "Their Irony, Humor (and Art) Can Save China," the article lauded artists' lifestyles and attitudes as radical gestures against an oppressive government.[39] In the new post–Cold War era, the contention that artists could "save China" fueled stories of salvation through individual expression. The article also delivered a remarkably candid assessment of the place of art in such politicized accounts. As the title indicated, while artists carried out a salvific mission, "(and Art)" remained relegated to a parenthetical position.

The curiously limited role of art in accounts of contemporary Chinese art did not escape notice in the 1990s. Throughout the decade, artists and critics complained that Western curators expected their art to serve merely as explanations of sociopolitical conditions in China. Such interpretations bounded artworks in two ways: they were tied to specific political tropes and further confined to a narrowly construed "Chinese" frame of reference. Thus, even as artists from China ascended to new international heights, their work remained both politically and spatially circumscribed. Observing how differently their art was treated from work produced by their Western counterparts, artists saw these imposed limitations indexed to a disparity in global power relations. In 1998, artist-critic Wang Nanming (born 1962) charged, "People do not pay attention to Chinese art because it is art."[40] Echoing this grievance, artist Lin Tianmiao—facing the additional task of contending with gender—similarly

asked, "If one were to have removed the words 'China' and 'Women' from the exhibition, would anyone have come, would anyone have paid attention?"[41] Skeptical of the assumptions that drew audiences to their work, artists' critiques hit on one of the most trenchant by-products of reading art as a confirmation of politicized stories about China. If contemporary Chinese art wasn't ever seen or appreciated as art, how could it be treated as such?

Many existing histories of contemporary Chinese art focus on how artworks registered the country's social and political changes. While these are significant studies, this book deviates from such accounts. Rather than reading works for their subject matter—for example, as an address of urban reform—I argue that they reveal an equally compelling trajectory: what artists and critics thought about art. Given the great efforts that artists took in locating their own ways of thinking about art—in defiance of trailing Western art—it's not surprising that they balked when Western critics and curators interpreted their work as politically reductive, culturally essentialist, or simply derivative of Western art. Such readings not only failed to see artists as actors but also failed to recognize the deep-seated questions and decisions about art that motivated these experiments.

These tendencies are not merely a remnant of the past. The propensity to see contemporary Chinese art as a way of illustrating and furthermore "saving China" persists in current iterations. Artist Qiu Zhijie (born 1969) recently voiced weariness regarding this tendency: "For Westerners, in particular, the political story is much more simple and easy to tell. Nowadays, even Ai Weiwei's story is told like this: always about Big Brother and the fight for democracy."[42] Qiu connects the flattened understanding of Chinese politics to a similarly one-dimensional treatment of art. Even for an artist as charged as Ai Weiwei (born 1957), there are important aspects to his narrative and his art that go missing when only a legible political story is sought.

Qiu's comments also point to how such a "political story" has confined ways of viewing contemporary Chinese art at large. Indeed, the fact that Ai Weiwei has become so internationally recognized as the face of contemporary Chinese art should give pause. In subscribing to the "single story" of China that he represents, audiences need to ask themselves—as art critic Mark Stevens—does, "What makes him, in Western eyes, the world's 'most powerful artist'?"[43] Stevens aptly reminds readers: "The answer lies in the West itself. Now obsessed with China, the West would surely invent Ai if he didn't already exist."[44] As a perpetual thorn in the side of an authoritarian government, Ai continues to confirm the subversive role of art in politicized narratives of dissent.

This way of thinking not only supports gravely narrow views of China

and art, it also invariably limits who receives opportunities for exhibition. Ai's popularity speaks to the stakes of who gets recognized, exhibited, and written into Anglophone art histories. But beyond just looking for "less political" work as a means of providing a more comprehensive view of art from China, it is necessary to dive deeper to attend to the questions and approaches that inform interpretation to begin with. When a subversive lens is the principal way in which art is recognized as functioning, what are the implications of this on how art is seen at all? "Seen" in this case refers to not only what is being made visible but also how it is being made legible. This returns again to the perennial problem of the parenthetical confinement that prevents contemporary Chinese art from being seen *as art*.

This point has recently picked up momentum as evidenced in the 2016 exhibition *What about the Art? Contemporary Art from China*. Taking up the role of curator, artist Cai Guo-Qiang (born 1957) organized the exhibition to draw attention to how artists pursue creativity "in terms of artistic methods and methodology, attitudes, and concepts" and see this in light of "their own contribution to global culture."[45] In calling out "artistic practice" and "artwork," Cai notes the utter neglect in attention to these facets: "All too often, we seek out the political and social significance in an artist's work while ignoring the rich significance of the artist's attention to form."[46] This book continues this pursuit to recognize the art of the artists. In doing so, I do not ignore the political and social significance of the art, but rather argue that close observations of form, concept, and method can, in fact, yield even deeper understandings of sociopolitical conditions, particularly when seen in light of artists' ambitions and objectives as actors in the world.

Through microhistories and a focus on meta-art, *The Future History of Contemporary Chinese Art* opens up new ways of thinking about artists and their work. At the same time, it shines a light on the unquestioned assumptions about interpretation and dominance of geospatial paradigms that have guided existing ways in which these artists have been viewed. Through a zoomed-in lens for analysis, the scope of the project is magnified to exceed the limited ways in which domestic and global relevance have been determined. The details revealed in each chapter bring forth new understandings of seminal artworks that can be used to reconsider the generalizations and hierarchies present in histories of contemporary Chinese art, the global art world, and the intersections between.

Spaces of Self-Recognition

In 1988, in his third year at Capital Normal University in Beijing, Song Dong (born 1966) skipped his school's annual sketching trip. During his first year, the class had gone to northern Shaanxi Province to observe the peculiar cave dwellings where local farmers reside. In his second year, they went to see members of the Yi ethnic minority group. In each case, students closely examined the livelihoods of Chinese people so different from themselves. They would eat the food of locals, sleep in their homes, and hike from one small village to the next. Along the way, they paused to sketch the scenery, but most importantly the people who occupied it. These trips promoted sketching as a foundational skill in the Chinese art academic curriculum by sharpening students' abilities to mimetically capture the external world. Even more importantly, they forced students to leave the classroom and venture out to witness the lives of others.[1]

The term given to this exercise is *xiaxiang xiesheng. Xiaxiang* means to go down to the countryside, and *xiesheng* refers to drawing and painting from life. In the 1950s, the government championed the rural areas of China as the heart of the nation while vilifying urban areas as parasitic. Since the founding of the People's Republic of China in 1949, rustication campaigns sent young people out from urban areas to partake in the labor of agricultural production. Similarly, artists, writers, and directors celebrated the work carried out in the country's factories and farms by conducting trips that materialized the Maoist slogan of *shenru shenghuo,* or to enter deeply into life.[2] After all, only by sharing in the glory and struggles of the people could cultural workers be expected to describe them accurately. The assumption underlying this tradition was that the lives worthy of representation were not those of the cultural producers. Instead, as articulated in Mao Zedong's "Talks at the Yenan [Yan'an] Forum on Literature and Art" (1942), the people—always the source and beneficiaries of art—refers to workers, soldiers, and peasants.[3] Art functioned as an instrument for inspiring them and defeating their class enemies.

When art academies reopened following the Cultural Revolution (1966–76), sketching trips persisted as a cornerstone of the curriculum. Abbreviated as *xiaxiang* at this time, these trips were as much about political training as art education. Attitudes toward this exercise changed, however, as concurrent governmental policies on urban development emphasized growing capitalist cities as the new engines driving national development.[4] For those artists raised and educated in the city, *xiaxiang* decreasingly carried the weight of a political mandate for reeducation. Instead, it was treated as a chance to visit what were now seen as the "peripheries" of the country. The sense that they needed to deny their own lives and focus on China's rural regions was gradually replaced with a growing urban self-consciousness. In his third year of college, Song Dong began to wonder: "Why should I enter into someone else's life? Why should I watch other people? Isn't my life also a life?"[5] Rather than participating in the trip—this time, to Yunnan Province in southern China—he stayed in Beijing and studied his own surroundings.

Not all students objected to these activities. Yu Hong (born 1966), who attended the prestigious Central Academy of Fine Arts from 1984 to 1988, enjoyed these chances to visit far-flung places. She greeted sketching trips as opportunities for adventure and travel to other parts of China. In the end, however, the expeditions confirmed for her how remote these subject matters were from her life.[6] When left to devise her own paintings, she focused instead on depicting what was closest to her. While continuing to work predominantly in the realist style of her training, Yu Hong's decision to prioritize her own life—to paint those whom she identified as similar to herself—marked a break from the prevailing ideological parameters dictating cultural production in China.

Yu Hong's paintings from the late 1980s feature images of young people sitting, leaning, or otherwise engaged in idle activities. As exemplified by her 1989 *Beige Portrait* (Figure 4), the level of detail the artist devotes to every fold of clothing and each facial feature attests to her rigorous training in achieving verisimilitude. At the same time, this specificity convincingly points to the fact that the subject is an individual—in this case, a second-year student named Bian Jing from the Department of Mural Painting—rather than an idealized youth from her imagination. To achieve such meticulous detail, Yu Hong took photographs of her subjects and used them as the basis for painting. This was a practical measure as it would be impossible to ask her peers to pose for the three to four weeks it took to complete one canvas. At the same time, she remarks that working from a photograph also resulted in a departure from the relationship between painter and subject cultivated during direct observations from nature.[7]

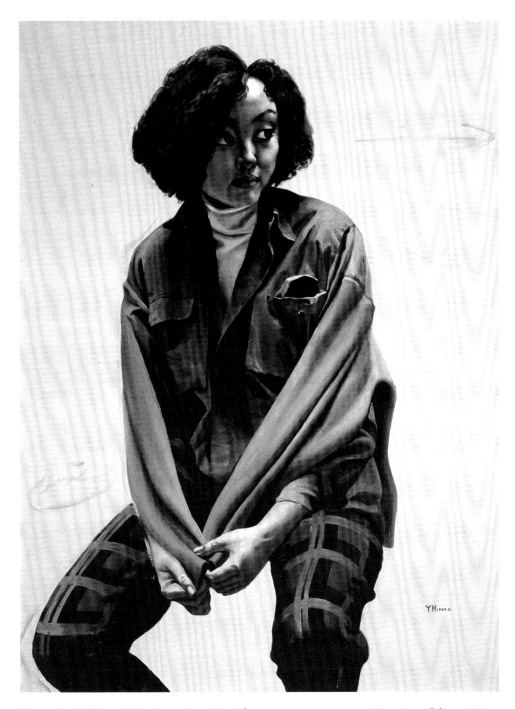

Figure 4. Yu Hong, *Beige Portrait*, 1989. Oil on canvas, 130 x 97 cm. Courtesy of the artist.

When portraying a figure from life, Yu Hong notes, a rapport can develop between a painter and her subject. This is particularly the case during *xiaxiang* trips where the goal is to learn from the subject. Drawing from her immediate surroundings, Yu Hong was already granted an intimacy with her subject. This existing familiarity allowed her to bypass the ideological demands of observational studies. The assistance of photographs, moreover, enabled her to complete the works in solitude. Rather than the Maoist requisite to learn from and give art over to the subject, this process enabled Yu Hong to center her paintings back on herself.

While depicting lives that appear idle and lingering, the artist's underlying prerogative was pointed and penetrating. Prior to this, Yu Hong never saw paintings that featured young city dwellers like herself.[8] In her choice of subject matter, she used art to acknowledge their—that is, her—existence. While her style for depicting figures adheres closely to her academic training, she occasionally leaves behind an abstract brushstroke across the surface. Insistently material in its trace, these marks physically implicate the artist's painterly existence as part of an overall effort to see herself in art.

Yu Hong also discusses these paintings as an address to her generation. To her, they all represent young people positioned on the verge of adulthood and uncertain about the future. These concerns can also be situated within a broader social instability of the time, and the anxieties of waiting for what lies ahead. Her use of empty backgrounds lends to the rootlessness of the figures, further turning away from the images of heroic youths that had dominated the visual landscape for decades prior. More than simply a turn from the rural and heroic to the urban and ambivalent, Yu Hong's paintings point to class distinctions within the city's population. Her paintings focus on particularly fashionably dressed and well-coiffed subjects selected from the student body at the Central Academy of Fine Arts. She and her subjects were part of an elite, intellectual milieu. In her paintings, Yu Hong demonstrates not only a turn to her own urban existence as a subject for art but also a parsing of categories of identification according to class and age.

After graduating in 1989, Song Dong, too, continued to draw on his own life in his art projects. While Yu Hong identified herself with a young bourgeois urban generation, Song Dong focused on the daily life that he lived and witnessed in Beijing's *hutong,* the labyrinthine alleyways that line the city's courtyard neighborhoods. From 1992 to 1993, he carried out a project titled *Yishu zai nin shenbian (Art Is by Your Side)* (Figure 5). At the time, he was assigned in a work unit as a middle school art teacher. Every week, he would ride his bicycle from home to work through the *hutong* of the Xisi neighborhood in

請 柬

【艺术在您身边】

宋冬艺术展示 1992－1993

您走出大门，向（ ）看有（　　　）

那是艺术

1992. 冬.

北京 胡同

Figure 5. Song Dong, *Art Is by Your Side,* 1992–93. Pencil on paper, 29.7 x 21 cm.

Beijing. Along the way, he would take note of things in the winding alleyways. Perhaps a stack of bricks or a haphazard pile of produce would catch his eye.

Taking out an A4-sized paper template, he would stop and quickly complete a sketch in the designated space halfway down the page. Walking to a nearby courtyard residence, Song Dong would then note the direction from which he could see the depicted object. He would fill in this information on his template and leave it for occupants. Upon collection, a recipient would follow instructions such as, "Walk out of your doorway, turn right; you will see a pile of cabbages," under which would be the artist's drawing. The text and sketch together signaled to the recipient to search out this very thing in real life. Song Dong's final statement on the sheet declares, "That is art."

In the project, Song Dong brought to bear two fundamental exercises from the academy: drawing from life (*xiesheng*) and quick sketching (*suxie*). His project depended on his capacity to accurately and rapidly render what he saw. The sketch had to bear a likeness to the actual object in order for people to see it and acknowledge its significance. This work, however, departed from the academic tradition in a key way. The hand-drawn sketch was not the final product but rather a deictic. As announced by the text, his sketch pointed to what he now construed as art. One could consider "that is art" as Song Dong's introduction of the readymade to viewers. Or, one could conceive of the entire process—from the artist's instructions to his empowering of the viewer—as constituting the art. Either way, his training in achieving verisimilitude operated as a tool for inverting the relationship between signifier and signified. In asking people to look anew at their surroundings, now re-designated as "art," Song Dong shared with viewers his claims for what art was and wasn't.

Yu Hong and Song Dong were both born in 1966 and entered college when the movement known as the '85 Art New Wave was coming into full swing. As students, their involvement in the movement was more at the level of observation than participation. Even still, as older peers and teachers penned manifestos and experimented with expanding styles and forms, this younger generation of students shared in the era's deep skepticism toward existing definitions of art. While both Beijing-based artists are of the same generation, Yu Hong and Song Dong are rarely discussed together in accounts of contemporary Chinese art. Scholars and curators often situate Yu Hong exclusively alongside other women artists. Moreover, because of the tendency to divide artists according to medium and style, realist painters are frequently left out of, or used as a conservative counterpoint to, seemingly more avant-garde experiments. I bring these two artists together to point out their similar questioning of, and subsequent interventions in, contemporary ways of thinking about art.

Both artists recognized the significance of their own lives over and against the class-based, rural emphasis of socialist realism. In doing so, they both drew from their respective existences to identify with specific communities within urban spaces. After graduation, Yu Hong received the coveted opportunity to stay on to teach at the Central Academy of Fine Arts, the site where she would continue to live and work. Song Dong, meanwhile, focused on those who, like him, inhabited the courtyard homes and alleyways of Beijing. The use of *nin* in the title of his project *Yishu zai nin shenbian* acts as a textual and phonological marker of place. While on the one hand *nin* can be considered an indication of formality in addressing a person (versus the more informal *ni*), for Chinese speakers, this is an immediate and recognizable feature of the Beijing dialect. By gifting drawings, Song Dong presented his everyday life as a worthy subject matter and further implicated surrounding urban residents as rightful subjects, recipients of, and even participants in art.

As a domestic narrative about China, Yu Hong's work can be considered a commentary on the loss of direction in urban youth. And, similarly, Song Dong's project may read as a futile effort to record changes in neighborhoods on the cusp of urbanization. By stepping back and seeing their works from a meta-art perspective, however, we can understand both artists' adaptation of their academic training to push against the ideological doctrine limiting whom art should depict and serve.

These narratives in self-recognition introduce how artists in the late 1980s and early 1990s used their work to intervene in definitions of art. Both examples, furthermore, showcase how artists channeled this initiative into making themselves visible through art. This way of grabbing hold of agency showcases one way of conceiving of the "self-" in self-recognition: as a reference to who is doing the recognizing. At the same time, the differences in whom Yu Hong and Song Dong each identified with—as anchored by place, class, and generation—indicate a second way in which "self-" operates: not only as the agent but also the subject of recognition.

Throughout the 1990s, these twin foci of self-recognition became increasingly spatially oriented. For Yu Hong and Song Dong, for example, the changing dynamic between center and periphery mapped onto an urban/rural divide. This, in turn, further broke down granularly according to neighborhoods, academies, streets, and other distinctions of place. As they investigated their physical environments and the people who occupied them, the artists brought their own lives front and center. By doing so, they both pushed back against practices that decentered the artist's self.

During this time, artists also experienced the scope of spatial identification

on a significantly broadened scale. In the late 1980s and throughout the following decade, Chinese artists saw the global art world transform from a potential platform for display to lived experiences replete with specific grievances. Faced with new contexts through which to be seen, artists and critics again turned to activating the dual aspects of self-recognition: of defining oneself rather than *being* defined, and figuring out what "self" entailed. This chapter opens up how artists' strategies for self-recognition contended with multiple, shifting, and overlapping spatial paradigms. In particular, I look at what happens when assertions of self-identification—initially directed at a specific urban environment—are made to address a global context.

The first part of this chapter reviews the vast debates among critics over how to construe the terms of identification in the face of increased international exposure. Throughout the 1990s, numerous art journals published roundtables and columns specifically addressing the question of "international identity."[9] The discourse on international exhibitions ranged from critics' opinions on global circuits of transmission to hashing out bitter experiences from Venice. Even when exhibitions weren't the explicit topic of discussion, worries sparked by these international venues seeped into writings at every level. Embedded within essays, interviews, reviews, and reports, phrases like *dangdai huatan* (contemporary art circles) and *guoji yitan* (international art circles) pointed to anxieties over how China was being positioned in this broadened space.

Artists and critics took part in heated arguments over whether distances and differences could be bridged. These debates escalated when artists returned home after traveling abroad and relayed their realizations to peers in China. They came back shocked that they were already seen as occupying the periphery. In 1996, after his travels abroad, artist Zhang Peili (born 1957) noted that the West's lack of attention and understanding of China was similar "to the attitude that people in China's urban centers have towards peripheral areas. News from those peripheral areas might be topics that people discuss in their leisure time, but it won't be the focus of their concern."[10] Recognizing that they were the ones on the margins of a Western-centric global art world, artists turned to the familiar impulse to emphasize themselves and their current environment. They mobilized terms like *minzu* (alternately understood as nation, race, and ethnicity) to take control of acts of definition in the face of Western cultural authorities. In spite of these collected efforts, there was little consensus on how to do so. Categories and concepts for relating self to space emerged as critical sites of contestation.

The second part of this chapter focuses on how critics employed rhetorical and conceptual strategies in their claims for cultural subjectivity. They focused

in particular on artists who addressed their localized environment. This returns again to Yu Hong's urban-centered art, which critics in the early 1990s positioned within the category of "New Realism." The surprising claims made for New Realism bring to light the specific ideological and historical framing that critics appealed to in order to orient the future of contemporary Chinese art in the world. While Yu Hong tied her paintings to recognizing the lives of bourgeois urbanites like herself, critics reconfigured the relationship between socialist ideology and cultural identity to argue for what was distinctly "Chinese" when placed in a global context. While later chapters will follow how artists negotiated these intersections of self and space through their art, this chapter focuses on the discursive arguments made on their behalf.

Overall, from the address of their immediate surroundings to debates over geopolitical relations, artists' and critics' myriad ways of thinking about space expanded and converged on a new urgency toward self-recognition. When applied to a global scope, they exceed the use of geospatial mobility as the determining factor in describing an artist's relationship to the world. Instead, as examined in this chapter, these new pathways, systems, and experiences intersected with existing changes in how space was being conceived. The deliberately expansive understandings of space here make room for the multiple frames through which artists saw themselves defining a place in the world.

To introduce the discourse surrounding questions of how to position art, this chapter focuses on art critics' debates and stances. Art critics were graduates of art history and art theory programs, often coming from the same elite art academies as artists. As art academies in the 1980s had only a couple of hundred students at a time, students from across the institution knew each other well. They lived together and engaged closely in this intimate intellectual environment. Like their artist peers, they also found positions in the cultural bureaucracy upon graduation. Many became editors of art journals, taught in art academies, or held positions in other cultural institutions. The term "art critic" is a catchall for the multiple roles they occupied: they were theorists, writers, researchers, teachers, editors, and later they took on the role of curating as well. Even if their fields of academic specialty were based in Western art or Chinese literati painting, these individuals closely observed their peers and found themselves deeply invested in the future history of contemporary art from China. Zhou Yan has remarked that art critics at the time were akin to "activists," and has declared that contemporary Chinese art was for them "an endeavor to which we have devoted our lives, as those fellow artists of our generation have done."[11] In their capacities as writers and commentators, they historicized and championed trends as they emerged. Through trends such as

New Realism, critics struggled to move contemporary Chinese art out of the looming shadow of Western-centrism. Their efforts give voice to the seething urgency felt by all in the contemporary Chinese art world to define themselves.

Heading toward the World

The rise of the global art world is often traced to the *Magiciens de la terre* exhibition (1989), which famously brought "fifty artists from the periphery and fifty artists from the center" together at the Centre Georges Pompidou in Paris.[12] Rather than starting the narrative of the global art world from this perspective, however, this section tracks its intersection with debates already simmering in China over the place of contemporary art in the world.

As noted in the introduction, a discourse on "heading toward the world" pervaded China in the 1980s. With Deng Xiaoping's reform and opening movement under way, the phrase referred specifically to a turn to capitalist countries. As contemporary artists began to anticipate global flows of circulation for their work, they contemplated the implications of this kind of deliberate movement "toward the world." By decade's end, while prospects for the global transmission of contemporary Chinese art remained slim, critics and artists penned texts imagining what this would look like.

The first blush of a larger commercial system served as one pole by which to catalog qualifications.[13] One author in 1989 warned that for Chinese art to "head toward the world," it was not simply a matter of participating in a couple of commercial exhibitions in New York. Instead, contemporary Chinese art needed to maintain its "own independent character" and find "its own unique language."[14] That same year, an article in *Meishu* aptly titled "How Can Art Head toward the World" drew a distinction between just opening the door to the outside and actually moving through it: the former implied the sale of a few pieces of art to tourists whereas the latter entailed partaking in top-tier international exhibitions such as the Venice Biennale.[15] Although Chinese artists would not exhibit at Venice until 1993, by that point the biennial was already long considered a target for advancing ambitions. Alongside these desires for inclusion, the question of how to maintain autonomy within this developing system endured.

Starting in the early 1990s, possibilities for circulating contemporary Chinese art abroad blossomed as a slew of globalizing exhibitions extended first-time invitations to contemporary artists from China: Venice Biennale in 1993, São Paulo Biennial in 1994, and Documenta in 1997. For the Chinese artists on the receiving end of these summons, exhibitions encapsulated the spa-

tial dimensions of marching toward the world in multiple ways. Breaching geographical boundaries, many artists used these opportunities to travel outside China for the first time. Once on-site, their art took part in spectacles that purported to be global in scale.

These exhibitions have been cited as key nodes in the historical expansion of the global art world. However, as Gerardo Mosquero pointed out in the early 1990s, the circuits of transmission at the time largely focused on bringing artists from the periphery to the centers.[16] This effectively amplified the power of the latter rather than seeking to forge connections among the former. To rectify this, by the mid-1990s, biennials and triennials began to take root in new host cities. The contemporary art exhibition thus emerged as a mechanism through which artists and curators on the periphery sought to alter the power relations of this spatial paradigm.

This way of thinking is apparent in a 1995 text from *Hualang* magazine by Shen Guanghan titled "The Place and Power of Asia," which envisages the contemporary exhibition as an instrument to demonstrate China's rising position within the topography of art in the world.[17] Shen argues that Chinese artists' inclusion in the Venice Biennale and São Paulo Biennial evidenced a structural blurring of "center" and "periphery." He goes so far as to claim that this demonstrates the "Euro-American hegemony of the international art world recognizing its own centrism and rectifying this."[18] Notably, this argument is embedded within a review of the exhibition *600 Seoul International Art Festival* at the National Museum of Contemporary Art in Seoul, South Korea. Calling the exhibition a common dream for all Asian countries, Shen urges China to hurry and produce its own such event. He reasons that if China can host an international contemporary art exhibition presenting an equal dialogue among artists of different countries, "only then can we say: contemporary Chinese art is an organic part of humanity's contemporary art."[19] This reference to "humanity" continues in Shen's lauding of the exhibition's theme—"Humanism and Technology: The Human Figure in Industrial Society"—as a unifying framework relevant to people all over the world. The very existence of the exhibition and its theme are cited as evidence of how such an event can serve as connective tissue for humanity, bringing together prominent Euro-American artists with celebrated artists from Asia, Latin America, and Africa into the same time and place.

This review advocates a particularly rosy narrative of the equalizing power of contemporary art exhibitions. At the same time, it inadvertently reveals the underlying anxieties that continued to lead people to issue qualifications dictating how China could assure its participation in a global art community. In the spatial paradigm Shen proposed, the global art world was not imagined as a

world without any centers. Rather, the challenge to Western hegemony would be achieved by the assertion of multiple centers, including those in Asia. Even while suggesting that China's contemporary art position still needed to be verified, this review exemplifies an important shift in China in the 1990s toward articulating globalization as a two-way process. In addition to artists venturing out to established centers of the art world, China too could position itself as a center and bring other parts of the world within its borders.

Even as some saw the possibilities presented by these exhibitions in roundly positive terms, a more prevalent view harbored intense skepticism. In 1995, for example, art critic Lu Hong rebuked artists for looking to such exhibitions as a guidepost for "global trends." He argued that in order to become worldly, Chinese artists needed to "walk out of the shadow of Western-centrism."[20] Other critics, too, employed this same spatial terminology: rather than "heading toward the world," for example, there were now calls to "head toward one's native land *(zouxiang bentu)*."[21] For these critics, rather than a shared humanity, the global art world was still dominated by a Western hegemony insidiously reinforced by Chinese artists' own infatuation with and sense of inferiority toward Western culture.

In order to move out of this, Lu maintains that Chinese artists must emphasize their own path by developing Chinese standards and objectives for art rather than looking abroad. Lu concedes that building one's own criteria for advancement may result in a kind of cultural isolation, but he also argues that just such a period of loneliness would be necessary. This highlighted what was potentially at stake in building up China as a center for contemporary art. The refusal to sacrifice one's standards and self for the sake of conformity gave credence to calls to maintain national cultural priorities. Whether it was Chinese curators bringing foreign artists to exhibit in China, or even Western curators arriving of their own accord, Lu Hong focuses his attention on the question of why others should head toward China. What was motivating this interest, particularly by those from the West? And what was motivating the desperation for this on the part of China? Lu contends that if Chinese artists establish their own path of contemporary art, Western art critics and curators will eventually arrive in China. It won't be because China has followed the West or pandered to it. Rather, it will be because Chinese artists will have developed a contemporary art of their own design that will inevitably elicit outside attention. These pronouncements for contemporary art emerged out of a perceived necessity for Chinese artists to lay claim to their own path as a measure for securing their power in the world.

As artists began to take part in international exhibitions in the 1990s, their

experiences increasingly turned hypothetical opportunities for circulation into new, urgent realities. Even as Western centers of contemporary art attended to art outside Western Europe and North America, Chinese artists came to see that "this kind of cultural exchange is not only about taking your paintings somewhere."[22] The savvy needed when speaking with the media, the necessity of claiming one's space in an exhibition hall, and knowing how to communicate with curators and audiences introduced unfamiliar social norms and behavioral codes. Chinese artists and critics were quick to realize that simply being included in international exhibitions did not rectify the existing unequal power dynamics undergirding selection and interpretation.

Artists' experiences filtered back into China and moved exhibitions beyond abstract statistics and benchmarks. For the artists who participated in them, these exhibitions yielded deeply personal and bitter realizations of what it meant to be positioned on the periphery. Indeed, the responses to the 1993 Venice Biennale reveal the poignant distinction between what was imagined for these exhibitions and what was ultimately experienced. These experiences— published, circulated, and discussed in China—continued to fuel discourses on how Chinese artists should position themselves in the world while providing cautionary counsel for what these new contexts meant. Some artists and critics continued to view exhibitions as operational mechanisms for recentering the art world while others argued that they were detrimental nodes of authority and purveyors of cultural misrepresentation. As artists returned from Venice, their experiences hardened these positions and redoubled resolve. Only a few years earlier, an invitation to the Venice Biennale was considered a hallmark confirming China's global status. In his reflections on Venice published in November 1993, Li Xianting—a renowned Chinese art critic and consultant for the biennial—remarked that participation in the biennial did not automatically testify to Chinese art's global and contemporary caliber.[23] Moving forth, Li argued, contemporary Chinese artists would need to define cultural identity, contemporaneity, and being global for themselves.

These concerns were heightened by a shared apprehension over the pretenses under which Chinese artists were included in the Venice Biennale in the first place. The theme that year, chosen by the chief commissioner of the biennial, Achille Bonito Oliva, was "Cardinal Points of Art." In an effort to subvert the institution's historical nation-state paradigm—in which artists from each nation exhibit in a national pavilion—Oliva encouraged pavilions to host foreign resident artists. This acknowledgment of diasporic artists aided his effort to challenge the "purity of a national nucleus." As he writes in the catalog, "We must acknowledge the positive contribution of a transnationality, of an

intertwining of nations capable of producing cultural eclecticism and necessary interracial unity."[24] Alongside his emphasis on cultural nomadism, Oliva heralded the idea of "voyage" within the so-called cardinal points of art. While he contended that "voyage" was an indisputable condition of the new decade, his claims for it occasionally resonated with shadowy echoes of primitivism: "contemporary art has to accept the idea of 'voyage,' the idea of referring to 'other' cultures to rediscover energy and expressive strength."[25]

Chinese artists' participation that year was concentrated in one such named "voyage": the special exhibition *Passaggio a Oriente* (Passage to the Orient). In consultation with Beijing-based art critic Li Xianting and Francesca Dal Lago of the Italian embassy in Beijing, Oliva included fourteen Chinese artists in this section.[26] The invocation of a "passage" encapsulated for viewers a voyeuristic journey to a faraway place. Rather than collapsing cultural and geographic boundaries, this appeared only to harden them, placing Chinese participants in a metaphorical space away not only from other exhibited artists but also the grounds at Venice altogether.

Discontentment over the inadequacy of exhibition space at the biennial lent a concrete dimension to the existing implications of their inferior placement within a spatial schema. Fang Lijun, in particular, expressed dissatisfaction with what he characterized as the small, cramped "Third World" space to which Chinese artists were relegated.[27] Even this reference to "Third World" in disparaging terms speaks to the vast changes in worldviews being concretized in the 1990s. During the 1960s and 1970s, China saw itself as a champion of the Third World in its challenge to imperialism. At Venice, artists saw themselves through the lens of Western curators, and accordingly perceived "Third World" as a lamentable category to which they were being derisively assigned. Disputes surrounding the selection and installation of their works played out as an affront to the participants. The artists also recount in a roundtable for *Hualang* how they were crowded out of their designated space by artists from other countries, making their allotted area even smaller.[28] The congested design of their installation resulted in what Fang called the "poorest looking exhibition hall" in the whole biennial.[29] That they had to vie for even these scraps of space with artists from other nations heightened the paradigm of global competition. In this literal jockeying for position, Chinese artists were evidently marginalized and felt woefully unprepared to contend.

That the artists were included in a special exhibition, alongside artists from Japan, furthermore accentuated the utter difference between their participation in relation to those in national pavilions. In spite of the rhetoric of transnationalism touted for the pavilions, it was apparent in the reification of

SPACES OF SELF-RECOGNITION

"the Orient" that this expanding global art world was still deeply centered in a Western perspective. In the discrepancy presented by these distinct spatial frames, Chinese artists realized that without their own pavilion, they were still at the mercy of Western curatorial authorities.[30]

The bitter disappointment that Chinese artists felt in the early 1990s has sometimes been attributed to unreasonable expectations and inflated attitudes of the invitees prior to going to Venice.[31] Rather than simply laying blame on the artists, however, it's important to examine the roots of this disconnect between what they imagined and what they encountered. Indeed, the sense of injury incurred was more than a result of venturing to a new place or seeing their work in a new context. It was a matter of seeing themselves spatially displaced.

In 1977, when art academies reopened following the Cultural Revolution, these artists were the handful who successfully tested and were selected from among thousands of applicants. At these elite institutions, they interacted with other young intellectuals. They appointed themselves leaders in the '85 Art New Wave movement, penned manifestos about art, and persevered to create artworks in trying times. In the 1980s, as part of China's planned economy, all art academy graduates were allocated jobs in state-run work units as cultural workers in China's sprawling art system. Many artists earned their salary through teaching or working in other cultural institutions, but also performed experiments outside the classroom, independent from the work unit. The notion of being a "professional artist" by making a living off the sale and patronage of their work was unfathomable at the time. Instead, they toiled to create art in their free time, dedicating the little funds left over from their salaries to buying art materials and texts, and striving to arrange exhibitions. While they were situated on the margins of the Chinese social mainstream, it was this very location relative to the rest of society and other artists that defined their avant-garde position in China. One of the most common terms used at the time to mean "avant-garde"—*qianwei*—bears the same spatial implications of being ahead or in front of.

From the peripheries of Chinese society, they saw themselves at the forefront of its small yet ardent contemporary art world. Their invitations to Venice seemed to concede this importance and, indeed, legitimate their value not just in China but within the global art world. The artists selected for Venice expected to be feted upon arrival. The rude letdown at Venice resulted from this expectation of being at the center of the contemporary art world globally, but instead finding themselves on the far-flung peripheries. Dislocation then wasn't just a case of culture shock, it was also the whiplash sustained from being decentered from their expected position within contemporary art. Upon

their return, the question of how to center contemporary Chinese art became the most hotly debated issue in the art world. This wasn't merely a matter of "centering" in terms of global positioning but also a question of how to corral and define contemporary Chinese art as a centralized entity.

Centering *Minzu*

As seen with Yu Hong and Song Dong, shifts toward self-definition and self-recognition were already under way in art in China. Their upending of existing class prescriptions for creating art brought attention to themselves as urban subjects and further distinctions in identification. In the early 1990s, as identity became tied to cultural boundaries within the global art world, those earlier nuances in identification—class, age, community—became quietly subjugated within the demands of a global art world predicated on cultural representation through cultural difference.

The question of what should serve as a basis for a centralized identity appeared most clearly in artists' and critics' invocations and interpretations of the term *minzu*. Notoriously ambiguous and mutable, *minzu* can be variously translated as "race," "ethnicity," "nation," "nationality," and "the people."[32] It was first imported from Japanese in the early twentieth century to help a struggling postimperial China conceive of itself as a nation-state.[33] Prior to this, China saw itself occupying the center of the world surrounded by tribute states. This kind of meaning has led to the term's translation as "nation" and "nationality" with patriotic inclinations. At the same time, it has been used to mean "ethnicity," such as in describing the fifty-five groups of "ethnic minorities" *(shaoshu minzu)* in China. In these cases, it can reference China as a multiethnic country. Since the second half of the twentieth century, the Chinese government has invoked the predominant term *Zhonghua minzu* to demonstrate the unifying reach of Communist ideology and its power to civilize the frontiers. Translated as the "Chinese nation," the term has been used to suggest the persistence of a bounded, collective unity of disparate ethnicities through time.

In the case of contemporary art in the early 1990s, *minzu* is often paired with "culture" *(wenhua)*, "tradition" *(chuantong)*, "color" *(secai)*, and "spirit" *(jingshen)*. These references utilize *minzu* as a centering concept. It operates as a tool for inciting cultural pride by asserting a shared heritage and implied coherence to a country that contains vastly different regional identities, let alone ethnic identities and histories. These invocations never explicitly state whether *minzu* is determined by blood, race, ethnicity, or national boundaries. This is because they already start from an assumption that readers don't re-

quire such a clarification. It was simply a given that *minzu* was equivalent to cultural unity; however a reader chose to locate the points of identification was secondary.

The wielding of *minzu* as a vehicle for self-definition linked concerns regarding the position of Chinese art in a global context with existing anxieties over Western influence. Appeals to *minzu* appeared with frequency at the end of the 1980s in response to an emergent retrospective narrative describing the decade. This narrative dwelled on artists' enthusiasm for Western art and art history throughout the reform and opening movement. While the turn to Western sources was initially considered liberating, by the end of the 1980s, this eagerness toward Western artistic trends and art history was already being reduced to a tale of Chinese artists indiscriminately copying Western art.

By 1989, critics chided artists for believing that this was the only path to achieving modernity and saw the following decade as the crucial period in which Chinese artists would cease trailing behind Western art and art history. Thus, by the time "heading toward the world"—particularly in the form of exhibitions—seemed to be an actual possibility, this both coincided with and heightened concerns over the overwhelming influence of Western culture on Chinese artists. Artists and critics increasingly recognized the need to shift from just being "non-Western" to explicitly identifying "contemporary Chinese art" as an entity unto itself. By 1990, there was already a widespread urgency toward drawing upon their own culturally defined art history. As one artist stated, "Chinese oil painting needs to stand in the world. It's right that we studied Western painting in these past few years; now it is time to research Chinese art."[34] The call for Chinese artists to draw upon their own art history as a means of recovering pride in their identity exemplifies the instrumental role of *minzu*'s cultural endurance.

In such cases, *minzu* operates as a perpetual force in possession of a luminous culture and history. Lu Hong, for example, specifically uses the term *minzu* to demonstrate China's power and persistence in the world: "In the vigorous collision of East and West, as an ancient *minzu* with a resplendent culture and our own cultural system, there is no need to be under the influence of 'Western-centrism,' imitating its value system, and going so far as to abandon our own superior culture."[35] When *minzu* is presented as a long-standing coherent and bounded entity, "our own cultural system" appears to follow seamlessly as the contemporary manifestation of a historical product. Even while at the expense of reducing the richness of the past to a streamlined coherence, this assumption of a timeless cultural heritage was necessary to pave the way for claiming the inheritance of this unified cultural identity in the present.

The pervasiveness of this binary between East and West contextualizes critics' repeated calls for Chinese artists to retain an "independent character" *(duli pinge)*.[36] This was not simply in accordance with an individual artist's character. Even more importantly, an "independent character" was guided by the perceived need to be independent *from* Western art.

Even as critics appealed to *minzu* as a means for maintaining independence from the West, the question of how it would actually interface with other cultures often led to a vague reference to "dialoguing" *(duihua)*: "Being global depends on whether we have the capacity to hold a dialogue with the international art community . . . all the while maintaining our own independent character."[37] What would be the content of such a dialogue? What kind of conversations and resonances would emerge? This was rarely addressed as defining "dialogue" was still subsidiary to asserting oneself as a partner capable and worthy of engagement.

When *minzu* was treated as a fixed entity—with art and identity secured around a historical constant—this gave the impression of an unmovable counterpart to "the West." Even while maintaining an East–West binary, some critics allowed for a more malleable understanding of *minzu*. Critic Li Xianting, for example, saw the future of contemporary art tied up in looking outward rather than looking backward. Moving forth, the "contemporarization of *minzu*" would need to treat outside influence as a necessary fact. Li presents this as something simply to be accepted, not to be shirked or lamented: "In history, there is no culture that developed outside of foreign impact."[38] This thus set up a scenario in which one needn't choose between being Western and Chinese as two completely irreconcilable forces and instead accepted *minzu* as an evolving entity.

Although Li also uses the vague term "dialogue" to describe the development of *minzu* by means of international engagement, he provides an illuminating historical analogy to *baihua*, or written vernacular Chinese. During the May Fourth Movement of 1919, intellectual reformers agitated for a radical change: transitioning from classical Chinese—a language of the elite—to the use of *baihua* in literature. Li highlights two points about this monumental reform: "The vernacular represented a new linguistic model that, on the one hand, suited the inner needs of modern Chinese people and, on the other hand, undoubtedly absorbed influence—the structure and regulations—from translations of Western texts."[39] To Li's latter point, translations of Western books modeled the usage of punctuation, which appears sparingly in classical Chinese grammar. Li's point that these different factors contributed to *baihua*

provides a precedence for a cultural model that accepted Western influence yet remained unassailably Chinese. Li's analogy advocated an understanding of Chinese culture rooted in change, one with an explicit history tied to modernization and cultural democratization. At the same time, the question of how Chinese art would "dialogue" with "international art" to form a new cultural model was left vague. This very vagueness speaks to the challenges in artists' desiring to join a larger art community yet also needing a separate space and system by which to define themselves.

These writings present *minzu* as a naturally understood touchstone for identity. Sometimes in the form of cultural references, other times simply as "the lifeblood of the nation," *minzu* was treated as a composite unity of categories binding people together and pulsing through a person's very being. Even while Li Xianting argues for the evolution of *minzu*, he sees an individual's identification with it as persistent and unchanging: "Internationalization won't dissolve the specific characteristics of region or *minzu*, because an artist first and foremost must confront oneself and the environment of one's existence."[40]

The Social Responsibility of New Realism

During the early 1990s, artists' intimate connections with their environment quickly became identified as key aspects of expressing identity. While spatial identification can be considered part of *minzu*, its emphasis here helped to ground the terms and give a literal dimension to how an artist's identity could be pictured. In many ways, it was paired as an external counterpart to an internalized *minzu*.

As indicated at the beginning of the chapter, artists like Yu Hong were already engaged in seeing themselves in relation to a specific place. She, along with a group of young artists from the Central Academy of Fine Arts, such as Liu Xiaodong (born 1963), was championed for her focus on her immediate surroundings. In his observations of young artists in Beijing, critic Yin Jinan dubbed this phenomenon "close-up looking." He described these artists as engaged in "depicting trivial matters from daily life, often making the people most familiar to them central subjects in their works."[41] Critics' support for this trend derived from the same anxieties that motivated the invocation of *minzu*. "Artists' attention to society" brought focus on places and issues specific to their own lives in a move away from the 1980s' fervor for Western culture and philosophy.

Artists' interests in portraying their surroundings have often been discussed in terms of a domestic historical context. Yin Jinan cites, for example,

the "general spiritual fatigue" caused by both political unrest and new market reforms. And, like the shift away from the grandiose philosophies of the 1980s, interest in their immediate surroundings offered a place for mundane quietude after the chaos of recent years. But rather than just seeing this as art receding into an inward withdrawal, Yin Jinan also makes a case for the significance of this trend as an assertion of worldly positioning. Artists' addressing of their own environment rejected the assumed need to be "synchronous" with the rest of the world: "The pursuit of synchronicity—this way of thinking—has tormented Chinese artists for a long time. . . . Chinese artists don't have to feel that they need to answer some kind of 'international art question.' . . . Chinese artists in Beijing don't need to feel that they have to answer cultural questions in New York or Paris."[42]

Before, it was assumed that recognition of contemporaneity required a "synchronicity" dependent on an address of "international" subject matters. The privileging now of Chinese artists' examining their own lives freed them from assuming that this would automatically position them as backward or behind. Yin's comments point to the possibility of multiple contemporaneous temporalities. In the service of pushing back against an overreliance on Western influence and a singular temporal track, the turn to *minzu* and spatial specificity facilitated self-determination in one's art and contemporary status. More than simply a case of subject matter, artists' depictions of their own lives concretely confirmed their location in a specific time and place. That this was framed, in turn, as a validation of their rightful place in the world showcases the larger context in which critics positioned contemporary Chinese art.

In interpretations of Yu Hong's works, the ideological interventions that jump-started her paintings—the desire to see her life depicted in art—fell to the wayside. The value of referencing her immediate surroundings became tied to cultural specificity rather than class or age. In 1990, amidst a discussion about the future direction of oil painting in China, art critic Yin Shuangxi commented: "I believe that the most basic difference between Chinese oil painters and Western oil painters is that no matter what generation—young, middle-aged, or old—they [Chinese painters] all earnestly focus on China's social reality . . . and aren't just idly and purely studying points, lines, surface, form, and color."[43]

To Yin, it wasn't merely artists' depictions of scenes of life in China that made this art Chinese. It was the underlying impulse for social relevance that set Chinese art apart from Western art. The connection to social reality brought with it an inherent earnestness that contrasted with the "idleness" ascribed to Western formalist painting. Yin's comment offers an enlightening window

into deeply held beliefs connecting artistic purpose and social responsibility. His recognition of artists "restor[ing] anew the power of realism" specifically holds up realism as a way of demonstrating Chinese art's moral superiority to Western art.[44] This recognizes and takes pride in an explicitly ideological artistic lineage. As will be explained later in this chapter, the discourses around realism since the early twentieth century—from academic realism to socialist realism—expressly tied art to national salvation. Yin's arguments for realism harness the historical weight of this lineage in an effort to activate its relevance in a global art world. His identification of realism as a source for defining Chinese art leverages its extant history to show the innovative directions of young artists while simultaneously proceeding from an established genealogy. Moreover, this historical background and its upholding of social relevance assert a clear distinction from Western art.

Many experimental artists—like Song Dong—studied oil painting in the academy only to abandon it after graduation. This has resulted in a view that all easel painting, particularly realism, is antagonistic to experimental art. These divisions, however, ignore the surprisingly similar motivating factors for many of these artists: a desire to sustain a direct connection between their art and their own social reality. But the initial motivations for rejecting the ideological restrictions concerning *whose* social reality were conveniently bypassed in interpretations of these works in the early 1990s. Artists like Yu Hong, whose works critics were labeling as "New Realism," were now seen as endorsing a specifically Chinese art and ideology. Thus, even as artists may have originally rejected the ideological restrictions espoused by the academic curriculum, supporters argued that these works inherited the legacy of what realism should be. The very fact that artists addressed their own lives was now celebrated for maintaining the "social relevance" particular to Chinese art over and against contemporary Western counterparts.

Artists like Yu Hong and Liu Xiaodong were applauded for their ability to observe reality beyond just copying it, and to reveal social truths the way past realisms were tasked with doing. Liu Xiaodong's paintings from this time, like those by Yu Hong, feature his peers. But unlike Yu's sparse or solid backgrounds, Liu fills his with detailed sites of urban existence. Often awkwardly cut off in the composition, figures are placed directly in the foreground and middle ground. In *Frustration* (Figure 6), the table surface tilts at a peculiar angle such that we expect the clutter on it to tumble forward at any moment. In his 1990 feature on Liu Xiaodong for *Meishu* titled "Liu Xiaodong's Realistic Expression," critic Fan Di'an focuses on how these distorted forms indicate a latent authenticity: "These interior spaces bring a clear taste of common life

(putong shenghuo), making clear that what he wants to show is a trustworthy reality *(kexin de xianshi).*"[45] The phrase *putong shenghuo* gestures at the seeming casualness of these images; their interiors don't appear formally staged. At the same time, the implications of this phrase as ordinary and common also aids in eliding apparent class distinctions. What is depicted is certainly the life of young, educated, bourgeois city dwellers, but the suggestion that they are scenes of *putong shenghuo* implies a broadly shared reality that omits the particularities of class.

Fan continues: "Liu Xiaodong's way of viewing reality possesses a kind of concretization to reality; he doesn't set out to express a fictional scene before he paints, but rather sincerely confronts the perceptions of actual forms."[46] Fan applauds Liu for not relying on metaphors, symbols, or preconceived narratives, and instead directly grasping the reality "in front of one's face." This focus on perception leads the author to argue that Liu's paintings have a kind of "acknowledgment of reality and expression of reality's specific character."[47] As exemplified by Fan's text, writings about this group of artists are replete with terms like veracity *(zhenshi),* reality *(xianshi),* and actual *(shishi).*

In these references, we hear the echoes of the 1980s discourse on *shishi.* Deng Xiaoping invoked the phrase *shishi qiushi*—seek truth from facts—to "realign representational reality with objective reality."[48] Deng's focus on "objective reality" extends beyond pragmatic "fact" and needs to be seen as rooted in a claim for moral truth. This is, in fact, congruent with the ways in which realism has been framed in Chinese art history. The return to this kind of language to describe New Realism in the 1990s mirrored the terms used to assert the moral mission of realism in the early twentieth century.

When realism was first pitched as a means of modernizing China in the 1920s, it was perceived as more than simply techniques and effect: "'The real' could mean both metaphysical truth and social reality, materialized through the depiction of the real world."[49] As Wang Cheng-hua notes, this was articulated in writings on realism through terms such as "*xieshi* (Realism), *xianshi* (the real world), and *zhenshi* (veracity), all with the key character *shi* (substance, reality, or truth)."[50] In the 1990s, these same terms acted as agents to argue for how New Realism continues this historical ideal of issuing an unvarnished reality. In the early twentieth century, the training of artists to apprehend reality through drawing from life *(xiesheng)*—itself facilitated through the science of linear perspective—brought representational and scientific truth into convergence.[51] In the 1930s, when artist and educator Xu Beihong brought academic realism back to China from France, he aligned artists with scientists in their mission to seek truth.[52] Xu's later roles as chairman of the Chinese Artists'

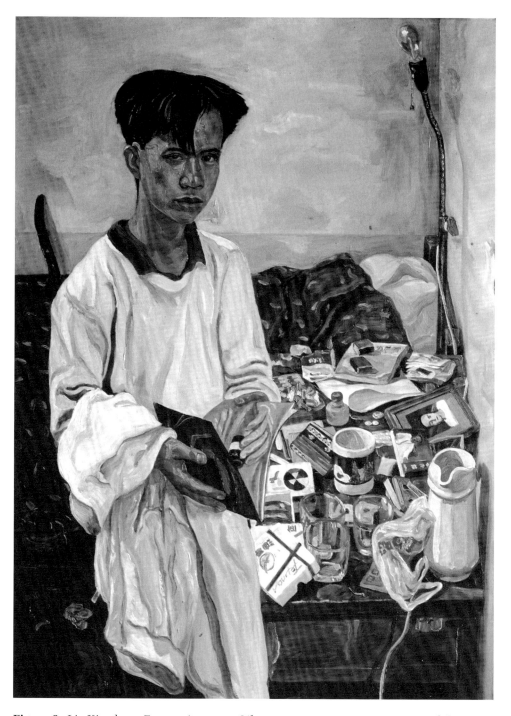

Figure 6. Liu Xiaodong, *Frustration,* 1991. Oil on canvas, 130 x 97 cm. Courtesy of the artist.

Association and president of the Central Academy of Fine Arts cemented realism as the art for a new nation. As a powerful political tool, it could be wielded both to depict the present and construct aspirational visions, all of which were assumed to bear truth-value.

After the founding of the People's Republic of China in 1949, the practice of observing from life occupied a key role in rendering truth. As one newspaper article from 1950 explained, "It was a hard task at first to reform some of the students who were worshippers of Matisse and other modern French artists. They refused to go to the farms and factories. They wanted to study art in classrooms. . . . Under the new system the students have improved both in political understanding and technique."[53] The reeducation of bourgeois intellectuals emphasized the revolutionary value of realism and its basis in the lives of the proletariat. Even as socialist realism moved continuously toward creating heroic ideals and away from capturing verisimilitude, the foundational skill of drawing from life remained a core component of the curriculum when art academies reopened after the Cultural Revolution.[54]

In the early 1980s, these emphases on learning from the people yielded paintings in the vein of Native Soil Art. Artists such as Luo Zhongli (born 1948) used these experiences to monumentalize the hardship and struggle of peasants. Chen Danqing (born 1953), meanwhile, injected his series on Tibetans with a primitivist spirit. While their works departed from narrative expectations of past realist art, they nonetheless upheld the value of directly learning from the lives of their subjects.[55] Still working in the realist idiom, they imbued their artworks with a kind of heroism and sympathetic romanticism.

The fact that New Realist painters focused on their own urban bourgeois existence should have been condemned under socialist art parameters. But art critics' discussions of *minzu* deliberately overlooked these class distinctions. The significance of these works was now chalked up to "close-up looking" and revealing reality, but with nary a mention of whose reality and whose existence. Indeed, in his claims for New Realism, art critic Zhou Yan notes how these artists have done away with the idealist romanticism that marked earlier incarnations of realism. He also makes sure to note that "no one can say these works are divorced from life, no one can say they're divorced from the masses."[56]

It's important to see Zhou's identification of these urban youth as "the masses" as a radical departure from the Party-State position at the time. In the wake of the Tiananmen Square massacre, the government used its cultural organs to issue mandates on what needed to be "corrected" and "rectified" in art. Situated under the Party-State-run Chinese Artists' Association, the magazine *Meishu* organized conferences focused on the development and direction

of contemporary art in China. Conference proceedings, published in *Meishu* throughout the early 1990s, identified the ills of the '85 Art New Wave and its culmination in the 1989 *China/Avant-Garde* exhibition. The greatest offense was found in artists' preoccupation with "self-expression" *(ziwo biaoxian)* and "placing oneself at the center" *(yiwo wei zhongxin)*.[57] In its most rigid formulation, the socialist understanding of art refuted "self-expression" in order to express only the will of the people. Representatives of the Party-State reiterated Deng Xiaoping's points: "The people need art, art needs the people even more," and "the people are the mother of art and literature workers."[58] Accordingly, they condemned art that could not be understood or accepted by viewers.

That art critics like Fan Di'an and Zhou Yan would describe work that was "expressing the self" using the vocabulary of "the masses," "authenticity," and "common life" was a strategic feat. This vision stood in distinct contrast to what was exhorted by the Party-State. Interestingly, while critics did not adhere strictly to the Party line, they adapted the language and even in some cases the logic of socialist ideology to support their positions. In the politically sensitive atmosphere following 1989, critics navigated between what was politically acceptable and what they deemed the right path when issuing opinions on the direction contemporary Chinese art should take. Even while working within state institutions, they were not spokespeople for the Party-State. They issued opinions that—while fairly moderate and mild—diverged from the Party-State's thick rhetoric and narrow views of art. From 1989 to 1992, in particular, many actually found themselves on the receiving end of hostility from the Party-State delivered both through published attacks in *Meishu* and pressures within their own institutions.[59] As Shui Tianzhong would later reflect, the Party-State needed to flex its muscles in campaigns to "tidy up" and "rectify" cultural production after Tiananmen. And while he and other art critics weren't making radical suggestions or even agreed on where to put their energies moving forward, they were still publicly critiqued by the Party-State because "political movements need an opponent."[60]

This points to the peculiar time in which all parties—artists, critics, and the Party-State—were still staking out stances that increasingly took the global positioning of contemporary Chinese art into consideration. These incremental deviations in perceptions and usages of socialist ideology show a nuanced range of standpoints and strategies. Critics' tactical invocations of realism and the social responsibility of art were pitched at positioning Chinese art globally. Part of this arose from how critics saw themselves—both through their institutional roles and self-defined interests in contemporary art production—as uniquely situated to orient contemporary Chinese art.

With an emphasis on the importance of social relevance, moral superiority, and the recognition of objective reality, the discourse on contemporary Chinese art mirrored how critics envisioned their responsibility: to identify healthy artistic developments and justify their value. Histories of Chinese art criticism have seen this period of writing as lacking in "theoretical depth" and "micro-analysis."[61] This is unsurprising given that critics at the time were more focused on verbally constituting what they saw as necessary developments in art. They used tactical language to uphold New Realism—authenticity, sincerity, and reality—locating it in an existing cultural genealogy whose contemporary iteration declared itself to be Chinese in subject matter and moral disposition alike.

That critics saw themselves as guides and guards to contemporary Chinese art became all the more vital as "Cynical Realism" began to enjoy favor among foreign audiences from 1993 onward. Popularized by Li Xianting in 1991, Cynical Realism—along with Political Pop—quickly became a darling in the global art world. Works of Cynical Realism, such as *Revolutionary Family,* by Liu Wei (born 1965) (Plate 1), took the deliberately distorted perspectives and intimacy of Liu Xiaodong's paintings to new levels of disfiguration and confrontation. That this too was called "realism" offended many Chinese critics who proceeded to condemn works labeled as Cynical Realism. Objections ranged from its unhealthy influence to its negative portrayal of the country. Underlying these assessments was the most grievous offense of all: a sheer lack of recognition of what constituted reality and realism in China.

In 1993, writing in *Jiangsu Huakan,* Lü Peng complained of the overproduction and attention paid to cynicism abroad. Lü argued that contemporary Chinese art had become a politicized plaything outside of China and called out Cynical Realism as "selected by those (including Oliva) who don't understand Chinese culture, tradition, and the current social reality."[62] In addition to critiquing the limited selection of art and its politicization in international exhibitions, Lü was disturbed by foreign curators' assumption that they understood the "reality" ostensibly presented in Cynical Realism. The capacity to recognize reality in art was a role Chinese critics had set out for themselves. The fact that Cynical Realism obscured both that which was "real" and the moral responsibility of realism made its popularity all the more vexing.

In 1994, Shao Dazhen responded directly to this trend, finding the labeling of these works wrong on two counts:

> What has been called "Cynical Realism" needs to be concretely analyzed. The content of some of these works is not in fact cynical, but rather realist, especially those that describe the conditions of existence

of the artist himself and surrounding people. . . . These should be positioned as "New Realism.". . . For the other kinds of "Cynical Realism," I think these aren't new, and don't truly have any realism *(xianshi xing)* of which to speak.[63]

To Shao, the very label "Cynical Realism" misunderstood the genuine and sincere observations present in some of these works. Paintings, such as those by Liu Xiaodong and Yu Hong, were not cynical. At the same time, those that focused on psychological deformity were not representative of reality at all. Shao's comments draw a fine distinction between how and why the application of "real" could and should be used.

The grievances launched at Cynical Realism focused on its unhealthy direction for art, its misrepresentation of realism, and the lack of understanding of realism's historical legacy. The overrepresentation of "cynicism" unveiled deeply rooted issues that pitted Chinese critics against Western curators: Who understood reality in China and who had the right to explain it? Who can distinguish between that which is distorted with sincerity versus disfigured in a harmful way? Who is protecting the future of contemporary Chinese art, its history, and its position worldwide? As artists turned to their own environment, critics fretted that even this shift could be misconstrued and manipulated in the global art discourse.

The claims for the power of realism continue to be issued today by practicing curators and critics of contemporary Chinese art. In his essay "Realism Is a Kind of Ideology in China," curator Wang Chunchen entreats artists to return art to qualities that he sees in realism: "strong creative desires in the sense of a comprehensive creation from personal experience, and a self-display of national cultural mentality in a new era."[64] In his argument that realism "is not just a kind of reality seen through our eyes," he follows a tradition of invoking the tie between "reality" and artists' capacity to render truth. The persistent hold realism continues to have—not as style but as an ideological imperative and positive moral force—finds power both in its possibilities for social critique and within its extant cultural history. Writing in the post-2000 era, Wang Chunchen sees a particular urgency toward positioning "realist" as an attitude and a spirit in order to counter the "false motives" related to the market. In this way, his invocation of a "national cultural mentality" activates a twenty-first-century extension of the call for social responsibility that critics laid out for Chinese artists' striding out into the world in the late 1980s and early 1990s.

How do we understand the ideological doctrines and systems that have governed art production in China? Sometimes, interpretations of contemporary

Chinese art have been framed only in terms of knee-jerk subversion of these constrictions. In fact, this characterization has historically granted contemporary Chinese artists their cachet abroad. That is, because contemporary artists' identities and works are identified as countering broadly conceived ideological restrictions, they are labeled as "dissidents." To combat this view, some scholars have also claimed that art needs to be seen beyond the ideological conditions of its production. In other words, while the ideological needs of cultural production are periodically trumpeted by the Party, contemporary art in China exists in its own autonomous, market-driven sphere that functions apart from the reaches of the Party. The need to see contemporary Chinese art as either countering or more than just according to China's ideological context has led to claims that artists were interested in forging "reality free from ideology" and, in turn, encourages seeing "contemporary Chinese experience in universal terms."[65]

In both cases, however, the rush to identify art as operating either out of or in opposition to an established set of ideological parameters has often foreclosed further examinations of ideology and art. This is also because of the tendency to categorize art and expectations of its political functions as either overtly critiquing or obsequiously serving. In doing so, however, we miss nuances of the particular aspects of ideological concerns that were called attention to, reconstrued, and framed to make claims for art.

It is in critics' explanations that we can see what they saw fit to highlight, what they were defining value against, and what they were trying to move art toward. The reasoning and rhetoric employed to defend New Realism in the early 1990s reveal what some critics deemed best for the future of contemporary Chinese art. While the defense of realism may seem surprisingly conservative given the more common association of contemporary Chinese art with the desire to break away from ties to the academy, the reasons given for its support showcase the peculiar place of contemporary art in the early 1990s in China. Similarly, as artists' depictions of local environments have often been situated within a "domestic turn," this can mistakenly imply isolation from the global context, or even active defiance of it. But it is important to recognize how these same features of spatial specificity were held up as a defense against the looming threat of Western hegemony.

Artists' addressing of their immediate surroundings as a means of self-identification could also be directed at multiple, intersecting spatial paradigms. Yu Hong's own encounters with Western contemporary art reveal yet another take on this. In 1993, she moved to New York for a year. Prior to going, she recalls seeing photographs of Western contemporary art that made little sense

to her, in particular, images of demolished cars that had been compacted. It seemed like such a strange concept with little resonance for her: "Why would someone make such a work?"[66] Living in New York, however, she saw firsthand the prevailing automobile culture and suddenly images of vehicular detritus made sense. What had seemed utterly foreign and abstract struck a familiar chord. The message she gleaned was that "contemporary artists in the West were creating art about their lives and surroundings."[67] She notes that at the time in China, few people had personal cars. But, seeing the context in which such art could be made, she now realized that other artists, too, were creating work tied to their own lives. This revelation provided a sense of connection and became a means of unlocking contemporary art from other parts of the world. Even more importantly, Yu Hong's realization confirmed that this was indeed the trajectory she wanted to pursue. While critics placed her work in terms of global cultural difference, Yu Hong's experiences saw her cultural specificity as a means of facilitating connectivity.

The following chapters continue to show artists' efforts to use their work to validate their experiences and histories. For many, what was at stake was the capacity to define themselves and the rightful direction forward in order to establish their place in the world. And, within this, a discovery of how the dual emphases—on their own existence and the everyday—could be used to recognize the specificity of contemporary Chinese art as a declaration of worldly belonging.

Zhang Xiaogang
Bloodline *and Belonging*

Zhang Xiaogang's *Bloodline* series has the dubious honor of being well recognized across the world as an iconic representation of contemporary Chinese art. Soon after Zhang debuted the earliest incarnations of *Bloodline* in 1993, it skyrocketed to international fame. In 1994, it exhibited at the São Paulo Biennial and in 1995 was selected for the Venice Biennale. Over the years, Zhang's smoothly rendered figures have stared out from numerous exhibition catalogs, magazine covers, and newspaper articles. Each wave of publicity, however, has also prompted backlash, simultaneously driven by and reproducing accusations that the series deliberately caters to Western tastes. In subsequent historiographical efforts to unmask the power relations underlying the formation of a contemporary Chinese art canon, Zhang's series has often been cited as an example of the selective propagation of particular artists and works. While rightfully critical, these narratives rely on recycling well-trodden interpretations of *Bloodline* as politically cynical and historically nostalgic.[1] This, in turn, perpetuates allegations that Zhang panders to the Western predilection for dissident art and upholds views of a backward and enigmatic China. These critiques, however, confuse the subsequent treatment of *Bloodline* with its intended meaning.

In fact, Zhang's series emerged out of his self-conscious mandate for Chinese artists to establish "contemporary Chinese art" for themselves. That these paintings began in defiance of being defined by a Western-centric global art world makes the hijacking of their meaning all the more ironic. This chapter begins by giving credence to Zhang's efforts at self-definition. It follows the artist's changing parameters for conceiving of art and how he arrived at such an explicit cultural agenda. Centering the narrative on the artist's inquiries into art interrupts three frameworks that have dominated interpretations of *Bloodline* by reconsidering how the paintings themselves assert terms of worldly engagement, art historical lineage, and pictorial representation.

Too often, the relationship between art and the world remains limited to geospatial parameters. When "global participation" is based on a work's exhibition and renown abroad, this fixates on what has been *done* to an artwork. This way of accounting for global participation reinforces an alarmingly passive role for contemporary Chinese art where it can only be *made* global. This has furthermore doubly constrained perceptions of *Bloodline*: while geographical circulation of the art as object is used as a marker for inclusion in the global art world, assessments of the art as image remain within a strictly domestic narrative. Indeed, scholars and critics often only see the relevance of Zhang's images of lovers, comrades, and families in relation to localized conditions and concerns. Analyzing the artist's techniques, form, and content as assertions of worldly belonging pushes back against current assessments of both the artist's work and the limited ways of registering global participation.

Zhang approached *Bloodline* as declarations of "contemporary Chinese art." In this way, he identified these works as being both culturally specific *and* deviating from the West. This is apparent in his 1996 comment on the series: "Compared to the West, Chinese people's individuality is hidden; in China we emphasize 'relationships' *(guanxi).*"[2] The need for *Bloodline* to have both of these features—cultural specificity and contrast with the West—emerged from the artist's views on how contemporary Chinese art should operate in the world. This chapter opens up how Zhang employed specific changes in his artistic process to achieve this through *Bloodline* and, furthermore, how this actively worked against his earlier perceptions of what it meant to belong in the world.

Positioning Zhang's address of "relationships" within shifting perceptions of an artistic community helps align his thinking about the topic beyond just familial and sociopolitical relations. While the familial aspects are compellingly present in the work, the critical importance of relationships in art extends even further for Zhang. This requires going beyond the tendency to read a work only through its subject matter. Instead, this situates Zhang's winding path to self-definition—particularly as a matter of "relationships"—against a background of radical shifts in conceptions of shared art histories and artistic traditions. When Zhang found a cache of family photographs in 1993, his intensive study of them reached past extracting subject and style. He saw them as an opportunity to locate a place of belonging in the historical tradition of picturing relationships. To this end, this chapter excavates the multiple ways in which *Bloodline* references belonging, not only in terms of the literal imagery of family, but also as invocations of cultural heritage and formations of artistic lineage.

Although the earliest incarnations of *Bloodline* were paintings based on extant photographs, Zhang's efforts to locate an artistic lineage also led him

ZHANG XIAOGANG

to move beyond this source. Nevertheless, Zhang's focus on family portraits has often led scholars to gloss his paintings as imitating photography. In 1994, his paintings began to take on a characteristic smoothness. His concealment of any emphatic mark making has been described simply as a photographic finish. These characterizations, however, overlook the artist's measured tactics for picture making. The resulting smoothly rendered surfaces weren't reached solely through a process of building up the canvas but also through a method of subtraction and distillation. *Bloodline* departed from the artist's previous material vocabularies and attendant understandings of how subjectivity manifests in art. To say that he was "imitating photographs" overlooks the artist's struggles in trying to figure out how he could meet the imperative of self-definition through art.

Similarly, as the figures in his work have taken on similar facial features and expressions both within and across paintings, scholars and critics have interpreted the combined smoothing over of texture and features as a process of metonymic standardization. With its focus on family and its seeming move toward anonymization, *Bloodline* has thus been read as the artist's critique of the socialist suppression of individualism in China.[3] However, the continued acceptance of these works only as ideological critique is a symptom of the restrictive politicized expectations placed on contemporary Chinese art.

By interrupting the dominant narratives about *Bloodline*—from the limited terms of global participation to the artist's visual language—this chapter reconsiders the shift toward what appears to be visual "anonymization" as part of the artist's radical rethinking about pictorial representation. This follows his serpentine journey toward coming to terms with "what is Chinese" and why this mattered for art in a globalizing era. At its heart, this traces the intentional artistic and political experiments in *Bloodline* as part of Zhang's efforts to untangle and define a place of belonging in visual, art historical, and global contexts.

Bonded Brethren

To understand the significance of belonging as a matter of self-location, it is necessary to return to the 1980s both in terms of how Zhang experienced the decade and the historical revisions that he subsequently imposed on it. Throughout the 1980s, Zhang Xiaogang exuberantly consumed newly translated texts on Western philosophy and vigorously debated them with his peers. Looking back on those years, however, Zhang now refers to them as a period of "misreading" *(wudu)*.[4] With the retrospective knowledge of the multiple

shutdowns of the *China/Avant-Garde* exhibition and the devastation of the Tiananmen Square massacre, it is unsurprising that many artists look back on the 1980s with lament. Indeed, it is common to hear artists dismiss it as a time of immaturity and cite their indiscriminate copying of Western art styles and adoption of Western philosophy as examples of naïveté.

When reviewing Zhang Xiaogang's writings from that time, however, it is clear that what was subsequently labeled as "misreading" was also a period of discovery, eagerness, and possibility. While Zhang would later cite the connectivity in *Bloodline* as distinctly "Chinese," the deep-seated notions of belonging that he experienced in the 1980s extended beyond the national and permeated his earliest feelings about art. During the mid-1980s, the proliferation of regional art groups during the '85 Art New Wave showed the appeal of power in numbers. Zhang, a member of the Southwest Art Research Group, was deeply cognizant of these effects, noting that the members thought of themselves first and foremost as a collective.[5] Even as these kinds of groups dissolved in the 1990s, the desire for belonging did not dissipate. Instead, as the artist drew new lines of identification within an entangled web of artistic, historical, and global ties, he channeled that yearning into calls for cultural solidarity.

Zhang was part of the first generation of students accepted into the art academy after they reopened in 1977. Because colleges had been closed during the Cultural Revolution, the ages of the incoming students ranged wildly. Zhang's class, for example, included Luo Zhongli (born 1948), Cheng Conglin (born 1954), and He Duoling (born 1948). As Zhang was born in 1958, these classmates were all five to ten years older than he. In the early 1980s, Luo would quickly rise to fame as a Native Soil painter whereas Cheng Conglin's paintings of the recent past pioneered Scar Art. He Duoling's dreamy images extended a particularly contemplative vein of Scar Art. Perhaps owing to his younger age, but more likely because of a "radically different artistic orientation and aspiration," Zhang found himself pulled in another direction.[6] For his *xiaxiang* sketching trip, he spent a month and a half sketching Tibetan communities. When he returned, however, unlike the sympathetic images produced by his classmates, his sketches were all in the style of Vincent van Gogh.

During his years at the Sichuan Fine Arts Institute, Zhang eagerly absorbed the influx of newly available translated texts and art catalogs. In addition to whetting his appetite for knowledge, the experience of learning modeled a supremely social process of collective sharing and debate. At the academy, he found other young artists equally enthralled with impressionism, expressionism, and surrealism, and eager to discuss the philosophies of Sigmund Freud and Friedrich Nietzsche. Through these intellectual endeavors, art and art his-

tory provided a rarefied site for identification and belonging. Most immediately, this included locating like-minded peers in the academy. But this also reached further into art history as artists found thinkers within the pages of Western art catalogs and texts that they counted as brethren.

More than simply delivering content, the texts artists studied served as sources from which to seek guidance and form connections. For Zhang Xiaogang and his compatriots, particularly those in the Southwest Art Research Group, solace and historical antecedents could be found in Western art history. In a letter to his fellow artist Zhou Chunya (born 1955) from May 24, 1984, he writes: "We, the captives of the Muse, should dedicate our sincerity to her so that we can approach the divine step by step, get closer to the edge of the world and embrace everything in existence, which is the biggest nothingness. In this respect, Michelangelo, El Greco, and Cézanne are our greatest ancestors. And Gauguin."[7] The artists he turned to most were not simply a source for stylistic borrowing and experimentation; they were the very figures alongside which he situated and defined himself. And the fact that this was shared among his close peers—fellow "captives of the Muse"—further ensured a kind of collective belief and intimacy among the group.

This sense of a shared lineage was especially vital after leaving the academy. Most graduates were assigned to jobs as cultural workers in remote places. To battle the isolation, they used their art—and art history—as the basis for maintaining a sense of belonging. Although isolation did come, it also intensified the desire to seek out connections. After graduation, Zhang was assigned to work for a theater troupe in Kunming, Yunnan Province, where he painted and wrote letters at night to sustain himself. When he was transferred to a teaching position at the Sichuan Fine Arts Institute in 1986, he spent time back in the school library again, poring over publications from abroad. Zhang was especially enamored of narrations of artists' lives; in many ways, it was their existence as models that gave him something to hold on to when what he sought was so much on the periphery of social acceptability. Seeing these Western painters as "gods," he says, "They gave us encouragement."[8]

For Zhang, this identification with and through Western art history continued into the early 1990s. His close friend and fellow artist Mao Xuhui (born 1956) similarly wrote about Western art as a point by which he oriented himself: "I didn't know how to express my feelings after reading [your letter]. I immediately went to the foreign-language bookstore to search for something that could convey my emotions. I bought a cassette tape: Brahms's *A German Requiem*. The tape should arrive at your address very soon. Let's listen to this sound of the soul together!"[9] Zhang and Mao's love for specific artists was

rooted deeply in the belief that they possessed a special appreciation for and, indeed, inheritance of these expressions. Over the years, these letters and discussions of Western art helped fend off feelings of alienation when the two were far apart. Sharing music and declaring passions, and through references to the Western artists that they held so dear, they maintained a bond of brotherhood deriving from a collective sense of artistic purpose and lineage.

While reading texts and debating their contents was one way of bringing ideas to life, for artists it was the physical process of art making that truly enabled them to bridge that historical gap. In this way, for Zhang and his peers, the very act of painting was the corporeal complement to their attempts at mentally and intellectually effecting closeness through textual learning. Reproducing, emulating, and manifesting the art and artistic spirit of Paul Cézanne and El Greco, for example, cultivated an intimacy with even the most remote "ancestor." In doing so, they inserted themselves into an existing artistic legacy.[10] History thus served as a critical access point for defining both self and the possibilities of art. Rather than a culturally specific history, Zhang aligned himself with those he saw sharing his understandings of and desires for art. At the time, Zhang also took great interest in Chan Buddhism. As these sources had also been banned during the Cultural Revolution, he—like many peers—sought out both translated Western texts and books on ancient Chinese philosophy. Yet, even though Zhang used these sources to inform his ideas about "ancient mysticism," the specific artists he cited as brethren were always Western.

Throughout the 1980s, his paintings and letters are suffused with a fixation on psychological and pathological references to the state of the "soul," interjected with allusions to loneliness, pain, and trauma. But, it was after June 4, 1989, that his paintings specifically turned to address the tensions between individual alienation and social connection. At the time, Zhang was a teacher at the Sichuan Fine Arts Institute in Chongqing and witnessed, as at other campuses, the agitation of student protest and subsequent shutting down of those voices. The tragedy of Tiananmen profoundly affected Zhang: "Understanding violence, what is violence, it's not simply killing a person, but rather destroying someone's spirit in a moment. This feeling was especially strong. . . . That was the first time I experienced it; ah, society changes in a moment, idealism is crushed."[11] That he wanted both to excavate his soul and showcase the shared pain of individuals in society led to his *Private Notes* series, which he produced from 1989 to 1992.

All of the *Private Notes* paintings depict interiors in which the fragmented body parts of a person—presumably the artist—engage in different activities.

One Week of Private Notes (Figure 7) comprises seven paintings, the order of which is indicated by the calendar hanging on the back wall in each picture. The numbers, 1 through 7, indicate the days of a week and serve as the only references to a temporal logic as the depicted scenes refuse any kind of discernible, ordered narrative. Days 1, 2, and 3 focus on the interaction between a decapitated head and a gesturing headless body. Actions in days 4, 5, 6, and 7 take place on and around a sealed box or trunk: on day 4, a disembodied hand writes letters while a floating head looks on; on day 5, a legless figure (with a pair of legs suspended on the back wall) lies face down reading letters; on day 6, a red disembodied hand points to a passage in an open text; and, on day 7, an outstretched arm lies diagonally, palm facing upward, across a stack of letters.

While the dismembered body and parts lend the works a jarring quality, what we actually see here is a series about monotony and malaise, and the difficulties of communication—both textual and visual—implicated within this. From day to day, the changes in activity are muted by the sameness of the space and the recurrence of the same symbols. The sense of repetition is further implied by the temporal unit of the series. The calendar numbers point not to a particular day but merely to the painting's specific point within a cycle. As we imagine the cyclical time frame of the week continuing in endless perpetuity, the figure's actions and existence correspondingly strike us as increasingly trivial. In his writing, Zhang reveals, "I often feel that as a contemporary Chinese artist, the first thing I must confront is an inherited misery, conflict, repeated absurdity, etc. . . . living in one vicious circle after another."[12] Here, the very act of painting that he engaged in day upon day was a part of this seemingly endless cycle. In the repetition of motifs and the continual depiction of this space, painting these images implicated his body in the very subject and format of seriality. In this way, painting precisely manifested the same formulaic pattern addressed in his canvases as a monotony of existence.

In their depictions of reading and writing, however, the paintings also proposed a way of reaching outward. In Zhang's life, writing continued to serve as a vital complement to his painting. He pored over missives from artist friends and let his writing serve as a release of his deepest thoughts and psychological turmoil. Whether the stack of letters depicted in the scene is to be delivered or has been received, it evidences a desire, if not a promise, of connectivity. Even in the bleakest state of isolation, there was something to be shared, even if it was the sense of isolation itself: "These were all very private, related to the intellectual, representing the kind of forlorn helplessness of being discarded into a corner. The relationship between society and man's privacy is very ambiguous; private things are very fragile, easily forgotten and easily destroyed.

Figure 7. Zhang Xiaogang, *One Week of Private Notes,* 1991. Oil on paper. Days 1, 2, and 3 are 53 x 39 cm; days 4, 5, 6, and 7 are 39 x 52 cm. Courtesy of the artist.

My works are actually exploring what exactly is the relationship between the individual and society."[13] It's easy to view these paintings like his personal diary entries. Yet, while rooted in his own depression, these notions about the absurdity of human action, alienation, loss, monotony, and meaninglessness of individual existence were the very content of the correspondences that he maintained with his friends. Painting, in this way, displayed both the pain of loneliness and the possibility of transcending it through expressions of communication and connection.

Throughout, Zhang draws on the material and formal vocabulary that he associates with expressionism and surrealism. To Zhang, expressionism was not simply an emotional outlet through painterly forms. It was through material expression that the artist articulated his relationship with society. He positioned the interiority of surrealism in contrast to this, with its concentration on translating a person's dreams and unconscious. It's not surprising, then, that he drew on these two styles, as his conceptions of them visually translated the vivid reciprocity he felt between isolation and belonging.

In 1990, in a letter to the critic Lü Peng, Zhang described his recent progress and creative process:

> After finishing my fifth painting, I forced myself to stop and undergo some cleansing. On reviewing the history of Western art and observing contemporary expressionists domestic and foreign, I once again found myself most fond of artists like El Greco, Hieronymus Bosch, Giorgio de Chirico, James Ensor, René Magritte, and others along this line, like Alberto Giacometti, Francis Bacon, Balthasar Klossowski who all belong in the same class. And, of course, there is Odilon Redon.[14]

As a means of "cleansing" his mind, Zhang's review of Western art history was a reminder of an inspired sense of place and purpose. In *Private Notes*, he relied on narratives of fragmentation, symbolism, and facture to show the intellectual's relationship with society. In his life as an artist, he relied on these old friends—El Greco, de Chirico, Magritte—to maintain a sense of self.

Misreadings and Misgivings

In 1992, Zhang took a three-month trip to Germany. When he returned, his realizations foreshadowed those that his fellow artists would experience. After the 1993 Venice Biennale, for example, his colleague Zhang Peili (born 1957) stated, "It was very clear how much we lacked understanding of the West . . .

which is to say China's own views of contemporary art were somewhat exaggerated before and our view of Western art was too simplified."[15] The disillusionment between shining myth and pale reality wasn't simply due to treatment on-site, but also to the retrospective embarrassment over how eager Chinese artists had previously looked to the West. One of the most evident sites for this was in Zhang Xiaogang's subsequent abandonment of the "'painterly effects' that he wistfully says "used to intoxicate me into self-complacency."[16] Upon his return from Germany, he gradually excised the thick brushstrokes, textured patches, scratches, and fabric layered on canvas. For an artist so enamored of expressionistic material effects and surrealist symbolism, it took a tremendous jolt to lead him to lament these as aspects that needed to be discarded.

Over the course of his three months in Germany, Zhang toured museums where he encountered works by artists whom he had long admired. In Kassel, he reported on the behemoth once-every-five-years contemporary art exhibition Documenta for *Jiangsu Huakan*. It was during this visit that he began to fundamentally change his understandings of how the world and its histories are structured. During his visit to a series of museums, he faced wrenching discoveries about the sources with which he had spent the previous decade identifying. To Zhang, his earlier overreliance on text had failed him twice over. First, he had privileged writers' descriptions and weaving of mythologies based on artists' lives rather than the artworks. Second, his exposure to original works clarified the poor quality of the reproduced images he had embraced. Zhang's use of the term "misreading" thus speaks to the chasm between the original works and the iterations he consumed. "Like many of my fellow artists," he wrote, "I started studying art through printed works. This means that when you come across a masterpiece that is poorly printed, not only must you rely on reading and studying related information to understand the background from which the artworks emerged, but also you must develop a good sense of imagination in order to picture the original piece of art."[17] The original work revealed itself in each brushstroke: each dimensional application of paint, the relationship of surface to frame, of paint to surface, and of paint with paint. These physical features clarified in an instant the "misreading" that had occurred. During the 1980s, it was through the act of painting that he could breach a geocultural and temporal distance. Seeing Van Gogh's and Magritte's actual treatment of surface in person, for example, shattered that illusion of connection.

Zhang gives a specific example: he had been completely enamored of the mythology of Van Gogh throughout the 1980s. Through textual descriptions, he believed—and wanted to believe—that this expressionist master merely

"used yellow and blue paint carelessly, flinging the paint onto canvas."[18] Upon his inspection of Van Gogh's works, however, he realized: "It was very clear to me that he mastered the layering of paint, he understood how to engage the melodic sense of line and contour, etc."[19] That skilled mastery had been conveniently glossed over in romantic and tragic accounts of the artist's "genius."

For Zhang, when he observed such works in person, he was stunned to see that the objects held the residue of specific life experiences that had failed to be communicated in both the reproduced image and the accompanying text. The materiality of paint made clear the direct connection between the artist's lived life and the resulting physical gesture of application. Being on-site in Europe—from Germany, he also traveled to Amsterdam and Paris—he was also finally able to make a connection between what artists had painted and where they had come from. In the most direct sense, he says, "When you see the landscape in Amsterdam, you can tell immediately that Van Gogh was Dutch."[20] That sudden clarity in the connection between artists and their places of existence was a tremendous shock. First, it reframed how he viewed these artists and their works. The stylistic bases of art that he had previously credited to flights of imagination were actually grounded in physical places of identification. Second, this intensified for him the circuitous and indirect nature of how his own art arrived. Looking back, he realized that his works not only lacked any such ties to place but also had been filtered through Western prints and Western art history that he now saw as products of his own "misreading."

While any art history is necessarily a limited translation of the original lived experience, Zhang came to see the versions that he and his peers consumed as simulacra: copies of copies borne of fiction. In many cases, his enthrallment with an artist's biographical narrative had colored his assumptions about the art. Confronting the originals, he saw the peeling away of the actual work from his imaginations of it. He began to question the textual accounts on which he had based his expectations. In this way, the entire version of Western art history he had come to know fell under suspicion. It was a misleading reproduction removed entirely from any kind of "original." While he still loved many of these artists, the pretense of a shared lineage painfully eroded away. "Misreading" thus became a benign means of describing his revelations about art history. The term captures the immediate desire to dismiss the history that he and his peers had bound themselves so closely to in the past. And, it accurately references the textual basis for their understandings—or misunderstandings—of art history.

This resulted in a sharp realization for him: "After I made a round in Europe of seeing all of the Great Masters I had admired, I made a decision to

give up expressionism. . . . I had always tried to find a way to synthesize expressionist and surrealist things. . . . Later I realized that actually both of these systems needed to be cast aside."[21] Throughout the 1980s and early 1990s, he saw expressionism and surrealism as a pair. The former, while seemingly personal, was actually about an outward expression of social critique. The latter, meanwhile, was more about interiority as evoked through one's dreams and nightmares. For so long, Zhang operated under the assumption that his own desire to express an individual's relationship with society could be answered through a combination of the two languages. Seeing these works in person, however, extinguished this desire. In its place burned the need to find his own visual language, and not—as he came to see it—follow Western stylistic conventions.

The intimacy that he had imagined shattered even further when he saw these museum works in conjunction with the contemporary art exhibited at Documenta. Unable to access the contemporary art on display, he came to another excruciating realization:

> Actually, what we were reading was from a hundred years ago. But we treated it as a guide for life today. In 1992, when I saw actual contemporary art, I felt like I couldn't understand any of it. My knowledge and frameworks were all according to things from sixty years ago, what I could understand was from sixty years ago; that is what I responded to emotionally. So, as for the contemporary, I had to get used to it. . . . We believed we knew what art was. But it was actually based on sixty years ago in the West.[22]

The statement "we believed we knew what art was" succinctly conveys the devastating results of this realization of temporal disjuncture. If what they "responded to emotionally" was decades old, were they effectively living in the past? The realizations of temporal contrast and geocultural distance expanded a growing chasm between those who occupied "contemporary art" and those like Zhang who felt utterly unprepared to understand it, let alone participate in it.

Part of the utter inability to access contemporary art at Documenta arose from what he saw as Western artists' own departure from the "Muse"; that is, the passions that he had been the captive of during the 1980s. In addition to realizations about the historical, geographical, and temporal dissonance accounting for the differences that he witnessed, he was deeply unsettled by the utter superficiality that presided over the contemporary art world in the West. At the exhibition, he saw a galling celebration of Western consumption and hedonism.

ZHANG XIAOGANG

He reports that the exhibition was little more than a high-profile, star-studded event, complete with political dignitaries, royalty, important art critics, and movie stars.[23] That the display of art was so closely tied to capitalist spectacle made him wary of the motivations for art making in the West.

To Zhang, his own art had persevered through emotional struggles and political challenges. Throughout the 1980s, art was a salve during periods of isolation and alienation and had been conceived of as forms of political motivation and ideological emancipation, invested with a deep spirituality and a need to connect. In the pageantry around Documenta, however, he saw the opposite. This further confirmed the ever-growing gulf between what he had imagined Western art to be and his encounter with its materialization. For Zhang Xiaogang—who had found passion and necessity in art—the spectacle of contemporary art in the West was both jarring and acutely disheartening.

One of the most clarifying aspects of Zhang's trip abroad was the utter sense of difference that now structured his understandings of art and art history. Rather than consisting of imagined brethren of the past, he became aware of the impenetrable lines of difference drawn between art in China and the West. In letters penned to his friends during the trip, Zhang continually draws sharp comparisons between his perceptions of the two. Ultimately, his disillusionment with Documenta pushed him to further define himself according to cultural lines, by identifying his purposes against those he saw abroad. In a private letter to his friend and fellow artist Ye Yongqing (born 1958), Zhang dwells on how the capitalist influence on contemporary art and life in the West left art utterly commercialized: "They've had too much fun, which leads to a loss of goals."[24] In contrast, Zhang holds up Chinese artists, whom he sees as having endured greater hardship and, thus, who infuse their art with a passionate sense of mission and commitment to human nature and human dignity. Over the course of his three-month trip, he became increasingly cognizant of how the principles that seemed to underline contemporary art originating in the West differed so markedly from his own.

Seeing these markers of cultural difference, Zhang was profoundly aware of the potential threat Chinese artists faced within a Western-centric global art world. He was particularly concerned about the ways in which "difference" could be used to enforce neo-primitivism or cultural colonialism. He was moved to articulate these concerns for the possible future treatment of contemporary Chinese art and its history in a letter to his friend: "At present, there's no such a thing as contemporary Chinese culture for the West. Westerners only wish to satisfy their curiosity about China as a rural culture; this is similar to their purchasing African sculptures. . . . Or, perhaps, they want to study

contemporary Third World culture from the angle of colonial culture."[25] During his trip, Zhang visited the exhibition *Encountering the Others,* which featured only artists from Africa, Asia, and Latin America and operated as a "counter-Documenta."[26] He was disappointed by what he witnessed. With paltry attendance, it appeared more like a "sidekick," effectively "third-worldiz[ing] the art from non-Euro-American regions."[27] Alarmed, he concluded in his letter that China's most urgent task was to advance according to its own terms.

While abroad—between the commercialism of Documenta and his revised impressions of Western art history—he was forced to consider himself as a "Chinese person" and think about Chinese art as such. He writes in his letter to Wang Lin, "What exactly real contemporary Chinese culture is, only we know. But we have yet to come up with clear concepts and images to show to the world."[28] He returned to China resolved to articulate a distinctly contemporary Chinese art and thus began to experiment with what would become the basis for his famed *Bloodline* series.

The motivations activated by Zhang's trip abroad reveal the startling and deeply emotional effects of cultural difference. He now regarded the championing of the slogan "heading toward the world" as "hollow" and "ridiculous." He explains: "Taken out of its own cultural context, Chinese art attempts to join the Westerners' carnival, only to appear worthless and meaningless."[29] To Zhang, the problem wasn't the display of contemporary Chinese art abroad; it was artists' eagerness to adhere to "some imagined 'international standard.'"[30] The assumption that "heading toward the world" necessarily meant divorcing oneself from one's own cultural context rendered the resulting art meaningless. Instead, one needed to understand China as already a part of the world. To this end, he proposed that "we should participate in constructing the world's new cultural scene."[31] Participation as an act of construction posits Chinese artists' agency. Tracking the consequent artistic choices that mark the arrival of *Bloodline* reveal the experiments in artistic process and language that Zhang carried out in order to materialize this goal.

Zhang's penetrating insights abroad gave him "a very intense feeling that 'I want to be a Chinese artist, I want to attend to China's contemporary [state].'... When I was in the West and saw those Western masters, I had the profound realization that their paintings were all directly related to their lives. But Chinese artists had only studied these things from books; the things [we] painted were all indirect."[32] While Van Gogh's works, for example, communicated the emotions, places, and experiences occupying Van Gogh's life, Zhang realized that his own works had been filtered through inadequate translations, imagined alliances, and anachronistic references.

Chinese Places and Faces

Charged with the cultural mission to articulate "contemporary Chinese art," Zhang returned to China with a hunger to pull directly from personal experiences. As apparent in his two subsequent series—one centered on Tiananmen and the other on his friends and family—this encompassed both public and private realms.[33] Rather than the text-based understandings of art that constituted his earlier studies, his new artistic explorations privileged observability and specificity.

Keenly aware of how artists' surroundings profoundly shape their lives and work, Zhang found himself particularly attuned to the built environment. In Europe, he became particularly conscious of, for example, the recognizable impact of the German landscape on a German painter's work. The vast differences between what he experienced of spaces in Europe versus those at home armed him with a compulsion to clarify these contrasts. He set his sights on examining how this manifested in "the highest place of political authority" in China.[34] A couple of months after his return from Germany, he was presented with the opportunity to visit Beijing. He jumped at the chance.

While in the capital, he dedicated half a day to wandering around Tiananmen Square. His goal, he says, was to experience what was specific to Chinese spaces and architecture. While there, he witnessed how the site invited people to recognize their own "smallness."[35] A photograph from that trip shows Zhang standing alone in the foreground (see Figure 1). Lines of the gray pavers noticeably converge behind him as the Tiananmen gate extends across the background. In Zhang's resulting series, he utilizes these same components—the square, the gate, and the perspectival lines—to emphasize the feeling of "smallness" within a vast expanse of space. Across three works, Zhang presents the gate at different distances from the viewer. In *Tiananmen No. 1* (Figure 8), the gate is pushed toward the top of the picture plane. In *Tiananmen No. 2* (Figure 9) and *Tiananmen No. 3* (Plate 2), the horizon line bisects the canvas. While the pink gate of the latter stretches across the entire width of the painting, the gates in *Tiananmen No. 1* and *Tiananmen No. 2* are much smaller in scale, giving the illusion of sitting farther away. In all of the *Tiananmen* paintings, the artist occupies the space of the ground with the most robust brushstrokes, drawing attention to the energizing power of the square. Further marking the mutual engagement between architecture and space, roots reach out and seep in toward the central monument, lending sharp emphasis to the perspectival lines that they trace. The iterations of *Tiananmen* show his reliance on personal observation as the basis for tracking constancy through changes in positioning.

Figure 8. Zhang Xiaogang, *Tiananmen No. 1*, 1993. Oil on canvas, 100 x 130 cm. Courtesy of the artist.

Figure 9. Zhang Xiaogang, *Tiananmen No. 2*, 1993. Oil on canvas, 100 x 130 cm. Courtesy of the artist.

They furthermore attest to his discovery of the cultural specificity of spatial experience as both a Chinese citizen and an artist.

In his other series of paintings, Zhang featured the faces of close friends peering out through the canvas. In *Portrait in Yellow* (Plate 3), a red wire extends from an outlet in the wall, passes through a television, snakes into the subject's ear, and out the other side of his head before finally connecting to a heart resting on a bed. The interior space and inclusion of peculiar symbols across the background harken back to *One Week of Private Notes*. Rather than comprising a scene of narrative action, however, the figure—pushed all the way to the foreground—engages the background only through the slender red wire. This wire calls to mind the linear slivers of color found in *Tiananmen*, both of which are clearly a predecessor to the red lines running through *Bloodline*. Even more significantly than these pictorial features, Zhang's *Tiananmen* series and paintings of his friends paved the way for new developments in harnessing personal observation for artistic process.

For both, Zhang channeled observability and specificity through his use of photographs as sources for his painting. Previously, he had used printed materials, including photos, as elements of collage in his works. Images of the artist's studio from 1993 and 1994, however, reveal how they now operated as references. Pictures of Tiananmen Square taken from different distances run across one of the wooden boards (Figure 10). Similarly, another board teems with photographs of faces, from well-known images of political leaders at the top to his own pictures of peers at the bottom (Plate 4). Unlike the straight-on, formal published images of Mao Zedong and Deng Xiaoping, the faces of his friends tilt at different angles as they lean in toward the camera. In his resulting paintings, Zhang draws upon the peculiar distortion of features captured by the subject's close proximity and peculiar angling toward the camera lens. As instruments for close study, these photographs enabled Zhang to conduct empirical examinations of such visual effects and reproduce them in paint.

Zhang's photographs of friends also facilitated his venture into producing portraits. *Portrait in Yellow* so closely draws upon one photograph in the bottom left-hand corner of his board, that it is immediately recognizable as the source. This adherence to likeness radiates outward into real life as those who are familiar with the artist's circle of friends would immediately be able to identify the subject as his close friend and fellow artist Ye Yongqing.

Beyond just intensely investigating individuals, Zhang also meticulously delved into how to render Chinese people's faces in the first place. Zhang realized that in his art, he had never studied how to do so. In the art academy, students based their drawing exercises on classical plaster casts. Zhang was

Figure 10. Zhang Xiaogang in his studio, Chongqing, Sichuan Province, 1993. Photograph courtesy of the artist.

thus adept at drafting the idealized bone structure of Venus and David. But, when given the choice to seek out models, he rarely selected Chinese faces as he didn't take them seriously as a subject of portraiture.[36] His training, based on Western models, constituted yet another case of learning as divorced from the people and places of his existence. While he painted self-portraits in the mid-1980s, the figures that appear in his early works appear distorted and fragmented. Drawn from his imagination, their facial features could be said to be neither categorically Western nor Chinese. In his new initiative to produce "contemporary Chinese art," he began to correct this gap in his learning by starting with specific Chinese people and sites. The scrutinized photographs granted a level of intimacy through observation. By possessing an image, he could make a careful study of it and familiarize himself with the details of its forms. In short, photography afforded the beginning of a sense of closeness and connection through the objective study of the physical features of Chinese faces and places.

The yearning for immediacy and direct connection primed Zhang for his discovery of a cache of old family photographs that he found at his home in Kunming in 1993. The appeal of family photographs makes utter sense for some-

one searching for art to begin from his own experiences. What they signaled, however, was not merely a straightforward image of familial intimacy. In fact, Zhang admits to how his own family—during the Cultural Revolution—wasn't together much because various members were sent away for reeducation. With the addition of his mother's mental illness, he saw his family situation as a "family in name only," where the absence of affection between parents and children was filled instead with a sense of obligation.[37] For someone who himself did not experience the solidarity that the photographs purported to celebrate, he inherently grasped what the pictured coherence concealed. That they so boldly announced this artifice—the formal rigidity of social ritual paired with the retouching of the product—made them all the more fascinating. They were a counterpoint to the assumption of visual empiricism that he invested in his own photographs of friends.

Even as his ideas about photographs expanded, he continued to utilize them as images of study to reproduce in paint. Zhang selected figures from different group photographs and combined them in his paintings. The details of clothing, hair, and facial features in his 1993 paintings still show a close adherence to his source objects. The female figure on the left in *Family No. 1* (Figure 11), for example, is clearly based on his mother from a photograph of the artist's parents from the 1950s (Figure 12). From the part in her hair to the shape of her face and even white-collared shirt, her likeness is captured in oil on canvas. When Zhang exhibited these earliest renditions of *Bloodline* in 1993 at an exhibition in Chengdu, Sichuan Province, he also showed the other series on which he was simultaneously working, the portraits of his friends and renditions of Tiananmen.

Together, these paintings from 1993 exemplify key features that characterize his initial phase in attempting to articulate "contemporary Chinese art." First, they all champion observability and specificity in the selection and rendering of subject matter. Second, they all treat the canvas as a place for bringing together different visual languages. On the surfaces of his 1993 paintings, Zhang inscribes musical scores as well as weather and temperature notations. As symbols, they can all be read as markers of time: the duration of a musical tune and its contemporary status as a pop song, the weather at the time of production, and their final inscription atop the canvas marking the finishing touches to a work. They also reference distinct visual languages: music translated into a score that is legible only to those familiar with its system of numerical notation versus universally recognized symbols for forecasts. What they indicate most of all is the artist's state of experimentation. He treats the

Figure 11. Zhang Xiaogang, *Family No. 1*, 1993. Oil on canvas, 100 x 130 cm. Courtesy of the artist.

Figure 12. Zhang Xiaogang's parents with one of his older brothers, 1950s. Photograph courtesy of the artist.

canvas as a place to synthesize languages through inscribed layers. The musical numbers and weather signs are scrawled at the surface while a thickly painted frame lines the perimeter of the canvas. The pictorial strata, temporal convergence, and spatial confinement all indicate Zhang's thinking of painting as combinatory and layered.

In 1994, Zhang excised all of these elements as his entire view of painting shifted away from such a collection of accumulated styles and languages. He discarded collaged materials, did away with the scattering of symbols, and in fact removed the defined interior space altogether. These signaled a definitive break from not only his former painterly habits but also the "misread" art histories from which they arose. He recognized that peculiar symbols and absurdist interiors were lingering traces of surrealist tendencies. The agitated impasto, too, followed his previous indebtedness to expressionism's emotion-laden language. Scholars have often discussed these decisions as a means of better approximating the image of the family portrait as pictured in a photograph. But such an explanation fails to recognize a fundamental shift in Zhang's thinking about art. Zhang's greatest change in 1994 was his realization that he no longer wanted to treat photographs as sources to be copied but rather as a visual mode to inhabit. In taking up a new visual mode, he actively worked to cut ties with his previous ways of producing art.

Mode and Matrix

It was in the old photographs that he discovered this visual mode. Unlike the photos of familiar sites and friends that he took with his own camera, these found images were historical artifacts and objects of a specific visual lineage. The fact that they had been retouched made them intermedial objects, lodged somewhere between painting and photography. In their retouching, Zhang saw not only a value standard imposed onto the people, but even more importantly one that had been applied to *pictures* of people. As an entire set of aesthetic codes, they guided the treatment of figures, background, and composition. The manipulation required a subtle touch that did not call too much attention to its own intervention. He saw a language of shadows rather than substance, of gradients rather than lines, of thin layers rather than thick facture. In many ways, it was the exact opposite of how he had practiced expressionism and what it had represented for him.

This language of subtlety and suppression also appealed to Zhang for its departure from the socialist realism in which he had been trained. Already, the stiff, seated bodies of family portraits contrasted with the heroic postures,

square jaws, and physical action of the figures featured in the socialist realist tradition. And, during the Cultural Revolution, family photographs were the private flip side to public political propaganda.[38] But retouching went even further in its reduction of corporeality. With the softening of facial features, bodies depended primarily on light and shadow—rather than sharp definition—in order to minimize figural forms. As a visual mode, they showed a clear divergence from both his earlier Western painterly tendencies and the institutionalized art of his own training.

After his experiences in Germany, Zhang's rejection of his earlier imagined lineages left him searching for a new language with which to articulate himself. Accompanying this, he also sought a place in art history that countered the Western art that had previously guided him, both in the academy and in his own "misreadings." Within the retouched old photographs, he saw the glimmers of a resolution to the problem of how he could define contemporary Chinese art in the global art world. By citing a mode that could be traced back to its own tradition, Zhang saw the opportunity to define "contemporary Chinese art" outside of just subject matter or imported styles, and instead as a cultural inheritor that could grant him just such an art historical home.

Zhang aligns retouched old photographs with early twentieth-century calendar posters *(yuefenpai)*. Featuring alluring young women, these posters married the appeal of the depicted figures with the practicality of a calendar. In one such example from 1932, a young woman sits squarely in the center of the image dominating the foreground (Plate 5). While she holds up an embroidered handkerchief, as if to show off her use of the advertised products made by Coats & Clark, the focus remains on her elegant figure. Even as she engages directly with the viewer through her gaze, her entire demeanor is softened by the pastel color palette and emphasis on curvilinear lines and shapes. A graceful fluidity drops down from her finger wave curls to her rounded shoulders and the gentle flare of her dress as it drapes off her legs. Overall, this softness is achieved through a technique called "rub-and-paint" *(cabi shuicai* or *cabi dancai)*. Francesca Dal Lago describes this as a combination of Chinese colorful fine-brush painting *(gongbi)* and photographic retouching. She details the process: "The face—the central and starting point of each composition—would first be modeled through rubbing, shading, and erasing charcoal powder with the aid of a cotton wad or a paper tortillon. This would result in a soft, illusionistic effect without the use of line drawing. A pale wash of watercolor would then be added to create the rouged skin, mainly on the cheeks and the forehead."[39] The results were luminous women with supple skin tones and tender bodies. The softened facial features, light pastel colors, dependence on delicate

modeling, and smooth surface of posters are all features that appear prominently in Zhang's 1994 *Bloodline* paintings.

Scholars have traced this use of powdered carbon and softly colored wash to nineteenth-century portrait painting. Zheng Mantuo (1888–1961), who is credited for perfecting this technique, received training in this kind of portraiture and worked in a photography studio where it was common practice to create paintings based on photographic prints.[40] Zheng's use of charcoal created volume through subtle shading that lent a vivid dimensionality to his figures. These female bodies were quickly recognized as well suited for advertising, and Zheng subsequently became one of the most recognized calendar poster painters of the early twentieth century.[41] After 1949, even as the commercial purposes and overt sexuality of this format made them a target for political authorities, the techniques for achieving such soft three-dimensionality endured and were adapted for propaganda posters.[42]

Zhang refers to this visual tradition as a kind of popular art *(minjian),* a reference to its development outside of academic settings.[43] To Zhang, the appeal of this lineage was not only that it was Chinese but also how sharply it challenged the artistic devices in which he had been trained and which he had adopted in the 1980s. At the same time, he says, "If I just copied *yuefenpai,* then I would be a *yuefenpai* artist."[44] His goal instead was to find his own voice even as he built on this culturally specific aesthetic tradition. To do so, he homed in on how this visual tradition marked its non-Western and noninstitutional status: its use of color and light to create forms.

Zhang's particular enthrallment with this aspect lays bare an important shift in his treatment of these old photographs. While he studied them for visual effects, he also began to depart from necessarily following the same conventions. Instead, he selectively located what he responded to most in the visual mode and developed his own language within it. His examination of numerous group photographs enabled him to understand their apparent compositional templates. For example, where women sat in relation to men and how age determined an individual's placement in a family portrait. He maintained this organization in his paintings as well. Where he diverged was in how he employed light and shadow.

Almost all the old photographs he studied utilize three-quarter lighting. Bathing the faces in light in this way made them look plump and full while minimal shadows appear toward the remaining quarter of the face. Even as they lend dimensionality, these shadows were also diminished to prevent too dramatic a contrast. In Zhang's 1994 paintings, as exemplified by *Bloodline— Big Family: Family Portrait No. 2* (Plate 6), he began to shift the line between

light and shadow closer to the center of the face. On the shaded side, he also deliberately darkened the shadows. He recognizes that "this kind of lighting would never be allowed in photo studios."[45] Studios avoid split lighting—with one side light and the other dark—because the appearance of so much shadow falling across the face was considered both unflattering and visually distracting.

This decision to deliberately alter how his figures are illuminated allowed him to further foster methods for creating volumetric form relying only on subtle variations in color and light. In Zhang's 1993 paintings, he had experimented with using strange patches of light on the figures' faces. In *Family No. 1*, for example, the patches suggest an unsettling inconsistency in lighting, lending the image a sense of mystery and absurdity. Unlike in later instances, the presence of light here is not used as a device for modeling the faces. Instead, the artist continues to rely on painted contour lines to portray facial features.

In 1994, Zhang started to use transitions in light and shadow to suggest dimensionality. He struggled, however, with how to do so as his own training and past painterly tendencies had favored the use of emphatic brushwork and strong contours. In the end, he relied on a slow process of thin layering. The first layer roughly laid out the transition from light to dark along the nasal bridge. After this base layer dried, he applied a second layer that gradually darkened areas of shadow on the left side while leaving a circle of light around the eye. He then added a third layer of brighter paint to the right side of the face to give the impression of receiving direct lighting.[46] The incredibly subtle handling of paint to produce these illusions of volume emphasized what was particularly distinctive and appealing about the visual mode of calendar posters and photo retouching.

His interests in dramatic lighting were tied to a fascination with the relationships suggested and effects produced. First, it emphasized a binary yet reciprocal relationship in which "light uses shadow to appear."[47] Second, to Zhang, the half-lit face carried with it an allusion to a transient temporality. When faces are fully lit, Zhang says, "people don't think about time."[48] With light appearing as if to pass over the figures' faces, meanwhile, one instinctively thinks about a concurrent passage of time. His efforts at invoking ideas of impermanence, movement, and change in a static painting challenged the intentions that he saw in the original photographs, whose lighting choices sought to capture a vision of timelessness in an instant.

This feature alerts us to a significant adjustment: Zhang was no longer beholden to the photograph as a source to be copied. The biggest misconception embedded in continued descriptions of *Bloodline* as imitating photographs

is the assumption that Zhang was still upholding likeness as an artistic pursuit. When Zhang's 1993 paintings used family portraits as objects of study, he maintained an indexical relationship between the painting and the extant photograph, and between the pictured individuals and the people as they existed in real life. Although he exaggerated facial features and forms, they still adhered to observable details and mimetic representation. This use of photographs as a pictorial reference to be reproduced still sustained the objectives of verisimilitude that had underscored his training in socialist realism. He sought not only to break away from this academic style but also to sever its underlying logic and objective. In his first phase of articulating contemporary Chinese art in 1993, he focused on specific personal experiences and people. But, what began to get in the way was specificity itself.

Readings of the resulting *Bloodline* paintings from 1994 onward need to be seen in light of Zhang's break from indexicality. As the painted figures begin to lose the facial features that could tie them to specific images, and in turn specific people, this was not simply a case of critiquing socialist China as oppressing people's individuality. While calendar posters of the early twentieth century *did* anonymize and standardize women into commercial types, this is not necessarily what is occurring in *Bloodline*. Instead, Zhang's shift toward what appears to be anonymization was a function of his break from copying photographs. In his process of finding a way to paint group portraits that were not directly tied to an existing image, he found a way of producing figures whose "individuality" was no longer pegged to an external referent.

By departing from an adherence to a logic of external referentiality, Zhang centered referentiality back into the paintings. Rather than identifying them with existing individuals outside the frame, he related the figures within and across his paintings to each other. Zhang states that after 1994 all of the adults were based on the image of his mother while all the children were based on the image of his daughter.[49] He has not, however, painted them as recognizable individuals nor as identical figures of standardized sameness. Instead, they serve as the basis for creating a multitude of figures whose distinguishing features are measured in terms of incremental differences from each other. This tactic of measuring difference as slight changes from one figure to another emphasizes identification within a relativistic matrix. A figure is identified as an individual because they are distinct from the next figure. By presenting his figures in this way, Zhang visualizes how our identities are not about ourselves as individuals, but rather always in relation to those around us. This way of identification challenges readings of Zhang's pictures as a critique of socialist standardization and instead sees his paintings as, conversely, asserting

relationships as the very means by which we identify ourselves. This was his positive answer to what he had been seeking for so long: a way of picturing belonging without depending on indexicality.

Zhang's divorce from indexicality can also be traced through his discarding of the musical score and weather symbols that inscribe his 1993 paintings. As symbols *of* and references *to* external referents, these features were experiments in how symbols operate as layered languages within the frame and how they are connected to an outside world. Ultimately, however, Zhang saw this way of thinking about indexicality as limiting.

When Zhang first encountered the visual mode suffused in old photographs, he tried to reverse engineer this into his paintings. What it required wasn't simply the discovery of new subject matter but rather what he called "a revolution in mode *(fangshi)*." And it took this "revolution in mode to lead to concept."[50] It was *after* realizing this visual mode that all of the connotations of the "concept" of family came tumbling forward. This crucial link and the direction of this process are important for seeing his paintings as more than just "imitating photographs." Generated through Zhang's yearning for belonging, these paintings led him to locate both a place in a lineage and an articulation of this very way of locating a person through his relationships.

Forms of Belonging

While in Europe in 1992, Zhang faced heart-wrenching realizations about his past (mis)understandings of art history. Although it was possible to wallow continually in the idea that China was woefully backward, he instead came to a different conclusion: it wasn't that China was backward, it was just that its present cultural strengths hadn't yet been displayed.[51] Part of this gap in showcasing the force of Chinese culture was due to his earlier preoccupation with Western art history. This stemmed from an idealized, though mistaken, belief that Chinese and Western artists could partake in a shared lineage, which itself may have arisen from a veneration for Western art as more progressive. But, in his shock of seeing the Western-centrism of the global art world, he was struck by not only the utter differences between China and the West, but also the incontrovertible need for Chinese art to assert its own terms for participation. The first step would be to confront what it meant to be Chinese. In this way, he says, he could mine the rich cultural resources that were specific to China and present them to the world.

Zhang's confrontations with the specificities of his own existence entailed critical observations and analyses of how government authority manifested

itself. Zhang's examinations of the architectural space of Tiananmen show his candid recognition of how a study of the place and culture of China required unpacking what some might have considered its unseemly underbelly. Although acutely aware of the tragic nature of the site, Zhang also saw that excavating it would lead him toward an understanding of what made China "Chinese." This paved the way for *Bloodline* to also function as a way in which what might be viewed as a sociopolitical critique of "standardizing individuality" could simultaneously be perceived as a picture of cultural belonging.

Even while in Europe in 1992, Zhang's commitment to realizing contemporary Chinese art necessitated an attitude shift, turning what could be interpreted as weakness into a vision of strength. For example, even while he grieved over his misreadings, Zhang still saw a silver lining. In that divide between the "real" and the "reproduction," there was a chasm that—out of necessity—was a place for imagination. While the art history that they had known was one that was reliant on poorly printed reproductions, he and his fellow artists ultimately had to imagine for themselves the texture, surface, and colors that made up the works. While what they pictured ultimately diverged from the original, Zhang believes that this exercise showed how absence could be generative. Even in these deceptive prints—and Chinese artists' overreliance on them—the work and ideas that sprang from earlier readings and discussions had served as a kind of emancipation, even if it wasn't the kind that they had assumed. Seen in this light, what these artists had been doing wasn't imitation at all but in fact a form of "original" mental creations.[52]

Similarly, the dearth of exhibition opportunities for contemporary art in China at the time could have been perceived as a shortcoming. This was especially apparent when seen in contrast to the numerous institutions dedicated to displaying art in Europe. But Zhang came to appreciate that it was precisely because of the difficulties of organizing events in China that made their collective efforts all the more noteworthy.[53] Unlike in the West, they fought and struggled for their opportunities to create and exhibit art in China. Even while he was in Germany, Zhang continued to correspond with his friends as they planned for an exhibition—*Jiushi niandai de Zhongguo meishu: Zhongguo Jingyan* (originally translated as *Chinese Fine Arts in 1990s: Experiences in Fine Arts of China*)—which was to be held in Chengdu, Sichuan Province, the following year. Zhang discusses the exhibition within broader observations about people's aspirations: "In China . . . people still have dreams of better lives. They might live in fantasies, but illusions energize their lives. China is reforming its economy at a breakneck pace. Next year we'll have two exhibitions, which motivate me to go back and paint, and do what I should do."[54] The rhetorical

maneuvering here is enlightening as it shows a remarkably positive spin on the market reforms driving China and the value of "fantasies" in providing surprising occasions for realizing dreams. It is in this very hopeful mindset that we can see Zhang's efforts at creating "contemporary Chinese art."

The arduous two-year preparation for the exhibition culminated in December 1993 at the Sichuan Art Gallery. It featured five artists: Zhang Xiaogang, Ye Yongqing, Mao Xuhui, Zhou Chunya, and Wang Chuan (born 1953). All close friends since the 1980s, they were all born and schooled in southwestern China in either Sichuan or Yunnan Province. Although the listed curator was the art critic Wang Lin, the organization of the exhibition transpired through their collective effort. This exhibition was the first place that Zhang exhibited his *Bloodline* series.

The first image in the slim accompanying catalog is a group portrait. It is a black-and-white photograph featuring the curator and five participating artists; three seated in front with three standing behind. This same photograph was featured on the exhibition invitation (Figure 13). The photograph shows only their torsos as they are situated in the middle ground. The orderly positioning is immediately recognizable as the intentional picture making associated with a formal group portrait. The rigidity and somberness of this staged picture contrast markedly from the other group photographs in the catalog in which the artists, for example, enjoy a casual picnic and sit on a sofa in someone's studio. This photograph was taken specifically to mark the exhibition. While there is no printed caption underneath, a handwritten inscription across the top of the photograph reads: "Taken as a memento of *Chinese Experience Exhibition,* Winter 1993."

When printed alone on the page facing the curator's text "A Preface to *Chinese Experience Exhibition,*" the portrait serves as a complement to the curator's introduction.[55] As a visual entry point, the image both frames the exhibition—showing the participating artists and curator—and is framed by the central theme of "Chinese Experience." The two go hand in hand: the photograph implicitly speaks to the relationship among the participants, utilizes the identifiable visual format of the group portrait, and remarks on its alignment with the theme of "Chinese Experience." Wang Lin jokes: "Once you open the book, it looks like it will be Zhang Xiaogang's solo catalog!"[56] Indeed, the format of the group portrait was so distinctive that its identification as an existing cultural practice was immediate. And its identification with Zhang's paintings—featured at the tail end of the catalog—was just as readily apparent.[57] Unsurprisingly, it was Zhang's suggestion to have the image taken at a local photography studio in Chongqing. This photograph bears testimony to

九十年代的中國美術："中國經驗"畫展

主持人

批評家　王林

參展人：

藝術家　毛旭輝
藝術家　王　川
藝術家　葉永青
藝術家　張曉剛
藝術家　周春芽

圖爲前排左起張曉剛．王川．周春芽．後排左起葉
永青．王林．毛旭輝

Figure 13. Exhibition invitation for *Chinese Fine Arts in 1990s: Experiences in Fine Arts of China,* 1993. Courtesy of the artist.

the contemporary relevance that this format held for him. Historically, such photographs were taken to commemorate particular events in people's lives, where image making and group unity together formed a ritual for documentation and observance. By the early 1990s, with more people owning cameras, the ceremony of getting a group portrait at a photography studio no longer held the popularity it once did. To wit, that same photography studio went out of business a year later. Yet, for Zhang, this format was an important one. In the tradition of old photographs, they also asked the photographer to write the inscription directly on the film for an additional charge. As a format, it bore visual witness to the connection among this cohort of artists, both confirming and further magnifying the implication of a shared lineage simultaneously through a group photograph and a group exhibition.

Because Zhou Chunya (far right, front row) was in Chengdu at the time, he had his picture taken at a local photography studio there. The studio in Chongqing then assembled the negatives together, ensuring that the scale and lighting were accurate, and then inscribed and printed the resulting image. The value of the reproduced image was not in capturing an actual event that occurred in this exact manner, but rather in preserving a vision of belonging.

Figure 14. Zhang Xiaoang and friends, Kunming, Yunnan Province, 1978. Zhang Xiaogang *(front row, right),* Mao Xuhui *(back row, second from right),* Ye Yongqing *(back row, third from right).* Photograph courtesy of the artist.

This turns the "fiction" of reproduced imagery on its head. The use of photography as "an agent in the collective fantasy of family cohesion" can be read for its negative connotations.[58] But rather than seeing this as a deceptive fiction to lament, the artists used this function of picturing to actively "produce its own integration."[59] Like the exhibition itself, the photograph in this occurrence was not just an act of documenting experience and belonging, but also a force for creating it. Not limited to the past, and not restricted to a nuclear family, the format's associations could be altered to showcase the strength of togetherness, particularly when signifying the existence of contemporary Chinese art as a field unto itself.

In his personal collection of photographs, Zhang has two that also employ a similar group format with friends. One was taken when he was sent to the countryside to be reeducated. Another was taken with his painting friends *(huayou)* when several were on the verge of leaving for college (Figure 14). Like the photograph featured in the exhibition catalog and invitation, this one also includes Ye Yongqing and Mao Xuhui, a testament to their longstanding friendship. When asked if the *Chinese Experience Exhibition* portrait was again a picture of "painting friends," he replies, "More like comrades *(tongzhi),* all united toward a common goal."[60]

We can see Zhang's paintings of 1993—and the publicity images for the exhibition that year—married together in a new urgent mission for the future. As Zhang sought to define himself against his past understandings of art, he came to inhabit and refine a visual mode that could articulate what it meant to create "contemporary Chinese art." The new visual mode gave him both a connection to place and a defined space in art and art history. Zhang's *Bloodline* paintings picture togetherness as a stepping away from referencing what was outside to now discovering a contained logic within.

Wang Guangyi
Pop and the People

In 1989, Wang Guangyi exhibited *Mao Zedong AO* (Figure 15) at the landmark *China/Avant-Garde* exhibition in Beijing. In this triptych, three identical gray-scale portraits of Mao loom in horizontal succession. Meticulously applied over each canvas is a stark black grid. When officials surveyed the exhibition, they rebuked Wang's work for "putting Mao into a jail."[1] In 1998, *Mao Zedong AO* appeared again in *Inside Out,* the first major exhibition of contemporary Chinese art in the United States. In his review of the show, *New York Times* art critic Holland Cotter asked of the work, "Is Mao-behind-bars a prison warden or a captive?"[2] Separated by almost a decade, these interpretations reveal a pervasive impulse to see the triptych as overt ideological critique. Predicated on perceiving the paintings as a pictorial scene of incarceration, the two readings share the mistaken assumption that the subject of the work is Chairman Mao. In fact, what is under scrutiny here is not Mao directly. Instead, the artist is taking aim at Mao's picture.[3]

Starting in the late 1980s, Wang Guangyi used his paintings as sites for investigating extant images from Chinese visual culture. This chapter traces why he chose such imagery, his exploratory treatment of it, and what he sought to achieve with his reproduction of these pictures in paint. As such, Wang's thinking about art is unpacked on two levels: first, his investigations into the historical meaning of political image making; second, his assertions for the contemporary stakes of picturing as displayed in his resulting paintings. Tracing these two trajectories unveils Wang's visual tactics and objectives, particularly in his treatment of Mao's portraits and later in his employment of Cultural Revolution propaganda. Raising Wang's meta-art inquiries interrupts the assumptions of dissident critique that follow these works. They also intervene in the dominant understandings of Political Pop, the category with which Wang Guangyi is overwhelmingly identified.

When art critic Li Xianting popularized the term Political Pop in 1991,

Figure 15. Wang Guangyi, *Mao Zedong AO,* 1988. Oil on canvas, triptych 150 cm x 360 cm. Courtesy of Wang Guangyi Studio.

Wang Guangyi was—and remains—its most visible representative. The first part of this chapter details the debates over Pop in China in the early 1990s. Skeptics doubted that Pop in China could ever satisfactorily reconcile its connections with Western art. Meanwhile, ardent supporters like Li Xianting argued that Chinese Pop could, in fact, lead Chinese art to divest from a Western center. This section revisits the surprising claims that Li put forth for Political Pop at the time. In particular, his appeals to art history in his rationale for its cultural importance. In his essays, Li frames Political Pop as part of a larger effort by Chinese artists and critics to define contemporary art for themselves, a mission in which he no doubt saw himself participating. However, in histories of Political Pop—and contemporary Chinese art more broadly—these aspects of his arguments have largely fallen to the wayside. Indeed, even while Li's curatorial achievements in 1993 brought artists such as Wang Guangyi international acclaim, suspicions toward why Westerners enjoyed Political Pop led many to dismiss it as ideological critique swathed in an imported style.

The term Political Pop can mislead people to believe that "Pop" refers to a set style while "Political" describes the content. In fact, for Wang Guangyi, neither was a fixed idea. The second part of this chapter traces the evolving concepts and discoveries about art that Wang uncovered through his study of political imagery. As he analyzed and reproduced political images in his paintings, Wang began to recognize the power of a visual tradition that derived not only from Chinese experiences, but more poignantly the Chinese people. The

multiple and converging inquiries that led Wang to *Great Criticism* (see Figure 3)—the series most often dubbed Political Pop—reveal the tensions that gave rise to the artist's championing of Chinese popular culture and its status in contemporary art.

Multiple monographs on Wang Guangyi seek to show the artist as more than the poster child for Political Pop.[4] To do so, they often emphasize Wang's theological and philosophical musings, or concentrate on his other series outside of Political Pop. These attempts to provide a richer view of the artist, however, can also inadvertently reinforce a reductive reading of paintings like *Mao Zedong AO* and the *Great Criticism* series. Rather than trying to bypass these works of Political Pop, this chapter dives into the questions and agendas for art that led to their emergence.

Recent reassessments of Pop as a "global movement" have found the goal of trying to define Pop as one that necessarily defies a unifying definition. While the appearance of Pop around the world during the 1960s is linked to circuits of mobility, scholars now understand the need to resist seeing a narrative of its history as simply cultural adaptations of a Western Pop. In its place is a focus on artists' engagements with their own "immediate cultural realities."[5] This has led curators of the 2015 exhibition *International Pop,* for example, to settle on seeing Pop as a "capacious Pop": "one that must remain a shifting definition, unmolded and unresolved."[6] In so doing, they now accept the unwieldiness of the question of whether Pop is a "style, ethos, or catch-all term."[7]

In fact, these same kinds of questions were already being debated in China in the early 1990s. With no real consensus, the point is not to arrive at a single definition of Pop. In tracking its history, this chapter instead focuses on how critics and curators discussed its value. By recovering these aspects of Pop's history in China, this analysis sheds light on the challenges that have consistently mired efforts to see Pop in China outside of a Western center, and seeks to keep them from being reproduced. Tracing Wang Guangyi's meta-art inquiries reminds us as interpreters of art and art history similarly to ask what "art" even meant to artists at the time. Rather than rushing to impose assumptions about "Pop"—let alone assumptions about "art"—the goal is to seek to contribute to reexaminations of the historical categories of Pop and contemporary Chinese art as they have operated in China and around the world.

Pop in China, Pop out of China

In the early 1990s, as some critics argued for the cultural specificity of Chinese Pop, others rejected this possibility outright. Skeptical that Pop could ever be

decentered from the West, Peng De stated in 1992, "Pop Art in the West was aimed at challenging three thousand years of classical art-centrism. Chinese art should be challenging Western-centrism."[8] Peng De's central point that Chinese art should be resisting "Western-centrism" arose from two intertwining anxieties in the early 1990s: to continually guard against undue Western influence and for contemporary art in China to show that it is developing of its own accord.

Proponents of Chinese Pop argued that it could, in fact, carry out these timely objectives. While Peng De believed that all Pop would necessarily be bound to a Western center, others maintained that Chinese Pop's fundamental difference from Western Pop would be enough to sever those ties. Supporters located this difference in Chinese Pop's inherently political nature. This was deemed its "special characteristic" (tese). As critic Zhang Qing described it: rather than Western Pop's concerns with "material excess" in a consumer culture, Chinese artists focused on "political excess." Like other critics, Zhang rooted this in both China's recent history and contemporary circumstances: "Chinese Pop uses the basic form of Euro-American Pop, while its cultural focus exists in a difference in 'nature' (zhi). This kind of difference in 'nature' demonstrates how Chinese Pop artists have experienced things that Europeans and Americans have had no way of experiencing: the Cultural Revolution, these past ten years, a country that has one fifth of the world's population, etc."[9] While acknowledging morphological similarities between Chinese and Western Pop, Zhang's emphases on history and ideology are used to account for the exceptional, and fundamentally distinct, nature of Chinese Pop.

It seems self-evident that differences in experience lead to differences in artistic production. But art critics realized that not everyone was willing to identify this correlation. Even Wang Lin, who displayed great skepticism toward the value of Chinese Pop, noted that acknowledging any independent value would be up to Chinese critics: "The other day, when I spoke with someone from the French Consulate about Chinese Pop, he thought that to a large degree Chinese Pop was still an extension of Western Pop. Of course, he can say this, using the Europeans' inherent mentality to look at contemporary culture with Eurocentrism; this is based on their history. As for our own cultural strategy, what kind of attitude we should adopt is an important question."[10] Ever conscious of how Chinese art was being viewed, critics realized that it would be up to them to choose how to make the case for Chinese Pop's divergence from how Pop had appeared in the West.

As outlined earlier here, some critics in 1992 heralded the political nature of Chinese Pop as a marker of cultural specificity. The following year, however,

as Western audiences grabbed hold of this feature, these very references to politics led many Chinese art critics to retract and reverse support. Studies of Pop as a global movement primarily look at examples from the 1960s and 1970s, when Pop first appeared outside Europe and America. In the case of China, the tethering of Chinese Pop to a Western center comes out of not only Pop's entry into the country in the mid-1980s but also its exit back out through international exhibitions in the early 1990s. The following section analyzes how the reception of Chinese Pop via these circuits has had an impact on, and indeed limited, its historicization.

Histories of Pop in China invariably mention, if not start from, the 1985 exhibition of American Pop artist Robert Rauschenberg in Beijing.[11] From November 18 to December 8, 1985, Rauschenberg presented *ROCI CHINA*, a sprawling display of photographs and mixed-media installations at the National Art Gallery. Part of the Rauschenberg Overseas Culture Interchange (ROCI), the show occupied four large exhibition halls in the state museum. As the first exhibition of contemporary Western art held in China, *ROCI* attracted more than three hundred thousand visitors over the course of its three-week run. Reviews were decidedly mixed. Exasperated that torn-up tires and other detritus could be art, some members of the public denounced the show for its lack of accessibility.

For many artists, meanwhile, the exhibition was eye-opening. While they were familiar with readymades and installation art through translated publications, experiencing the spatial and material dimensions of works on-site proved exhilarating. Gao Minglu describes the direct impact on young artists at the time:

> At a time when Chinese painters strenuously searched for new ideas within a pitifully narrow space for thought, this exhibition was undoubtedly a breath of fresh air. Although in the West it was an old "thing" that had appeared in the 1960s, it was still new to China. Subsequently, in every region, groups of "little Rauschenbergs" soon emerged, who were by no means ashamed of this designation. An artist at the *Shanxi Modern Art Exhibition* said, "We are copying Rauschenberg; and, as for 'copying' *(mofang),* who can avoid it?"[12]

As the '85 Art New Wave gained momentum, multiple art groups sprang up across the country absorbing Rauschenberg's tactics into their zealous art experiments. Excitement toward the new was so great that many students eagerly toggled among different learned styles on a daily basis. Inspired by

Rauschenberg, young artists' resulting works of cardboard and string contributed to broadened ways of thinking about art.[13] Primarily an avenue to greater experimentation, there was little concern for the original contexts of Rauschenberg's works or how Pop had evolved to meet his specific demands.

As such, most accounts of Pop in China acknowledge the importance of *ROCI,* but locate the start of a homegrown Pop to a slightly later period.[14] In his essay from 1996 outlining the history of Pop in China, critic Gu Chengfeng admits that there were experiments that looked like Pop in the mid-1980s. He dismisses them, however, by claiming their lack of any kind of discernible impact on the public owing to their inability to be seen. Instead, he pinpoints the start of Pop in China to the *China/Avant-Garde* exhibition in 1989.[15] Specifically, Gu vividly recalls seeing Wang Guangyi's *Mao Zedong AO.* He was so moved by this encounter that he penned the following revelation at the time: "I realized that 'avant-garde art' is predicated on its critical relevance to its particular culture."[16] While ostensibly about where to stake the beginnings of Pop in China, Gu's passage describes a broader feeling that permeated the close of the 1980s. Although accusations of copying were dismissed by "little Rauschenbergs" in the mid-1980s, by the tail end of the decade, the accumulated weight of Western influence had taken its toll.

That Pop should not be defined stylistically, but rather by specific historical conditions and cultural exigencies, defends against seeing its origins as shameless ahistorical copying. Like the debate between Zhang Qing and Peng De in 1992, later attempts at historicizing Pop in China were exceedingly conscious of needing to continually account for its Western "origins." The revelation that Gu Chengfeng expressed when seeing *Mao Zedong AO* underscores the seminal role of Wang Guangyi's work in generating a fundamentally different kind of response to Pop than had previously existed. *Mao Zedong AO* brought audiences face-to-face with their own visual culture. It answered what critics like Gu Chengfeng were searching for at the time: work that was culturally specific and critically relevant. That this could be triggered by the manipulation of potent familiar imagery points to how jarring such a tactic was at the time. At the same time, this also marked a radical kernel of possibility for writing a history of Pop that didn't necessarily resort to a Western center.

When Li Xianting used the term Political Pop, his defense of the category hinged on this art history. His championing of Political Pop was lodged within a larger hope for the 1990s: to register a recognition of the vast differences between the historical conditions for modern art in China versus the West, and the resulting necessity for each to carve out a discrete path.[17] To Li, the tendency in the 1980s for artists to turn to Western art as a key to accessing

WANG GUANGYI

"modern art" was a grave misstep. He argued that any formal similarity between Western and Chinese art at the time was the result of the latter simply "borrowing an external facade."[18] Chinese artists' love for Western philosophy did not make them participants in a universalized modern art movement. Instead, he saw this as further evidence of the dearth of this kind of extant background in China. He famously claimed that the '85 Art New Wave was not an art movement at all.[19] This was his push back against the tendency to align it as a counterpart to (or even a part of) modern Western art.

Li was neither striking an explicitly anti-Western pose nor blaming Chinese art for *not being* modern Western art. He focused his criticisms on artists and critics who made the case for a shared modernity. To him, this failed to recognize the specificity of Chinese art's history. In Li's account, the modern art movement as it transpired in the West excavated the intrinsic qualities of artistic form and language. Chinese artists in the 1980s, however, simply adopted these as styles to apply to their philosophical sentiments. Stylistic application thus became a shorthand strategy for demonstrating artists' vociferous stances, leading to a decade of imported, ahistorical styles. To this end, he draws a distinction between "style" and "language." In contrast to style, he heralds "artistic language" as a way of thinking about the production and interpretation of art.[20]

Thus, while "Political Pop" and "Cynical Realism" are often glossed as "styles," for Li, it would be more accurate to call them "languages." In proposing to replace the reliance on "style" with "language," Li makes a case for how Political Pop and Cynical Realism drew on Western art influences, yet also how this differs significantly from the previous decade. In the 1980s, artists' adoption of style was equivalent to applying a set formula. He warns of the dangers of "stylism" in this way: "An artist's work necessarily produces a style, but the style is an outcome, and not a goal."[21] To Li, an artist should start by seeking meaning within social reality and then grapple with language to materialize it, rather than searching for a ready-made style to suit a specific philosophical idea. This presumes that language is the result of a series of choices that derive from within a person's perceptions of the surrounding world. Much like many of the ways of fixing terms at this time, Li defines "language" against "style." That style was viewed more as a technical instrument for application made language all the more rich, thoughtful, and original.

Li's stance is important for seeing the larger art historical claims that he makes in—and for—the early 1990s. He asserts these positions in his essays on Political Pop and Cynical Realism, most notably in connection with the exhibition that first ushered these works into the international limelight: *China's New*

Art, Post-89. Li cocurated *China's New Art,* which first took place in Hong Kong in 1993 and soon traveled in different iterations to Australia, Europe, and the United States. Political Pop was widely featured in the exhibition, its accompanying catalog, and even in promotional materials.

Li's celebration of Political Pop and Cynical Realism derived partly from a radical change in artists' treatment of Western sources. In these works, he argued, the artists were finally addressing their own social reality. When the author does raise Andy Warhol in reference to Political Pop, he does so in order to distinguish the psychological effects of American ideology—"crippled by commercialization"—versus in China where people are "constrained under the pressures of political propaganda."[22] He applauds these works as evidence of the long-awaited acknowledgment of the failure of "Western modern intellectual history" in "rescu[ing] and reconstruct[ing] Chinese culture."[23] At last, rather than rooting around in Western philosophy and styles in order to write themselves into modern art, artists were recognizing the specificity of their own conditions of existence through language.

Li's essays set out to recognize artists' and critics' agency in carving out their own future histories. Yet, for many audiences, his provision of a sociopolitical context ended up overshadowing these larger art historical objectives. More often than not, the artworks he described were interpreted by Western readers as unself-conscious by-products of, rather than thoughtful ruminations on, artists' surroundings. Western audiences picked up on Li's description of contemporary China in lines such as, "People were forced to face the hopeless landscape of spiritual fragmentation," but failed to see the very significance of artists turning to their immediate environs at all. There was little effort to follow Li's larger point that the address of these conditions marked a new path for Chinese artists. Instead, the terms "Political Pop" and "Cynical Realism" entered an international art lexicon as little more than descriptions of a crumbling socialist country and vehicles for sociopolitical critique.

It is perhaps unsurprising that the art historical stakes of Li's arguments have received little attention. As the category of Political Pop began to gain momentum abroad, most voices of support in China trailed off. In fact, the political nature that had only recently been considered Chinese Pop's "special characteristic" soon became its greatest liability. In February 1992, Wang Guangyi's *Great Criticism: Coca-Cola* landed a coveted spot in the foreign media gracing the cover of *Flash Art* magazine (Figure 16). Positioned beneath the tagline "the leading European art magazine," three blocky figures—a worker, farmer, and soldier—stand unified through identical postures and a sense of fixed resolve. Reaching laterally, they together clench an upright fountain pen,

INTERNATIONAL EDITION

USA & OTHERS $ 7 • CANADA $ 9 • GREAT BRITAIN $ 4 • ITALIA L 10.000
DEUTSCHLAND DM 14 • NEDERLAND g. 16 • FRANCE FF 45
BELGIQUE BF 280 • SWITZERLAND SF 12 • AUSTRIA ÖS 90
JAPAN Y 1000 • ESPANA Ptas 900 • AUSTRALIA $ 12 • USSR RB 6.50

0 73361 64783 2

01

Flash Art

THE LEADING EUROPEAN ART MAGAZINE • VOL. XXV - N° 162 JANUARY/FEBRUARY 1992 • US$7

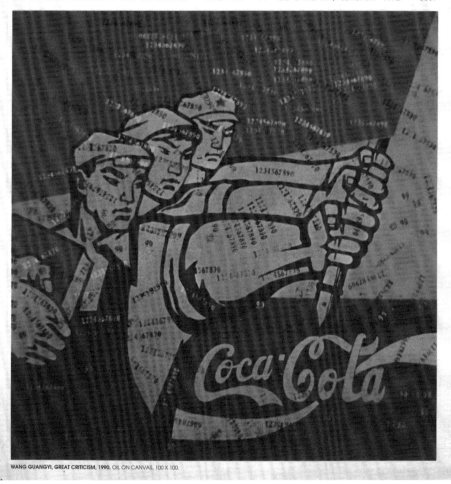

WANG GUANGYI, GREAT CRITICISM, 1990. OIL ON CANVAS, 100 X 100.

Figure 16. Cover of *Flash Art* XXV, no. 162 (January/February 1992).

gripped fist upon fist upon fist. Beneath the pen, the appearance of swooping white letters reading "Coca-Cola" appears to engage the men in a scene of attack. In the wake of the Tiananmen Square massacre and the resurgence of Deng Xiaoping's economic reforms, the painting seemed to confirm Western views of a ham-fisted though woefully anachronistic communist ideology. The following year, other works from the *Great Criticism* series continued to enjoy acclaim in exhibitions in Venice and Berlin.

Swiftly after these exhibitions, Chinese critics denounced the selective view of contemporary Chinese art being shown to the world. In 1994, for example, Wang Lin published a scathing indictment of Western curatorial authority titled "Oliva is Not the Savior of Contemporary Chinese Art." In the essay, Wang accuses Achille Bonito Oliva, chief commissioner of the 1993 Venice Biennale, of deliberately choosing ideologically charged works that presented China as a "living fossil of the Cold War."[24] In his essay, Wang specifically cites Political Pop as an egregious example of contemporary Chinese art that is overrepresented and corresponds to Western tastes. As Western perceptions of its ideological meaning led to its eminent popularity, Political Pop became a regular target for Chinese critics. Hou Hanru's 1996 article for *Third Text,* for example, yokes "the promotion of 'Post-89 Political Pop'" to what he calls "ideologic-centricism."[25] Against this, Hou championed works from China that aligned more with "conceptual art" in their absence of overt political symbols. Political Pop was thus positioned as a straw man, shouldering the blame for having been chosen over and over again for international exhibition. The blame, however, should instead be placed on the limited interpretations of Political Pop that have been so readily accepted.

In fact, Li Xianting's defense of the value of Political Pop offered one such interpretative framework. In the introduction to his catalog essay for *China's New Art, Post-1989,* Li writes, "China's new art is not a combination of the art of traditional Chinese culture, nor is it a rehashing of Western modern art: rather, it is a new integration of myriad influences and myriad cultural and aesthetic factors."[26] He reiterates his point more firmly in the concluding line: "China's new art is now poised in the wings of the international art arena, and has launched its prologue in the establishment of a new dialogue with Western culture. Above all, it is our hope that, as contemporary Chinese art comes into its own, it will develop a unique aesthetic language that will signify and communicate the reality of our times."[27] The "new art" to which he refers quotes the exhibition title and encapsulates how Li saw contemporary Chinese art on the precipice of a long-awaited change. That he calls it "new" signals a release from the allure of "Western modern art" to which artists had previously been beholden.

While Li and others might have seen its political content as a way of breaking free from Western-centrism, the nuances of this entire argument failed to make headway. For Li, his discussion of context was a means of explaining how they functioned as markers of a historical shift toward self-realization. In common readings of Political Pop, however, context was only used to support simple politicized views of artistic dissent. The overlooking of Li's finer points—his specific use of context and championing of language—parallels the treatment of the works to which they refer. Both Li's explanations of "Political Pop" and Wang Guangyi's *Great Criticism* have been emptied of their original motivations and instead positioned as Western toadies, exactly the opposite of how they were originally conceived.

Part of this tendency results from the common conflation of artists' "apathetic" or "parodic" attitudes toward life with how they viewed their own work as operating: as passively illustrating cynical malaise or treated as a joke. But for many artists, their art in fact operated as a place in which they could think about how acts of expression unfurl through considered tactics, formal decisions, and experimental propositions. Even if artists harbored a sense of disillusionment or even malaise, this doesn't preclude their artwork from functioning as sites in which these same grievances could be unpacked. When artwork is viewed as an explanation for sociopolitical context, there is little room for thinking about attitudes toward art outside of serving as a reservoir for emotional outpouring and knee-jerk dissent.

In fact, as will be shown in the following section, one of the most vital areas through which artists began to address their own immediate context was through an interrogation of art itself. In his selection of Mao's portraits and Cultural Revolution propaganda, Wang Guangyi turned his attention to studying the artistic nature of this kind of political art. His experiments unfold as not only his own discoveries of their "special characteristics," but also the swelling need to claim this for contemporary Chinese art in a global context.

An Artist's Mao

Aligning with Li Xianting's characterizations of the late 1980s and early 1990s, Wang Guangyi fundamentally changed how he used visual sources at the time and did so with an eye toward referencing his own life. He did not, however, depict urban scenes of his everyday. Instead, he looked at the images that filled his existence. He treated his art as a space for rethinking the purposes and effects of these images, and offered new claims for their meanings by manipulating their materialization.

Wang embedded the shift in his treatment of visual sources in his 1988 mantra "cleansing humanist enthusiasm" *(qingli renwen reqing)*. That year, at a nationwide gathering for artists, he raised objections to the ways in which art had amplified myths, including the utopian ideals of cultural enlightenment that coursed through China during the mid-1980s.[28] As art historian Gao Minglu explains, humanism at that point was explicitly tied to questions of how to achieve "Chinese modernity," most notably by "producing a spiritual order in which a new future would be built."[29] This precisely corresponds with the metaphysical musings that preoccupied Wang Guangyi in the early to mid-1980s. The group to which he belonged, the Northern Art Group, stated as much in their manifesto.

Armed with a mission to perfect humanity, the group set out to "awaken human rationality" and to "make human society healthier, loftier, more ideal, and more vigorous."[30] Group members tasked their art with pursuing "a new civilization." They saw this civilization as neither Chinese nor Western, but one that they alternately called the Culture of the Post-Arctic and the Culture of the North. At the time, Wang's work operated as a means of visually translating these lofty goals. Characterized by an abandonment of theatrical, poetic, and pastoral sentiments, these paintings favored static compositions, cold color palettes, flattened planes, and geometric forms. In this way, they set out to convey a sense of solemnity, stillness, vastness, and "the eternal."

By 1988, however, Wang saw how these vague and misplaced "humanist enthusiasms" had resulted in a dire situation: art and artists were no longer moored to social reality.[31] From how artists conceived of art to the work produced, the entire field of art making had strayed too far from lived experiences. Accompanying his call to anchor art in people's lives, Wang also began to depart from his earlier cosmopolitan ideals. He looked with growing skepticism at the possibility for transcending cultural boundaries in the name of grand, civilizational goals. When Wang Guangyi used his mantra to denounce the state of art in 1988, he did not spare himself. Even as the phrase served to disavow Wang's earlier artistic leanings, he was also positioning himself as a leader in forging the necessary changes ahead.

Wang's earlier beliefs in transcendence are particularly evident in his *Post-Classical* series from 1986 to 1989, when he began applying "arctic" qualities to renowned Western paintings. His intention was not to parody Western artworks, but rather to study and substitute the power they issued. In his 1987 *Post-Classical—Death of Marat A* (Plate 7), he takes on Jacques-Louis David's eighteenth-century painting *Death of Marat*. In Wang's rendition, the foreground figure of Marat now appears faceless and featureless, pictured as a

flat silhouette. Wang's painting process examines David's painting while also attempting to drain it of its original warmth and individual details. Mixing turpentine into his oil paints, he produced a matte effect that contributed to the image's understated restraint, relying on only the barest applications of color and thin gradations of paint to suggest modeling.[32] In replacing David's forms with the stylized organic shapes, thin layers, and cold, dark hues of the so-called Culture of the North, Wang explored how visual effects transpire and can be transformed for new civilizational ends. Even as he produced *Post-Classical* paintings, however, Wang began to have mounting misgivings toward this dependence on Western visual sources.

In 1988, this led him to begin experimenting with pictures of Mao. Unlike abstracted faceless figures or revisions of Western paintings, Mao's portrait resided firmly in Wang's history, personal memories, and present surroundings. Throughout his childhood, Wang inhabited a world "under the radiance of Mao Zedong," the bright sun around which his entire childhood education had orbited.[33] For an artist intent on deconstructing mythologies, Mao's portrait served as a test case for how this could be carried out.

Wang set out to combat art's tendency to aggrandize modernist myths and pursue metaphysical flights of fancy. To do so, he focused on revealing art as a series of concrete processes and empirical observations. He was already well trained in the close examination of a picture's material and technical components. But rather than a means of mythologizing civilizational goals as in *Post-Classical,* he now concentrated on laying bare the visual techniques entrusted with producing such a function. In cleansing humanist enthusiasm, Wang set out to show how Mao's portrait culminated from a prescribed production process.

In exposing how a picture mediates, Wang unveils the tools of its mediation—most significantly, the grid. During the Cultural Revolution, the grid delivered the power to infinitely expand the monumental capacity of Mao Zedong. It was a tool for visualizing Mao's divine status. In this process, a grid is first applied to an existing picture. The artist then draws a grid onto a larger canvas and proceeds to reproduce the details proportionally according to each square. Wang described his adoption of this process, and his thinking toward it, in a brief text in 1989 published in the weekly newspaper *Zhongguo meishubao*:

When I painted *Mao Zedong,* my frame of mind was very calm, just as if I were describing the most common object. I first drew thin, small squares on a photograph of Mao Zedong; then I enlarged it onto a canvas. I applied paint from the top left corner and ended at the bottom

right corner. After it was entirely dry, I then used an angle square to slowly make equally divided black squares. Then at the four corners of the canvas I wrote AO, OA.[34]

Mirroring his "very calm" mindset, Wang's description of the process imparts a step-by-step matter-of-factness. While it is the grid at the surface that gives viewers pause, Wang significantly testifies first to the one he applied beneath. In the act of enlarging Mao, the artist engaged in a square-by-square study of the portrait. Moving methodically from top left to bottom right, Wang sees the picture simultaneously as a whole yet ultimately constructed of individual units comprising abstract forms. In visual production and again in a distilled verbal replay, Wang relates the steps as a process of precision and predictability. And, significantly, he premised his approach on breaking down an image before assembling it back into coherence. For Wang, seeing the image as a pictorial process of mechanical formulas helped clear his humanist enthusiasm for the portrait and see it instead as "the most common object."

The grid at the surface is an attempt at granting viewers this same change in perception. After spending two months completing the three enlarged paintings of Mao, Wang carefully cut out and laid strips of paper of different thicknesses on the canvases to determine how best to visually translate this sense of remove.[35] The grid had to be commanding without covering too much of the image beneath. He sought to create a visual disturbance but not a busy distraction for his viewers. The grid simultaneously distances the viewer from the portrait while also asserting the painting's flatness. In revealing *Mao Zedong AO* as a made object, Wang announces to viewers, "This is not Mao, this is a picture of Mao." Or, more accurately, "This is not Mao, this is a painting of a picture of Mao." In leading viewers to confront this tearing apart between reality and representation, the artist aimed to expose the mythologizing effects of representation on reality.

On a photographic film of a study for *Mao Zedong AO*, the letters in the corners of the painting read *A, B, C, D* (Figure 17). In the end, Wang decided that this sequence would be too familiar to audiences and didn't imbue the painting with enough mystery and distance.[36] He thus changed it to *A, O, O, A*, granting enough inscrutability to cause viewers to pause. His additions to the surface of the painting—in triplicate no less—sought to visually arrest viewers long enough to grant them the same shift in perspective that he experienced in its making.

While oftentimes Political Pop's strategy of "deconstruction" has been interpreted as shorthand for outright critique, it would be more accurate to describe this tactic as a process of analytical breakdown. Adhering to the

Figure 17. Wang Guangyi, study for *Mao Zedong AO,* undated. This accompanied a letter to Wang Youshen, arts editor of *Beijing Youth Daily*. The text of the letter, from 1989, outlines the artist's self-described efforts at cleansing humanist enthusiasm. Wang Youshen Archive in Asia Art Archive. Courtesy of Wang Guangyi Studio, Asia Art Archive, and the artist.

original meaning of the term "analysis"—and similarly, its Chinese counterpart, *fenxi*—this process points to the dissection of a thing as a means of understanding. Wang's grid materializes this analysis as a division of a whole into constituent units and further analyzed as an accumulation of individual stepped stages. He thus reconfigures the grid from an ideological tool for deification into a rational measure. Wang's engagement with analysis—and his picturing of this process for the audience—evinces his meta-art interests. Through his experiments, he sought to remove the myth of creation by revealing pictorial reproduction to be a series of formulaic steps carried out through basic drafting principles and formal decisions.

In the end, however, Wang Guangyi lamented that his efforts at trying to cleanse the portrait were misunderstood. In "Concerning *Mao Zedong*," he writes, "Observers multiplied the humanist passions by a hundredfold to imbue *Mao Zedong* with even more humanist import."[37] With *Mao Zedong AO*, Wang confronted the limitations in extending a separation between a visual icon and its invocation of unbridled passions. Even still, his attempts at doing so launched vital epistemological inquiries in situating art in relation to politics: "*Mao Zedong* touched on the question of politics. Though I was avoiding this question at the time, it really touched on it. But, at the time I wanted to use an artistic method to resolve it; a neutral attitude is better, as a neutral attitude is more of an artistic method."[38] This articulation of a "question of politics" and an "artistic method to resolve it" shows the crucial beginnings for his thinking about art as a method and an attitude to be wielded against politics. In *Mao Zedong AO*, he does so by showing it as an apparatus composed of technical steps. At the same time, his statement points to another broader understanding of art: as a sphere where one could even entertain the possibility for neutralizing a picture's immeasurably mythical weight.

Wang here posits art as a site for dissection that grants the capacity to strike a "neutral attitude." Calling this an artistic experiment guarded against immediately seeing *Mao Zedong AO* as defacement, which "would have been both dangerous and entirely out of character."[39] Instead, as an investigation into picture making within the realm of art, this didn't automatically assume straight up-and-down political critique. Yet, when presented back to the audience in *China Avant-Garde,* the slippage between the realms of art and politics could not carry out the "artistic resolution" he sought.

Nevertheless, for Wang, this opened up critical possibilities for approaching political imagery through the lens of the artist. Even without a clear picture of what this meant, he saw it as a space ripe for experimentation. This was not without its challenges. When Wang selected Mao's portrait as an example of an

Figure 18. Wang Guangyi, study for *Mao Zedong AO*, 1988. Ink on magazine print, 35 x 27 cm. Courtesy of Wang Guangyi Studio.

image from his own life, he had to confront the effects of what happens when it is acknowledged as such to begin with. As Wu Hung notes about Mao's portrait, "It represents Mao himself. People were supposed to worship this image. They wanted to take the artistic and human elements out."[40] Viewed from a political angle, any disruption to the illusion of an unmediated experience with Mao could be considered sacrilege. Yet, rather than solely viewing Wang's explorations here as acts of political negation or incarceration, it's necessary to recall that his impetus began with an agenda to reform art.

It was only by moving away from seeing Mao's portrait as an icon that Wang could begin to even consider its generative contributions to new ways of thinking about art and art history. This was facilitated by Wang's breakdown of the image as described earlier. But it's important to recognize that his occupation of the perspective "as an artist" began earlier in his studies for *Mao Zedong AO*. In just beginning to see Mao's portrait as a visual source for his work, this already granted him a way of thinking about the image as "the most common object." He initially experimented with embroideries and printed images featuring Mao that he collected from the flea market. Ultimately, he settled on a picture of Mao from a back issue of *Renmin Huabao* (China Pictorial) captioned as "Our Great Leader Mao Zedong," across which he drew a grid (Figure 18).[41]

Removing the picture from its published source and treating it as the start for his own artwork represents the change accompanying Wang's shift in pulling Mao's image firmly into the realm of art.

Following *Mao Zedong AO*, Wang continued to explore the productive promise of seeing political imagery as art. Alongside this, he also proceeded to clarify the need to reference images from his own personal experiences. Wang's preoccupation with these two issues—the political versus artistic, and Chinese art versus Western art—forms the vital background to *Great Criticism*. In the following two sections, each of these issues is addressed through representative works. They not only converge in *Great Criticism* but also crucially open up the multiple ways in which Wang saw his work operating.

Artist versus Political Participant

The possibilities for thinking of political imagery from the perspective of art were put to the test in *Weather Report* (Plate 8), the first painting Wang made after June 4, 1989. Although he lived in southern China at the time, Wang was in Beijing for the lead-up to the crackdown on student protests at Tiananmen Square. He was at the square, but departed for Zhuhai on June 3, 1989. When he was on-site, he considered himself a participant in the movement, calling for freedom and democracy alongside like-minded individuals. In the quiet months after the Tiananmen crackdown, as he turned to painting to sort out his response to the tragedy, he again examined *Renmin Huabao* to select an image source. At the flea market, he found a photograph of Tiananmen from a 1960s issue and from there began painting.

Occupying the center of the painting is a rendering of the classical architecture of Tiananmen in clearly defined angles and gradations of orange and red. As the linearity of the buildings extends laterally into fading geometric gray and white blocks, overlapping patches of paint descend inward from the outer edges of the canvas. The mechanical detail, meticulous description, and fidelity to reproduction that characterized *Mao Zedong AO* are all notably absent here. The difference between the two is most readily seen at the center of *Weather Report,* where we encounter a painting within this painting. The context tells us that this is Mao's famed portrait at Tiananmen, but Wang's painting of it reveals little more than a featureless ovoid face above brief sloping angles against a solid-white background. Deliberately blurred, the portrait fluctuates between an image aborted and one purposely obfuscated.

The entire painting, in fact, speaks to a teetering between states of being. The drips and slashes of exuberant color offer a vacillation between visual and

material readings of paint. The application of vibrant blue, for example, initially reads as a preternaturally bright sky behind the gate, but then peters out to reveal itself to be just the material remnants left by a dry brush tip. Patches of hastily applied colors linger at the surface and trickle downward. With the suggestion of the symbol for "rain" in the upper left corner, these dribbling forms visually hover between being pictorial forms of showering clouds and physical traces of heavy drops of paint. Unfolding from the center, the historical constancy of the central monument gives itself over from descriptive clarity to a riotous eruption of impulsive expression. The title of the work connects this to a stated subject matter. As Wang explains it, the weather symbols across the surface signify the limits of human prediction over an outcome.[42]

The visual lack of clarity and literal message of unpredictability stand in sharp contrast to the regimented process and intentionality behind *Mao Zedong AO*. Even still, *Weather Report* continues the experimentations that Wang first explored there. He remarks that with *Weather Report,* he wanted to put himself in the role of artist rather than that of a political participant.[43] With this in mind, art offered a site for rumination and even reserve when confronting such politically and emotionally charged topics. The implied distance enabled him to render an image that departed from the immediacy of protest art. This echoed his explorations in interrupting ingrained responses to Mao's iconic image. As an artist, he could move away from using his canvas for either knee-jerk condemnation or unquestioning adulation. Instead, he stepped back to picture fluctuation and unpredictability. This tendency to dwell in ambiguity, rather than taking a specific ideological position, would inform the ways in which art could complicate clear political positioning in *Great Criticism*.

Firsthand versus Secondhand

Wang Guangyi's use of images from his own life confirmed for him the importance of drawing from one's own cultural surroundings. This accompanied a growing skepticism toward his previous reliance on Western sources: "For Chinese artists at the time, this [information] lcft us faccd with any of a number of quandaries: how could we develop our art? By looking to our own cultural heritage or by absorbing elements of foreign cultures?"[44] In his account, Wang labels the process and products of this thinking as a transition in his oeuvre from picturing "secondhand" to "firsthand" cultural experiences.[45] His earlier revisions of Western motifs and dependence on learned philosophies were now considered "indirect" as they drew from translated publications rather than his own life. In 1989, he issued a particularly pointed commentary on his previous

Figure 19. Wang Guangyi, *Famous Paintings Covered with Quick-Drying Industrial Paint,* 1989. Industrial paint on print, 18 x 25 cm. Courtesy of Wang Guangyi Studio.

affinity for Western references in two related series: *Famous Paintings Covered with Quick-Drying Industrial Paint* (hereafter *Famous Paintings*) (Figure 19) and *Famous Tunes Covered with Quick-Drying Industrial Paint* (hereafter *Famous Tunes*) (Figure 20).

Famous Paintings uses a beloved tome on Western art appreciation that Wang purchased in college. Although in the early to mid-1980s, he had scoured printed reproductions of Western paintings, just a few years later, he was dismantling this publication for *Famous Paintings*. He detached the pages from the spine, laid them out on the floor, and poured industrial paint down each color plate. He selected what he considered to be the ten most visually evocative results, inscribed them with letters and dotted lines, and burned the rest. This act of obfuscation can at first be read as obliteration. But, more than simply a rejection, Wang also offers up a play in contrasts. As forms of mark making, the flows of spilled paint depart mightily from the careful aesthetic of the oil paintings they now covered. Announcing new possibilities for making and defining art, the cascades of black paint operate at once as an eclipsing shroud, a blank slate, and abstract forms in their own right.

WANG GUANGYI

Figure 20. Wang Guangyi, *Famous Tunes Covered with Quick-Drying Industrial Paint*, 1989. Industrial paint on print, 29 x 21 cm. Courtesy of Wang Guangyi Studio.

In the related series *Famous Tunes,* Wang enacts a similar tactic onto pages removed from a collection of sheet music he purchased at a flea market. Full of scales and chords to be practiced, the book's pedagogical function immediately caught his attention. By introducing students to exercises for mastering classical music, this compendium of drills resonated with his catalog of Western paintings. Both were instruments for indoctrinating taste and cultivating skills. The catalog he used for *Famous Paintings* had been foundational in forming his understandings of Western art. They had served as the very basis for many of his past works, and furthermore proclaimed to him what deserved to be entered into art history. Now, ever conscious of how picturing operates as a tool for cultural inculcation, his previously cherished prints of paintings were newly perceived as deriving from "secondhand" sources. His equivalence of the two series—*Famous Paintings* and *Famous Tunes*—is made even more poignant when he admits, "I can't read music."[46] With a commitment to the legibility of "firsthand" sources, Wang turned his attention to images specifically drawn from Chinese visual culture. This path ahead progressed through an attention to his past.

Political Nonstandpoint

With Cultural Revolution propaganda and Western commercial logos sharing a canvas, *Great Criticism* has prompted debates among critics and curators over whether Wang Guangyi is upholding the power of socialism or siding with capitalism. In recent years, Wang has insisted that the works—much like in *Weather Report*—present multiple states rather than arguing for any one. He uses the phrase "nonstandpoint" *(wu lichang)* to articulate this: "Most critics think these works have a clear stance, as I am criticizing something, or opposing the West. . . . Very few critics understand my attitude of neutrality."[47] Rather than necessarily agreeing or critiquing, he claims that he is simply displaying a basic condition of his existence: socialist ideology and capitalist products existing side by side in China.

Art critic Huang Zhuan's 2008 essay "The Misread *Great Criticism*" raises a second aspect of "nonstandpoint." Huang elaborates: "The 'non-standpoint' does not indicate 'not having a standpoint,' but rather a repudiation of set modes of thoughts and biases, using a kind of 'neutral' relationship to make the object present a more varied and open 'potential.'"[48] Huang's reading of nonstandpoint reminds readers that by refraining from taking a singular biased stance, Wang allows for the validity of multiple possibilities. In his presentation, Wang

leaves these choices open to the viewer "to construct an imagined relationship that can be explained in multiple ways."[49]

Wang's *Great Criticism: Coca-Cola* showcases how he adapted source material to allow for this potential (Plate 9). In the image source on which this image was based, imperialist-capitalist bodies writhe in pain, pinned down by the pointed end of a flagpole (Plate 10). The 1970 publication in which Wang found the image brims with depictions of class enemies under attack. In his adaptation, Wang replaces the end of the flagpole with a pen nib. By further removing the figures, he muddies the meaning. Is the nib writing the logo or about to pierce it? Are the symbols conflicting or colluding? With this choice, Wang steps away from an obvious picture of protest.

Even still, the overwhelming desire to locate a clear stance led many Western viewers to still see a straightforward critique. When Westerners encountered Wang Guangyi's work for the first time, the familiarity of the graphic aesthetic led many to conclude that he was simply applying a Pop "style." As one reviewer stated in 1993, "There are signs . . . that younger painters have only just discovered Western Pop Art, so for Westerners there is a déjà vu quality about the work of such as [*sic*] Wang Guangyi."[50] Such opinions advocate a view of contemporary Chinese art belatedly tracing the steps of established Western predecessors. This contributed to a perception of the ascension of Western power in both economic and cultural arenas. That is, just like the import of Western commodities and ideology into China, the morphological similarity between Wang's painting and American Pop suggested a similar takeover by Western culture in China.

While the consumer logo embodies the graphic aesthetic of consumer advertising, the political propaganda draws from a different source entirely. Strong carved lines and flat planes of color were common in Cultural Revolution imagery, which in turn derived from the visual tradition of revolutionary woodblock prints. That they blend so seamlessly suggests the shared visual tendencies of two contrasting ideologies. Wang plays up this surprising harmony by integrating the socialist propaganda and capitalist advertising into remarkably coherent compositions. In *Great Criticism: Coca-Cola*, for example, all the components are carefully balanced in thirds. Dynamic diagonals pair with repeating primary colors to make the contrast between sharp angles and curving forms all the more complementary. Thus, while the symbols communicate distinct ideological messages, their pictorial similarities unify in the resulting painting. In the balance struck between the forms, Wang shows how the two both seek to reach the masses, generate desire, and rely on many of the same tactics

to do so. In this vacillation between conflict and coherence, between symbolic and pictorial operation, Wang invites viewers to contemplate the multiple ways in which the "imagined relationship" between the two may exist visually and even politically.

Scholar Tang Xiaobing has argued that Huang Zhuan's emphasis on Wang's nonstandpoint "runs the risk of neutralizing Wang Guangyi's politics altogether."[51] Indeed, it seems that Wang goes to such great lengths to claim a "nonstandpoint" that it leaves viewers to puzzle over how the artist's personal politics can be excised. In fact, Wang's repeated claims for "nonstandpoint" are not just a political statement (or nonstatement). This defensive posturing needs to also be seen as a means of drawing attention to the status of his works *as art* and not just knee-jerk political commentary. This mirrors his efforts to present political imagery as separate from either protest or adulation. Seen in this way, the artist's personal politics are not absent at all. Instead, they are presented through his claims for the artistic nature of the political imagery he pictures.

Wang's mining of the visual history of propaganda continued his earlier realizations about the cultural specificity of techniques arising from his experiments with Mao's image. As he bid farewell to the very sources of Western art he previously held dear, the question remained: how would he depict firsthand cultural experiences without immediately falling back onto the academic training he received? In his studies of political imagery, Wang came to see the productive potential of propaganda for resolving this problem.

Artistic Standpoint

The possibilities for propaganda arrived out of Wang's existing experiments and realizations: that political imagery could be treated as art and the necessity of addressing his own circumstances. In this section, I show how Wang's visual choices claim the validity of propaganda's visual history and its place in both a "firsthand" art history and contemporary art.

Although Wang's sources for *Great Criticism* often are glossed as "Cultural Revolution propaganda," he made a specific choice within this broad pantheon of visual, political culture. He did not, for example, re-create oil paintings like Dong Xiwen's *The Founding of the Nation* (1953) or Liu Chunhua's *Chairman Mao Goes to Anyuan* (1967), as did some of his peers. He also did not copy posters that were themselves the result of mechanical reproduction. Instead, his paintings are based on *baotou*.[52]

Bao means to announce and inform. It can also reference the common vehicles for doing so: newspapers *(baozhi)*, blackboard newspapers *(heibanbao),*

big-character posters *(dazibao),* and wall billboards *(bibao).* The term *baotou* is often translated as "masthead." It refers to the clip art–like images used as headings to accompany texts. The government distributed slim booklets filled with *baotou* to towns across China as artistic sources. These booklets contain hundreds of images in black and red, including border designs, seal-like designs, and slogans in different fonts. The vast majority of the images, and the most detailed ones, depict fearless revolutionaries, often holding little red books, weapons, and writing implements. These were widely employed as "all local towns and villages needed to put up and constantly renew large propaganda billboards, and a large number of half-trained or self-trained painters were recruited for these jobs."[53]

The circulation of these booklets ensured the reproduction of the same kinds of images and rhetoric on walls across the country. But it's important to see *baotou* here as different from the mass production of posters. Instead, they were hand-copied by local "half-trained" artists. The rendering of *baotou* entailed a degree of artistic choice and responsibility. Greeted with a vast range of images, people could decide from the array of options and organize what they determined to be most visually effective for their purposes. At the end of one booklet, for example, a section with "a short explanation of the editorial layout and design of wall newspapers" instructs: "The layout needs to pay attention to the relationship of the part and the whole. One should start from the whole layout as quotations, *baotou,* banner headlines, essays, illustrations, etc., have to all be considered together in the design."[54] A series of visual examples follows to show how to integrate and balance vertical and horizontal texts and possible places to include illustrations (Figure 21). Decades later, as Wang, too, turned to these same manuals to choose and arrange his compositions, he directly drew upon this same visual tradition and practice.

Wang establishes a clear connection with this visual and political history in the title of the series *Great Criticism.* The dissemination of information during the Cultural Revolution was never a neutral act. As a means of shaping public opinion, reporting and informing were always attached to criticism. *Baotou* thus participated in the important act of ferreting out counterrevolutionaries, fomenting paranoia, and generating support. Given the importance of criticism as a revolutionary responsibility, it's unsurprising that the phrase "Great Criticism" was regularly featured in slogans during the Cultural Revolution and frequently illustrated as such in these *baotou* booklets. Images of figures holding writing implements and reading wall newspapers are splashed with slogans such as "Tightly Grasp Revolutionary Great Criticism" *(zhuajin geming da pipan)* (Figure 22). Such graphics had two functions: they showed local

Figure 21. Example of design layout. *Meishu cankao ziliao 1: Baotou xuanji* (Beijing: Renmin meishu chubanshe, 1971).

artists what their labor would yield, and they were also pictured as images that could themselves be reproduced for audiences. Thus, a figure grasping and writing a poster that reads "Launch Revolutionary Great Criticism" *(kaizhan geming da pipan)* could, in turn, appear on a wall poster to confirm the visual significance of criticism as both form and content.

Through its title and featured images, Wang Guangyi's *Great Criticism* participates in this self-referential visual tradition. In his choices of figures, Wang selects peasants, soldiers, and workers armed with writing and draw-ing implements. Although this does appear as a motif in posters, it is far more common in *baotou*. In drawing attention to a visual tradition that pictures its own importance, Wang both engages in its continuity as visual form, and in its emphasis on the people as the producers. His choice to reproduce imagery from *baotou* makes visible this history of meta-picturing, and continues it through his participation.

Wang used his canvases to feature this visual tradition in order to acknowl-edge its value as a distinctly Chinese art history. What better art history than

Figure 22. "Tightly Grasp Revolutionary Great Criticism" *(zhuajin geming da pipan), Meishu cankao ziliao 2: Baotou xuanji* (Beijing: Renmin meishu chubanshe, 1972).

one that shows the very actors, actions, and instruments of image making? Wang came to see this picturing *of* the people—and *by* the people—as a quintessential component of the firsthand art history that he sought. He called this transition from secondhand to firsthand sources a shift "from the art of artists to the art of the people."[55] Of his own creations, he states, "I drew on their work, changed it a little bit, so I say that half of this was completed with the help of the people."[56] Wang's claim that "half" of the work was completed with the aid of "the people" was a way of positioning himself as part and parcel of this history. As a conduit between a history of propaganda that emphasizes "the people" and contemporary art that emphasizes the author, Wang conveniently claims both standpoints.

Through *Great Criticism,* Wang set out to reinsert "the people" back into conceptions of art and, furthermore, incorporate their contributions into contemporary art and art history. On March 22, 1991, *Beijing Youth Daily* ran a full-page feature on Wang Guangyi. The four paintings reproduced in the paper presented the first public showing of the series in China in any format. The

following headlines surrounded the images: "An Artist Selected by Society" and "Walking toward Real Life." Both are quotes from the artist and articulate his belief in maintaining closeness to his social environment. In the published interview, he warns against the dangers of using the "pure language of 'scholasticism'" and "being too individualistic in expression" as both yield art that is inaccessible and irrelevant to reality.[57] Instead, he proposes that "for contemporary art, it should be a kind of public, synchronic experience of reconfiguration; it touches on all people."[58] In drawing on a visual tradition that was "by the people," he saw the possibilities of tapping into this again with a contemporary audience.

It seems particularly fitting that the sources Wang used for *Great Criticism* were publications for propagating art and education. *Famous Paintings* and *Famous Tunes* showed his sensitivity to how pictures instill cultural values through pedagogy. *Mao Zedong AO* reminded him of the technical processes specific to political imagery in China. *Great Criticism* picked up on all of these aspects. More than simply graphic illustrations, the booklets on *baotou* explained the ideological premise and revolutionary value of the visual. In one booklet, for example, a section titled "Foundational Methods for Drawing Figures" espouses:

> Learning to draw is a premise for the proletariat to persist in upholding political command, one must pay attention to investigating, analyzing, and physically training one's eyes and hands, to see more and train more, seeing something, the heart records it, the hand draws it, over time one can slowly and with great facility draw well.[59]

The book also outlines the particular principles governing how bodies are rendered according to class:

> The broad masses of workers and peasants . . . braving the elements, sturdy bodies, muscular, broad shoulders, big hands, big feet, thick necks, from the outside, it gives people the feeling of a healthy, well-proportioned beauty. This conforms to the rules of proportion discussed above. Some are even broader and larger. The exploiting class, the landlord class, capitalists, don't labor and lead parasitic lives; from the outside, one must draw these characteristics: some are fat and fleshy with big stomachs.[60]

These explanations accompanied illustrations on anatomy, diagrams for rendering heads and faces, and samples of different facial expressions. The descrip-

Figure 23. "The Grid Method for Enlarging" (*fangge fangda fangfa*), *Meishu cankao ziliao 1: Baotou xuanji* (Beijing: Renmin meishu chubanshe, 1971).

tion of drawing as a matter of physical training implicated the artists' bodies in the same kinds of corporeal class distinctions they were being called upon to render.

These specific bodily proportions departed radically from the academic training that Wang had received in college. Thus, when he first began *Great Criticism,* he adhered to the very processes of reproduction outlined in these small pedagogical manuals. Indeed, one booklet instructs and illustrates for readers how to enlarge images using the grid method (Figure 23). Wang used this exact practice to enlarge his selected *baotou* and preserve its exaggerated bodily proportions. Similarly, he wanted to retain the enlarged proportionality of the writing and art implements held by the figures. In these cases, the grid served as a necessary device to aid in reproducing the blocky figures. His training in the socialist realist tradition had not included these kinds of everyday propaganda pictures. It was only after painting a few canvases that he was able to then emulate it on his own and didn't require the grid for scale. Thus, more than simply an adoption of propaganda imagery, Wang engaged in the very training processes, artistic principles, and class logic underscoring this

system of image-making. In all respects, he wanted to leave behind the standards, skills, and even concepts of "painting" that he learned in school, which for all intents and purposes to him was a "Western system."[61]

The materials he used facilitated this remove. *Great Criticism* employs the same quick-drying paint from *Famous Paintings* and *Famous Tunes*. It was a kind of industrial paint found in hardware stores and used for painting interiors. While he continued to use oil paints in some areas for maintaining opacity, for the most part, he relied on these industrial paints. After carefully drawing out the composition, he would use black paint to create crisp lines simulating those of woodcuts. He added paint thinner to the yellow to brush across the bodies and then a layer of red for the background. In all cases, he utilized paints directly from the can and didn't adjust their colors. He enjoyed the "coarseness" of the paint as a step away from the refinement of oils. For Wang, this was another way of simultaneously asserting a departure from a rarefied position of oil painting to one that could be of and for the people.

Both of these aspects can be seen in one of the most puzzling features of the *Great Criticism* series: the numbers haphazardly strewn across the surface of the paintings. While echoing the print aesthetic of his pictures, the numbers are not painted by hand but rather applied using a commercial stamp set. Wang notes that the numerical stamps are a way of striking a balance between hand application and the value of reproducibility and that they—like the images themselves—are manufactured by anonymous people and recall tools used by everyday people.[62]

As a visual device, the numbers leave an imprint of deliberate visual ambiguity, a tactic for enticing viewers to pause and contemplate further the very nature of the pictures presented. Like the grid in *Mao Zedong AO*, these stamped numbers would, in Wang's view, interrupt viewers' assumptions: "People looking at it will suddenly not be clear about its meaning. It will attract you, so at the time I used this term for what I hoped for when audiences looked at my works, that they had a feeling of *terminating* aesthetic evaluation. Upon termination, they will think of some questions: why was the work made in this way?"[63] In 1991, he remarked in his interview for *Beijing Youth Daily*:

> Contemporary art . . . touches on all people. It is a great "game," [and] it urges the public to enter it. From its surface, the public might not be able to clearly see what this game looks like; this is a little like the public watching the evening news on the television. Some parts of it are clear, that is, contemporary art [is] reminding the public to pay attention to a most basic issue: the news and games lead us to our real lives.[64]

Wang bids viewers to enter the painting through a veil of stamped numbers. With some parts clear and some parts not, the painting invites them to consider social reality from another point of view: a reality manipulated by the very images that populate viewers' lives. By *Great Criticism,* the intimate connection between imagery and "social reality" was no longer a matter of plucking images from reality, but an acceptance of how images construct reality.

This acknowledgment of the agency of art to affect, indeed construct, reality speaks to Wang's greater objectives for *Great Criticism.* By upholding the art historical imagery and ideological logic that informed it, Wang was making a case for this art to be part of art history. And, even while making claims for the people, he was also affirming his own role as the one picturing this *into* contemporary art.

The necessity for cultural definition, and its manifestation in art history, crystallized during Wang's travels abroad in the early 1990s:

> After you go abroad, you see a lot about your own art that is insufficient. This was a very strong feeling. In Western countries, the artists' force is very strong. In the West, every major city has a museum. We didn't have any museums before, just the National Art Gallery, which exhibited ink painting. This had dual meaning for us: after returning, we needed to build our own cultural tradition and build our own contemporary art.[65]

These experiences abroad brought into culmination the skepticism that began with Wang's mantra of "cleansing humanist enthusiasm" and its call to draw art closer to social reality. When he began to demythologize Mao's portrait in *Mao Zedong AO,* he also arrived at a deeper recognition of its culturally specific pictorial and material components. He recognized that the visual culture he inhabited was made up of particular tactics, images, and processes. These gradual realizations intersected with the concurrent turns toward "cultural heritage" and "cultural specificity" that echoed across contemporary art at the time. In Wang's case, he called it a transition from relying on secondhand cultural experiences—learned through text—to firsthand cultural experiences that he had lived through. He recognized that in order for China to build its own contemporary art, it would also need its own art history. As Wang Guangyi excavated his own visual culture, he located a visual tradition that both pictured the people and was produced by the people. In his reference to "the people," Wang clarifies: "I am using the term from a rather positive perspective, which is connected to the Maoist education we received. Mao said . . . 'People, and only people, are the true momentum behind the creation of history.'"[66] Wang's *Great*

Criticism thus appeals to the power of art to confirm art history, not only for art history to confirm art.

The Popular and the Everyday

Over the years, Wang has been repeatedly asked about his relationship to Pop Art. In the beginning, he avoided answering these questions. But over time, he has articulated an answer. In one interview, he responds, "Pop refers to an art based on the most ordinary, popular imagery."[67] His response aligns with what he was seeking in the late 1980s. It also serves as a reminder that for all the attention given to Western Pop's historical focus on humor, graphic design, and consumerism, there was another aspect of these works that resonated with artists in China: its display of the everyday.[68]

In fact, this response was evident even with some viewers of the Rauschenberg exhibition. While *ROCI CHINA* functioned primarily as an early introduction of new approaches and materials to Chinese artists, two interesting responses shed light on the revolutionary potential of Pop for Chinese artists. When viewed from the perspective of narrative access, Rauschenberg's works could be easily condemned as being too far removed from the standards of socialist realism. But an observation by Gu Shangfei, a graduate student in Marxist cultural theory, reveals surprising ideological resonances: "The works of Rauschenberg do not contain any trace of an aristocratic spirit. They are concerned with the everyday life of common people. He uses the most ordinary materials to create aesthetic forms. His art reaches into every sphere of life, thus reducing the distance between art and life."[69] His comments, delivered during a symposium on Rauschenberg organized by the newspaper *Zhongguo meishubao*, were printed and circulated in the paper on December 21, 1985. The second response is by the artist Xu Bing (born 1955), who recalls that during the exhibition, he searched for anything that was similar to what he was seeing. As relayed by Hiroko Ikegami in her study of *ROCI*, "The only thing he knew that looked remotely similar . . . was a farmer's house decorated with a variety of farming tools, which he had seen in the countryside where he was sent during the Cultural Revolution."[70] Their comments mark early insight into the striking value of seeing the everyday of "the people" in art.

This way of thinking about Pop does not locate popular culture in commercial advertising or even in its graphic aesthetic. Instead, it is tied to the "people's culture." Conceiving of the everyday in this way was a throwback to the Cultural Revolution, when "popular culture" was an expressly revolutionary culture, as cultural historian Liu Kang explains:

Mao's national form, or the culture of the masses . . . was conceived primarily at the everyday level, too, precisely as a counter hegemonic formation to Western bourgeois, imperialist, and colonialist hegemony. Mao's strategy was to emphasize the concrete, the material, and even the bodily functions, forms, and structures of the everyday, which were rooted in the textures, temporalities, and rhythms of Chinese peasant life.[71]

This understanding of "popular culture" is an explicitly political and historical formation. It reminds us that "Pop" should not be considered an established style or even a case of consumerism. Instead, it should be viewed as a language arriving out of specific circumstances and through an attention to one's surroundings. In this light, we can see Wang Guangyi's *Great Criticism* paintings as a contrast of visual traditions arising from different ideas of popular culture. Thus, even while Wang continually asserts a political nonstandpoint, he puts forth a clear artistic standpoint in his pitting of their respective histories and concepts about art. In this case, Wang's visual choices in comparing the two visual products of capitalism and socialism are telling. For the former, he chooses a logo. For the latter, he chooses the people.

Wang has characterized the distinction between his work and Warhol's as a matter of a difference between art "that comes from the photography industry or commercialized production" versus art "all created by the people and people's artists."[72] His deliberate depiction of an active agent for the visual tradition of propaganda serves as a reminder of the actors in Chinese cultural production. Through his own meta-art experiments in how to see political imagery through the lens of art, he came to value this tradition as comprising its own visual forms, principles, pedagogies, and concepts. While graphically similar to Western Pop, the very core of its history, and its invocation of the people, in fact, freed it from the constraints of Western-centric views of Pop.

Wang's argument for a distinctly Chinese visual tradition should also inform how Political Pop is positioned in art history. The repeated references to social reality and closeness to the people—in both Li Xianting's and Wang Guangyi's words—resonate with broader trends across contemporary Chinese art in the early 1990s. From site-specific engagements with spaces of the everyday to "realist" depictions of the mundane scenes of one's daily existence, these ways of more closely approaching reality have historically been termed a "domestic turn" in contemporary Chinese art.[73] Due to its notoriety on the global art circuit and perceived imitation of Western Pop, Political Pop has often been excluded from evidencing this domestic turn. But, when placed alongside other

kinds of art of this time—from Apartment Art to New Realism—Political Pop helps show the widespread objectives and tactics shared by artists to address Chinese visual sources.

Positioning Political Pop in this way also challenges tendencies to perceive the domestic turn as a post-Tiananmen retreat into cynicism. This misreads and mischaracterizes the inward look of 1990s art as myopic. Political Pop—and Li Xianting's and Wang Guangyi's claims for it—reminds us of how excavating one's localized environment can also be embedded in a desire to deviate from a Western-centric past in the 1980s and to forge new paths forward for contemporary Chinese art. Far from myopic, it was a calculated strategy by Chinese artists to picture their own art history and establish their own value in the world.

Plate 1. Liu Wei, *Revolutionary Family,* 1992. Oil on canvas, 100 x 100 cm. Copyright Liu Wei. Courtesy of Sean Kelly, New York.

Plate 2. Zhang Xiaogang, *Tiananmen No. 3,* 1993. Oil on canvas, 110 x 130 cm. Courtesy of the artist.

Plate 3. Zhang Xiaogang, *Portrait in Yellow,* 1993. Oil on canvas, 108 x 90 cm. Courtesy of the artist.

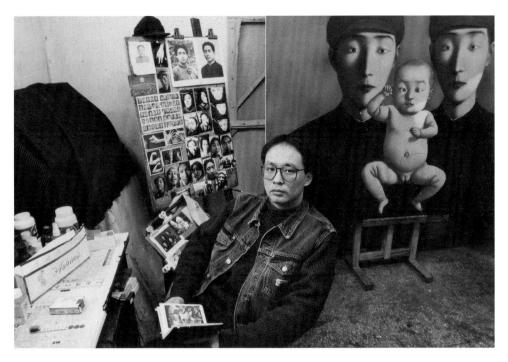

Plate 4. Zhang Xiaogang in his studio, 1994. Photograph courtesy of the artist.

Plate 5. Hang Zhiying, advertisement for The Central Agency, 1932. Lithograph, 30 x 20 inches. Courtesy of gallery neptune & brown, Washington, D.C.

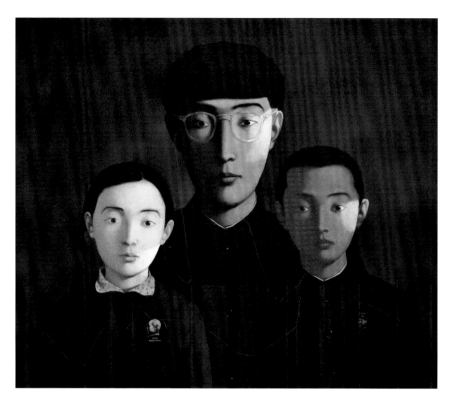

Plate 6. Zhang Xiaogang, *Bloodline—Big Family: Family Portrait No. 2*, 1994. Oil on canvas, 150 x 180 cm. Courtesy of the artist.

Plate 7. Wang Guangyi, *Post-Classical—Death of Marat A*, 1987. Oil on canvas, 116 x 166 cm. Courtesy of Wang Guangyi Studio.

Plate 8. Wang Guangyi, *Weather Report*, 1989. Oil on canvas, 120 x 150 cm. Courtesy of Wang Guangyi Studio.

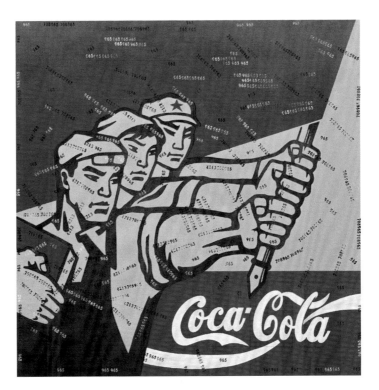

Plate 9. Wang Guangyi, *Great Criticism: Coca-Cola*, 1990–93. Oil on canvas, 200 x 200 cm. Courtesy of Wang Guangyi Studio.

Plate 10. *Geming Da Pipan: Baotou xuanji [Revolutionary Great Criticism: A Selection of Mastheads].* Hangzhou: Zhejiang renmin meishu chubanshe, 1970.

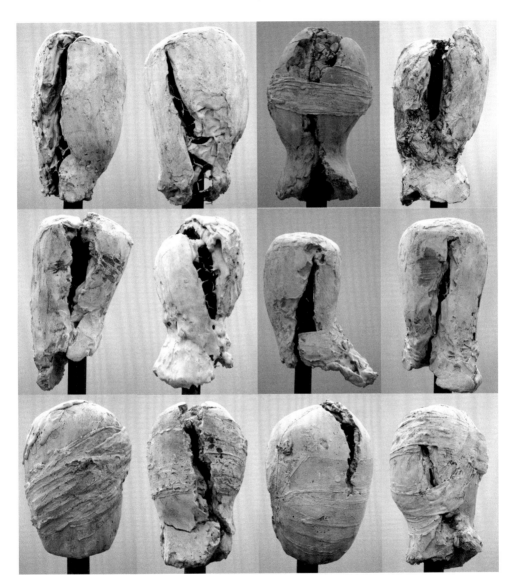

Plate 11. Sui Jianguo, *Hygiene*, 1989. Plaster and mixed media, dimensions variable. Courtesy of the artist.

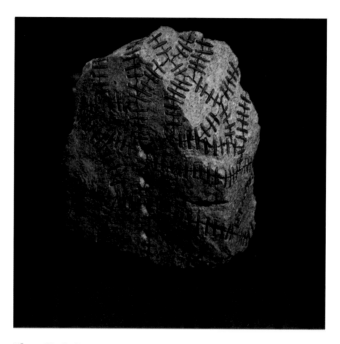

Plate 12. Sui Jianguo, *Inter Structure #3*, 1990. Granite and iron, 75 cm (height). Courtesy of the artist.

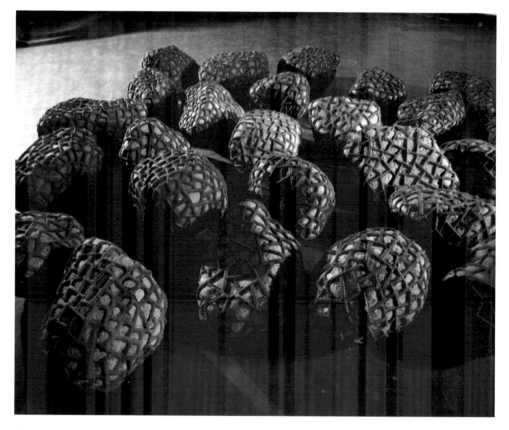

Plate 13. Sui Jianguo, *Earthly Force*, 1992–94. Stone and rebar, dimensions variable. Courtesy of the artist.

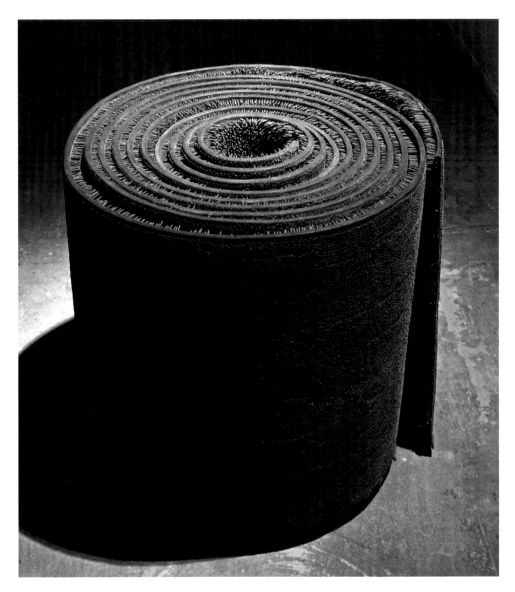

Plate 14. Sui Jianguo, *Kill*, 1996. Industrial rubber and nails, 65 x 65 x 65 cm. Courtesy of the artist.

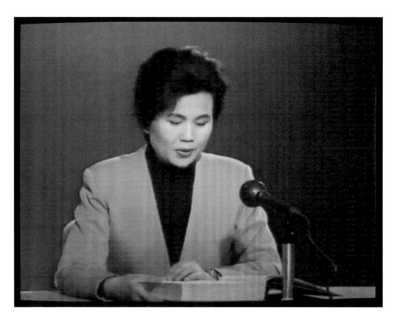

Plate 15. Zhang Peili, *Water: Standard Version from the Cihai Dictionary,* 1991. Video (color, sound), duration 9 minutes, 35 seconds. M+ Sigg Collection, Hong Kong (by donation). Copyright Zhang Peili. [2012.1369]. Courtesy of the artist and Tilton Gallery, New York.

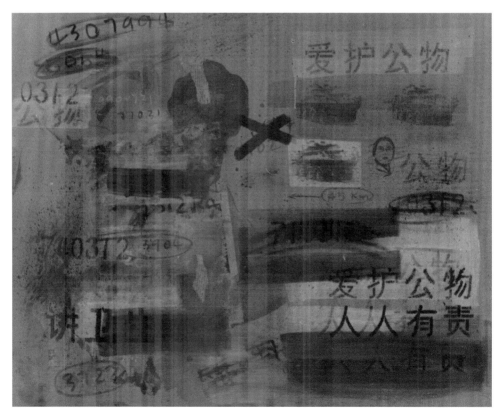

Plate 16. Zhang Peili, *China Bodybuilding: Standard of 1989,* 1990. Oil on canvas, 80 x 100 cm. Zhang Peili Archive, Asia Art Archive, Hong Kong.

Plate 17. Lin Tianmiao, *High*, 2000. White cotton thread, fabric, video projection, dimensions variable. Installation view at Rockbund Art Museum, 2018. Courtesy of the artist.

Plate 18. Lin Tianmiao, *Day-Dreamer,* 2000. White cotton thread, fabric, digital photograph, dimensions variable. Installation view at Rockbund Art Museum, Shanghai, 2018. Courtesy of the artist.

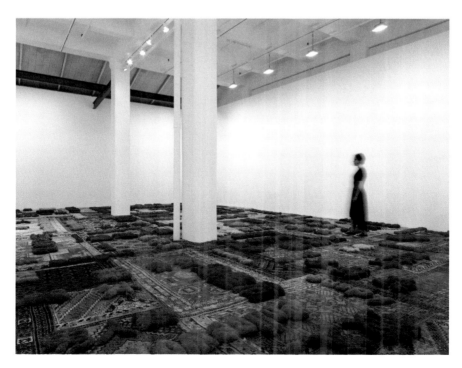

Plate 19. Lin Tianmiao, *Protruding Patterns,* 2014. Wool thread, yarn, acrylic, dimensions variable. Copyright Lin Tianmiao. Courtesy of Galerie Lelong & Co.

Sui Jianguo
The Matter of Endurance

When describing the "spirit of the stone" as an idea present in Chinese mythology and literature, Sui Jianguo is careful to avoid leaning too heavily on claiming ties to folkloric stories. While this genealogy helped to assert a distinct cultural identity for his art, Sui also recognized the trap of being seen as mired in the past. This was the bind that many artists found themselves in during the 1990s. In the early 1990s, as a critical mass of Chinese artists encountered the realities of the global art world for the first time, the urgency toward self-definition escalated to new heights.

Were cultural references automatically a sign of "playing the China card"?[1] Or, were they, in fact, a sign of self-respect? Even as artists and critics agreed on the necessity of grabbing hold of their capacity for self-definition, they differed on whether cultural identity needed to be specially marked. The contemporary iteration of this issue presents itself as the relationship between an art history for "global contemporary art" and the place of contemporary Chinese art within it. Is there even a need for "contemporary Chinese art" as a category? Is this category actually limiting possibilities of cross-cultural connections and constraining artists within rigid cultural categories? Or, is it acknowledging the exceptional nature of a context-specific history? Any hope to resolve this must start from giving credence to the complex resolutions that artists posed when addressing these problems in their own encounters with the global art world decades ago.

To this end, this chapter focuses on the artist Sui Jianguo, whose art and conceptions of art unpack nuanced articulations for self-identification. As a sculptor, his case has the added benefit of challenging metrics of contemporaneity attached to assumptions about medium. This chapter tracks Sui's intersecting arguments for the place of culture and the place of sculpture in contemporary Chinese art. Unlike artists such as Zhang Xiaogang and Wang Guangyi, who sought to share in "modern art" with Western precedents during

the 1980s, Sui was knee-deep in the decade's root-seeking *(xungen)* movement. Committed to excavating and displaying the kernel of Chinese identity, his works in the 1980s make explicit reference to ancient Chinese myths. In *Sun Bird,* for example, he balances nine clay birds atop each other, referring to the story of the legendary archer Hou Yi, who shot down nine suns (Figure 24). His search for a way out of the bounds of socialist realism saw him experimenting with abstracted schematized shapes.[2] In the 1990s, Sui continued to argue for a deep historical lineage and individual artistic language. But, by this point, he also recognized the need to articulate its importance in careful terms, lest he be accused of resorting to self-Orientalization and essentialism. Or, worse, seeming shackled to the past. This chapter follows Sui's artworks from the 1980s through the early 1990s. And, just as importantly, the ways in which he frames their meaning.

Sui's hypersensitivity to questions of what constitutes "contemporary" and "Chinese" art is also tied to his identity as a sculptor. After receiving his master's degree from the Central Academy of Fine Arts in 1989, Sui stayed to teach there, eventually becoming chairperson of the Sculpture Department. Alongside his teaching career, he had a prolific output as an artist and exhibited widely both at home and abroad. As a participant in the *China's New Art, Post-1989* exhibition in Hong Kong, his sculpture was exhibited alongside other mediums and formats deemed to be "new art from China." Inside China, he arranged exhibitions and participated in symposia related to sculpture. Like his fellow artists, he used opportunities in exhibition and print to dialogue on urgent issues that loomed large over the world of contemporary art in China. He joined with his fellow artists in their struggle to situate contemporary Chinese art within the global art world. But, as a sculptor, he also faced the additional challenge of carving out a space for sculpture within "contemporary art" in China.

Indeed, one of the key strategies for demonstrating "contemporaneity"— often cited in accounts of Chinese art from the 1990s—was the adoption of new mediums and formats.[3] Lured by fresh possibilities, artists embraced installation, performance, and video art as means of departing from the confines of existing mediums and their conservative associations. At the time, these new forms were recognized as ways to participate in the "international language" of contemporary art. Recording this trend in historical accounts as an unambiguous process of adoption and equivalence, however, paves too smooth a path.

While this way of thinking about mediums did initially take hold, over time artists questioned its hierarchical logic. Many historical accounts, however, have simply accepted these clear-cut divisions rather than tracing the

Figure 24. Sui Jianguo, *Sun Bird*, 1984. Clay on stone pedestal, 45 cm (including pedestal). Courtesy of the artist.

discourses that scrutinized their evaluative implications. In this ordering of mediums, new formats serve as shorthand for "advancement" based on their associations with worldwide trends. With the introduction of "new media," particular mediums have been disparagingly deemed as "old." This has affected the dismissal not only of "old" mediums as staid and stale, but also "new media" and formats that are just as quickly marked as broadly "international" and "unofficial." These kinds of cursory definitions and connotations have affected how mediums are treated: within this teleological narrative, the category of medium has often been used to enforce rigid dichotomies between old and new, official and unofficial, and static and innovative.

Sculpture occupies a curious position in these narratives and appropriately disrupts them. It is precisely because of its marginalized position in "experimental art" that it offers an important vantage point from which to study how these hierarchies worked, how they were challenged at the time, and how they continue to inform narratives today. During the 1990s, even as discussions moved forth on paths for pursuing contemporary art, many critics remained skeptical over whether sculpture had any place in this at all.

The first part of this chapter covers the larger discourse concerning the place of sculpture in contemporary art. The second part follows Sui Jianguo as he navigated multiple forms of marginalization. By tracking how he contended with the hierarchy of mediums and formats, this chapter shows the convergence of Sui's conceptual, rhetorical, and artistic strategies for positioning himself. This is particularly important given that these medium-specific biases remain entrenched in historical accounts of contemporary Chinese art today.

Sui's art and articulations, furthermore, shed light on the specific challenges and opportunities raised by the renewed emphasis on cultural context in contemporary art. Were markers of tradition counterproductive to assertions of "contemporaneity"? How important were declarations of collective identity? Variants and degrees mattered a great deal here as appeals to culture could quickly devolve into perceptions of cultural essentialism, patent nationalism, or unintended critique. And, within this, where did "individual experience" fit in as a concept? Sui Jianguo's works and words showcase the strategic tactics employed in order to confront these challenges.

Reading Sui's interviews and writings alongside his artistic investigations offers insight into the connections between the conceptual turns in how he perceived art and his own artistic practice. Sui did not simply treat his art as a place for the passive reflection of his theorization. He used his art to address these pressing issues *about art*. In doing so, he imbued his work with agency to discover and materialize revelations. Sui's trajectory in thinking about and

projecting his concerns for art offers a fascinating look into how artists set out to intervene in conceptions of individualism, nationalism, and globalism within and through their art.

The Place of Sculpture

On the occasions when sculpture was granted consideration in relation to "experimental art," a common refrain was the very lack of attention paid to sculpture at all.[4] In his report on the 1992 *Contemporary Young Sculptors Invitational* exhibition and accompanying conference, Sun Zhenhua—one of the curators—highlighted its marginalized standing: "Chinese sculpture has never been accorded the cultural status that has been granted to painting and architecture."[5] For Sun, this placed a two-pronged burden on practitioners of the format: to establish a clear position in art history and pursue its own contemporary character alongside other art formats. Even with this exhortation, however, two years later, Yin Shuangxi's review of the exhibition *Sculpture in '94* begins with a similar lament: "The creation of contemporary sculpture . . . has been carried out on the sidelines of modern Chinese art."[6] The continued subsidiary position of sculpture in the discourse on "modern Chinese art" was perhaps unsurprising. Placing sculpture alongside other formats—both old and new—only seemed to confirm its ultraconservative reputation.

As one of the core majors in every art academy's curriculum, sculpture—like oil, ink, and printmaking—is weighed down by its historical closeness to the academic parameters governing expectations of art. Even as sculpture was parenthetically thrown in with these other formats under the phrase "easel art," its assumed conservatism was distinctly marked from that of its neighboring art forms. Given the materials and machinery necessary for making sculpture, many sculptors remain attached to either the academy or factory-like spaces even after graduation. While the prospect of being an independent artist began to gain traction during the 1990s, sculptors faced impediments to seeking the spatial reclusion that other artists were able to find in peripheral art communities. During the 1990s, while performance artists, photographers, and painters lived and produced work in Beijing's art districts such as the Old Summer Palace and the East Village, or engaged in Apartment Art, sculptors used the facilities at the Central Academy of Fine Arts or places such as the Sculpture Creation Graduate School (*diaosu chuangzuo yanjiusuo*).[7] In addition to maintaining access to resources and facilities, these arrangements also carried financial incentives. The government commissioned teams of sculptors from these places to produce public monuments. The storied history of

socialist realist sculpture projects, the collective nature of these undertakings, and sculptors' continued participation in such systems of cultural production all contributed to the singularly ambiguous position of sculpture in contemporary art.

These facets all contributed to sculpture's becoming the perfect straw man against which to define the "contemporary" character of newer formats. Installation art's transitory nature, use of unconventional materials, and international cachet cast sculpture's permanence, publicness, and political functions in direct contradiction to what was enticingly new. Artists and critics in the early 1990s were particularly preoccupied with the dividing line between sculpture and installation art. The replacement of the former with the latter—in production and critical discussion alike—seemed to offer a logical path forward toward signaling artistic progress.

The impulse to dismiss sculpture fit into a widespread discussion in the 1980s and early 1990s over the merits of *buke*. Translated as "making up a course," *buke* characterized the widely held opinion of many artists and critics in the 1980s that China needed to catch up with the West. This applied to both the learning of Western art history and the adoption of new formats, styles, and trends. Unsurprisingly, some of the most trenchant challenges to these pursuits were issued by unapologetic representatives of the academy. In 1990, in celebration of the fortieth anniversary of the Central Academy of Fine Arts, for example, the renowned sculptor and educator Liu Kaiqu stated:

> Some people say modern Chinese sculpture lacks the "modern feeling" of Western formalism. Others say that not copying classical traditions is not national[istic] *(minzu)*. This kind of argument is erroneous. Sculpture, no matter how it is expressed in form and technique, only needs to express Chinese people's thoughts and feelings, to be advanced and beautiful, to inspire the people, give a sense of beauty, and to have the dignified air of the Chinese nation.[8]

By locating the heart of sculpture not in a particular form but rather in its ability to inspire, Liu maintains the centrality of its ideological function. While seemingly open in not specifying a particular "form and technique," he went on to warn: "Some students believe that there is nothing to learn in school, that they only need to do their own artistic creation, but this kind of thinking is not right." Liu's comments reveal the extent to which defenders of the academy still held tight to a nationalistic objective and reframed its utility accordingly in the contemporary discourse. The adherence to nationalism gave license to

disregard—and, indeed, rebuke—fears that China was lagging behind others in the art world. By pegging the importance of art to "express[ing] Chinese people's thoughts and feelings," Liu questioned the relevance of Western formalism to the Chinese context. Behind this lay a more pointed critique directed at the perceived distance fomented between art and the "Chinese people" by those blinded by the desire to be more "global" and "contemporary," and who willingly placed the criteria and recognition of each in the hands of others.

As Chinese artists began to exhibit abroad in the early 1990s, their calls for self-definition and self-determination echoed throughout the discourse. The direction forward, however, remained up for debate. Was it possible to secure global parity without resorting entirely to abandoning Chinese history or tradition? Did declaring one's own path require assuming the kind of isolationist stance that Liu Kaiqu's dismissal put forth? When seeking to lay claim to "contemporary Chinese art" in the global art world, was it so black and white that one could either evoke nationalism in order to maintain cultural identity, or equate modernization with Westernization? Over the course of the 1990s, proponents and practitioners of contemporary art in China sought ways out of this bind.

Even as artists saw the adoption of new mediums as a possible way forward, a concomitant discomfort arose over the all-or-nothing proposition of either following modern Western art or being condemned to the presumed backwardness of academic tradition. As people began to challenge and chip away at this conundrum, it was precisely sculpture's storied political and academic lineage that exposed what was at stake. As Sun Zhenhua asked in 1992, was it necessary to "neglect the achievements of one's predecessors in order to satisfy a contemporary spirit"?[9] By the mid-1990s, growing self-awareness among artists and critics led to a retrospective skepticism in the discourse. In a roundtable discussion in 1996, critic Qian Zhijian, commenting on the rise of newer art forms, asked, "These are all things that were taken from the West. To what degree have they connected with the Chinese context"?[10] Were global contemporary trends simply the newest iteration of modern Western art? Qian's invocation of a "cultural context" gave voice to the perennial concern over who was defining the parameters for contemporary status in the global art world.

At face value, such cautionary reminders guarded against blindly following established models. Embedded within these concerns, however, were significant interpolations. In calling for the specificity of context to be taken into account, Chinese artists and critics were laying down demands for what constituted contemporary art. Critics like Qian were not rejecting these newer

art forms outright. Rather than accepting the premise that to be considered "contemporary" in the global art world was a matter of adoption or rejection, they approached it instead through a strategy of adaptation. What might have started as a reactionary measure—the emphasis on cultural context—paved the way for proactive intervention. Participation in the global art world did not mean needing to accept predetermined "international languages" and, indeed, a predetermined definition of what constituted "contemporary art." By treating contemporary art as a place where revisions and contributions could be made, Chinese artists and critics showed a claim of ownership over its terms and definitions. Calls to recognize difference—in the form of cultural identity, relevance, and context—furthermore opened up the dual directions of worldly engagement. By demanding multiplicity in understandings of contemporary art, they were expanding the terms of global participation such that it was no longer predicated on Chinese artists' pleading to be let into an exclusive club. Instead, in their calls for contemporary art to incorporate "cultural context," they were broadening its defining features to accommodate their ideas and circumstances.

Within this discourse, sculpture was granted a second look. Following the questioning of "new formats," critics displayed a similar self-consciousness toward how "old formats" had been treated. For his 1996 exhibition *Sculpture and Modern Culture,* curator Wang Lin begins the accompanying text: "Because there seems to be an opposition between sculpture as focused on technique versus installation as founded on the selection of materials, this has given rise to a misunderstanding in China: installation seems to be a more advanced art than sculpture."[11] Like Qian, Wang questions the past enthusiasm for adopted art forms. But he goes even further by implicating the metrics of advancement that misled assumptions about contemporary art. As definitions of "contemporary art" became untethered from what was "new" and "international," the utility of "cultural context" promised to redefine the parameters for determining contemporary art. These reevaluations of previous assumptions unveil the unevenness in the thorny path toward claiming the status of—and, one could argue, becoming—contemporary art. While often explained as a linguistic shift from "modern" to "contemporary," or a series of strategies—such as exhibiting abroad or adopting new mediums—the transition toward "contemporary art" was rocky and reworked. In confronting asymmetrical power relations, artists and critics concerned with the repercussions of "global" and "contemporary" continually adjusted, revised, and redefined their meanings.

Root Seeking

The question of how to position Chinese sculpture internationally was already of primary concern for Sui Jianguo in the 1980s. His years as a college student at the Shandong Academy of Art, from 1981 to 1984, coincided with the height of the root-seeking movement. Advocates of root seeking contended that recuperating native culture would both recover what had been lost during the Cultural Revolution and offer an alternative to the government's economically oriented modernization project.[12]

Celebrated author Han Shaogong, one of the most prominent proponents of root seeking, stated at the time:

> Taking place here and now are spectacular economic reforms, economic and cultural constructions, "grabbing" from the West everything we can use in science, technology, etc. and moving toward a modern way of life. But . . . China is still China, especially in regard to literature and art, as well as the deep structure of national spirit and cultural characteristics. We have our national identity; our responsibility is to release the energy from modern concepts to recast and galvanize this form of identity.[13]

With cultural subjectivity at stake, root seekers set out to restore a national identity. As a young student, Sui Jianguo became particularly committed to applying this to sculpture and sought to locate "power and origins within the fountainhead of one's own national culture."[14] The understanding that China should have a distinct source for its own way forward cast China–West relations within a comparative framework. The need to resist Westernization went hand in hand with locating the roots of Chinese cultural identity.

Like other root seekers, Sui looked outside the remnants of the Cultural Revolution, as they saw this as a period in which the "roots" of Chinese culture had been suppressed. In art, this meant going beyond socialist realism's guiding principles in the academic curriculum. During the early 1980s, Sui found inspiration for this through sculptors such as Bao Pao (born 1940) and Wang Keping (born 1949), both of whom exhibited in the groundbreaking *Stars* exhibitions in the early 1980s.[15] Wang Keping's distorted figures emerged from his self-taught background. His overt political messaging—referenced through symbols like a red star cap and the Little Red Book—have made him especially recognizable in the canon of contemporary Chinese art. But, Sui was more influenced by Bao Pao, who had graduated in 1967 from the Sculpture

Department at the Central Academy of Fine Arts. Bao's distilled and subdued geometric forms contrasted mightily with the heroic forms of Soviet socialist realism in which all academy students were trained. These experiments incited young sculpture students like Sui Jianguo who were intrigued by alternatives to the curriculum.[16]

Throughout the 1980s, Sui encountered translated texts on world art and histories of sculpture that limited entries on Chinese sculpture to ancient examples. The gap in any cultural representation from the modern era charged him with a mission to fill in this blank space. But what would the contours of this history look like? One of the most impactful sources for thinking about the shape of such a history came courtesy of the Taiwanese art journal *Lion Art (Hsiung Shih)*. From March to June 1982, the magazine published a four-part series titled "Western Sculpture since Picasso's 1909 *Woman's Head*."[17] As a possible template for organizing histories, the articles informed him of the established attributes and categories governing art historical narration: lengthy, linear, culturally bounded, and medium specific.

The series was authored by Chen Yingde (born 1940), a painter and art critic who studied art history in Taiwan before moving to Paris in 1969 to pursue a doctoral degree.[18] Chen's historical account begins with the First World War and continues through the early 1980s. Starting with Pablo Picasso and Marcel Duchamp, the series continues through Louise Nevelson's wall pieces to Hans Bellmer's reconstructed dolls and ends with "body art," "land art," and "conceptual art." The emphasis on performance is particularly strong in the fourth part and even includes images of Gutai artist Kazuo Shiraga's 1955 *Challenging Mud* and Hsieh Teh-ching's *One Year Performance 1981–1982 (Outdoor Piece)* in New York. The inclusion of these artists is notable given the title of the series, "Western Sculpture," suggesting a broadening, or perhaps decentering, of both terms. In addition to the range of works included, the very notion of an organized historical account showcased what could be made possible in an authoritative, chronological history.

Typical of *Lion Art*, the series is well illustrated with more than one hundred photos across the four issues. Either inserted directly next to the text, or printed three to a page, each picture is captioned and referenced in Chen's history. Sui recalls being so absorbed by the pictures that he filled an entire sketchbook with his drawings of each. During the 1980s, when photocopying or purchasing a personal copy was out of the question, copying an entire book by hand was a common practice among young people. Reproducing imagery was a natural extension of this fervor for learning. Sui's production of a personal

copy was a means of facilitating and documenting his passion for knowledge and possessing it for future studies. The layers of translation were extensive: from Paris to Taiwan to mainland China; from three-dimensional sculpture to two-dimensional photograph to printed image to drawing. All of these levels of translation testify to the vast distance and desired intimacy between young Chinese artists and modern Western art history at the time.

Even as Sui copied the images, he wasn't interested in imitating them in his own sculptural practice. He was impressed by what he saw in *Lion Art*. His exposure to Western art did not lead him to be anti-Western. Rather, it galvanized him to address the lacuna of a comparable "modern Chinese sculpture." To fill in this gap, he sought to locate pockets of creativity that had been suppressed during the Cultural Revolution. While some root seekers emphasized regional ethnic minorities as a possible source, Sui Jianguo joined those who searched for Chinese native culture in ancient philosophy and classical texts. It was at this time that he first fell into writings on Chan Buddhism and encountered foundational Daoist texts by Laozi and Zhuangzi.

In Sui's root-seeking endeavors, however, it wasn't simply a case of reading and inserting ancient philosophy into art. The larger question was how to frame these ideas for "modern art" and position them in relation to existing histories of modern art from other cultures. Even though Sui was not beset by the need to "catch up" with Western art in the sense of copying or imitating styles, the anxiety toward creating a rival to "modern Western sculpture" belied the same impulse.

Sui cites the influence of an interesting source for how to situate ancient Chinese philosophy in relation to both modern times and extant Western histories: *The Tao of Physics*.[19] First published in English in 1975 by the Austrian-born American physicist Fritjof Capra, the book can be easily critiqued nowadays for its New Agey reduction of disparate East and South Asian philosophies. Capra centers primarily on Hinduism, Buddhism, and Daoism, and refers to them collectively as "Eastern mysticism." Central to Capra's text is the idea that all these belief systems share a core tenet: "The cosmos is seen as one inseparable reality—forever in motion, alive, organic; spiritual and material at the same time."[20] Reception of the Chinese translation of *The Tao of Physics* didn't focus on how the author was simplifying these distinct belief systems. Instead, in Capra's alignment of these ideas with modern physics, Chinese readers found a model for applying ancient philosophies to the present day, and bridging the yawning chasm in comparisons between China and the West.

Capra offered an even more enticing perspective for Chinese readers in

his proposition that Eastern mysticism could lead Western science to a better understanding of itself. Indeed, he states that one of the purposes of the book is "improving the image of science by showing that there is an essential harmony between the spirit of Eastern wisdom and Western science."[21] He suggests that modern physics should be seen beyond the limitations of "science." And, in fact, seeing physics through the lens of Daoism could offer a path to spiritual knowledge and self-cultivation.[22] Capra's recognition of the value of ancient ideas for contemporary application resonated with Sui's root seeking. Furthermore, his proposal of a mentoring relationship between the two cultures offered a reprieve from the prevailing belief in China that the direction of influence only ran one way.

It is easy to see why Capra appealed to so many young Chinese intellectuals, including Sui Jianguo. But even as Capra's book suggested that the West had more to learn and lent credence to the value of Chinese tradition, it still maintained the same essentialist associations of ancient China versus the modern West. Capra's discussion of parallels and convergences did not dispute the notion of a singular path to modernity. And while science could benefit from the wisdom of Eastern mysticism, the realms of science, technology, and industry remained the purview of the West. That Sui cites Capra as an influential source speaks to the craving for examples of merging "tradition" and "modernity." But it also shows the limitations of models where identification of the East with ancient philosophical traditions did nothing to dispel prevailing binaries.

Even as Sui's objective to create "modern Chinese sculpture" seemed to escape blindly following Western art, the very premise and parameters of how he perceived of categorization already conformed to established historical schemata. Histories of "modern Western sculpture" and "world sculpture" dictated a spatiotemporal organization of the world. Given the established divides across culture and time, Sui's goals were informed both by what would be deemed "Chinese" and what was necessarily "not Western." The desire to *join* an established world history, and offer something comparable to "modern Western art" thus seemed to necessitate conforming to existing systems of categorization.

It wouldn't be until the following decade when a gradual call for self-determination would lead to the upending of these terms and categories altogether. For Sui, this shift was motivated by a deeper problem that festered within his dissatisfaction with extant art practices. Throughout the 1980s, he had searched for the forms to comprise "Chinese modern sculpture." He experimented with ancient symbols, incorporated unconventional materials, and played with process. It was in 1989, however, that he arrived at some clarity in approach.

Limits of Representation

In 1989, he directed his search for language through two different strands of resistance. The first adhered to the techniques, forms, and goals of academic realism, but shifted them toward new ideological ends. The second emerged in reaction to the failures of this undertaking and took the form of distortion and fragmentation. In both cases, his dissatisfaction with results of his attempts at "rejection" (and rejection of rejection) left him aware of the very problems in how he directed his search for language to begin with.

In 1989, Sui was in the final year of his master's degree in the Sculpture Department at the Central Academy of Fine Arts. While he remained deeply invested in the power of sculpture to assert an international identity, his experiences in 1989 clarified the limitations of how he was thinking about art and cultural identity. At the end of May that year, Sui Jianguo and his fellow classmates were hired to create the *Goddess of Democracy,* the iconic sculpture that would be wheeled into Tiananmen Square.[23] Even while he, like his peers, experimented with the parameters of "modern"—Chinese, Western, or shared—they ultimately turned to the familiar language of academic realism to produce a symbol for the people.

In her collection of firsthand accounts of the making of the *Goddess of Democracy,* Tsao Hsingyuan writes:

> The students, with the strong academic training that young artists receive in China, chose a thoroughly academic approach to their problem: they decided to adapt to their purpose a studio practice work that one of them (or perhaps it was several of them) had already made, a half-meter-high clay sculpture of a man grasping a pole with two raised hands and leaning his weight on it. It had been done originally as a demonstration of how the distribution of weight is affected when the center of gravity is shifted outside the body.[24]

Working from what was essentially a classroom exercise, the students repositioned the arm to appear as though the figure held up a torch. After molding the body into a female form, the students then modeled the neck and face after Zhang Zhixin (1930–75), a critic of Mao's cult of personality during the Cultural Revolution who eventually was executed by decapitation. The students affixed this head onto the previously constructed body.[25] Enlarged to ten meters tall, she was constructed from a metal armature and foam, and covered in plaster. While the *Goddess of Democracy* was born from a commission,

Figure 25. Sui Jianguo, *Hygiene*, 1989. Plaster and mixed media, dimensions variable. Photograph by the author.

the sculpture brings to life a remarkable convergence of the students' academic training, personal experiences, and political idealism. It also speaks to a belief in the efficacy of realist sculpture to embody and transmit ideological fervor for a public audience. Arising from their training in socialist realist techniques, the students adapted curricular exercise into a singular image for the world to see.

Only five days after the *Goddess of Democracy* was created, she was struck to the ground by violent forces. In the aftermath of June 4, Sui recalls tearfully riding his bicycle past tank tracks on Chang'an Road and being subjected to reeducation campaigns. In the studio, Sui created the series *Hygiene* (Plate 11). The title is a reference to the "cleansing" that was called for by the government in the wake of Tiananmen, and the condemnation of students like him as possessing "poisoned" bodies and minds.[26] Made from wire and plaster, twelve heads appear on tall metal poles (Figure 25). Their misshapen, featureless faces are ripped open and greet viewers at eye level.

These disembodied heads offer a compelling complement to the *Goddess of Democracy*. Instead of adhering to the ideals of wholeness and harmony, Sui fragments and disfigures these forms. In doing so, he similarly distorts the intentions of academic realism by exposing the mournful results of a failed movement and the place of sculpture within it. In his gradual breaking apart of forms, Sui not only offers a reflection on the broken emotional state of the students, but also uses this to strip down and expose the constructedness of sculpture. He splits open the plaster shell to reveal a slapdash interior of chicken wire, laying bare the materials and sculptural innards to the viewer (Figure 26). In this, we see two simultaneous goals in *Hygiene*: first, the artist's channeling of pain and outrage through these mutilated figures; second, a rejection of the artistic principles undergirding the revolutionary heroism ascribed to sculpture.

Even as he tore apart forms, Sui remained dissatisfied with the results. That is, although he was seized by a need to express, he realized that he was still confining himself to the same principles of descriptive representation. He realized that he was just pitting realism against itself. In his language of "rejection" and "frustration," he was ultimately still operating within the same parameters of visual representation. Only now he was distorting forms rather than making them whole.

Sui's glimmer of a new approach can be seen in his initial forays into *Hygiene*'s experiments with medium. In his use of plaster, he explores its function as both metaphor and artistic material, referencing the plaster bandages used to wrap broken and bloodied bodies and the plaster strips used for layering onto a metal armature. The bandages show the necessity of healing and wholeness even as the material makes visible its shattered state. In his growing frustration with existing languages, the need for a new approach was as pressing as ever. What was demanded wasn't so much direct *resistance,* which still necessarily engaged the same language and principles. Instead, he sought new possibilities and concepts. Sui's eventual turn to studying materiality and medium can be considered an alternative to the educational curriculum. Its arrival, significantly, did not come through an impulse to counter visual representation *through* visual representation. He realized that his approach—and even his approach to an approach—required something apart from this. The need to dissemble what were considered to be core components of art left artists looking for entirely new possibilities in thinking. This left Sui open to material investigations when they presented themselves to him later that year.

Figure 26. Sui Jianguo, *Hygiene* (detail), 1989. Plaster and mixed media. Photograph by the author.

Material Relations

In the fall of 1989, Sui Jianguo brought students from Beijing to Tianjin, a city located 130 kilometers southeast of the capital. For the better part of a month, he guided sculpture students through *da shitou,* an exercise that translates to "striking stones." An annual event organized by the Central Academy of Fine Arts, the activity familiarized students with different types of stones and processes of manipulation. Sui was ostensibly there as a newly minted teacher in the Sculpture Department, from which he had just graduated with his master's degree. But on the heels of the crackdown on democracy protests at Tiananmen Square—a stone's throw away from the CAFA campus—he had also gone as a reprieve from the emotional turmoil and political uncertainty felt in the capital.

Although he was there to lead the students, Sui had never engaged in *da shitou* before. At the Shandong Academy of Art, his training had been more focused on clay rather than stone. The new and deeply intimate experience of striking stones led to an epiphany: "Once I began to carve stone I instantly felt the endurance and reserved strength of the material."[27] Sui's enthrallment with stone launched a number of series over the next five years. Even before he had a clear idea of what they would become, he carted boulders from quarries to his small studio on the CAFA campus. As stones slowly amassed in the corner of his studio, Sui was duly struck by their physical presence. His subsequent series—from *Inter Structure* to *Earthly Force*—aptly demonstrate his abiding interest in the perceived strength emanating from these stones.

These series are often read solely in conjunction with Sui's immediate political context in which the focus on resilience offers a commentary on the tragedy of Tiananmen and life in its wake. Indeed, the material evocations of silence and confinement in these works are poignant and powerful. However, confining art to political metaphors limits understandings of art and politics alike. For Sui, too, the limiting of art to this kind of messaging was precisely what he found insufficient. When treated as a blank support, medium remains a static receptacle, constricted to a one-way relationship with the artist. With stone, he found a material that responded with its own energy and force. When employed in the academic curriculum, working with stone was necessarily preceded by molding a maquette or vignette out of clay. Like metal and plaster, stone was expected to be formed into a preconceived figure or scene. But in his encounters with stone, Sui was struck by the power that appeared to already exist in its unyielding nature.

One of the first series to emerge from his new fascination with material was *Inter Structure.* The series comprises a number of experiments in severing,

chaining, and repairing stones. In *Inter Structure #3* (Plate 12), a boulder that has been broken apart is mended again with metal staples inserted perpendicular to the broken lines (Plate 12). The short stitches lend greater visibility to the cuts in the stone and penetrate the substance to hold the pieces together. This emphasis on stitches continues the study of repair that Sui began with his *Hygiene* series. Rather than a reliance on a figural form, however, Sui's literal infiltration of the material sees a turn toward engaging with both the weighty substance of stone and its very absence in the multiple seams of breakage.

In another work in the series, *Inter Structure #12*, he cuts a stone cleanly in two and affixes thick metal chains to occupy the chasm between the two halves (Figure 27). He again works with the stone's fracturing and the different possibilities for understanding the ties that bind them together. They can be seen as akin to shackles, or as an attempt to mend and keep the two halves secured. While the series investigates unity and breakage as depicted through metal and stone, it begins first with an acknowledgment of why the metal is required. Unlike in plaster or clay, lines of fracture in stone cannot be patched and concealed. Indeed, this is what calls for the aid of metal for repair. It is the very solidity and permanence often associated with the materials that make any cracks and fissures indelible traces of its past.

This aspect of *Inter Structure* harks back to a visit Sui took with friends to the Ming Tombs, the imperial tombs of the Ming dynasty (1368–1644) located on the outskirts of the capital. While there, he came across a giant stele that had been smashed during the Cultural Revolution and subsequently repaired with cement. Although made physically whole again, the stone still openly revealed its history through scar-like lines. Penetrating back to front and across its surface, these lines showed the dual capacity to signify destruction and recuperation.

Sui similarly drew on the long-held artisanal methods of repairing everyday objects. Staples were commonly used for rescuing ceramic vessels and extending the life of damaged crockery. In many ways, this continued the theme of recuperation and "broken unification" that appeared in *Hygiene*. But rather than just translating these ideas into metaphorical or descriptive representations, he studied them through the physical material of stone. Similarly, his references were not simply a signal of the artist dipping into a collection of techniques, or wanting to apply "traditional" methods to working with stone. Instead, it was the stone itself that offered Sui a means of making visible the lived history of his material.

This notion of the lived life of stone continues into his following series, *Earthly Force,* in which a collection of large stones sits quietly on the floor (Plate 13).

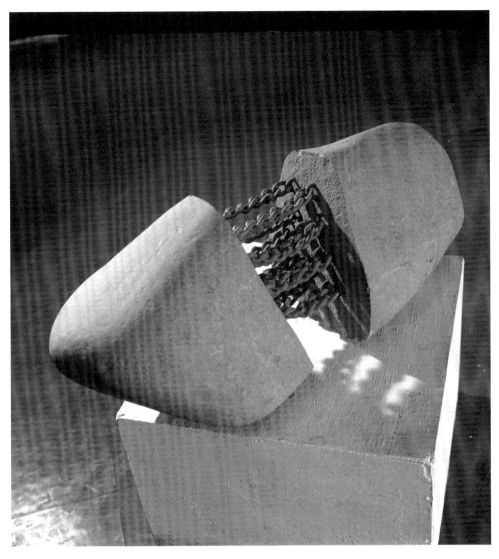

Figure 27. Sui Jianguo, *Inter Structure #12*, 1990. Stone and iron, 40 cm (height). Courtesy of the artist.

Embracing the exterior of each is a lattice of steel. Significantly, Sui maintains the physical integrity of each boulder, keeping the overall shape and solidity of stone intact. While *Inter Structure* emitted a greater sense of active, kinetic breakage and subsequent repair, *Earthly Force* studies the capacity for stone to endure over what seems like interminable constraint. Sui moved away from a process of scarring stones to instead studying the pressures and strength already present in a stone's life.

In his choice of stones for *Earthly Force,* Sui gravitated toward large, rounded

boulders (Figure 28). To him, they evince the mineral hardness and strength of what remains in the aftermath of a long journey.[28] Some had tumbled down through winding rivers and were lapped by water into a polished state. Others, found in quarries, had been subjected to abrading and rubbing, similarly losing angular edges until appearing egg-like on the outskirts of the city. All rocks are hard, of course, but over the long process of erosion, it is the core hardness that remains.

The material offered Sui two ways of thinking about the life of a stone. The first was in the physical traces of its lived life, and the second in its *jingshen,* often referred to as "spirit." To the latter point, this was not simply a case of admiring the stone's inner fortitude but more importantly a kind of living energy. Sensing the life in the stone, Sui shifted from thinking about working *on* a material to working *with* it. Rather than seeking to transform it into something else, he instead allowed the artistic process to unfold as a course of studied engagement. Sui's recognition of the spirit and life within these stones guided him toward creating works that did not simply describe but rather *enacted* relationships. In the process of making, an exchange of mutual energy is unleashed. Thus, what we see in the resulting works is not simply a representation of tension, but in fact a study in the physical enactment of this tension.

The more Sui contemplated the life and life force of stone, the more he recognized this kind of reverent belief in classical Chinese philosophy and literature. He was already familiar with Buddhist and Daoist ideals from his earlier root-seeking initiatives. Now, he focused on how these undertones were woven throughout popular literature. In particular, Sui cites *Dream of the Red Chamber* and *Journey to the West,* two of the celebrated Four Classic Novels in China.[29] The former novel, which is also sometimes called *Story of the Stone,* revolves around the character of Jia Baoyu. The protagonist—whose name literally translates to "precious stone"—was born with a piece of jade in his mouth. The origins of this particular stone are, in turn, fixed in the myth of the goddess Nüwa. When she patched the broken sky with stones, one remained left over. The entire first chapter of the novel recounts this creation myth wherein the leftover stone requests to experience the world. This sentient stone is thus reincarnated as the character Jia Baoyu while also maintaining a physical presence in the polished jade found in the infant's mouth.

The mystical properties of stone can also be found in *Journey to the West,* which follows the story of the monkey Sun Wukong. A combination of folklore, Buddhist, and Daoist teachings, the novel follows the monkey as he accompanies the monk Xuanzang on a pilgrimage to India. The first part of the story

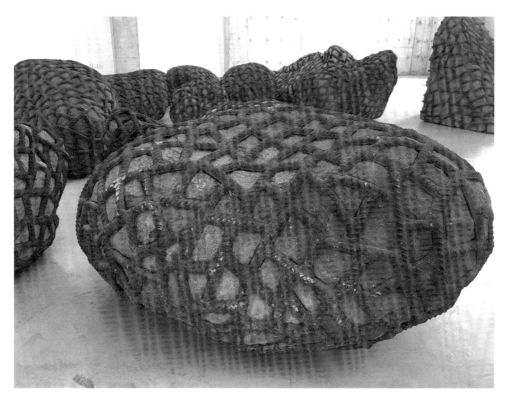

Figure 28. Sui Jianguo, *Earthly Force,* 1992–94. Stone and rebar, dimensions variable. Photograph by the author.

recounts Sun Wukong's birth, where he famously bursts to life from a boulder inside Flowers and Fruit Mountain. Even in the first chapter of *Journey to the West,* the phrase "stone egg" appears, much like the physical forms implied by Sui's stones. Like a womb for gestation, the primordial nature of stone springs forth as both a living and life-bearing force.

The centrality of stone to miraculous origin stories constitutes part of the genealogical history of Sui's series. As philosophical and cultural references, they hark back to Sui's root-seeking agenda from the 1980s. But to simply see Sui's adoption of Chinese philosophy as a marker of "tradition" and Chineseness falls back into a common trap. Quoting tradition may guarantee cultural authenticity, but at the same time, this can also quickly result in implications of backwardness. This was one of the very problems proponents of "modern Chinese art" encountered. In the rush to use Chinese markers to avoid being seen as derivative, artists could just as quickly be accused of being "nonmodern."[30] To bypass allegations of either "playing the China card" or miring

oneself in the past, it was necessary to formulate a new framework for treating such cultural references.

In a 1995 interview with *Hualang* magazine, Sui states, "There is a 'way of talking' about rocks as possessing a spirit. Our ancestors had a 'way of talking about rocks'—using today's language, we would call this a 'concept.'" He continues: "The results of my study and pondering of this set of concepts appeared in that group of works."[31] Sui's own way of talking about this "way of talking" carefully avoids speaking about the value of these sources as residing in cultural roots. Instead, he focuses on their articulation and amplification as a "concept." For him, their importance lay in the theorization of an entire set of attitudes, assumptions, and ideas regarding stone. This shows an important realization: the utility of tradition was no longer in its inclusion or exclusion, but instead in how this was conceptualized.

By 1995, Sui's journey through stone led him to describe his art in this way: "Not simply a fixed symbol or image, it is a way of looking at a question from an individual's point of view and depth; it has to do with an individual's experience."[32] For Sui, in 1989, the question of how to "look at a question" was directed at art itself. Ultimately, it was in the "way of talking about stone" that he found an answer. His work with stones, then, showcases not only the value of his focus on medium but also a recognition of the *value of approach* in talking about art.

With "cultural reference" removed as the root of his art, Sui significantly slotted the "individual's experience" into this vacancy. This had manifold implications. Rather than starting from established categories and relationships—"modern Chinese sculpture" versus "modern Western sculpture"; "ancient Chinese" versus "modern Western"—Sui was positioning the source for art in an "individual's point of view" and experiences. This offered a strategic way of sidestepping the biases that had trapped artists in the previous decade.

Sui's championing of an "individual's experience" strategically met two intersecting ends: first, legitimizing Chinese artists' contemporary status by already accepting their existence as contemporary; second, finding common ground between sculptors and other contemporary artists in China. In 1994, Sui organized and exhibited in *Sculpture in '94* at the CAFA gallery. The occasion provided important platforms—through the exhibition and its accompanying symposium—to announce these points. Rather than the standard group format of most exhibitions, *Sculpture in '94* promoted a solo model. Over the course of five weeks, five individual artists had one-week-long one-person exhibitions.[33] In reviews of the exhibition, individualism was doubly marked: in each show, the works on display revealed an artist's singular point of view and

use of sculptural language. And it was clear for those who visited all of the shows that each sculptor was quite distinct from the others.

During the accompanying symposium for *Sculpture in '94*, art historian Luo Shiping stated of the exhibited artists: "Even if their works absorb some things from Chinese and Western tradition, those are only through the process of study. After that process is complete, what they present to us today are very clearly individualized things."[34] Luo's deliberate assertion of individualism here effectively bypassed the circumscription of art according to either cultural framing or "derivative" stylistic trends. Pinning artistic value to an individual's experiences defended against accusations of being imitative or backward. Rather than predicating the acquisition of global parity on a perpetual need to catch up—whether to modern Western art or seemingly international standards—here, the location of contemporary began with a person's current existence. The shift to thinking about "contemporary art"—as a matter of attaining contemporaneity—was now rooted in a self-determined metric based on the individual.

This recalibration of what constituted "contemporary" was a way for Chinese artists and critics to recognize their own agency. One of the most significant changes signaled by this perspective was recognition that contemporary Chinese artists could be seen as contributing to ways of making and understanding art. Luo's final remark about the exhibited sculptors exemplifies this: "Because their concepts and systems of language bear no traces of anyone else, this is a contribution to the development of Chinese art or world art."[35] In such a fashion, the appeal to individual experience helped push perceptions of contemporary Chinese art and artists out of a passive and subordinate position. This was also significant in that although the exhibition only featured sculptors, the context for this discussion reached beyond medium and format specificity. Tying into the aforementioned debates over the "contemporary" status of sculpture, the celebration of individualism helped acknowledge the common ground between sculpture and other art forms. As artists, they all participated in shared challenges and potential resolutions for framing contemporary Chinese art in the global art world. That these five sculptors were treated as contributors to "Chinese art or world art" showcased a discursive shift in combating global cultural hierarchies and their accompanying hierarchies of format.

The argument for treating artists as individuals mirrored what Sui was calling for in treating formats. During the symposium, Sui remarked, "Perhaps from this point on, we can discuss sculpture not only in dialogue with its own past, but also in relation to all of art, all of culture, and not restricted to sculpture itself."[36] Thus, even as the exhibition was titled *Sculpture in '94*, the calling

out of the format was a means of rescuing it from marginalization. It was not to harden the lines surrounding sculpture but rather to recognize its expansive possibilities.

This was particularly useful in pushing back against divisive and hierarchical perspectives on medium. In his 1995 interview with *Hualang* magazine, Sui sweeps aside the interviewer's question about how to distinguish between sculpture and installation art. Sui challenges the very premise of this divide: "I don't really trust the theory of evolution. I trust the depth of an individual's spirit."[37] For Sui, the necessity of fighting from a doubly marginalized position required brandishing terms such as "individual's spirit" and "passions in an individual's life" *(geti shengming jiqing)* as the conceptual and rhetorical legitimization of an artist's contemporary status. This challenge effectively upset entire standards for advancement and systems of categorization.

These efforts to redefine terms both emerged from and contrasted with the anxieties toward "catching up" that underscored views of international relations in the 1980s. With the location of contemporaneity found in an individual's very existence, Sui was also calling for people not to operate out of a place of anxiety about being condemned as "backward." This would inevitably result in the dilemma of "catching up." Instead, believing in one's own point of view and one's "individual spirit" would automatically result in an address of what was contemporary. The necessity for such a rethinking was confirmed for Sui in 1994 when he visited India with the support of a grant from the United Nations. In India, he found contemporary artists mired in the same compulsion toward catching up with the West that had plagued artists in his home country. To Sui, India's colonial history presumably situated the country closer to modern Western standards than China. If artists in India were still intent on catching up, certainly this could never yield global equality for Chinese artists. Using the *buke* metaphor of "making up a class," he commented that those who pursued this path were "like elementary school students, looking at other people's textbooks to come up with good topics."[38] In contrast, he posited that "one must use one's own life experiences to pose one's own questions."[39] To this end, "individual experience" was not only a means of asserting one's contemporaneity but also a way of verifying one's rightful place in the world.

Oftentimes in accounts of contemporary Chinese art, artists' mentions of "individual experience" have been held up as evidence of the influence of Western neoliberalism over and against socialist collectivism. In the post-Tiananmen context, in particular, this way of thinking about "individualism" has been equated with an overt declaration of dissidence. These narratives,

however, overlook why and how "individual experience" and its iterations mattered for artists. Through artists like Sui, we can understand the use of these terms as a means of figuring an individual in accordance with, and not necessarily in contrast to, collective and cultural identities.

Although these assertions of the individual moved away from explicit declarations of "Chineseness," it would be wrong to assume that artists simply dismissed collectivity altogether. The desires for collective identity—even cultural identity—did not simply dissipate with the emphasis on individual experience. Wu Hung argues that following Tiananmen, artists "almost overnight . . . were transformed from soldiers in a heroic struggle into lone individuals facing an alien world."[40] But even this suggests too cleanly the ways in which artists reoriented difference. The 1990s have largely been read as a way of resisting "collectivity," either in reaction to the communal spirit of socialist thinking under Mao or in terms of the failures of the '85 Art New Wave. However, references to "individual artistic language" and the rhetoric around this need to be further examined. Even as artists saw themselves as individuals, motivations for locating difference lingered and found articulation in cultural terms.

A Genealogy of Endurance

Like the shift toward framing "cultural reference" and "tradition" as "concept" and "approach," a similar maneuver occurred with regard to "cultural identity." What artists and critics began to identify as a cultural bond was an attitude toward art making. Artists born in the 1950s and 1960s had grown up with art—in their childhood and then in their training—as an instrument for struggle, for political ends, as something to believe in, to fight for, and to figure oneself out through. This history of assertion, agitation, and negotiation both emerged from and contributed to the sense that art should be struggled for. In the early to mid-1990s, this appeared as a common refrain in artists' and critics' value-laden judgment of what was lacking in contemporary art outside China. This informs the surprising ways in which declarations of an "individual's experience" ended up as a cultural bond that wasn't about ancient roots or even described in terms of recent history. Instead, it was about the very purposes and driving motivations for making art.

Interestingly, Sui again found a connection between the struggle inherent in art making and his reading of Buddhist and Daoist texts. As he continued to pore through these texts, he was not only drawn to the philosophical content of each, but also inspired by the historical conditions under which each philosophy developed. As he describes it:

Daoism emerged naturally over a long period of Chinese society and culture. It was under a feudal society when people had no way of realizing their ideals that they formed a spiritual escape; they could not *not* do it. Chinese Chan Buddhism was not the invention of one brilliant Chinese person; it was the product of difficult predicaments. Today, they are all grand cultures, while the predicaments behind them have been hidden and have disappeared. . . . These are the products of challenging times, or struggles with those times. . . . There are many obstacles in making art.[41]

These texts revealed to him a pattern of persistence and endurance that resonated with ways of thinking about the imperative to create and generate. This location of an "attitude" within a set of historical conditions offers yet another take on the conceptualization of cultural reference in contemporary practice.

In fact, Sui's emphasis on "struggle" had a more direct relationship to collective identity, individual experience, and his treatment of materials in sculpture. The laborious nature of sculptural production—something he emphasized and even intensified in his own work—was one way of recalling the struggle that he saw as a necessary feature in art making. Sui notes that the factory-like conditions of sculpting—the use of assistants, intensity of manual labor, dependence on heavy machinery and industrial processes—have often led others to place sculpture in a separate, "lesser" category than other avant-garde art mediums and formats.[42] While others may have denigrated its approximation to "heavy industry," for Sui, this struggle and endurance were in fact central to what he viewed as a fundamental aspect of art.[43] It's not surprising, then, that what he found through stone in 1989 was not only an immediate political reprieve but also something much more central to what he sought to access in art and unleash through sculpture. His enthrallment with stone helped him to activate labor and struggle as central to thinking about what he required from art, and, in turn, realizations about how this figured into his self-identity.

In *Earthly Force,* for example, each of the bound rocks is the culmination of a laborious monthlong dialogue between Sui and the stone (Figure 29). When seen only in terms of containment and confinement, the resulting message is that of each rock subjected to quiet imprisonment. But even in the visual form, a kinetic tension is visibly activated by the lines of rebar vigorously crisscrossing each curve. And the interchange of energy is clear: both between artist and stone and then between stone and metal.

While most often the reading of these stones focuses on how the metal encases the stone, the reciprocal force shows that the stone has, in fact, also acted

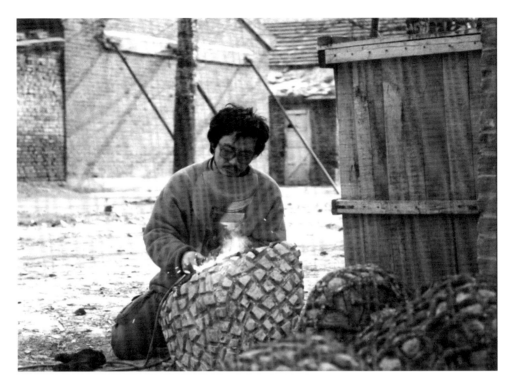

Figure 29. Sui Jianguo working on *Earthly Force,* Beijing, 1993. Photograph courtesy of the artist.

upon the metal. In the production process, as Sui carefully drills channels to fit and solder each length of steel, it is the original form of the stone that ultimately dictates the shape of the lattice. Each dimensional sweep of steel encasement follows the original contours of the rock beneath. That neither material passively accepts the other communicates the energy exchange that Sui valued in his own personal negotiations with these same materials. Sui's approach to his materials as a process of give-and-take—and, indeed, as a larger study about relationships—formed a significant subject of exploration in his art. This continues to pulsate through each bound stone, where life and force continue to shape each other.

Even when Sui moved onto working with rubber and nails in his following series, he continued to explore the implications yielded by the relationship between materials. Throughout, medium served as the site through which he explored possibilities for thinking about how meaning is formed and communicated. In *Kill* (Plate 14), he took rubber originally used for transporting coal and then discarded by factories. As with stone, he was impressed by the rubber's

sheer strength. This time, however, it wasn't through its hardness that the material emitted strength; rather it was through "tolerance" and adaptability—that is, its ability to be manipulated, even damaged, and yet still not tear or disintegrate. He had previously tried puncturing wood with an excess of nails, but found that the wood would eventually splinter. A sheet of rubber, meanwhile, could be punctured thousands of times (Figure 30). The rubber would grip each of the nails until the entire sheet looked like a pelt. And even with the density of nails, the rubber maintained its structural integrity. It didn't split apart, and could even be bent, suspended, draped over something, or rolled up.

The mutability of rubber contrasts with the unforgiving hardness of stone. But the two share in their durability. Unlike the rock that determines the shape of the steel in *Earthly Force,* in the case of the rubber and nails, there is a greater sense of give-and-take. As much as each nail perforates the rubber, the rubber in turn grips each nail. Through his process of experimentation, Sui was also struck by the transferring of "violence" and transformation of roles. In particular, as the nails puncture the rubber, they leave behind a literal mark of assault. The resulting piece of rubber—pierced through—appears like the casualty of violence: wounded. But, over time, in working with the material, he came to a new conclusion:

> The rubber went from being a passive victim to slowly—with the prick of each nail and the absorption of suffering—turning into an aggressor. For example, if we were to touch the surface of the rubber, we would be hurt by the nails. This work mapped out my thoughts on society: society has problems; every person plays a respective role; because of existence, we often have no choice but to compromise and cooperate.[44]

These final thoughts reveal the extent to which art—and more specifically, material—unveiled for Sui a way of thinking about life. This contrasts with the ways in which the relationship between art and life is often theorized as unidirectional, where art is treated as the mouthpiece for an artist's thoughts. Instead, we see here the numerous ways in which it was through process and material that he arrived at revelations and realizations about his own desires and demands for conceptualizing culture and identity.

Throughout the early 1990s, as Sui became more deeply drawn into stone, his explorations into the medium's physical properties swelled to embrace spiritual, social, and cultural connotations. As geological object, cultural reference, and psychological sounding board, stone thrust forth new avenues for Sui to theorize and confirm his artistic purpose. It sparked new directions for

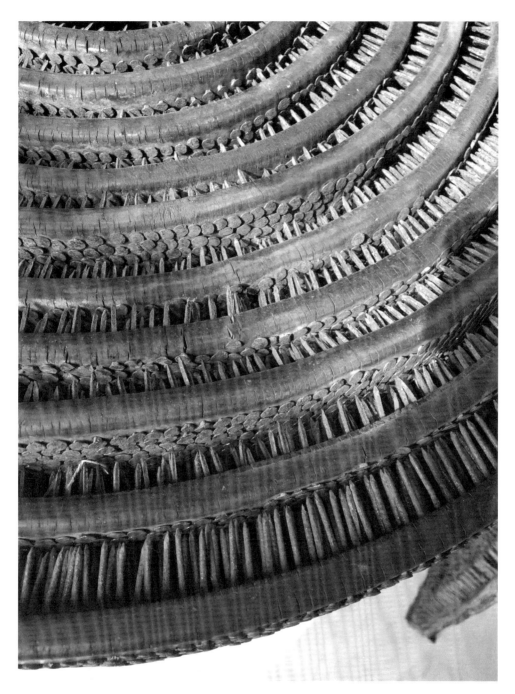

Figure 30. Sui Jianguo, *Kill*, 1996. Industrial rubber and nails, 65 x 65 x 65 cm. Photograph by the author.

conceiving of art and, indeed, the basis for realizing his own agency in conceptualizing his art and its place in the world.

At the time, opinions diverged over degrees of loyalty to differing forms of cultural solidarity. Some viewed cultural identity and individual identity as seamlessly integrated, while others expressed wariness toward any form of collective identification. Did championing individualism supersede nationalism by proposing a dialogue among individuals rather than between nations? Or did emphasis on the individual affirm the uniqueness of each person's cultural experiences, and thus could be rendered in the service of asserting "Chineseness" as something distinct from that which resided in the Western imagination? A declaration of Chineseness could be considered a path to combating the West, but remained open to accusations of playing the China card. The articulation of Chinese identity filtered through individualism emerged as a useful strategy—invoked by critics and artists alike—to defend against charges of either being derivative of the West or too entangled in cultural essentialism.

Sui's interests in material and materiality show how art served as a venue for addressing and articulating some of the most pressing problems at the time. The contrast with how he treated cultural references in the 1980s versus the 1990s reveals the problems of both collectivity and contemporaneity vis-à-vis identification by means of cultural markers. The rhetorical and conceptual gymnastics that ensued were part of the artist's larger efforts at locating a place for not only contemporary Chinese art in the world but sculpture's role specifically. The turn to materiality and medium as a site of inquiry rather than a divisive category was a way of moving the discussion beyond medium specificity and the hierarchies associated with it. The identification of struggle and endurance as a vital part of art making further located ways of reconceiving of cultural references beyond symbols and stories. This helped critics and artists to resituate cultural relevance as a form of worldly belonging while simultaneously asserting their agency to do so.

Zhang Peili
Dangers of Definition

For the entirety of Zhang Peili's video *Water: Standard Version from the Cihai Dictionary (Shui: Cihai Biaozhun Ban)* (Figure 31 and Plate 15), the renowned state-news broadcaster Xing Zhibin sits poised at a news desk.[1] Wearing a yellow blazer over a black blouse, the well-coiffed anchor stands out against the blue background of the television studio. A standing microphone on the right angles away from the camera and toward her body. From setting to posture to person, the scene immediately calls to mind a state-run news program. Its resemblance is so striking that a viewer would be forgiven for mistaking it for the real thing.

As a mouthpiece for the Party-State, Xing Zhibin's professional appearance and precise elocution alone propagate governmental standards for propriety and communication. However, when the audio begins, a curious dissonance starts to form between word and image. Over the course of nine minutes and thirty-five seconds, she reads aloud from the hefty tome laid open at her fingertips. The text, identified as the *Cihai* dictionary in the title of the work, is confirmed as soon as she begins speaking. Issued in the same measured tone, pacing, and cadence that she would reserve for a news broadcast, Xing enumerates the entries listed under the definition of water *(shui)*. Periodically looking into the camera to announce the compound characters—such as "shui gong" and "shui che"—Xing maintains the same self-assured pose throughout the video as she crisply enunciates the listed meanings.

Created in 1991, Zhang's video resonates with disheartened critiques of the state in the wake of Tiananmen. Even more specifically, it aligns with negative perceptions of CCTV (China Central Television) reporting at the time. On June 4, 1989, Chinese viewers witnessed a historic broadcast by two well-known anchors, Du Xian and Xue Fei.[2] Dressed in black, the two emitted mournful expressions as they reported on the tragedy that had just unfolded in Tiananmen Square. Departing from their own standard delivery, neither Du nor Xue could

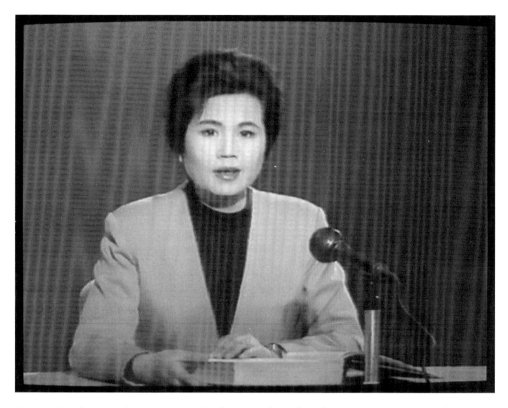

Figure 31. Zhang Peili, *Water: Standard Version from the Cihai Dictionary*, 1991. Video (color, sound), duration nine minutes, thirty-five seconds. M+ Sigg Collection, Hong Kong (by donation). Copyright Zhang Peili. Courtesy of the artist and Tilton Gallery, New York.

conceal their sadness and sympathy for the massacred students. In the aftermath of the broadcast, both were reprimanded for their off-script demeanor and never appeared on air again. In contrast, the steady appearance of Xing Zhibin on CCTV bore out the rigidly impersonal conduct exemplified and rewarded by the government.

Part of the sheer power of the work undoubtedly hinges on the absurdity of a state newsperson announcing the definition of water. In most interpretations of the work, art historians and critics treat the audio of *Water* as a means for neutralizing or parodying the control wielded by state-owned media. In her dispassionate delivery, Xing seems emptied of her own discretion and free will. By replacing her script, Zhang reveals her to be an unthinking apparatus, at once a manipulated vessel and an instrument of bureaucratic authority. In his reading of the work, Wu Hung centers on the artist's tactic of effacement: "While the video painstakingly retains the form of the CCTV program, it abolishes its content—the news—with equal determination. The substituted text—

ZHANG PEILI

nonnarrative dictionary entries—does not fill the void left from such erasure, it only reinforces the split between form and content."[3] In line with this focus on the effects of what has been absented, many descriptions of the work have called the verbal content "meaningless": from a "meaningless screed" to a "sea of meaningless words."[4] This term has also been used to explain the target of Zhang's critique: as revealing the "meaninglessness of the news media."[5]

As art historians and critics have located the efficacy of the work in its deviation from a broadcast program, it's unsurprising that they have focused on what the audio is not: neither news nor narrative. Consequently, there has been little attention paid to what it is: a dictionary definition. Shifting attention to this aspect of the work sees it as more than rendering meaninglessness. Instead, it acknowledges that the opposite is also happening. With each utterance of a dictionary definition, Xing Zhibin secures word to meaning.

The title of the work—*Shui: Cihai Biaozhun Ban*—notably informs viewers of the chosen entry as well as its source. As an encyclopedic dictionary, *Cihai* includes single characters and compounds from more than 120 subject areas and disciplines. Although it was first compiled in 1936, its current form is based on an extensive twenty-two-year revision that began in 1958. In 1958, just nine years after the founding of the nation, the government convened a conference to plan the editing processes of both the *Ciyuan* (Source of words) and *Cihai* (Sea of words) dictionaries. It was determined that the former would focus on classical, literary, and historical terms to serve as a tool for researching premodern China. *Cihai,* meanwhile, was revised to incorporate modern terminology, including scientific and technical terms, and serve as a reference for the people.[6] As a project in philology, this undertaking revolved around determining the boundaries of "legitimate words" and how to assign their meanings.[7]

Recognizing this aspect of Zhang's work moves away from regarding *Water* only as a pitting of audio against visual. Instead, it recognizes their alignment as forms of intersecting authority: one ideological and the other ontological. This approach not only opens up new interpretations of the work but also sheds light on the multifaceted and emergent ways in which the artist investigated assertions of meaning at the time. Zhang's deep skepticism toward defined standards is a well-recognized hallmark of his oeuvre. Art historian Huang Zhuan, for example, describes Zhang as consistently offering an "antithetical resistance to the mainstream of Chinese contemporary art."[8] Given Zhang's relentless scrutiny of fixed meanings, it is especially important to note when he *does* incorporate definition in his artwork, especially when it is as authoritative and accepted as a dictionary definition. Centering "definition"—and its implied claims over standards and authority—in this reading of *Water* clarifies how

the artist's views on "resistance" shifted throughout his oeuvre. It furthermore opens up three important vantage points from which to understand the artist's work.

First, the lens of "fixed meaning" reveals significant shifts within Zhang's strategies and attitudes toward artistic possibility. The first part of this chapter examines his artworks from the mid- to late 1980s as efforts to intervene in accepted ways of thinking about art. Pushing back against the constraints he perceived fettering artists and their work, Zhang's uses of text and video encouraged multiplicity and ambiguity as tactics for destabilizing expectations for artistic production and reception. After 1989, however, Zhang came to see the futility of his earlier experiments to effect change. No longer convinced that art could do anything at all, he instead observed how everyone was already always implicated by—and indeed complicit within—the systems of constraint that they inhabit. This introduces a second key point about Zhang's oeuvre.

While *Water* is regularly heralded as a groundbreaking video, the painting series Zhang produced alongside it—*China Bodybuilding (Zhongguo jianmei)*—has often been treated as a peculiar interlude in his body of work. Due to the sudden explosion in the series of symbols and slogans, it has often been dismissed as a case of Zhang jumping on the Pop bandwagon before settling into his role as the father of video art in China. Rather than seeing *China Bodybuilding* as dabbling in a trendy style, however, this chapter considers how these canvases enabled him to investigate the "fixed"-ness of symbols and the misplaced impulse *to* fix. As such, this chapter reveals how these paintings operated as vital sites for a radical questioning into artistic purpose and meaning making after Tiananmen.

Finally, this reading of *Water* sheds light on the blind spots that often accompany interpretations of contemporary Chinese art. In this case, the political machinery of state-run television is easy to critique for all of its orchestrated programming. And yet the authority of the dictionary as a source for fixing meaning has barely raised eyebrows. This is a reminder of the ways in which post-Tiananmen narratives so often privilege overt acts of opposition. This chapter doesn't dispute the strands of resistance in Zhang's work. Instead, it calls for recognizing the nuanced ways in which Zhang's work allowed him to ruminate on both "defining" and "defining against." Zhang has articulated about his approach: "I do not want to adopt any stance of opposition or resistance as the starting point of my creative process."[9] Seeing his works as meditations *on* art moves away from pinning his artwork to explicit acts of resistance. Instead, it sees his art as a place in which he investigates the nature of resistance.

The chapter culminates by connecting the penetrating scrutiny displayed in his art to his critiques of self-definition. This discussion acknowledges the devastation that Tiananmen wrought on the artist. But rather than glossing over Zhang's work as cynical opposition, this traces the effects as manifested in the artist's experiments about art. Studying Zhang's paintings and videos in terms of meta-art reveals his acute and canny observations about power and subjectivity. More than simply a localized address, the questions and observations present in his work from the early 1990s crystallized into an approach that he applied to debates over cultural representation and participation in the global art world. This shows how Zhang's thinking about art in the aftermath of Tiananmen—and the disillusionment of 1989 more broadly—set the stage for his unabashed criticisms of others' efforts to fix cultural identity. Rather than joining in the chorus of claims over defining "contemporary Chinese art," Zhang has remained ever critical of such pronouncements. Even as his peers promoted cultural agendas for defining art, he pushed back against the impulse to define at all.

Enacting Constraint, Freed from Constraint

A brief interview with Zhang Peili from December 1988 reveals the explicit ways in which the artist bucked expectations at the time. The interviewer's first question references a painting series and video work, respectively, from the late 1980s: "What do the gloves from *X?* and *30x30* symbolize?"[10] The interviewer, Cheng Xiaoping, bluntly adds: "I don't know why you repeatedly use this symbol[;] what does it explain, or what does it signify?" The interviewer's second question addresses Zhang's experiments across multiple mediums and formats: "I don't understand why you abandoned easel painting and moved towards these others." Cheng's queries reveal the mystification surrounding the artist's choices at the time. The candidness of the questions, furthermore, underscores the expectations that artists and their work be forthcoming and legible.

Zhang's incorporation of strange and ambiguous subject matter—such as gloves—deliberately denied a singular discernible meaning. This inclination expanded to his choices of materials and mediums. More than simply a desire to be a moving target, Zhang's experiments privileged expansive possibility over fixed expectations. His departure from both legible symbols and a signature medium encompassed a deeply rooted resistance to any forms of perceived constraints. This section introduces Zhang's strategies and objectives toward art during the mid- to late 1980s. In particular, he actively worked against the

limitations he saw imposed on ideas of art and expectations of artists. Zhang would later refer to his belief in the viability of change as "naive." While at the time he focused on confronting people's viewing practices, he would also later question whether such a narrow field of art could change anything at all.

From 1980 to 1984, Zhang Peili studied oil painting at the Zhejiang Academy of Fine Arts. Although he continued to paint after graduation, he also—as the interviewer notes—moved well beyond this. The profusion of new mediums and formats has been well documented as a key component of the '85 Art New Wave. But, rather than seeing this trend as a wholesale denial of painting, it's important to stay attuned to the different motivations guiding disparate artists and groups. Zhang's own critiques of painting were sometimes couched in concerns for communication, and other times directed at the conferment of status. While Zhang has consistently confronted assumptions imposed on art, the nature of who and what he challenged has changed according to his developments in thinking.

Since many artists majored in oil painting during college, their vast experiences allowed for a range of aspects with which to take issue. Sometimes it wasn't necessarily the format or medium of painting but rather what it manifested and represented. During the mid-1980s, competition among art groups and efforts to distinguish themselves contributed to diverse "rejections" of oil painting. The Southwest Art Research Group, for example, still held tight to painting, but chose to embrace emotional instinct and soul baring as the sources for their work. Artists in Guangdong, meanwhile, created compelling theatrical performances, stating, "Art is not just a painting on a wall. It can be any action."[11] The group to which Zhang Peili belonged, the Pond Society, meanwhile, declared in 1987:

> Easel painting, which we conventionally take as sacrosanct, is not the only medium for communicating ideas. We strove to break down the boundaries between languages, and proposed an undefined form, an exciting "artistic activity" that could move people. Here, painting, performance, photography, and environment (these are the categories of forms in our minds), and so on and so forth, are to jointly construct an organic and systematic relationship through the unique characteristics of visual language.[12]

The Pond Society's statement did not reject easel painting as much as the elevated status that had been bestowed on it. What they challenged first and foremost, then, were the boundaries that had been imposed between painting and

other formats. And, relatedly, the endowment of an authoritative status secured through a socialist realist curriculum. They were celebrating the belief that all formats share in some kind of "visual language." By emphasizing an organic and kinetic relationship among mediums, the Pond Society articulated two concurrent initiatives here: the mobilization of other mediums to share in the capacity to communicate, and the breaking down of the restrictive limitations that separated painting from neighboring realms.

The impulse to make visible and then dismantle frameworks of constraint manifested itself on a smaller scale in Zhang's push against the yoking of an artist to a particular medium. Zhang elaborates on this in his response to the interviewer's question from 1988: "An artist—outside of meeting their own internal needs—doesn't need to receive any kind of limitations. No one has the means to stipulate what a person should be doing or shouldn't be doing."[13] Zhang saw these constraints as symptomatic of a larger power imbalance between artists and audiences. In an essay from November 1988, "The Point of Departure for *Art Project No. 2*," he laments how artists have ceded the power to determine aesthetic standards to audiences. Likening artists to "waiters" or "attendants," he decries how they cater to the whims of viewers' tastes.[14] Viewers, in turn, see art, like food, as simply pleasure, something to admire, and even entertainment to be consumed.

Zhang's resolution sheds light on his propensity for big-picture thinking. Rather than just introducing new subject matters or styles, he calls for a macroscopic shift: "The key isn't to alter one's language or the public's involvement, but rather to change the artistic relationship between viewing and being viewed. As long as the audience remains in a carefree and relaxed state of viewing, then, regardless of how the artist changes his attitude and language, there is no way for him to subvert his position: anything gained would only be an illusion."[15] Zhang's turn to using art to enact "restriction" is thus imagined as a tactic for artists to reclaim authority over art. In this push–pull relationship, artists liberate themselves by unsettling the audience and rendering them into a state of discomfort, unfamiliarity, and uncertainty.

One of his strategies—as articulated in the 1988 interview—incorporates deliberately puzzling components. Returning to Zhang's response to the interviewer's inquiry about the recurring motif of gloves, he continues his argument that artists should not be beholden to fixed meanings and identities. Zhang notes that the very fact that many people have posed the question "what do the gloves mean?" indicates how latex gloves are in conflict with established aesthetic standards. They tellingly depart from subject matter that can be automatically

appreciated for its aesthetic qualities, and thus demand explanation. To which Zhang replies:

> My choice of latex gloves, first, tries to show my questioning of aesthetic standards. This peculiar symbol of latex gloves enters into the work and repeatedly appears to attack meaning; this attack is needed for art to achieve rebirth. Choosing latex gloves has another level of meaning that comes from it occupying a place between a thing and life. This kind of attribute is life receiving restrictions and still desiring to protect ambiguous symbols.[16]

Zhang amplified the mystery of the use of gloves by expending inordinate time and care on his paintings. For example, in *X? Series: No. 4* (Figure 32), the tonal richness, the monumental scale, and the isolation of the subject matter are further strategies for confounding viewers. Why treat these mundane objects with such precision? Why repeat this motif across numerous mediums? The times when Zhang does allude to a "meaning" for the gloves, he resorts to ambiguity: for example, how gloves seem to reside between inanimate objects and embodied organic beings. By leaning into contradiction and multiplicity, the artist embraces the lack of clarity as yet another way of denying a fixed state.

Zhang's turn to text-based works enabled him to both articulate and enact deliberately awkward viewing practices. By way of example, he discusses *Art Project No. 2,* which takes the form of a twenty-page textual document. The document includes an exhaustive list of procedures dictating the experiences of "peeping" and "talking back." By laying down an exceedingly "stringent artistic system of rules and procedures," he writes that such an experience would be "torture" for an audience so used to "calmly and blithely viewing art."[17] Similarly, his work *Procedure of "Ask First, Shoot Later": About "X?"* includes twelve pages detailing the creation of his paintings, their installation, and rules for the audience. For example: "visitors must spend not less than 23 minutes or more than 33 minutes in each room." Zhang's verbal portrayal forces audience members to reckon with their expectations and practices of viewing. By creating an experience of discomfort and regulation—in both form and content—he subverts established conventions dictating what art should be.

Art historians have described Zhang's use of text to instruct as "anti-visual."[18] Such a description, however, fails to account for his endorsement of multiplicity over and against the impetus toward negation. In this light, rather than seeing text as a way to "preclude meaning as a visible medium or surpasses visual categories," Zhang instead argues that "it enables visual experience to

Figure 32. Zhang Peili, *X? Series: No. 4, 1987.* Oil on canvas, 179 x 198 x 4 cm. M+ Sigg Collection, Hong Kong. Copyright Zhang Peili. [2012.38].

completely return to its core[;] it could be said that the depth of the visual image is even more real and rich."[19] In explaining this further, he notes how the text can seem restrictive, yet also allow for an unrestricted way of imagining the visual. *Procedure of "Ask First, Shoot Later,"* for example, describes the paintings in *X?* through their composition and application of light and dark colors. It lists the oil pigments as "ochre, black, raw brown" and further explains that they are mixed to a range "between ochre and gray." Yet, no matter how detailed the description of the resulting work, a viewer's imagination of the imagery can expand in any number of directions. There are unlimited ways in which audience members may picture a particular color or form in their mind.[20] As such, one could see Zhang's work as devoid of any visible imagery while also broadening ideas about the visual. This, again, is a way of understanding how Zhang might

seemingly be pitting one thing against another: text versus image. Yet, rather than dissolving or disavowing the visual, he instead finds a way of opening it up beyond how it has been seen.

In his pages of text describing art, Zhang offers a meditation on visual and material specificity versus the indeterminacy of imagined visuality. This points to the ways in which the visible representation of a subject matter itself operates as a form of fixing. Zhang seeks to go beyond this by using text to invoke mental imagery. He, moreover, demonstrates how even the most precise language can be inherently imprecise. At the end of *Procedure of "Ask First, Shoot Later,"* Zhang provides two possible explanations of the work to readers. The first notes how "telling" images to the audience is "defective" while the second states that this text-based approach may "become more important than or replace visual experience." Again, Zhang indulges in multiplicity by offering two seemingly contradictory statements about the relationship of text and visual experience. This deliberate conflict can be as much a "mechanism of constraint" for the audience as any of the enumerated guidelines. Zhang uses strategies of both extreme restraint and unlimited indeterminacy to confront viewers' expectations of a singular explanation.

In March 1989, Zhang wrote a slightly revised version of his 1988 essay that further emphasizes and clarifies his views on mechanisms of restriction.[21] This helps to show how he developed ways of provoking audience members in his later works: *Brown Book No. 1*, for example, notably infringes on people's living spaces, while *30x30* explicitly impinges on time. Between April 20 and June 21, 1988, Zhang mailed latex gloves to students at the Zhejiang Art Academy of Fine Arts and an explanation of the project in the form of a letter in the work *Brown Book No. 1*. Like his other text-based works, Zhang catalogs the step-by-step process of its creation. In his accompanying "statement of explanation," he lays out eight points that read like rules and regulations; for example, "Do not transfer this article to any other person." Zhang frames the work in his March 1989 essay as "another form of coercing the audience."[22] The unexpected experience of receiving Zhang's package in the mail differs from encountering his work in an art exhibition. By enabling the work to unfold in an unanticipated place, Zhang capitalizes on the anxiety and discomfort produced by the spatial transgression of the artwork.

Zhang's video *30x30* (Figure 33) turned to time to induce a state of unease and confusion. In 1988, he debuted *30x30* at the China Modern Art Conference in Huangshan to a room of critics and fellow artists. While Zhang intended for the video to run a full three hours, viewers forced him to turn it off after only fifteen minutes. *30x30*—said to be the first work of Chinese video art—thus

Figure 33. Zhang Peili, still from *30x30*, 1988. Single-channel video (PAL), sound/color, duration thirty-two minutes, nine seconds. Courtesy of the artist and Tilton Gallery, New York.

marks a peculiar starting point for new media in China. The circumstances surrounding the work's creation and exhibition reveal more than a desire to simply adopt the "international language" of new media or make claims for technological advancement. Instead, this video demonstrates Zhang's strategic interventions for disrupting dominant understandings of art and its reception at the time.

In the video, the artist's feet and gloved hands appear as he repeatedly drops a rectangular mirror to the floor. On the ground, five small vials of glue are haphazardly placed next to a pair of scissors. After half a dozen drops, the mirror finally splinters apart. The next cut zooms in slightly closer to show the artist's gloved hands meticulously reassembling the mirror. The camera focuses on the ground, but we can see as Zhang shifts body position, first from kneeling and then sitting cross-legged. The focus of the action is on his hands as they affix broken pieces side by side and then trace glue along the seams. Smaller shards are placed into the puzzle and glued in turn. The artist then

breaks the mirror again. This action—of breaking and piecing together—recurs in this segment and then literally repeats again when the video loops.

When the video begins, it appears to promise spectacle: the violence of the crashing mirror, the fragmented reflections, and threat of self-inflicted bodily harm all appear laden with symbolic meaning and suggest an enticing narrative development. The impulse to read a plot has led people to interpret the latex gloves that Zhang wears as a need for self-protection. But Zhang ultimately uses the linear movement of the video to continually bait the audience where he marries the suggestion of dramatic development with a continual deferral—and ultimately denial—of any plot at all. By withholding a narrative plot, he seeks to trap people with their own expectations for entertainment or didacticism.

By denying the pleasure of plot, the experience of watching the video bleeds over from frustration with the depicted time to infringement on the viewers' "real time." In watching, viewers become aware of time not only as fleeting but, even more damningly, as wasted with each passing second. Zhang intended for the video to be played in full. Anticipating the buildup in levels of audience irritation, he had planned to slip out of the room and lock the door behind him. The plan was foiled, however, when after a few minutes people asked him to fast-forward the video and then eventually turn it off. While Zhang's initial plan to lock audience members in a room did not come to fruition, *30x30* succeeded in accomplishing the original objective: revealing people's limited tolerance for work that defies expected parameters of legibility and duration. In his choice to perform the same action slowly in the video, he works against the linearity of temporal progression through an accumulation of repeated actions. As meta-art, a similar cycling through occurs in the push–pull between the video and the viewer. The artist's foreclosure on the promise of resolution is simultaneously depicted on screen and enacted in its viewing.[23]

Zhang's desire to successively promise and resist development challenged viewers' expectations for entertainment and instruction in both art and mass media. This was partly a function of viewing habits related to television programming. At the same time, when we return to Zhang's wariness against adopting a singular meaning, we are further reminded that in *30x30*, his act of repetition is not only a denial of visual pleasure and plot, but also a deliberate withholding of telling people what to think. By allowing for ambiguity, he refrains from determining meaning. Moreover, his description and enactment of tedious, laborious, and seemingly arbitrary actions heightened the confounding and constraining nature of his works. It's important to recognize these features of his art from the 1980s as they stand in stark contrast to his paintings

over the following few years. After 1989, Zhang's desire to dwell in a place of withholding and ambivalence dissipated.

Opposing Oppositional Positioning

As Zhang experienced the events of 1989 (from the *China/Avant-Garde* exhibition in February to the crackdown on democracy protests in June), he began to perceive the previous decade in a new light. In particular, he looked sharply at the motivations behind position taking in the 1980s. This informed his growing skepticism toward assertions of authority, no matter from where they came. The following section traces a key development in Zhang's thinking that germinated from his disillusionment with art in 1989. Rather than just a focus on his changing targets of opposition, this sheds light on how he revised his attitude *toward* opposition.

In February 1989, Zhang attended the opening of the landmark *China/Avant-Garde* exhibition in Beijing. He left disappointed. To him, it wasn't a great feat that "avant-garde" art had made it into the hallowed halls of a state-run museum. This just signaled how the art scene had turned itself into the very mechanisms of power against which it ostensibly stood. This has been described as Zhang's disillusionment with the "institutionalization of the '85 New Wave."[24] It's necessary, however, to unpack what is meant by "institutionalization." It wasn't just that art was co-opted by state-run forces. The problem was with how so-called avant-garde artists and supporters reproduced institutional power dynamics: "We were basically like the Chinese Artists' Association, but with a different head."[25]

In particular, he blamed organizers for reproducing the same ills of bureaucracy and organization that characterize governmental operations. The organizers' concessions to censorship and endless squabbling not only mimicked the gatekeeping and evaluation wielded by "official" authorities, it also subjugated the artworks to the curators' objectives: "Within this, where were the artists? They weren't important any more. All that mattered were the leaders. All that we could see were the leaders. Different leaders fighting. All they wanted in the end was an event, a big event. Art was already not important."[26]

In piecing together how the events of 1989 affected Zhang, one of the most profound ways manifested in his deep suspicion toward oppositional stances. After June 4, this was paired with a further disillusionment about not only the treatment of art but also its limited possibilities. Addressing art attitudes and activities of the 1980s, Zhang looks back on the '85 Art New Wave with withering criticism: "At the time, a lot of people opposed official art, but the

way they spoke was still like official art."[27] This pinning of art to an authoritative demeanor rather than actual institutional involvement bypasses the standard division of "unofficial" and "official."[28] To Zhang, the presumption of authority—even by those who believed they were in the service of civilizational enlightenment—replicated the very problem of dogmatic art. Zhang's critique of "unofficial" artists clarifies what he sees as an endemic problem: "I don't like people who frequently try to educate other people. Before 1976, everything was to educate people. After 1976, for a long period of time, including the '85 Art New Wave, it was also trying to educate people. This is a very scary thing. It seems that a lot of people tried to make themselves into sages saying, 'I have the qualifications to educate you.'"[29] This characterization of the '85 Art New Wave steps away from readily accepting the bright lines of opposition that have long organized histories of contemporary Chinese art. He rebukes artists who used their art to occupy positions of dominance. And, within this, he particularly criticizes those who saw themselves in the role of "resisters," yet ultimately ended up replicating troubling power structures.

These realizations about artists' objectives, attitudes, and desires for authority signaled a radical shift in his thinking. During the late 1980s, he thought it was possible to effect social changes through art. He began, however, to see his own efforts to "coerce" audience members as misplaced. The crackdown on student protests at Tiananmen on June 4 amplified the utter futility of his earlier objectives:

> I think that in the period before 1989, people were very naive—they could think purely about questions *about art,* they believed that art could change a lot of things. I wanted to change people's views toward art, people's views toward looking at art, how they recognized it. We continually thought about what to do and how to do it. But, after 1989, one suddenly realized art wasn't anything. It had no meaning. Because when facing such a huge thing, in front of power, what did art count for? At the time, a person's entire mood was disappointment.[30]

Toiling under the aegis of quiet despair, Zhang experienced a conflict with his art. He continued to make works in spite of his own doubt that it could achieve anything at all. He vacillated between abandoning art and just accepting the daily toil of it. After all, what else was there to do? Art making persisted with a stifling air of confinement as yet another representation of the inescapability of daily existence.

Zhang's experiences from 1989 granted him a hyperawareness toward the

faulty logic undergirding stances based on binary oppositions. In addition to the perils of trying to *define against,* Zhang recognized the dangers of those who sought to educate, assign themselves authority, and make declarative statements. This compelled him toward two different directions in his art.

On the one hand, he no longer wished to engage in strategies of withholding and ambiguity. Instead, after the events of June 4, he felt charged with a need for the explicit: "I thought that the most important thing was to create a 're-sponse,' a response that everyone could receive. . . . I wanted to very clearly say something, to express my attitude. This was a very big change."[31] On the other hand, this impulse to baldly express himself made him wonder if this made art any different from other forms of declarative messaging.

This line of reasoning led him to use his work as a way of studying these very questions. It is in this context that I position Zhang's *China Bodybuilding* series and the significance of his return to painting. Starting in 1989, rather than the confusion or frustration set up by a work like *30x30,* he sought to exploit the directness of an authorial voice. To do so, he turned to painting for the representation and delivery of visual language. As Zhang examined the direct messages in his surrounding political and commercial landscapes, he engaged both the symbolism of these images and their efforts to continually claim meaning.

Symbols and Slogans

The first work he created after June 4 is titled *China Bodybuilding: Charm of 1989* (Figure 34), which utilizes political slogans and commercial symbols. In their appeal to pleasure and didacticism, these signs entice and elicit targeted responses from visual consumers. The arresting image of the bikini-clad body-builder in this painting taps into the particular forms of pictorial pleasure that circulated widely in China in the 1980s. In the early 1980s, grassroots interest in bodybuilding led to its revival among peasants. But, the state disapproved of the sport's allowance of women's open baring of their bodies.[32] In 1986, the issue of whether or not female bodybuilders could wear bikinis was debated at the highest levels of government.[33] The State Sports Commission sanctioned the bikini that year, citing its requirement for international competition. This opened up the floodgates for the dissemination of images of female bodybuild-ers. Zhang, in turn, selected one such picture from a magazine to feature in his painting.

The composition of the painting is balanced between two sides: on the left a slogan reads from top to bottom, "*Fanshen,* never forget the Communist Party."

Figure 34. Zhang Peili, *China Bodybuilding: Charm of 1989*, 1989. Oil on canvas, 100 x 80 cm. Zhang Peili Archive, Asia Art Archive. Courtesy of the artist and Asia Art Archive.

On the right side, the glossy female bodybuilder poses with a large trophy. Small images surround this dominant figure, including advertisements for Procter & Gamble and Oil of Ulan (later known as Oil of Olay). Toward the left side of the composition, flanked by the slogan and the bodybuilder, a smaller female figure is shown from the waist up. With her entire body covered—save for her hands in midgesture—she stands in sharp contrast to the bikini-clad bodybuilder. The small figure has a darker layer across her chest: an apron emblazoned with a sickle. With an open mouth, and hands placed open in front of her chest, she exemplifies the oratory practice so common during the Cultural Revolution. We can imagine her emphatically shouting the slogan that runs down the left side. This talking head, now distilled to orange and white, also runs across the top and bottom of the picture plane, speaking to the significance of multiplication and reproduction as both a visual and aural tactic for dissemination. Using carbon paper first, Zhang traced each head and then hand-painted it. What may appear to be a rubber stamp is, in fact, the deliberative and careful act of reproducing by hand. Just as the multiplication of imagery implies the ideology of the-many-over-the-one, their open mouths articulate the forceful power of speaking in unison.

The contrast between the small replicated woman and the single dominant figure showcases the demonstrable change in values underscoring the body, its image, and how it is granted power. With ample use of highlighting, the bodybuilder's skin gleams like a metallic surface, echoing the same bouncing light apparent in the trophy that she effortlessly holds up. Visually connected by this gleaming surface, the woman and the trophy emphasize a new standard predicated on personal ambition and competition. With each liquid curve, the focus on the external, physical dimension of the figure presents a brazen image of show. Zhang's rendering of the figure makes the physical dimensionality a sight to behold. The focus on skin and surface—as not only visual traits but also central to personal habits—is further supported by the smaller images to the figure's left and right. On a pink vertical slip of paper affixed to the canvas, another repeating face appears. On this paper insert, however, the women's faces pair with the textual step-by-step instructions for applying Oil of Ulan. Emblazoned with the abbreviation "P&G," this reference to a foreign product pairs with the two bottles graphically rendered in crisp black outline on the right.

Laid out laterally, these images seem to communicate historical change: from the political revolutionary to the commercial model. Zhang's work, however, is not just about a matter of standardization and uniformity as imposed by changing value systems, but also how they are both enforced and perpetuated

through visual imagery. As such, Zhang presents more than just a view of the historical contrast among the images pictured. He also uses this canvas to study what is shared across these examples of visual communication. While one may emphasize vocal declarations and the other presents a culture of cosmetic display, both are connected by how they rely on being overt and direct in their communication. Their visual appearance corresponds precisely to their messages. In Zhang's re-presentation of them, he doesn't engage in tactics of ambiguity. Instead, he transmits their utter clarity in messaging.

These references to the oratory, gestural, and textual all emphasize the visible tools of declarative announcements. One of Zhang's key purposes in doing so was to figure out if, indeed, art could do anything *more* than serve as such a platform for broadcast. The work thus operates as a place for Zhang to interrogate the relationship and distinction between popular images and art. The clarity of composition, use of formal repetition, graphic precision, and imagery as illustration all work together to facilitate unambiguous pronouncements. By showing how these images so clearly state their meaning, he engages with the difficult question of whether or not art can do more than this.

Zhang notes, "Prior to this, I would never have included a slogan in my art."[34] Indeed, when we return to *30x30* and his text-based art, Zhang's works often used ambiguity as a tactic for pushing back against the fixing of meaning in art and representation alike. The artist admits that when making this painting, he could not tamp down a lingering question: *why* isn't there ambiguity in these slogans and symbols? In an interview, he muses about something he was thinking at the time: "Why does '*fanshen*' only ever have one meaning?" In Chinese, *fanshen* refers to the rural reforms of the 1940s, in which land was redistributed to emancipate peasants turned landowners.[35] Zhang breaks the term down to its literal meaning: "to turn over (*fan*) one's body (*shen*)."[36] He flips his hand from back to front to emphasize the motion and adds: "like one is tossing and turning in one's sleep." In the slogan, however, any implication of "turning over" is limited to strictly revolutionary class terms. Embedded within an exhortation to never forget, the slogan calls on memory and myth to chain *fanshen* to the Party's contextualization of its meaning. Zhang explains it as paternalism, like a parent telling his children to never forget where they came from and what their parents did for them. The implication being that people should always remember the glory that came with land redistribution as the reason for where they are and what they have. These ways of continually reinforcing the originary event of *fanshen* fix the term and the Party's authority over knowledge production: through memory, history, ideology, and finally language.

In the 1980s, Zhang used text as a way of evoking instability; here he recognized the ways in which language itself was already co-opted and inscribed with meaning. This is important for understanding how he now acknowledged the dominance of systems of constraint. Zhang says, "After the '1989 event,' I discovered that art is really just art, and can't be used to change society. It is only one part of society, and to a big degree it receives influence from mass culture."[37] This statement reiterates his realization of the smallness of art. His comment that it "receives influence from mass culture" acknowledges that art cannot lead society; it can only follow. His use of symbols and slogans from mass culture was more than simply experimentation with new visual sources. Their appearance was a reminder that art functioned as little more than a passive receptacle for his surroundings. Constraint was now an everyday condition, not something that could be rectified through art.

Writing to his friend Hans van Dijk in the early 1990s, Zhang laments the extent to which these paintings are suffused with sentiment.[38] This may seem peculiar given how impersonal they appear, but the emotion he speaks of is the stifling anxiety that infiltrated all aspects of life: the feeling of being trapped by the everyday.[39] Often his use of familiar symbols is discussed as a form of Pop in its showcasing of the vulgarity and superficiality of a new decade. While Zhang admits to being attracted to the graphic aesthetic of Pop at the time, it is important to recognize how the artist's turn to these images registered a sense of resignation. To Zhang, there was little outside of the tedium and absurdity of the everyday. His art could do little more than absorb it and spit it back out. Indeed, this is how he felt about painting at the time: as something to engage in, but with little room for solace. Even as he posed questions about artistic purpose, the continued act of art making filled him with the persistent and insidious tedium of feeling fixed in place.

This sense of being tethered to a daily existence was further regulated by the campaigns toward "health" that coursed through his everyday. The Chinese term for bodybuilding—*jianmei*—literally means "healthy and beautiful." Zhang connects this with the sloganeering of the time: "*Jiankang* (health), *jianmei* (bodybuilding), these aren't simply issues of the body, they are issues of the spirit *(jingshen)*."[40] He brings up the phrase *jingshen de jiankangxing* (the healthiness of the spirit) and points out how acts of cleansing are directed as much at a person's internal being as his or her external body. Zhang also connects this preoccupation with physical and moral fitness with broader efforts to create standards: "I wanted to touch on these ideas . . . what is good, bad, legal, illegal, healthy, unhealthy, when social evaluations are so clear and explicit. This society is like a big factory that tries to produce standardized people and

meanings."[41] Whereas in the 1980s, Zhang focused on "aesthetic standards," he now turned to investigate standardization as it operated in society. He also switched from his earlier tactic of attempting to change standards. Resigned to the unilateral directional flow of these images—of being assailed by them on a daily basis—he instead studies and observes them. While social standardization seems to come most directly at the hands of the government, Zhang also notes how such pressures can become internalized. The standards, then, are a source by which people measure their own well-being and, in turn, inflict it on others.

As Zhang continued with the *China Bodybuilding* series, his art also shifted from just thinking about the fixed meanings *of* symbols and standards to how they are used to assert meaning. In *China Bodybuilding: Standard of 1989* (Plate 16), the canvas is crowded with what appear to be hand-written numbers, stenciled characters, stamped numerals, and splatters, sprays, and slashes of paint to cover them over. While haphazard scribbles, an emphatic "X," and blocks of gray and white are all employed as efforts to obfuscate, traces of inscriptions still peek through. A barely discernible figure—with black hair and a red body—looms like a specter in the background. In his continued study of the visual tactics and visible evidence of social standardization, the blocky slogans he includes all relate to health and public decency: "Everyone has a responsibility," "take care of public property," and "discuss hygiene." Shown in different states of defacement, the characters in the lower right corner are shown covered over and reinscribed again. Peeking through the hastily applied attempts at concealment, the earlier applications appear like shadows across the surface.

The stratigraphic approach displayed in this painting—and several others in Zhang's *China Bodybuilding* series—explicitly references the *tumo* sprawling across the city at the time. *Tumo* refers to a casual kind of scrawling, doodling, or smearing. In its implied informality, the act of *tumo* in the city comprised a type of visual vernacular that incorporated multiple voices: anonymous individuals marking surfaces, government officials covering them up, and commercial interests that leave behind image and text.[42] By emulating *tumo*, Zhang turns a static collage into an image of dialogical action. Rather than multiple images side by side, as in *Charm of 1989,* they are instead placed atop each other. Text and image are jumbled together, crossed out, and covered over. This vertical juxtaposition of imagery and slogans enacts competing claims over the authority to occupy space. In Zhang's documentation of this practice on canvas, he shows a contested layering of multiple voices that collectively leave behind a transcript of addresses.

In these works, paint aggressively announces itself. The two characters that make up the phrase *tumo* unpack the material implications of this act. *Tu* means "to smear, paint," and *mo* is "to obliterate or rub out." The simultaneous acts of defacement and delineation recall Zhang's wariness toward binary oppositions. He explores here how each visual trace can embody a built-in antagonism: the meaning of each symbol is not only in the declaration of its visual representation but also now in what it appears to deny. In these *tumo* paintings, Zhang examines how such layers of obfuscation endow the symbols with a sense of attack and competition: each symbol and slogan asserts power through a demand to be seen while also conferring value by reifying the power of that which it obfuscates.

Continuing to draw upon his everyday, these paintings carry on his study of the motivations for image making in visual culture. Each day, he would encounter such surfaces across the city, from public bathrooms to city walls. Built up day upon day, these *tumo* functioned as a visual record of both the daily passage of time and the equally inexorable back-and-forth of opposing interests. The unfinished nature of these paintings implies their continuation in perpetuity.

The circularity of these assertions, in the end, is less about the explicit meaning of the symbols and slogans shown, and more about the right to declare meaning over and against an existing force. As the characters and images themselves are eroded, their message of upholding standards loses credibility along with the growing illegibility. The phrases calling for everyone to protect public property and exhorting people to bear responsibility ring especially hollow. Not only does the audience disregard them, but their original declaration gets garbled and conflicted with each reapplication. This painting shows Zhang's shift from studying symbols as *fixed* to the seemingly more important act of fixing. The following section shows how Zhang's study of symbols and their deployment in oppositional stance taking concretized around his wariness toward acts of self-definition.

Subjectivity, Control, and Complicity

In his study of symbols, Zhang came to realizations about the limitations of individual subjectivity and the futility of self-definition. Bodybuilding explicitly evidences not only a culture of display but also a culture of self-fashioning. In the case of bodybuilding competitions, contenders sculpt their bodies, apply oil to their skin, and compose intricate poses in stillness. Competitors construct compositions with negative and positive space in mind, conscious of

light sources, and attentive to frontal viewing. Bodybuilders' hypervigilance toward displaying themselves is tied to a calculated awareness of how they are viewed. They understand that they will be observed by a jury and spectators, and subsequently by an even broader audience when images circulate in print and broadcast media. Their consciousness toward viewing is thus heightened by expectations that they will be pictured. Whether through the horizontal frame of the television screen or the vertical framing of an advertisement, the bodybuilder has an enhanced cognizance of being perceived through the act of picturing.

But, who has control over the meaning of the image is actually quite unclear. While Zhang's bodybuilder has often been read as a symbol of the new ideological values of self-interest and superficiality, the story of bodybuilding in China is more complicated. It was initially disapproved of by the government, but then eventually advanced in the mid- to late 1980s with the government's blessing.[43] Under the guise of sports competition, bodybuilding was granted legitimacy as a means for competing on the international stage. While the passion for bodybuilding is a fascinating story, it was the thirst for *pictures* of bodybuilders that truly swept the nation in the mid-1980s.

Images of female competitors introduced the public to an unprecedented display of the near-nude body and, significantly, the right to look at it. In 1985, Chinese teams were organized to compete internationally. Images from these events were widely circulated, from posters to postcards and magazines for purchase. In the name of fitness, the bikini-clad women could be documented and ogled without censorship. The public's desire for such imagery led to its ubiquity, and the pictures appeared in magazines and periodicals that had nothing to do with athletics. The effort to *control* meaning, thus, was not a matter of one declarative voice.

The image of the bodybuilder thus presents a curious amalgamation of being simultaneously one of state-sponsored international competition and popular commercial consumption. For Zhang's purposes, what this throws into relief are the distinctions between how the bodybuilder engages in self-fashioning and how she is received. As Zhang studied how people get transformed *into* symbols and their subsequent function as mediums for asserting authority, he was hyperconscious as well of how their efficacy was ultimately always contingent on surrounding systems of constraint. The proliferation of images of the bodybuilder shows how systems of image production and image consumption are locked together in circuits of desire and control.

The person as symbol at the heart of this, then, comes to occupy multiple subject positions: "You can say that this person is a symbol and also a victim:

at once a person who can cause violence (*shanghaizhe*) and can also receive violence (*shouhaizhe*)."[44] At the hands of both state and consumer interests, the bodybuilder operates as a victim and a perpetrator of standardization. And even as the bodybuilder issues standards for others to emulate, her own self-expectations serve to constrain her. *Tumo* further shows the ignominious and unpredictable fate of these assertions scrawled on walls, unleashed into the world, and entered further into layers of image production and obfuscation. This nuanced way of thinking about people's positions gave Zhang insight: while people might view themselves as delivering particular messages and enacting opposition or declarations, they rarely reflected on how they were also being controlled. Zhang's use of the dictionary and his questioning of meaning dive into the subtle forms of authority in which everyone is always already entrenched.

If visual culture consists of the pervasive effort to announce and lay claim to standards, there is a parallel between *tumo* paintings and the image of the broadcaster. Both show the insistence on claiming space in the world by giving visible form to voice. Zhang's realizations of governing power structures are played out at two levels: the first being the ideological authority embedded in political structures; the second being a more subtle unquestioned authority embedded in language. For Zhang, then, the use of the dictionary definition in *Water* operates as a reminder of the succumbing to authority in which all people operate. And thus while we might see Zhang's manipulation of the broadcaster as a masterstroke in subversion, he also points to the ways in which a pervasive oppressiveness is always present. In language, in words, in definitions, in meaning making and knowledge production, these are aspects of life that are ultimately all-encompassing and inescapable.

Like many of his other works in the early 1990s, Zhang uses *biaozhun* (standard) in the title of the work. While "standard" can be seen in reference to the definition of water, the use of *biaozhun ban* in the title can also be seen as pointing to the "standard edition" of the *Cihai* dictionary. Following the state's ongoing lexicographical project of editing and standard setting, the second edition of the *Cihai* dictionary was released in 1979 and a third edition followed in 1989. It has continued to be updated every decade since. Thus, in addition to including the dictionary as a collection of standardized meanings, Zhang's designation of a "standard edition" shows how standardization is itself an open-ended process for constantly renewing authority. With standards always subject to revision, Zhang's inclusion of the dictionary points as much to the power of definitions as to the power to define and redefine. This brings together the same issues he was working through in his paintings. This way

of thinking about "announcement" as a consistent effort to assert authority is thus doubly apparent in Xing Zhibin's broadcast.

The fact that this aspect of the video has been overlooked speaks to the curiously uncontroversial status so often granted to the dictionary. This, in fact, resonates with one of the ways in which the artist originally conceived of the work. When Zhang was selecting a text for Xing Zhibin to read, he had to choose one that would not arouse suspicion. The content could be neither overtly political nor sexual lest she balk at his request.[45] That the dictionary did not flag suspicion speaks to its utter familiarity and sense of innocuousness. The same can be said of the entry he chose for her to read. What could be more seemingly bland and inoffensive than water? Just as the pretense of neutrality was used to gain Xing's confidence, the same act can be said to be performed on subsequent viewers of the work. It is people's ready acceptance of what sounds anodyne that has resulted in its being easily dismissed as "meaningless." Indeed, one can imagine that if the audio contained anything tacitly perceived as subversive, this would have quickly been embraced by critics and curators as upholding its dissident status. The fact that this aspect doesn't seem to do this has led to its being overlooked. This neglect, in fact, belies a trenchant critique of how contemporary Chinese art has been consistently interpreted.

With people quick to applaud *Water* as the artist's undermining of political authority, there is seldom a search for other possible ways in which the work is also operating. This can be seen as an unintended legacy of the work, perfectly demonstrating two of Zhang's long-standing critiques: people's unquestioning acceptance of existing meanings and their limited ways of perceiving "opposition"; and, in turn, their inadvertent complicity in the persistence of both.

His appeal to the seeming neutrality of this authority also reveals another aspect of the work: Zhang's acknowledgment of his own occupation within these inescapable systems of constraint. This is best demonstrated through the story of how such a work even came into being. At the time, one of the few places where video editing was possible was at government television stations. He would depend on connections (*guanxi*) to use the equipment at the local CCTV station. While there, he struck up conversations with a worker and asked if the camera people and editors were on good terms with the broadcasters. Met with the affirmative, he asked if this friend could facilitate a recording. Zhang then provided this person with the dictionary definition of "water." When asked why he wanted this, Zhang innocuously replied that he wanted to make an exhibition about water. He asked if they would be willing to propose this idea to Xing Zhibin. They agreed, and a few weeks later, he received the tape in the mail.

Art historians have written that it is a "re-creation" of a scene down to the last detail. But this is misleading. Zhang did not re-create the setting—it is not a replica—as this leads one to think that Zhang arranged a "simulation" of a broadcast. He did not restage and re-create. He infiltrated an entire system of production. With this insertion into the system, Zhang implicated himself in the question of authorial intention within a system of message production. Although he replaced the broadcaster's words with ones he selected, even he had to take into account the limitations on this approach. The text had to be long enough to make an impact on the audience of his artwork, and it had to appear anodyne enough so as not to cause suspicion. Zhang's navigation of these aspects of the governing system shows his own canny recognition of needing to abide by established standards of communication. The dictionary provided him with the tool to both facilitate the project and also acknowledge the very limitations of language in which he was operating. More than an overt act of resistance, the entirety of the project signified his revelations that no one can stand apart from existing systems of meaning making.

An Approach to Identity

Given Zhang Peili's realizations and skepticism about the entrapment of self-fashioning and identity creation, it's easy to see how he arrived at his extreme criticism of the debate on how Chinese art could establish an international identity. During the early 1990s, Zhang exhibited internationally alongside Zhang Xiaogang, Wang Guangyi, and Sui Jianguo. Unlike the other artists discussed thus far, however, Zhang has continually denied the need to adhere to cultural categorization. His response to participating in the 1993 Venice Biennale departs markedly from the claims for "contemporary Chinese art" that his peers issued. In a 1994 roundtable discussion, Zhang stated, "*Zhongguo fangshi* [Chinese mode] is not an a priori concept. . . . I personally want to leave this kind of concept of "nation" and "race" behind. . . . Being an artist, you can only ponder your own reasons and needs for work. If Chinese artists can become individuals thinking about issues, and not a concept of a country or race thinking about issues, then China's art will have some hope."[46] His rejection of the very premise for cultural representation as either a historical or contemporary entity makes him a valuable counterexample to the other artists studied. When he positions himself as an "individual," this is neither a conceptual vehicle for affirming his own contemporaneity nor a deliberate conduit for channeling representative experiences.

Zhang's invocation of the "individual" falls squarely within the evolution

of his thinking about self-definition and the perils of oppositional positioning. His reference to the "individual" was a means of sidestepping the land mines he saw undergirding fellow artists' and critics' calls for China-centrism. In a 1996 essay titled "Doing Battle with the West?," Zhang critiques the patriotism coursing through the art scene.[47] As he watched his peers position their art as a means of restructuring a Western-centric art world, Zhang argued for why such an objective was doomed to fail.

The title of his essay references the ways in which Chinese people and Chinese artists are motivated by a desire to vanquish and defeat. In "doing battle," Chinese artists cite "targets" of attack. To Zhang, this was another manifestation of how a dichotomous paradigm could inadvertently trap people into believing that they could, in fact, enact resolutions through acts of opposition. He explicitly connects oppositional stance taking across two decades: while opposition in the 1980s had been toward the "official," it shifted in the 1990s to "the West."[48] In the latter case, Zhang saw fellow artists championing China-centrism to fight against Western-centrism. Yet, to even do so, Zhang argued, adhered to a "peripheral" way of acting. Advocating for China-centrism perpetuated an underlying sense of inferiority that precisely confirmed a peripheral status. Just like the reproduction of the "official" in the authority taking of the "unofficial," he again sees that without a deeper questioning of the models for identity formation, the return to calls for "China-centrism" could never correct the asymmetry between China and the West.

On Chinese artists' part, Zhang cites a conflict between the desire to vanquish the power of the West and wanting the approval of the Western-centric global art world. In his argument against the vociferous claims being made about Chinese cultural identity through art, he wonders why artists are so eager to position themselves *as representatives at all.* Why make art "in the name of" or "under the banner of" country, nation, or even the "avant-garde"? As he questions the motivations, his skepticism burrows beneath the problem of cultural representation to question why artists so readily rely on symbolic representation. This plays out at two levels: the use of symbols in artwork and the urge to fix meaning.

Decades later, Zhang continues to point to how this take on the "individual" is a way of going deeper than an all-or-nothing mentality: "I do not wish to highlight the special character of my identity as a Chinese artist, nor do I use any symbol or image carrying Chinese elements to express such identity. And yet I am not consciously trying to get rid of that in order to seek a so-called international character."[49] Zhang again critiques the prevalence of a binary mindset where one can either use "Chinese" symbols to show cultural identity,

or absent them in order to prove oneself as "international." Ultimately, this displays the failure on people's part to question why they so readily accept the underlying logic of symbols. Why are people so willing to yoke themselves to a fixed meaning? The problem, he sees, isn't just in following this logic but also a misplaced belief in the efficacy of asserting such meanings.

Rather than supporting the declaration of identity as a means of issuing power, Zhang points to how these are ultimately limiting objectives. He raises one particularly compelling way in which "fixing" underlines the "double standards" held by Westerners: they see Western history and culture as constantly developing and transforming in a logic of progress. Yet, they continue to view China as an exoticized ornamental culture that is essentially static.[50] Beyond the problem of symbols, Zhang here takes note of the dangers of being fixed to a particular time and place.

The prevalence of identifying artists through opposition, and the subsequent seductiveness of such a narrative, has cast a long shadow over narratives of contemporary Chinese art. Whether self-imposed or imposed from the outside, this impulse to *fix* and *define* also reveals the dangers of reproducing existing structures of power, even those that one is presumably defying. As Zhang's criticisms are often targeted at authoritative structures and meanings, his viewpoints offer valuable ways of approaching how histories of contemporary art have been written. In the 1990s, in particular, critics liberally used terms that denoted affirmation and negation. These implied clear-cut spatial divisions (inside/outside, *nei/wai*), ontological status (non-, *fei*), and hierarchies based on teleological progress. Following the logic of binary oppositions, an individual operated either inside or outside a system (*tizhinei* or *tizhiwai*), or took part in something emblazoned with the descriptor "new" *(xin)* to differentiate from the existing and now old. These kinds of labels sorted art as it was produced and pushed artists into particular groups, ascribing characterizations, contexts, and classifications. For Chinese artists and critics, part of this tendency toward self-historicization extended from a desire to fend off Western curatorial frameworks and to lay claim to the authority to write their own history.

Rather than subscribing to this hierarchy, this chapter has foregrounded Zhang's works in light of his efforts to reveal the machinations and stakes of fixed structures of meaning production. In this chapter, for example, the artist's treatment of medium—whether it was properties of painting or video—served as a tactic and path for his investigations into art. Even as he moved away from painting in 1994 and 1995, he continued to use the logic he learned from *tumo*: of using a medium against itself. This is something that can be

traced in his later photographs and shows the power of reading his art as inquiries and interrogations. While Zhang is most commonly identified as the father of video art in China—a decidedly "contemporary medium"—his objective has never been to participate directly in assertions of contemporaneity. In the past, the tendency for art critics and scholars to celebrate video art as a sign of advancement has contributed to a hierarchical ordering of mediums. This microhistory joins with recent scholarly efforts to reassess how the isolation of medium has come at the expense of studying artistic intentions and tactics as they were shared across his experiments about art.[51] This chapter has focused on Zhang as a counterpoint to the impulse to define oneself and to define. In addition to reconsidering his body of work, this denial of fixed definitions helps us to challenge these same tendencies when they arise in art history and interpretation.

Lin Tianmiao
Threads of Resistance

When Lin Tianmiao (born 1961) states, "My art is an expression of my life, as an artist, as a Chinese, and I suppose, as a woman," she is responding to the art world's routine characterization of her as a "Chinese woman artist."[1] She uncouples these terms as a reminder to art critics and art historians that her work transcends such an essentializing label. While still accepting gender and culture as sources for her work, Lin's insistence that they are deeply personal aspects of an individual nature exhorts viewers to resist seeing her art as representative of a larger group or agenda. The final part of her statement—"I suppose, as a woman"—is especially telling as it reveals her reluctance to mention gender at all. This is the category by which she is overwhelmingly defined and, as such, that which she now adamantly resists.

The start of Lin Tianmiao's artistic career in the mid-1990s coincided with an explosion of interest in contemporary art by Chinese women, both inside and outside China. In September 1995, the Fourth World Conference on Women organized by the United Nations took place in Beijing and served as a catalyst for the recognition of female artists. From 1995 to 1998, Lin participated in the *Women's Approach to Chinese Contemporary Art (Zhongguo dangdai yishu zhong de nüxing fangshi)* exhibition at the Beijing Art Museum and two exhibitions at the National Art Museum of China, *Chinese Women Artists Invitation Show (Zhonghua nühuajia yaoqingzhan)* and *Century—Woman (Shijie nüxing yishuzhan).*[2]

Within these early exhibition and historical narratives, the phrase "women's art" often constricted artwork into generalized approaches and stylistic tendencies. As a "style," women's art was identified with particular materials, motifs, and traditions, distinct from work produced by men. Art historian Jia Fangzhou noted that the 1990s saw the rise of women's awareness toward themselves and their gender identity, and identified particular characteristics of the resulting art. Among the various characteristics, he stated that work by these

women emphasized intuition, drew on personal experience, and used materials from daily life. Women artists were also generally "apathetic towards politics, history and philosophy, and on the contrary, concentrating [instead] on the themes of nature, life, and humankind and survival."[3] Burdened by these descriptions, "women's art" served less as a rallying call for female artists and more as the start of a set of thorny parameters against which to navigate and negotiate.

The curator Liao Wen meanwhile granted more leeway in her formulations of the category, describing it as a space through which women could discover themselves. While admitting that a "women's approach" remained in an embryonic state, Liao noted the importance of this room for development given its historical absence in China's patriarchal society. She was furthermore clear about distinguishing Chinese art by women from a larger international feminist movement. Even still, her identification of particular characteristics—the material used, "silent subversion," and a greater "emphasis on women's particular feelings and experiences"—continued the trend of narrowing this term into definable attitudes and properties.[4]

In shows outside China, the interest in "Chinese women's art" followed the expanding reaches of the global art world. Exhibitions dedicated to the subject appeared in the latter half of the 1990s. In Germany curators noted that there were no women among the thirty-one artists featured in the 1996 exhibition *China!* at the Kunstmuseum in Bonn and thus organized *Die Hälfte des Himmels (Half of the Sky)* at the Women's Museum in Bonn in 1998. That same year, Lin also took part in *Against the Tide* at the Bronx Museum of the Arts, the first exhibition in the United States dedicated to art by contemporary Chinese women artists.[5]

That Lin's uses of thread could be read in terms of foot binding, craft, and women's work generated both great interest in her art and immediate assumptions about its meanings. These responses no doubt contributed to her particular fame. Other reasons, too, made her stand out from even the handful of female artists working in China. In the mid-1990s, for example, her active participation in the Beijing-based phenomenon "Apartment Art" put her at the center of a burgeoning art scene. When art historian Gao Minglu—a keen observer of this phenomenon—went on to curate *Inside Out* in 1998 in New York, he included Lin in this landmark show. In the accompanying catalog, Gao specifically describes Lin and her fellow artist Yin Xiuzhen as "two women artists who make Apartment Art."[6] Lin's provocative combinations of readymades and video further put her on the radar of foreign curators seeking artists who departed from painting and sculpture. This characteristic again facilitated

her inclusion in the group show *Another Long March: Chinese Conceptual and Installation Art in the Nineties* in the Netherlands. Her escalating exposure through both of these venues—"China" shows and those dedicated specifically to "Chinese women artists"—brought her substantial acclaim.

In both kinds of shows, her participation was always marked by her identity as a "Chinese woman artist." Through the imposition of this category, gender was soon trumpeted as the sole defining feature through which to access and understand women's artworks. While bringing much-needed attention to certain underrepresented artists, the reproduction of similar systems of narrative classification posed troubling problems for artists over interpretation and intent. For Western audiences expecting dissident art, work by women that could be read as commentary on social subjugation supported views of China as backward and belated. In 2001, Lin remarked on the burden of expectation that came with being labeled in this way: "You have the responsibility to expound on the current state of feminism and mentality of women in China when invited to attend international exhibitions."[7] By 2001, Lin was already speaking out against this kind of classification, particularly in the form of exhibitions:

> I think there are too many women's exhibitions. I myself have participated in five or six. . . . All seemed to be about the same thing. . . . All you saw were those concerned with "China" or "Women's" issues. I have always wondered if one were to have removed the words "China" and "Women" from the exhibition, would anyone have come, would anyone have paid attention?[8]

Lin partly targeted her frustration at the political agendas that curators, critics, and the public arrived expecting to see. In larger China shows they anticipated a window into a mysterious culture. As a female artist, however, Lin and her work seemed to also promise a way of bridging cultural difference by offering commentary on the shared female experience of patriarchy. These contradictory expectations encouraged a doubly marginalized status: consistently seen as secondary to the male-dominated mainstream of contemporary art in China, and regarded "simply as a local, particular instantiation of the 'universal' Western model" of feminist art.[9]

Even exhibitions that sought to extricate artists from these binds recognized the difficulty of doing so. The 2001 exhibition *Threads of Vision: Toward a New Feminine Poetics* in Cleveland, for example, positioned Lin Tianmiao alongside four other female artists from across the world. Curator Kristin Chambers notes up front that all of these artists refuse to be "neatly labeled as

'women artists' or as 'feminist artists'" just as much as they "desire to transcend the stereotypes accompanying their cultural roots and birth-lands."[10] *Threads of Vision* interestingly shifts from bringing artists together on the basis of their gender to emphasizing their shared experiences of being limited by this frame. In an attempt to go beyond this very frame, identity is understood here as evidence of plurality and richness rather than something necessarily limited. Even still, the discussion of Lin's work as commentary on female oppression can itself still seem limiting. Indeed, this remains as one of the reasons why Lin continues to bristle at being labeled as a "woman artist" and denies that her art is feminist. In particular, she cites the difficulty of applying Western theories to art created in other cultures and notes that such frames of reference circumscribe understandings of artists' works.

Over the years, as discourses on postcolonialism and postmodernism have brought attention to locating difference, Lin has become further entangled in the problems associated with the validity of using a gendered lens for interpreting art. While she may occasionally still be asked about how she represents women in China, she now more likely fields questions about how she feels being viewed exclusively in this light. This has resulted in articles with such titles as "Can Lin Tianmiao Break Free of Gender?"[11] This line of inquiry importantly pushes people to recognize the constraints brought by a gendered framework for interpreting art.

While the thorny traps of gender continue to haunt Lin's work, the question then remains: what other ways are there to understand her work? This chapter offers one preliminary path forward. The scope of this chapter is tightly construed: it does not explicitly address gender politics and the patriarchy in China. This is because it pointedly does not try to start at the level of imposing classification and instead starts with the art. This approach focuses in particular on a significant by-product of the penchant for classification: the lack of criticality paid to the art as such. Starting from a mode of categorization—for example, trying to decide if she is feminist or postfeminist—can often lead to blind spots in reading the art. This is most evident in the treatment of women's art as a "protected category" and pivoting works from being regarded in any other way.[12] Lin's desire for her art be appreciated on its own merits, and not simply because of her gender, led to continued assertions that her art derives from her identity not as a "woman artist" but as a woman and an artist.

This chapter thus focuses on interpreting Lin Tianmiao's art beginning from the role she gives primacy to in her self-identification: as an artist. Most studies of her work see her status as an artist as a fixed and transparent conduit for communicating cultural and gendered experiences. As such, the art-

ist's claims for conceiving of art as self-realization have been calibrated to biographical milestones that measure her growth according to life experiences as a woman and mother. While this was indeed an important factor in her work, it is also necessary to examine Lin's art as evidence for her continual thinking about art and her attendant development as an artist. Thus, alongside tracking her changing subject matters, an equally significant trajectory must also be mapped: how the artist conceives of art, tests its definitions, and poses possibilities.

To excavate her artistic concerns, I trace the artist's uses of thread. Thread has been a consistent part of Lin Tianmiao's works, but her associations with, manipulations of, and motivations for the medium have changed drastically over time. The first part of this chapter discusses the artist's earliest uses of thread and how common interpretations of her early installations have been largely built on symbolic readings and textual sources. As I track her works as inquiries into both art's capacity for communication and its material properties, the second part examines a group of works from the late 1990s and early 2000s that urge viewers to move beyond the level of symbolism and metaphor to study how the aggregate components of a work operate on-site.

By starting from the artist's formal, material, and spatial manipulations of thread, this approach reveals Lin's penetrating investigations into the visual and material dimensions of art, in particular, the distinction between that which is described and that which actively presents itself. Replete with taut lines and trembling vibrations, her work scrutinizes the properties and effects of her materials. Lin Tianmiao's repeated investigations into art's constituent components and functions reveal three key points. First, Lin's art demonstrates the significant interest she had in art itself as subject matter. Her deliberate address of art participates in a larger trend in the 1990s in China in which artists questioned received understandings of art and chartered their own definitions. Second, Lin's artworks served as a site where experiments could unfold—undertakings that together demonstrate a series of probing investigations into questions of process and how artistic meaning is conveyed. Lin says of her works, "Perhaps it is only six months or a year after you produce a work that you understand why you did it, and what you were trying to say. If you know beforehand then why would you go to the trouble of making it?"[13] Complicated and always unfurling in meaning, her works challenge the notion of an artwork as a final, culminating expression. She approached her art as opportunities for discovery through process and placed particular emphasis on her works as sites for experimentation rather than adhering to a fixed relationship between content and form. Third, these inquiries into artistic mediation

and expression were not claims for art as an autonomous realm, separate from her life or from larger social concerns. Instead, art served as a crucial venue in Lin's life for conducting investigations into the mediation and expression of meaning and, relatedly, the materialization of her own voice as an artist.

This study of the artist's inquiries *about art* and *through art* opens up Lin's tactics of interrogation and resistance, not least of which were her protests against practices of classification. As such, this chapter does not discount commentary on identity or gender but, rather, foregrounds the art itself to enable alternative and interrelated frameworks for understanding her work and how it has been historically treated.

Early Threads

While redefining art is a constant and ongoing process, Lin Tianmiao has encountered particular experiences that have forced her to tackle her assumptions and understandings of art head-on. For one year she took oil painting classes at Capital Normal University in Beijing, where she received training in the socialist realist tradition. She describes it in the following way: "The fundamental concepts, the ways to observe art, and the ways to judge what is good and bad were monolithic. There was no pluralistic thinking. No querying. No right to cast your doubt."[14] In the late 1980s she and her husband, fellow artist Wang Gongxin (born 1960), moved to New York, and she remembers the pain of not only adjusting to a new environment but also the deeply rooted questioning of the underlying "value systems" that governed what they thought they knew. That is, the evaluative logic that determined not only behaviors and habitual thinking but also judgments and ideological beliefs. This affected every aspect of their lives, including the question, "How do we understand contemporary art?"[15] While Lin worked as a textile designer at the time, she recalls how her husband "traversed the entire expanse of art history" in an effort to figure out what had been missed from their art education, what had governed previous ways of thinking, and ways of moving beyond both.[16] This was not merely a search for new styles and artistic tactics, but more fundamentally about seeking to understand, challenge, and expand the concepts that lay beneath them. It is unsurprising, then, that when Lin and Wang returned to Beijing in 1994, Lin already saw art as something that was ripe for interrogation and redefinition. In her early large-scale installations, she used it as a place not only to figure out her own ambivalent feelings about contemporary life but also to reconsider ideas about art.

In two of her early large-scale installations, *The Proliferation of Thread Winding* (Figure 35) and *Bound and Unbound* (Figure 36), she utilized thread as

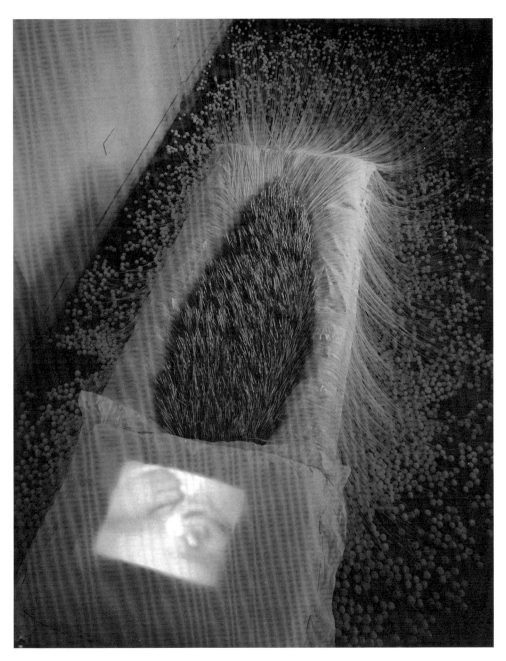

Figure 35. Lin Tianmiao, *The Proliferation of Thread Winding*, 1995. White cotton thread, rice paper, bed, twenty thousand needles, video, monitor; dimensions variable. Courtesy of the artist.

an explicit reference to the act of *chan,* or thread winding. In *The Proliferation of Thread Winding,* twenty thousand glinting needles protrude from an elevated bed covered with rice paper. Each steel needle measures twelve to fifteen centimeters and is attached to an individual stream of white thread. The strands radiate outward from the bedframe, each ending in a small, tightly wrapped ball of thread on the ground. At the head of the bed, a video plays beneath a pillowcase, showing two hands winding thread and reminding viewers of the arduous manual process by which each ball was formed. The video, materials, and balls of thread combine to capture thread winding in its entirety and in perpetuity.

Bound and Unbound also features this process, but further shifts from thread winding to thread binding. Rather than producing the balls of thread from childhood, the thread is now used to wrap daily household utensils. Fastidiously swathed in layers of white thread, more than eight hundred objects—ranging from cleavers and tongs to pots and pans—sit directly on the floor of the exhibition hall. A large video projection shows the artist's hand operating a pair of fabric shears, opening and closing the blades through a stretch of threads. Because the artist has replaced the video screen with a curtain of hanging strands, she highlights the distinction between the projected image of cutting and the physical threads that remain stubbornly unaffected. While the English title of this work implies two opposing states of existence, the title in Chinese, *Chan le, zai jiankai,* literally means "wrapped and to sever again," referring more to the laborious cycle that leads from one to the other rather than to two static states. The video makes clear this sense of endlessness, implying that the bound objects nearby are part of a seemingly inescapable and ongoing process.

As Lin reveals in her 1997 text "Wrapping and Severing," art was a place where she could test and reconcile the ambivalent feelings she held toward this relentless act of thread winding.[17] Most immediately, it invoked a sense of tedium tantamount to "corporal punishment." This derived from her childhood memories of helping her mother meticulously wind loose threads into skeins. Of this tiresome act, she writes, "All women experience this kind of 'corporal punishment' in their daily housework: if she were to end this situation, a new 'corporal punishment' would await her. Is it possible to sever oneself from these tangled circumstances?"[18] Informed by this text, one can read Lin's return to this activity so many years later as a representation of the situation that continues to ensnare "all women" in domesticity, a condition that is socially rooted and passed down from mother to daughter. Evident in her language, however, is also a sense of confusion as she finds herself reluctantly

LIN TIANMIAO

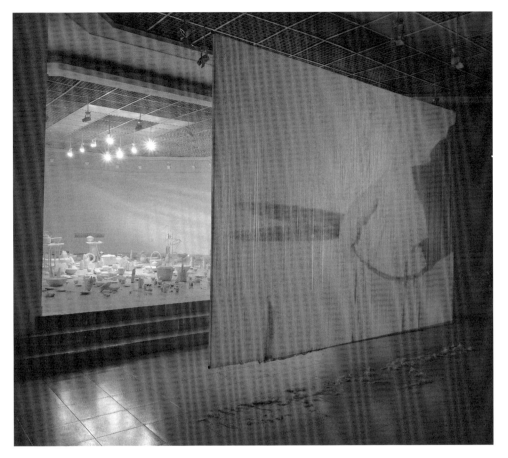

Figure 36. Lin Tianmiao, installation view of *Bound and Unbound,* Beijing, 1995–97. White cotton thread, video projection, household objects; dimensions variable. Courtesy of the artist.

drawn to thread winding through an odd sense of familiarity embedded in motion and memory. This is both a nostalgic lament for the passage of time and a questioning of the peculiar comfort found in this rote activity that seems to keep one trapped in the same state. It is this ambivalence that motivates her questioning of whether or not she will ever be able to cut herself free from this. Through the extensive labor of thread winding apparent in both works—two months for *The Proliferation of Thread Winding* and two years for *Bound and Unbound*—Lin reenacts the process as a means of showcasing and confronting her conflicting emotions. In both cases, the action is seemingly without end as the artist attempts to extricate herself to no avail. Subjecting herself to this, she continues an exploration of vacillation: Is this self-imposed punishment or socially conditioned placation? Is this action granting obsolescence or is it a platform for preservation?

Struggles with physical, mental, and social containment are evident through-out Lin's textual and visual representations of thread winding. These un-derstandings of thread have also been mapped onto gendered readings of the material itself. When Lin Tianmiao first exhibited these works in China in the middle to late 1990s, curators and critics cited her use of thread as a marker of feminine consciousness, representative of a distinctive female atti-tude and approach. In her essay for the exhibition *Women's Approach to Chinese Contemporary Art,* curator Liao Wen positions Lin Tianmiao in a section titled "Binding Knitting" and describes *The Proliferation of Thread Winding* in this way: "This sort of work utilizes simple and complex, unified and repetitive knotting textures, denoting [for] us one of the traditional activities of women of all times and all cultures. . . . [It] directly suggests the primitive activity of knitting and needle work, as it were trying to break the bearable limit of repeti-tive situations."[19] Liao goes on to refer to this as a "common characteristic" of women's art: that the selection and use of medium are tied directly to "physical and emotional experiences, accentualized by the release of personal emotions." The ties among materials, sensitivity, and gender are also evident in curator Jia Fangzhou's catalog essay for *Century—Woman,* in which he lays out "essential characteristics of women's art." Two of these characteristics are that "their methods of discourse are developed from traditional handicrafts" and "materi-als are often chosen from daily life and a sense of propinquity. Women artists not only prefer those of such traditional handicrafts, but are specially sensitive to these materials."[20] In addition to the alignment between thread and tradi-tionally female activities of sewing, crafts, and decorative embroidery, the idea that fabric and thread are somehow "emotional" seems to further suggest that female sensitivity to these particular materials derive from the soft, gentle, and pliable nature of women and fabric alike.

Beyond textual evidence and symbolic understandings of the things and actions depicted, these works also reveal the artist's growing interests in en-dowing art with the power to change perceptions. In this way, the ambivalence that Lin seeks to analyze goes far beyond emotional vacillations to encompass a broader project in fluctuating binaries. In *The Proliferation of Thread Winding,* she explores how the abundant repetition of visual form can transform one's reading of materials. What appears at first to be a soft layer of fur on the bed is revealed to be thousands of piercing needles densely packed, leading a viewer to swing wildly from tactile curiosity to surprise and perhaps even trepidation. Similarly, one lone ball of thread suddenly acquires a sense of swelling force when installed in the hundreds. In these cases, Lin explores the wavering that can occur through a person's expectations of and experiences with a work. In

her experiments with visual and material properties, she attempts to bring about a continual oscillation and thus questioning of what is anticipated versus what is seen and what one presumably knows.

Soon after *The Proliferation of Thread Winding* was first exhibited, art critic Qian Zhijian grafted these alternating perceptions onto an explicit male–female binary: "The 'masculine' sharpness of one needle appears to be soft like a pelt; and the feminized balls of thread appear in the installation to be like semen."[21] Thus, even though the artist's early interests in perceptual transformation were recognized, the tendency to situate this in rigidly gendered terms occluded discussion of the more fundamental exploration that Lin began attending to here. Beyond playing with perceptions of sexual difference, Lin attaches specific attention to the problem of how to invest her materials with power. From exploring strategies for changing perceptions to endowing inanimate objects, like a ball of thread, with a sense of organic growth and radiating energy, Lin Tianmiao reveals here a fascination with material manipulation and destabilization that continues in *Bound and Unbound*.

In analyses of *Bound and Unbound,* critics have primarily attended to the objects on display. Given their sheer number, they undoubtedly address the endless toil of winding that continues from *The Proliferation of Thread Winding.* The objects were chosen because they are markers of a life on the brink of imminent obsolescence and soon to be replaced by even newer goods and materials. One of the most remarked-upon uses of thread in this case is its intensification of the objects' lack of utility, bound up as if to mummify them in a solemn embrace.

But rather than simply issuing a final farewell to these silent objects, *Bound and Unbound* enacts significant explorations into the dynamic between the visual and material capacities of art. In particular, this can be found in the large video projection that greets viewers on-site. In choosing to project the video onto a curtain of thread, the artist enhances the ineffectiveness of the image. While the hands wielding the shears may try relentlessly to snip the vertical threads on which they're superimposed, the threads remain materially intact. As such, the strands participate in the visual illusion of the action while also proving its illusoriness by refusing to be severed.

Significantly, as the scrim onto which the image is projected, it is the materiality of the threads that grants the image visible form. That is, without the threads, the projected light would dissipate, absent of visible body and force. But even while materializing the image, the threads also disrupt its integrity. As the projected light streams through the gaps between each strand, the threads doubly evacuate the visual threat of the scissors, not only by remaining

intact in the face of severing but also by fragmenting the pictorial image. In this simultaneous avowal and disavowal of the image, we see the continuation of Lin's interest in perception and material manipulation. Her reduction of pictorial image to light and her emphasis on its dependence on thread showcase an investigation into the distinctions between an image and an image-bearing object. In examining the efficacy of each, Lin's breakdown of visual imagery and its material conditions of appearance mark the beginnings of a critical and persistent interest evident throughout Lin's art.

Visible Materiality

Lin describes a shift in her art during the late 1990s to "things having to do with my life and myself."[22] This signaled a move away from her earlier statements about "all women" and a challenge to those who upheld her as a feminist mouthpiece. Lin's focus on the individual self has been interpreted as her incorporation of pictorial and sculptural images of her own body and face. Along with this, I argue that her claims for a more personal bent extend beyond the pictorial. It was at this time that she turned even further into her works as sites for testing the tools of mediation and meaning making. Lin's interest in disassembling and studying art's core components can be read as her way of coming to understand the world and testing how things have agency, register meaning, and generate resonance.

As I approach each artwork as one step in the artist's project in unpacking the possibilities of what contemporary art can do, multiple works are studied in conjunction with each other rather than just the ones deemed most representative of Lin's career. In this section, I turn to three less studied works in the artist's oeuvre, *Family Portrait* (1998), *High* (2000), and *Day-Dreamer* (2000), to trace how the artist's early interests in the contrasts and relationships between the visual and the material, as well as the visual and the visible, became central constellations around which she continued to produce and examine art.

In the series *Family Portrait* (Figure 37), Lin Tianmiao installs a collection of meticulously thread-wrapped frames. While some are beveled and others are surrounded with rounded trim, all of the frames are united through color and treatment. Like the objects in *Bound and Unbound,* these wrapped frames suggest that they can be seen as quietly mummified objects on their way to obsolescence, or perhaps made sacred by this delicate treatment. *Family Portrait,* however, also has a more significant connection to the previous work: the possibility of altering perceptions of visual representation through attention to the material itself.

Figure 37. Lin Tianmiao, *Family Portrait*, 1998. White cotton thread, frames; dimensions variable. Courtesy of the artist.

On the one hand, the frame can be considered an object bound in its entirety and, like those in *Bound and Unbound*, denied of its intended purpose. With its back tightly wrapped and absent an image, the frame appears to be emptied of visual content. On the other hand, when one shifts focus from what is visually absent to what is materially present, we see that it is these strands of thread that are, in fact, framed. In this way, this interior thread is announced as significant and deserving of viewers' attention. With the suggestion that this, too, can be a "family portrait," Lin calls into question the conventional reliance on visual representation as purveyor of meaning. In the absence of a pictorial image, the tactility of the thread is insistently manifest and raises the question of not only what lies beyond pictorial communication but also what materials can communicate. Lin still allows thread to reference memory and metaphor, but by featuring the material as something to be intimately viewed, its multiple meanings are made clear: it is both the medium for winding the frame and the featured "image" at its center. In this tension between the visual and material, the latter effectively challenges the former through its emphatic

presence. Lin states, "This is an understanding of, or rejection of, or attitude toward painting."[23] As a continuation of her previous work, she suggests here that the material *is also visual* and can supersede the expressiveness of mimetic representation through its own tactile, visual, and dimensional nature.

In 2000, Lin Tianmiao's exploration of material presence expanded beyond its relation to visuality as she returned to delve into questioning visibility in her work *High* (Plate 17). In this work, thousands of thin white threads arc gently positioned between two large pieces of fabric. One piece of fabric acts as a screen onto which a black-and-white video of the artist's face is projected. While at first the face seems to be still, gradually it begins to smile. Individual knots of threads pierce the scrim and reach laterally across a gulf of space to a wall of fabric. From behind the wall, six speakers emit a range of sounds, from low rumbling tones to high-pitched emanations. The noises are human but unintelligible as words. The sounds, like the face, gradually shift to signify a change in mood. As suggested by the title of the work, these various components come together to convey the sensation of an incremental emotional escalation. The rising pitch generates a feeling of reaching up until culminating in an ineffable, intoxicating "high."

While the work as a whole may suggest the experience of emotional transformation, its aggregate parts serve as sites for the artist to test and affirm the audio, visual, and material properties of how such communication occurs. This is made clear through the display of contrasts and connections. The pictorial representation of the face, for example, stands opposite a blank wall of fabric. In addition to juxtaposing pictorial presence with absence, these two screens also stage a confrontation between projected light and projected sound. As one screen captures the illumination of a video, the other registers acoustic resonance. For the former, the fabric acts as a surface onto which the projected light is made visible as a focused image. In the case of the latter, the fabric quivers with the vibrations of sound waves. In her testing of light and sound, Lin makes evident the importance of the physical presence of the fabric in its power to grant visibility to immaterial forces.

It is significant that the artist uses individual threads to connect the two pieces of fabric. Knotted through both panels, they emphasize the porousness of the fabric and that these aren't simply surfaces but, rather, physical objects that exist in space. As light continues to stream through the screen to challenge its opacity, sound waves permeate the fabric wall to disturb the air between. The threads form a visible connection between the visual and the audio, between an image and blankness, where the light of the picture travels from one side and sound travels from the other.

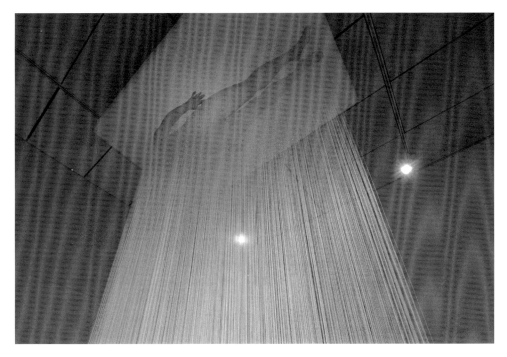

Figure 38. Lin Tianmiao, *Day-Dreamer,* 2000. White cotton thread, fabric, digital photograph; dimensions variable. Installation view at Rockbund Art Museum, Shanghai, 2018. Courtesy of the artist.

These threads also continue the task of lending material presence to sound and giving further nuance to its visibility. When the bass rumbles, the entire mass of threads shudders, but only the central threads vibrate when a higher timbre rings out. In this way, Lin continually tests how the communication of an idea—emotional escalation—can be demonstrated outside a pictorial image. She also tests the capacity for thread to register these changes physically, thus demonstrating its material power to render the invisible visible.

Exhibited in the same year, *Day-Dreamer* (Figure 38 and Plate 18) displays Lin's continued pursuit in materializing the immaterial and pitting the visual against the material. The artist again opposes one fabric panel with a pictorial image against another that is blank. Installed just inches from the ceiling, an image of the artist's entire face and nude body is digitally printed onto one fabric panel. Knotted through with individual strands of thread, the image is connected to a suspended white mattress beneath. Over the course of the exhibition, as the force of gravity pulls the weight of the mattress downward, the lines of thread continually tug the fabric of the mattress upward. The result is the gradual appearance of a ghostly body seeming to emerge from below.

This body, though free of illustrated features, is nevertheless endowed with physical form and even movement. The two bodies—one pictorial, the other material—complement and contrast with each other. Indelibly connected through thread, the pictorial representation of the body lends its external form to the body beneath, while the emergent body also strains insistently down and tugs on the image above. In both cases, the threads confer each body with an increasing physical presence over the length of the exhibition.

While *High* utilized the relaxed looseness of thousands of horizontal threads to materialize the effects of longitudinal sound waves, *Day-Dreamer* employs taut vertical lines of threads to register physical weight and the passage of time. In her study of the use of thread to register physical effects, Lin has shifted away from treating the threads as receptors to be acted upon by light and sound. Instead, in *Day-Dreamer* the constancy of the thread's tensile strength incrementally effects change on its connecting components. Lin has thus set up a situation that activates the agentic force of the thread to bring these bodies of fabric into visibility and dimensionality.

Lin's studies of the physical and material properties of thread are always in conjunction with material and immaterial surroundings. From sound and space to surface and text, the forces and objects that thread encounters bring about experiments in connectivity and change. As an adaptable medium for the humble line, thread leads, affixes, divides, makes discrete, protects, covers, starts, and ends. In her scrutiny of the visual, formal, and spatial possibilities of thread as both receptor and agent, she is consistently examining its function as an actor and mediator for meaning.

Speaking through Thread

One of the ways in which we can understand the artist's experiments with the material presence of thread is as part of a larger resistance to established linguistic systems. In 2004, continuing on the audio component in *High,* Lin appealed to thread as a medium for dialogue in *Chatting* (Figure 39). In the work, four nude women stand facing each other. Two more figures stand close together and off to the side; their physical proximity to each other seems to emphasize the isolated distance of the other individuals. The figures' bodies are meticulously rendered to represent women in middle age. Slumping slightly, their bodies are covered in white silk with small balls of thread and loose strands gathered and streaming from hands and skin. Their heads, replaced with rectangular monitors, crane forward as sounds emit from each

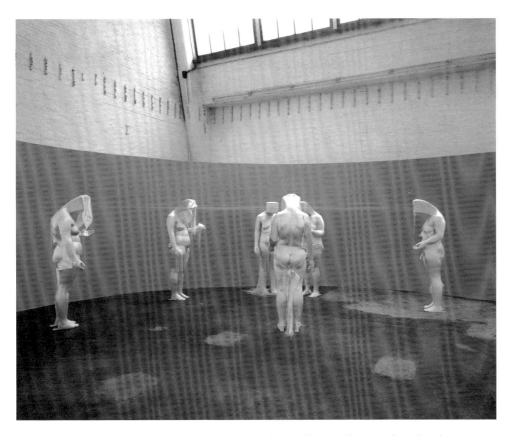

Figure 39. Lin Tianmiao, *Chatting*, 2004. Fiberglass, silk threads, mixed media; dimensions variable. Courtesy of the artist.

figure. The noises are unintelligible as words but are nonetheless recognizable as sounds of human emotion, from groaning to chattering excitement.

Reaching across the chasm of space that divides the women are long thin strands of thread. The white threads, while exceedingly fine, are accentuated against a searing pink background. As she does in *High*, Lin uses these strands of thread to engage and register the sounds, thus physically and acoustically connecting these figures. Her removal of faces was a deliberate choice to prevent viewers from too easily "reading" expressions. Barring both linguistic and facial accessibility, the artist asks audience members to consider another form of expression in its place, one made physically present and intimate through thread.

Precedence for this use of thread as a rhetorical device can be found in her material response to linguistic signs back in 1999 with her work *Shut Up!* (Figure 40). For the 1999 group exhibition *Magnetic Writing/Marching Ideas:*

Works on Paper at IT Park in Taipei, curator Ku Shih-Yung expounded on the exhibition theme in an eponymous text. His text prompts readers to attend to the bodily nature of art, particularly considering the loss of corporeal recognition in the internet age. This written text became the basis for Lin's *Shut Up!*

In the work, Lin reprints the curator's words and covers them with increasingly dense layers of thread. With stitches crisscrossing at haphazard angles, the threaded surface becomes coarse and textured. Beginning with just a few sutures, the buildup of white cotton thread begins a third of the way down the paper and completely obscures the text from the middle to the bottom of the page. The chaotic jumble of jagged stitches, progressively emphatic in force, conveys a forcible violence to the text.

Lin's work interestingly brings to bear what the curator himself noted: the corporeal labor of art is evident in the haphazard puncturing of the paper. The handling of the paper—like the handling of the objects in *Bound and Unbound*—is evident due to the masses of thread. At the same time, the work also seems to endow the thread with voice, as the thread becomes a ranting dialogic response. Endowing the thread with the energy to enact violence and to obscure another voice makes the thread powerfully present—even seemingly audible—through its physical properties.

This is a telling work on many fronts. It speaks to the artist's participation in the discourse surrounding the interpretation of art. Her work draws attention not only to the broader dialogue that occurs among artist, artwork, and audience but also to the ever-present role of curatorial and critical text as a way of explaining, describing, and framing a work and artist. The ways in which this textual intermediary gives meaning to the work or alters it is at the heart of *Shut Up!*: how a work's meaning comes to pass, and the possibilities for an artist to object to this practice and utilize art as discursive intervention.

This analysis of the rhetorical possibilities of thread aligns with the examinations Lin carries out in *Family Portrait, High,* and *Day-Dreamer,* where she tests and compares the efficacy of any kind of descriptive representational form. Throughout all of these works she sets up a dichotomy between that which is representational and that which is "real," that which seeks to describe and that which seeks to act. In this way, we can see not just her challenge in *Shut Up!* to curatorial categorization but also a challenge issued to didactic visual representation as a whole. Thread here is not simply a stand-in for the artist's response but operates as her materialized participation. As such, we can understand thread as the ultimate form of self-realization concretizing the artist's voice.

Figure 40. Lin Tianmiao, *Shut Up!* 1999. Paper, white cotton thread. Courtesy of the artist.

In this way, we can see how the *materiality* that she harnesses—as dialogue, as power, as agent, and as active registration—signals an examination of how art can be used to extend beyond visual description and to do more than what can be verbally articulated. When Lin states, "It is important that an artist has a sense that cannot be expressed in words," her resistance to text is paired with her desire to enact a more direct relationship with both audience and material—and to use that direct relationship with material as a primary component of the content and message of the work.[24] In this way, her "discursive intervention" through materiality is, in fact, a way of curtailing the discourse altogether. It is a way of resisting the continual ascription of gendered

interpretations to thread by furthermore calling attention back to what is happening in the art itself as a source for analyzing meaning.

Lin Tianmiao's early works started out with an ambivalence and awkward pull toward thread. Originally a way of trying to make sense of incongruities and a forum for exploring visual and material transformations, her later explorations led her to conduct investigations that could exploit and affirm the physical attributes of this material. In some ways this shift came out of a desire to push the physical properties to their greatest reaches; in other ways, it was a challenge to the imposition of narrowed readings of her work within a symbolic and metaphorical light. Thus, while thread might have initially entered her work as a marker of her childhood, its meanings changed significantly alongside the artist's strategies of interrogation and intervention.

When one follows Lin's interest in and usages of thread, this enables an alternative trajectory to come forth: rather than imposing a reading that assumes cultural or gendered meanings, this one starts from the question of what the artist is *doing with thread* and why. Within this, we witness a departure from basing the power of thread on visual symbolism, cultural encoding, and memories. This also sees a shift in attention away from just the visual effects of thread—such as in uniformity of color—and more toward an exploration into the material as such. In her efforts to realize the physicality of thread and what its presence can achieve on-site, there is a continuation of her utilizing art as a place through which emotions and concepts are worked out rather than just represented and expressed. But, the shift in *what* is worked out demonstrates a move toward positioning art itself—particularly, artistic language and its communication—as one of the key targets of her own inquiry.

This shift is significant. First, it signals a deeper excavation into how meaning manifests in art. That is, what is thread when it isn't used as a metaphor for being bound, or a trigger for memory and reference to domesticity? While art critics and art historians rarely acknowledge this transition, it is a vital aspect of Lin's explorations into the possibilities of contemporary art. In this way, through her work—from the subjects she tackles to the ways in which she struggles with pushing its most fundamental components to their utmost—we can see important facets of her changing concerns about art and representation. They became platforms through which she could announce and declare and disagree; they were sites where she could slowly work out basic relationships and ideas about visibility, new forums through which her own voice could be physically registered and visibly seen. These were important parts of her own ways of realizing the capacity for art and thread and for her own attention to self. In raising the artist's calls to treat her as an artist and realizing her

attention to materiality and voice, this further opens up the potential to draw compelling connections with other artists and practices *without* resorting to a gendered lens. This is not to ignore the problems of patriarchy in the Chinese art world and society but, rather, to allow for far more nuanced ways of perceiving how Lin participates in this very discourse through her art.

Take Two

The final part of this chapter focuses on an abrupt shift in Lin's efforts to curtail discourse. With her previous efforts for responding to critics in art and in interviews seeming to go unnoticed, she remained frustrated by the persistence of interviewers: "from the very beginning, people have asked me about *nüxing* (women) things. I find it incredibly bothersome and I have no interest in it."[25] But, at the same time, because she has had to field so many inquiries about the subject, she has been driven to take notice of and contemplate these very topics.

In the beginning of her career, she had very little sense of what interviewers even meant when they asked about feminism. Over the years, she was forced to inform herself. This was facilitated partly through her growing interactions with Westerners and her observations of how notions of gender equality penetrated their thinking and behaviors. But even as Lin learned about these issues and made her own observations about how they manifested in culture and society, she didn't seek to pursue these subject matters in her art.

She only did so—from around 2008 through 2014—because she wanted to be rid of these questions altogether: "It's very troublesome *(mafan)* and it disturbed and interfered *(ganrao)* [with my thinking] for very many years."[26] Lin decided that if she was going to be asked about being a Chinese woman artist, then she would arm herself with a comprehensive answer through her art. If people insisted on continuing to ask her to address these issues, then she could refer all future questions to this body of work. The result was *Badges* (Figure 41) and *Protruding Patterns* (Plate 19).

While reading one day, she came across a "dirty" word to describe women. As she explains it, while her notice of this term may have germinated from a rather arbitrary and intuitive place, it soon evolved into a mission of sorts. For someone who had felt so stifled by questions directed at gender, it is perhaps unsurprising that she would turn her attention to language as the focus of her new work. Over the course of six years, she looked for characters, words, and phrases that described and named women. She began with a search of historical terms, beginning with the Qing dynasty *Kangxi* dictionary and then

Figure 41. Lin Tianmiao, *Badges,* 2009. Embroidery hoops, thread; dimensions variable. Courtesy of the artist.

gradually moved forward through time. She ended with the contemporary era, where she found the greatest variety of terms on the internet. She notes the short-lived nature of these particular terms, popping up outside of government approval and thus quickly disappearing without anyone—except Lin— to record them for posterity. By the end of six years, she had collected over two thousand phrases and characters.

For the 2009 exhibition of *Badges,* she employed people to embroider each phrase and character into an embroidery hoop. With hundreds of hoops hanging from the ceiling, viewers move through a field of dangling words. As a metaphor for her own research experience, this immersive environment grants viewers the opportunity to see their surroundings littered with floating characters. That the words are contextualized by each other emphasizes their variety as well as sheer quantity.

The explicit use of embroidery hoops emphasizes the primary medium of thread here as a form of making the text legible. In a departure from her earlier work, Lin uses the hoops as an equally straightforward allusion to female crafts. Describing this as an "aesthetics of gender," curator Huang Zhuan points to how her choice of badges is subversive:

> In our lives, uniforms and badges are still symbols and markers of such social traits of male-dominated society as authority and violence. This work uses a "misapplication" of the badge's form of expressing author-

ity, using traditional methods such as needlework to create all kinds of badges of "womynism." With their exaggerated sizes and their "exquisite" crafting, they not only allude to the breadth and depth of this authority, but they also make a reserved mockery of it.[27]

Huang, a longtime observer of Lin's work, adds: "Such a display of political implications is rarely seen in Lin's art." Indeed, more than just the "political implications," it is the employment of such overt references, commentary, and direct textual communication that separates *Badges* from her other work.

With the power of thread pivoting solely on the capacity to be read as words, her tendency to highlight artistic mediation takes a noticeable backseat here to art as a site for legible display. That is, rather than using her art as a site of becoming, Lin conceives of it as a place to present her research. This aligns with how she viewed the project as a whole. She notes that *Badges* was not an attempt to respond to the state of women in China today. Instead, she describes it as an observation of a phenomenon.[28] This touches on Lin's comparatively impersonal approach to the subject: rather than starting from herself or her experiences, she instead began with society at large. This aspect of the work is thrown into vast relief when compared with her earlier ventures. Beyond simply those that used images of her face and body, her explorations into the material and visual properties of her mediums arose through her concerns about materializing herself and her voice. In *Badges*, meanwhile, her approach was cool and rational. Occupying the role of observer and researcher, she had the sense that "you're no longer making a work, you're just collecting words."[29] *Badges*, ultimately, was a place to "reproduce" her findings.[30]

Lin found more satisfaction with *Protruding Patterns*, the follow-up to *Badges*. For this project, she purchased hundreds of antique carpets, and employed people to sew them together and further embroider them with a selection of terms. Like *Badges*, this work also had an immersive component that communicated the expansive scope of the words. Unlike the hanging embroideries, however, these words sprouted upward and invited a greater sense of tactile encounter and discovery from audience members. Unlike the streaming threads of *Badges* that would drift away from viewers who approached them, the thick protruding pile of the rug invited people to enter and enjoy the space. It was the sense of play that Lin found satisfying about *Protruding Patterns*. People would walk gingerly over, lounge across, and feel encouraged to enjoy the changing thickness of textures beneath their feet. With words springing up in plush pile, people could choose to stop and read the different characters,

admire the decorative patterns of the antique rugs, or simply lie down on top of it all.

Lin's discussion of what she finds satisfying about *Protruding Patterns* seems to divorce the content from the form. She has an intense appreciation for the carpets and the enjoyment that people have when encountering the work. As for the message of the words themselves, it seems that the entirety of the project was directed at her own liberation. As much as she found it burdensome, the research she conducted *did* help her resolve some of the questions asked of her. She gathered information and observations to speak to the question of "how our society perceives women and how that perception has evolved."[31] And when asked how the words she collected showcase the changing perceptions of women over time, she has an answer now based on the years of research she conducted. But the greatest benefit was to her own sense of freedom as an artist:

> Since finishing this work three or four years ago, I haven't made any new work on this topic because I believe I've done a thorough job presenting a woman's perspective on broader cultural shifts in women's identities. I feel very much liberated now that this label has been removed, so I could finally participate in the making of culture as much as men.[32]

If ever there was a way of showing how women are bound and confined, it is exemplified by the trajectory of Lin Tianmiao's entire oeuvre. Ultimately, what she sought to be freed from were the expectations placed upon her. She defines freedom as being able to produce what she wants without interference. And, in her case, it was the interference of gendered interpretations that she felt ultimately prevented her from achieving freedom in her own art.

I have heard people ask: Why are people still saying "Chinese artists" and "women artists"? Why not just call them "artists"? They believe that using these categories continues to make these same issues surface. While the questions are well intended, the state of things reveals that simply asking people to treat everyone as an individual free of these boundaries does not, in fact, confront assumptions of advancement and belatedness. Why terms like "derivative" continue to sneak into reviews of solo artists, or how readings of art remain pegged to dissident critique, shows we are far from transcending the hardened categories of identity and moving past the harmful ways in which they can continue to stifle artists and prevent their art from being treated as art.

Conclusion
Art in the World

The Future History of Contemporary Chinese Art urges readers to see artists' works as studies of and contentions for art. Using this approach, the five micro-histories presented here uncover new readings of well-worn works that help reorient how we see these artists and the narratives in which they are embedded. Whether establishing historical lineages or enacting discursive interventions, artists activated their works to mobilize new understandings of art. At their core, these works all testify to artists' claims over the power to define art for themselves. Starting from artists' own conceptions of art allows for a vast range of possibilities in scope and meanings to surface that have hitherto remained obscured. This approach to art history is as much a necessity for reassessing the past as it is for opening up the future.

One of the reasons why these meanings have been overlooked is undoubtedly found in the limited interpretative contexts that have been imposed on contemporary art from China. Long-running dissident narratives have not only served to reaffirm a Western sense of superiority, but their dominance also suggests that there is little else of interest for viewers to learn from this art. In 1994, Hou Hanru wrote of Western observers, "Instead of discussing the artists' creative efforts and the cultural-intellectual values of the work, [they] concentrate their energies and interest on revealing how 'unofficial' artists suffer from political pressure in the country, as if the significance of both artists and work can only be found in ideological struggles."[1] Even today, the evaluation of Chinese art according to blanket sociopolitical and cultural assumptions leads to such comments by artists as, "It's not important that I'm from China" and "If art is good, it's good."[2] These remarks are directed at the unevenness in treatment between contemporary art from China versus that produced in other parts of the world. In addition to the problem of treating the address of politics in art as an all-or-nothing proposition, the circumscription of artworks to these narrow parameters means failing to ever appreciate, or

even see, their significance beyond this. Chinese artists are keenly aware that their earmarked status effectively excludes them from being regarded as creators and contributors to understandings of art. Instead, their value—like that of their artworks—always remains contingent.

Critiques of these Western-centric frameworks often end with the resolution that more kinds of contemporary art from China need to be seen. The logic here is that continuing to exhibit the same artists keeps these narratives of ideological antagonism alive. Scholars have rightfully criticized the disproportionate attention that Political Pop and Cynical Realism have received globally. But, as has been shown in this book, even these works have been subjected to reductive readings. The recycling of these readings are symptomatic of much deeper problems in interpretation. More than just the need to expand selections, it is necessary to reconsider the premises for previously constructed narratives. As Carol Lu recently wrote about those artists who gained international fame in the 1990s, "After so many years, *their work remains undescribed* in terms of its art-historical relevance. They circulate without being critically examined, considered, or analyzed. A widespread anxiety remains among these artists, born in the 1950s and '60s, about whether the attention placed on them will shift, with the passage of time, to their body of work."[3] Like Hou Hanru's grievance quoted earlier here, Lu points out that one of the gravest by-products of a limiting framework for understanding Chinese art remains the lack of attention—let alone rigorous analysis—paid to these works' artistic contributions. This is not just a problem for art at the time of exhibition, but also how this has continued in writings of art history.

This lack of engagement with the art points to a broader tendency in analyses of non-Western art to "privilege ethnographic mediations of cultural difference" over and against close readings of the art itself.[4] To fully delve into analyses of art doesn't mean bypassing cultural contexts. But it does mean reckoning with how the application of these contexts affects—or can even come at the expense of—a close looking at art. In an effort to bring together close readings of artworks with an informed understanding of the contexts in which they were made—without sidelining one or the other—this book begins by asking questions about how artists even thought about art. This thus sees their experiences of the world through their capacity as artists and, in turn, efforts to engage, intervene, and assert through their conceptions of and convictions for art. Attending to the works in this way does not mean retreating to an autonomous sphere of art for art's sake. On the contrary, giving credence to artists as producers in their own right opens up new possibilities for thinking about art's engagements with the world.

David Clarke has discussed the obstacles that stand in the way of people recognizing and pursuing this approach. When he calls for art historians to fully engage and unearth art's "primary discursive relevance," he argues for "recover[ing] the meanings of Asian art in the local contexts for which it was made."[5] Within this, Clarke goes to great lengths to point out to readers that the local is a context to attend to when understanding art, but should not be seen as the sole scope of its relevance. He explains that "the local being proposed here does not imagine a space of residual culture as yet untouched by globalizations but sees the local as a relatively distinct context within which the forces of globalization are mediated."[6] As Clarke makes clear, there is a danger in even bringing up a term like "local" as this can lead people to immediately confine its significance and meaning, seen only as an illustration of parochialism. He roots this tendency in a latent belief about the fundamental value of contemporary art from Asia: "It is hard to point to European or American artists who feel they have anything to learn from contemporary Asian art."[7] The very notion that Chinese artists can contribute to, for example, new understandings of the world or new ways of conceiving of art, still needs to be given its due in art histories.

These limited frameworks for analyzing artworks are symptomatic of larger issues surrounding the question of how to foster inclusivity in art history and the global art world. While gatekeeping mechanisms of inclusion and exclusion—in exhibitions and art histories alike—has loosened, simply bringing in artists from different parts of the world is not enough.[8] Geographical expansion alone cannot remedy the deeper biases that prevail in existing methodologies. Jonathan Hay points out how the two-way process of globalization between "the West and the Rest" actually "masks a fundamental asymmetry, in which the Rest attains subjecthood only to the extent that it becomes part of the West."[9] It is important to recognize this asymmetry as it has played out in the treatment of art, for example, adhering to expected essentialized meanings or simply casting "the Rest" as derivative of Western art. While tracking how these historical conditions have shaped art, it is vital not to reproduce this asymmetry through contemporary models for interpretation.

When, for example, the history of contemporary Chinese art is posited as a matter of "merging into the international monoculture," this allows for the argument that "any viewer familiar with today's visual lingua franca, derived primarily from Western avant-gardism of the turn of the last century, will find contemporary Chinese art accessible. Even its strains of inherent Chineseness are reasonably interpretable when one takes into account certain key effects of history and sensibility."[10] While this kind of reasoning can be seen as a way

of making contemporary Chinese art legible to viewers who may not be familiar with Chinese language or history, such a statement reinforces a historical schema that only allows Chinese artists to act as global beneficiaries. This erases artists' efforts to arbitrate over their own art and art history, both in the past and present, let alone for the future. As shown in this book, by the 1990s, artists and critics were confronting the dominance of Western curatorial authority and engaging in intense debates over the dangers of pursuing Western trends. Rather than simply adopting and adapting mediums and styles of the "international monoculture," artists instead launched significant experiments, ranging from a focus on the logic of pictorial representation to arguments over medium and the value of collectivity. Like the problem of only ever using political dissidence for our context of understanding, when using "Western avant-gardism" as the sole point of artistic reference, this denies uncovering the richness and diversity in artists' invocations of "contemporary Chinese art."[11] For contemporary interpreters, furthermore, this kind of schema flattens the significance of turning to the particularities in language and history as central to both artists' efforts and art historians' evidence in bringing these assertions to light.

Understanding these experiments requires taking seriously artists' agency as producers and, in turn, their claims to define "contemporary Chinese art" for themselves. This challenges a homogenized or reified usage of the term while also disrupting the premise that anything that looks "Chinese" can be easily understood as a localized variation of an established lingua franca.[12] Rather than a unified "Chineseness," this category helped artists to think through how to make their own voice visible. And, furthermore, it opened up entirely new ideas in their art and contexts for framing it. Instead of avoiding this category out of fear of pushing forth a narrative of exceptionalism, it's important to actually unpack the differing ways in which artists thought through its meanings in order to assert their own terms for worldly belonging. Only then can we unearth the trove of strategies that artists enacted to claim their own lineages and concepts and, furthermore, see how they, in fact, resisted both the cultural essentialism imposed by Western curators and institutionalized ideas of heritage from the state. To dismiss this category before fully understanding how it informed artists' thinking about art does not erase the past problems with its imposition, but it does render invisible the agency and strategies of artists who have offered productive meditations and mediations on its value. Furthermore, when seen as artists' efforts to conceive of their place in the world and put forth new ways of thinking about art, these motivations and

theorizations can actually open up resonances with art and art histories from other parts of the world.

The need for a reassessment of interpretative frameworks is more important than ever given how the artists in this book are being used as a point of contrast against which to explain younger generations of artists. This has repercussions for both narratives of contemporary art from China and questions of how to write globally inclusive art histories. Undoubtedly, artists today are no longer saddled by the same baggage as those in the 1990s. As such, there is a tendency to box up the past as a way of moving beyond it. But this boxing up is often done in order to draw a clear historical division between political art and nonpolitical art, such that popular Western media outlets can now publish articles titled "Why Young Chinese Artists Are Avoiding Political Art" and "Beyond Ai Weiwei: How China's Artists Handle Politics (or Avoid Them)."[13] This all-or-nothing treatment of politics perpetuates reductive understandings of art from the past while also foreclosing the possibilities of interpretation for art of the present and future.

This idea may seem surprising given that one of the reasons for making this distinction seems to be in the service of opening up ways of understanding art now. That is, in describing young artists as engaging in whatever they would like to engage in, the implication seems to be that any attempt to use a politicized lens to understand their work would burden them with an interpretative mode more suitable for a bygone era. The growth of this seemingly more enlightened view, however, can unfortunately continue to operate within a field of simplified contrasts. Truly broadening ideas of what art can be would include accepting that even so-called political art deserves to be seen as art. Without acknowledging this blind spot, rich commentaries and questions about art—enacted through art—can continue to go unearthed. Beyond this, however, the limited parameters of what constitutes "art" versus "political art" can lead to equally simplified distinctions in associated meanings and motivations.

Without a reassessment of the narrowness of these designations or the repercussions of their employment, authors today are in danger of reproducing the same limitations—and, indeed, global power relations—that they presumably seek to break out of. Philip Tinari, for example, points out that newer generations of artists are rendering questions of "national history" and "globalization" obsolete. By way of example, he brings up Liu Wei (born 1972), whose paintings of abstracted forms and colors suggest a "formal language that raises the sort of first-principle aesthetic questions that have historically been the province of artists from the center, not the 'already-read' periphery."[14] As this

description illuminates, because Liu's precise geometric shapes at once invite questions of form and deny knee-jerk legibility of culturally specific content, his artwork can finally be granted access to a line of inquiry that has historically been the privileged preserve of nonrepresentational art and Western art. Thus, even if artists are no longer concerned with questions of global hierarchies or identities, the selective application of interpretative frameworks can remain trapped within entrenched biases. It's necessary, then, for art historians to recognize how their own selective approaches to reading work can remain complicit with inherited models of Western-centric standards, evaluations, and historical narrations. As we guard against this moving forward, we are also reminded that there are rich histories of how artists have experimented in thinking about and conceptualizing form that have yet to be recovered.

Just as certain kinds of art have been granted primacy as such, when recent contemporary art from China is described as fitting "more seamlessly into a global conversation," this is less about the kinds of art produced and more about the increasing porousness of what is seen as "globally conversant."[15] But, as noted earlier in this conclusion, when evaluations of art are still pegged to how closely they approximate familiar styles and schemata, it is clear that the term "global" continues to cloak the reproduction of Western-centric values of art. Similarly, it's necessary to recognize that discussions of what is "global" cannot become a stand-in for the whole conversation on how art relates to the world. To do so would continue to undermine artists' self-determination and self-definition. Rather than tying their efforts to external designations, it is important to unearth artists' efforts to "remake the world" as already present in their works.[16] Thus, instead of continuing to place artists and their work in a passive and reactive position, this book has focused on how artists as actors asserted themselves by embedding their art with the capacity to form their own terms of wordly engagement.

In 1989, Craig Owens commented in the "Global" issue of *Art in America* that "global culture" would be the West learning to speak to, rather than for, others.[17] Beyond the interpretation of art, Owens's comment points to the continued dominance of English as the lingua franca of contemporary art and art history. Ladislav Kesner argues that—even more so than the description or interpretation of art—"it is the use and understanding of English . . . as opposed to the respective language of local art histories" that conditions readings of art.[18] It is with the understanding that "local art histories" are composed of their own claims to artistic languages—and forms of worldly engagement— that I seek to uncover the very understandings of art on which they are based. Rather than the assumption of a fixed or universal definition, my account ac-

cepts artists' choices as particular, in progress, iterative, thoughtful, and assertive. In *The Future History of Contemporary Chinese Art,* I offer an approach and a reminder of the vital claims that artists make about art through their artwork. These microhistories together show how a meta-art framework offers greater possibilities in recovering and thinking about artistic agency. Given current efforts to track resonances, connections, affiliations, and affinities between artworks across the world, it is important to first go back to track how artists positioned their art *as art*. As an art historian writing in the lingua franca, I see it as my responsibility to both past and future histories to start from these definitions—indeed, self-definitions—of art.

Notes

INTRODUCTION

1. Zhang Xiaogang to Mao Xuihui, July 8, 1992. Fineberg and Xu, *Zhang Xiaogang,* 283.
2. Zhang Xiaogang to Li Xianting and Liao Wen, August 9, 1992. Ibid., 286.
3. Ibid.
4. Ibid., 90.
5. Zhang Xiaogang to Wang Lin and Ye Yongqing, August 24, 1992. Ibid., 288.
6. Yee, "The Three World Theory," 249.
7. In 1980, this phrase was adopted by China's National Commission to mobilize a new goal for international sports competition. Xu Guoqi writes that it "became the rallying cry for China's sports initiatives—and symbolized more broadly China's newfound self-confidence as an emerging member of the world economy." Xu, *Olympic Dreams,* 196.
8. Zhang and Meng, "Xinshidai de qishi," 47. Translated by Kela Shang in Wu, *Contemporary Chinese Art: Primary Documents,* 36. For more on the '85 Art New Wave, see Fei, *'85 Xinchao dang'an.*
9. Peng, "Miandui xinchao de zhongjie," 1. Translated by Kristen Loring in Wu, *Contemporary Chinese Art: Primary Documents,* 127.
10. Wang, "Shijiexing, shangpinhua, qiantu," 18–19.
11. Yan, "Managed Globalization," 34.
12. Both Hans Belting and Peter Weibel use a lens of cartography to map out exhibitions in their history of the rise of global contemporary art. Belting, Buddensieg, and Weibel, *The Global Contemporary.* Caroline Jones recovers the work that is done on audiences through art in biennials and other global exhibitions. Jones, *The Global Work of Art.*
13. Cheah, *What Is a World?,* 28.
14. Ibid., 5.
15. This builds on scholars who have recently argued for seeing artists' works as ways of "worlding" and "reworlding" by emphasizing the agency of art. For example, Sonal Khullar—drawing on Pheng Cheah, Gayatri Spivak, and Martin Heidegger—emphasizes the world as produced "by and through imagination" wherein "art is constituted by the world, and art constitutes the world." Khullar, *Worldly Affiliations,* 23. Sasha Su-Ling Welland, too, cites these same sources to show how artists draw on a web of images to "remake the world." She describes the stakes of this power "to represent their relationship to the earth" as a challenge to colonial worldings. Welland, *Experimental Beijing,* 29. See also Antoinette and Turner, *Contemporary Asian Art and Exhibitions*; Smith, "Currents of Worldmaking in Contemporary Art."

16. For example, the category of "world images" in Wu, *Contemporary Chinese Art: A History,* 160–66. A representative example is maps in Hong Hao's *Selected Scriptures* series, which are also used as examples in Mitchell, "World Pictures," 263–64.

17. Gao, "85 Meishu yundong," 107–8. Translated by Kristen Loring in Wu, *Contemporary Chinese Art: Primary Documents,* 52.

18. See Zheng, "Waves Lashed the Bund from the West." John Clark also argues that for some artists who went to Paris, the city offered lateral international connections, not just vertical ones between China and France. Clark, "The Worlding of the Asian Modern," 67–88.

19. Gao, "85 Meishu yundong," 108. Translated by Kristen Loring in Wu, *Contemporary Chinese Art: Primary Documents,* 53.

20. Ibid., 52. See also Gao, *Total Modernity and the Avant-Garde,* 66.

21. Zhang, "Yu xifang zuozhan?," 374. The east wind versus west wind was a common trope evoked by Mao Zedong, who articulated it most clearly in 1957: "I believe it is characteristic of the situation today that the East wind is prevailing over the West wind. That is to say, the forces of socialism have become overwhelmingly superior to the forces of imperialism." Mao, "Speeches at the 1957 'Moscow Conference.'"

22. Mittler, "Popular Propaganda?," 469.

23. Building on this, art historians have also started to question why the periodization of contemporary art in China is always pegged to the end of the Cultural Revolution. Jiang Jiehong, for example, has raised the question of whether "contemporary art" in China is only conceivable after encounters with Western art during the reform era. Jiang, "Introduction," 123.

24. Zheng, "Looking Back at Thirty Years," 39.

25. Yu, "China and the Third World," 1038–39.

26. See Lovell, "The Cultural Revolution."

27. Hou, "Théâtre du monde," 71.

28. See Clark, "The Worlding of the Asian Modern."

29. Ginzburg, "How Does One Life Help to Understand the World History?," video, 14:32, June 2015, http://serious-science.org/microhistory-2893; see also Ginzburg, "Microhistory: Two or Three Things."

30. Ginzburg, "Microhistory and World History," 462.

31. For examples of historical accounts based on case studies of individual artists, see Smith, *Nine Lives*; Köppel-Yang, *Semiotic Warfare.*

32. Ginzburg, "Microhistory and World History," 462.

33. This draws on W. J. T. Mitchell's concept of "metapictures." Mitchell, *Picture Theory.*

34. Yi, "Xiandai zhuyi de kunjing yu women de xuanze," 13. Translated by Kela Shang in Wu Hung, *Contemporary Chinese Art: Primary Documents,* 129.

35. For example, in her curatorial essay for the exhibition *Art and China after 1989: Theater of the World,* Alexandra Munroe traces lateral resonances of political changes in 1989 as an expanded context in which to situate contemporary art from China. The choice of objects for the exhibition was also guided, in part, by an emphasis on "conceptualism," which Munroe describes as an "attitude toward art's expanded social function that linked agitators in places as disparate as Jakarta, Johannesburg, and Abu Dhabi from the mid-1970s through the 1990s." Munroe, "A Test Site," 30. Munroe speaks about this choice further in an interview: "We are also looking at this from the vantage of the Guggenheim

Museum—an international museum—and not the Asia Society. And we are landing on a strain of this material that is conceptual, and placing it within the context of global conceptualism." Goldstein, "The Guggenheim's Alexandra Munroe."

36. Tomii, *Radicalism in the Wilderness,* 16.

37. Gladston, "Somewhere (and Nowhere) between Modernity and Tradition." See also Gladston, *Contemporary Chinese Art: A Critical History.*

38. Rojas, *Homesickness,* 285.

39. Solomon, "Their Irony, Humor (and Art) Can Save China."

40. Wang, "Xifang shuangchong biaozhun yu dangdai yishu piping de qitu," 2.

41. Erickson, "The Rise of a Feminist Spirit in Contemporary Chinese Art," 67.

42. *Dai Hanzhi,* exhibition pamphlet, n.p.

43. Stevens, "Is Ai Weiwei China's Most Dangerous Man?" For more on the tendency to subscribe to a "single story," see Chimamanda Ngozi Adichie, "The Danger of a Single Story," filmed 2009, TED video, https://www.ted.com/talks/chimamanda_ngozi_adichie _the_danger_of_a_single_story

44. Stevens, "Is Ai Weiwei China's Most Dangerous Man?" Bo Zheng points out the difference between how Ai Weiwei's projects are perceived in the United States and the United Kingdom versus in China. Zheng, "From *Gongren* to *Gongmin.*"

45. Cai, *What about the Art?,* 29.

46. Ibid., 23.

1. SPACES OF SELF-RECOGNITION

1. Chumley, *Creativity Class,* 112.

2. Zheng, "Looking Back at Thirty Years," 24.

3. Mao, "Talks at the Yenan [Yan'an] Forum on Literature and Art."

4. See Visser, *Cities Surround the Countryside.* On the broader institutional changes in the art world, see Kraus, *The Party and the Arty.*

5. Song Dong, interview with the author, Shenzhen, China, July 16, 2017.

6. Yu Hong, interview with the author, Beijing, China, July 30, 2017.

7. Ibid.

8. Ibid.

9. See Shao, "The International Identity of Chinese Art."

10. Zhang, "Yu xifang zuozhan?," 375.

11. Zhou, "Writing an English-Version History of Chinese Contemporary Art from Chinese Contemporary Perspective," n.p.

12. Martin speaks more specifically about the intentions and processes behind *Magiciens de la terre* in Buchloh, "The Whole Earth Show."

13. See Wang, "China's Emerging Art Market."

14. Yi, "Xiandai zhuyi de kunjing yu women de xuanze." 13. Translated by Kela Shang in Wu Hung, *Contemporary Chinese Art: Primary Documents,* 130.

15. Zhang, "Meishu zenyang zouxiang shijie." Jane Debevoise discusses the sale of art to tourists in the 1980s in Debevoise, *Between State and Market,* 113–23.

16. Mosquero, "Some Problems in Transcultural Curating."

17. Shen, "Yazhou de shili he fangwei." This was also the reasoning behind the Shanghai Biennale. The first two iterations featured only artists from China, and the event was

intended to become increasingly open over time. The second iteration, curated by Wang Lin in 1998, for example, included installation art. The third, in 2000, invited foreign artists, a Chinese expatriate curator, Hou Hanru, and was considered a major shift in the state's support of experimental art. Wang Lin, interview with the author, Beijing, China, November 8, 2007.

18. Shen, "Yazhou de shili he fangwei," 34.

19. Ibid.

20. Lu, "Zouchu 'xifang zhongxin' zhuyi de yinying," 32.

21. Yang, "Zouxiang bentu," 27–28.

22. "Cong Weinisi dao Shenbaoluo," 63.

23. Li, "Yishu de 'minzu dangdaizhuyi,'" 24.

24. Oliva, *XLV International Art Exhibition,* 10.

25. Ibid., 9.

26. The artists were Ding Yi, Fang Lijun, Feng Mengbo, Geng Jianyi, Li Shan, Liu Wei, Song Haidong, Sun Liang, Wang Guangyi, Wang Ziwei, Xu Bing, Yu Hong, Yu Youhan, and Zhang Peili. In the Aperto section, Kong Chang'an contributed as a curator and selected artist Wang Youshen to join. Francesca Dal Lago relayed some of the difficulties on-site during the panel "Exhibition as Site—Extended Case Study (China 1993)." See "Sites of Construction: Exhibitions and the Making of Recent Art History in Asia" symposium, Asia Art Archive, Hong Kong, October 22, 2013, video recording. https://www.aaa.org.hk/en /programmes

27. "Shenhua," 20. Independent curator Hou Hanru, active in China in the 1980s and in Paris in the 1990s, also recalled this situation: "For the Biennale of 1993, the first Chinese avant-garde was exhibited in the pavilion where you now have the press service. It was an insulting presence of Chinese contemporary art, which stole the name avant-garde and showed the most cynical works. It was the first marketing of so-called Chinese Political Pulp." Thea, "The Extreme Situation Is Beautiful," 32.

28. "Cong Weinisi dao Shenbaoluo." According to Fei Dawei, the space at first was divided into larger and smaller portions, with the former initially designated for the Chinese artists and the latter for the Japanese invitees. Upon arrival, however, the Chinese artists received the smaller space instead. Fei Dawei, interview with John Clark, July 4, 2001, recording, Asia Art Archive, Hong Kong.

29. "Shenhua," 15.

30. Shao Yiyang makes this point about the 1999 Venice Biennale as well. Shao, "The International Identity of Chinese Art." China was not granted its own national pavilion until 2003. Due to SARS, the installation of the pavilion at Venice was canceled and relocated to the Guangdong Museum of Art. See Wang, "Officializing the Unofficial." In 2005, the commissioner, Fan Di'an, a longtime supporter of contemporary Chinese art, wrote of this momentous occasion: "The premier pavilion will be a vehicle through which to explore or re-locate the influence of China's political, economic and cultural establishment on the international contemporary art community." "China Pavilion at Fifty-first Biennale de Venezia: Virgin Garden, Emersion," March 25, 2005, http://universes-in-universe.de/car /venezia/bien51/eng/chn/text-1.htm

31. Fei Dawei, interview with John Clark, 2001.

32. See Crossley, "Thinking about Ethnicity in Early Modern China," 20n40. Thomas S.

Mullaney provides a historical account of the formation of *minzu* as a census category in Mullaney, *Coming to Terms with the Nation*.

33. Lipman, "How Many *Minzu* in a Nation?"

34. "Zhongguo youhua de fangxiang," 26.

35. Lu, "Zouchu 'xifang zhongxin' zhuyi de yinying," 32.

36. Yi, "Xiandai zhuyi de kunjing yu women de xuanze," 13. Translated by Kela Shang in Wu Hung, *Contemporary Chinese Art: Primary Documents*, 130.

37. Ibid.

38. Li, "Yishu de 'minzu dangdaizhuyi,'" 24.

39. Ibid.

40. Ibid.

41. Yin, "Xin shengdai yu jin jüli," 16. Translated by Lee Ambrozy in Wu Hung, *Contemporary Chinese Art: Primary Documents*, 155.

42. Yin, "Xianzhuang guanhuai," 62. Yin makes similar comments in his remarks at the April 1991 Xishan symposium as reported in Shui, "'Xishan huiyi'—huiyi yu sikao."

43. "Zhongguo youhua de fangxiang," 27.

44. Ibid.

45. Fan, "Liu Xiaodong huo zhenshi de chenshi," 64.

46. Ibid., 63.

47. Ibid.

48. Huang, "Rural Class Struggle in the Chinese Revolution," 135.

49. Wang, "Rediscovering Song Painting for the Nation," 237.

50. Ibid. Wang also points out the pervasive use of terms like *minzu jingshen* to argue for the connection between art, realism, and nation building, providing another connection between the early and late decades of the twentieth century.

51. See Gu, *Chinese Ways of Seeing and Open-Air Painting*, 16–40.

52. For more on Xu Beihong's turn toward socialist realism, see Du, "A Turning Point for *Guohua*?"

53. Hsia, "Art Education in New China," 8.

54. For more on the complicated history of socialist realism in China, see Lee, "Recoding Capital."

55. Debevoise, *Between State and Market*, 47–59.

56. Zhou, "Jinqi tansuoxing meishu zhuizong," 3.

57. Cheng, "Xuyao fenxi," 9.

58. Gu, "Renmin shi wenyi gongzuozhe de muqin," 8. These points are repeated again a few issues later in Li, "Shehuizhuyi meishu fazhan wenti zuotanhui," 9. While the most egregious examples were works that could not even be accessed by "the people," any art that strayed from representing "the people" was condemned as misguided and in need of correction. In the most ideologically passionate terms, art needed to continue the revolutionary mission of class struggle. This was articulated by Li Qi: "It should represent the radiant course of people's revolutionary struggle . . . rouse people, lead people to advance, arouse people to socialism, Communism, and the fervent zeal of struggle (*fendou*)." Li, "Zhuxuanlü suixiang," 11. This revolution-laden language also permeated concerns over "heading toward the world." In addressing this, participant Yuan Lin lays blame at the feet of artists who possess "a kind of blind world-centrism consciousness, which mistakes the West's

avant-garde art as the standard for 'modern.' . . . Facing the world to draw lessons from and interact with is absolutely necessary, but our standpoint and target should still be China and our national conditions." Quoted in Li, "Shehuizhuyi meishu fazhan wenti zuotanhui," 10. While these kinds of remarks overlap with those expressed by art critics discussed thus far, the comments made by mouthpieces of the Party-State were rooted in the belief that Western capitalism marked a fundamentally mistaken route forward. As such, people who upheld the Party platform positioned *minzu* as a national polity with political needs rather than a timeless cultural entity. Even if art critics, too, were wary of being too influenced by Western art and art history, they still upheld pluralism in art.

59. Lang Shaojun was made into one such example. After he published an article in defense of "elite art" in 1989, he was subjected to multiple rounds of published attacks. The original offending article appears as Lang, "Chongjian Zhongguo de jingying yishu."

60. Shui, "'Xishan huiyi'—huiyi yu sikao," n.p.

61. Yi, "Criticism on Chinese Experimental Art in the 1990s," 99.

62. Lü, "Qianwei yishu 'xiake.'"

63. Shao, "Zhongguo dangdai youhua san tiyi," 6.

64. Wang, "Realism Is a Kind of Ideology in China," 76.

65. Alexandra Munroe, quoted in Guggenheim Museum, "Guggenheim Presents Art and China after 1989: Theater of the World," news release, October 5, 2017.

66. Yu Hong, interview with the author, Beijing, China, July 30, 2017.

67. Ibid.

2. ZHANG XIAOGANG

1. For example, Christoph Heinrich describes Zhang's works within the context of the destruction of family photographs, and thus the loss of memories during the Cultural Revolution, Fibicher and Frehner, *Mahjong*, 154–55. Or, when describing Zhang's figures according to their "inconsequential identity," the Saatchi Gallery uses terms like "hollow and clone-like"; https://www.saatchigallery.com. Even in cases where the artist's work is not seen as "cynical," they are still described, for example, by Arne Glimcher in a catalog preface, as "essentially Chinese paintings presented in western style." PaceWildenstein, *Revision*, 1.

2. Shu Kewen, "Ba yishu zuocheng pinpai," 238.

3. See Li Xianting, "Zhang Xiaogang's Epitome Portraits," 35–37. Karen Smith offers a detailed account of the artist's life and in particular his psychological concerns in Smith, *Nine Lives*, 263–99. Lü Peng describes the *Bloodline* series in terms of memory, the artist's psyche, and aesthetic principles of monotony, repetition, and uniformity. Lü, *Bloodlines*, 318. See also Fineberg and Xu, *Zhang Xiaogang*.

4. Zhang Xiaogang, interview with the author, Beijing, China, December 2007.

5. Tang Xin, *Huajiadi*, 49.

6. Wu, *Contemporary Chinese Art: A History*, 55.

7. Zhang Xiaogang to Zhou Chunya, May 24, 1984. Fineberg and Xu, *Zhang Xiaogang*, 246.

8. Zhang Xiaogang, interview with the author, Beijing, China, July 25, 2017.

9. Mao Xuhui to Zhang Xiaogang, November 24, 1990. Fineberg and Xu, *Zhang Xiaogang*, 275.

10. This occurred throughout the '85 Art New Wave and was not isolated to Zhang Xiaogang and his peers. Wu Hung writes about Chinese artists reading Western art history in the 1980s: "Although separated by time and historical experience, Chinese artists of the 1980s saw themselves as direct followers of great modern philosophers and artists in the West." Wu, "A Case of Being 'Contemporary,'" 294.

11. Tang, *Huajiadi*, 51.

12. Wang Lin, *Yishujia Wenzhai*, 333.

13. Tang, *Huajiadi*, 52.

14. Zhang Xiaogang to Lü Peng, October 18, 1990. Fineberg and Xu, *Zhang Xiaogang*, 272.

15. "Shenhua: Xifang yu Zhongguo," 16. The application of different tactics for integration to justify the use of Western art practices in China also took place through art history; see Cacchione, *"To Enter Art History."*

16. Huang Zhuan, "Report from the Artist's Studio," 10. Translated by Yinxing Liu in Wu, *Contemporary Chinese Art: Primary Documents*, 191.

17. Zhang Xiaogang, "Wo de zhiyi—Magelite." Zhang cites a precedent for this realization in 1982 while visiting an exhibition of Armand Hammer's masterpieces on display at the National Art Gallery in Beijing. But his later interviews crystallize the turning point to be a decade later, after he had more fully absorbed the history of Western art and experienced the shock while in Europe. This is cited in a 2011 interview with the artist in Lu, Liu, and Su, *Individual Experience*, 99.

18. Ibid.

19. Ibid.

20. Zhang Xiaogang, interview with the author, Beijing, China, July 25, 2017.

21. Zhang Xiaogang, interview with the author, Beijing, China, December 2007.

22. Ibid.

23. In particular, Zhang points out that attendance by the king of Belgium and queen of Holland evidence the "aristocratic" nature of Documenta. His impression that the exhibition is "nothing more than another opportunity to spend money" also arrives from the "luxurious decoration" and large-scale, costly installations that take up the grounds. Zhang Xiaogang to Li Xianting and Liao Wen, August 9, 1992. Fineberg and Xu, *Zhang Xiaogang*, 286–87.

24. Zhang Xiaogang to Wang Lin and Ye Yongqing, August 24, 1992. Fineberg and Xu, *Zhang Xiaogang*, 288.

25. Ibid.

26. Wolbert, "World Art, Framed Walls," 67.

27. Zhang Xiaogang to Wang Lin and Ye Yongqing, August 24, 1992. Fineberg and Xu, *Zhang Xiaogang*, 288.

28. Ibid.

29. Zhang Xiaogang to Li Xianting and Liao Wen, August 9, 1992. Fineberg and Xu, *Zhang Xiaogang*, 286.

30. Zhang Xiaogang to Wang Lin and Ye Yongqing, August 24, 1992. Fineberg and Xu, *Zhang Xiaogang*, 288.

31. Ibid.

32. Tang Xin, *Huajiadi*, 82.

33. He also briefly dabbled in another series focused on musical scores overlaid with schematic images of people in erotic positions.

34. Zhang Xiaogang, interview with Tang Xin, *Huajiadi,* 82.

35. Zhang Xiaogang, interview with the author, Beijing, China, July 25, 2017.

36. Zhang Xiaogang, interview with Tang Xin, *Huajiadi,* 82.

37. Ibid., 100.

38. Huang, "Locating Family Portraits," 680.

39. Dal Lago, "How 'Modern' Was the Modern Woman?," 55.

40. Laing, *Selling Happiness,* 116.

41. Cochran, "Marketing Medicine and Advertising Dreams in China," 73.

42. Flath, "'It's a Wonderful Life,'"138.

43. For more on the contested meanings of the term *minjian* and other ways of conceiving of "popular," see Wang, "Guest Editor's Introduction." For more on the curriculum of the art academy, see Andrews, *Painters and Politics*; Chumley, *Creativity Class.*

44. Zhang Xiaogang, interview with the author, Beijing, China, July 25, 2017.

45. Ibid.

46. Ibid. Zhang also discusses this subtle layering process in Huang Zhuan, "Report from the Artist's Studio," 10. Translated by Yinxing Liu in Wu, *Contemporary Chinese Art: Primary Documents,* 191.

47. Zhang Xiaogang, interview with the author, Beijing, China, July 25, 2017.

48. Ibid.

49. Zhang Xiaogang, interview with Tang Xin, *Huajiadi,* 84.

50. Ibid*.,* 85.

51. Zhang Xiaogang, interview with the author, Beijing, China, July 25, 2017.

52. Zhang Xiaogang, "Wo de zhiyi—Magelite," 72. Translated by Lina Dann, *post: Notes on Modern and Contemporary Art around the Globe,* https://post.at.moma.org/sources/12/publications/146.

53. Zhang Xiaogang to Li Xianting and Liao Wen, August 9, 1992. Fineberg and Xu, *Zhang Xiaogang,* 287.

54. Zhang Xiaogang to H. Y., September 10, 1992. Fineberg and Xu, *Zhang Xiaogang,* 289.

55. In his essay, Wang Lin makes five points about the exhibition: "(1) Maintains a distance from the superficial, popular, and hedonistic, and instead preserves reflection on the spiritual and cultural and reflects on depth and power; (2) Refuses to identify with the myth of money and the market; (3) Attends to the changes in China's social ideology; (4) Is willing to confront contemporary people's psychological conflict, the resistance that arises from a confrontation between spiritual conflict and individual existence and alienation; (5) Has a foothold in the construction of contemporary Chinese culture (not just in the existing centers of culture)." Wang, *Chinese Fine Arts in 1990s,* 13.

56. Wang Lin, interview with the author, Beijing, China, November 8, 2007.

57. The catalog is slim but replete with text. The first fifty pages feature transcripts of discussions among the artists and select critics, dated between 1991 and 1993 and ranging from reflections on what it means to be a contemporary Chinese artist to topics such as "the problem of language" and "the creation of an artistic spirit." Peppered alongside these texts are photographs of the artists, individual shots as well as group images. Some are photographs dating back to their friendship from the 1980s, while a few are captioned to show

meetings that took place to plan for this very exhibition. The catalog presents their desires in generating a place for contemporary art in China through art, discourse, and the event itself. Wang, *Chinese Fine Arts in 1990s.*

58. Krauss, "A Note on Photography," 56.

59. Bourdieu, *Un art moyen,* 48. Translated in ibid.

60. Zhang Xiaogang, interview with the author, Beijing, China, July 25, 2017.

3. WANG GUANGYI

1. Gao, *Total Modernity,* 154. Censors granted permission for its display only after the artist appended a note and made a slight revision to the painting. The revision was his partial addition of paint over the letter *O* such that it now appeared like a *C* in the corners. A translation of the appended note appears in a review of the exhibition titled "Chinese Exhibit Opens Again without Performance Art," *Globe and Mail* (Canada), February 11, 1989: "A great figure such as Mao Tsetung [Mao Zedong] . . . ought to be analyzed and evaluated historically, objectively and soberly. This piece is considered the painter's (Wang Guangyi's) rational thinking on this question in the form of visual art."

2. Cotter, "A Great Chinese Leap." Cotter continues this line of questioning two months later when he writes of Wang's placement of the figure behind a grid: "as if he or the viewer were confined behind, and perhaps protected by, prison bars." Cotter, "Art That's a Dragon with Two Heads."

3. For the phenomenon of contemporary artists addressing Mao, see Clarke, "Reframing Mao"; Dal Lago, "Personal Mao." Both primarily situate contemporary art's address of Mao within the "Mao Craze" of the early 1990s. While this was a fascinating and important trend and one that undoubtedly influenced later artists, it's important to note that Wang Guangyi's *Mao Zedong AO* predates the Mao Craze.

4. See Huang Zhuan, *Thing-in-Itself*; Huang, *Politics and Theology*; Paparoni, *Wang Guangyi.*

5. Alexander and Ryan, *International Pop,* 84. *International Pop* took place at the Walker Art Center from April 11 to August 29, 2015. The same year, *The World Goes Pop* opened at the Tate Modern in London and ran from September 25, 2015, to January 24, 2016.

6. Alexander and Ryan, *International Pop,* 8.

7. Ibid., 78.

8. Wang Lin, *China—Art of Post 89,* 90.

9. Ibid.

10. Ibid., 88.

11. For example, Yi, "Political Pop and the Crisis of Originality," 21.

12. Gao, "85 Meishu yundong," 119. Translated by Kristen Loring in Wu, *Contemporary Chinese Art: Primary Documents,* 61.

13. Ibid.

14. A notable exception to this is Gao Minglu, who locates Pop in terms of an aesthetic attitude of cynicism and finds traces of this in the late 1970s. Gao, *Total Modernity and the Avant-Garde,* 255.

15. Gu, "Zhongguo Bopu qingxiang," 93. Translated by Phillip Bloom in Wu, *Contemporary Chinese Art: Primary Documents,* 172.

16. Ibid.

17. This idea is outlined in Li Xianting, "Major Trends in the Development of Contemporary Chinese Art." But it already existed in Li's writings, most notably in his 1986 essay published under the pen name Li Jiatun. Li, "Zhongyao de bushi yishu." Translated by Kristen Loring in Wu, *Contemporary Chinese Art: Primary Documents,* 62–63.

18. Li, "Yishu de 'minzu dangdaizhuyi,'" 24.

19. Li, "Zhongyao de bushi yishu," 1–2.

20. Li, "Yishu de 'minzu dangdaizhuyi,'" 24.

21. Ibid.

22. Li, "'Hou bajiu' yishu zhong de wuliaogan he jiegou yishi." Translated by Kela Shang in Wu, *Contemporary Chinese Art: Primary Documents,* 165.

23. Ibid., 158.

24. Wang Lin, "Aoliwa bushi Zhongguo yishu de jiuxing," 10. Translated by Peggy Wang in Wu, *Contemporary Chinese Art: Primary Documents,* 366.

25. Hou, "Towards an 'Un-Unofficial Art.'"

26. Li Xianting, "Major Trends in the Development of Contemporary Chinese Art," xx.

27. Ibid., xxii.

28. Wang Guangyi, "Guanyu 'qingli renwen reqing.'" Translated in Paparoni, *Wang Guangyi,* 17–18. Owing to the vagaries of the term "humanist enthusiasm," scholars have also pointed to the individual expression revealed in romanticism and the transcendental purposes ascribed to art as additional culprits in the eagerness toward humanist enthusiasm. But Wang saves his gravest concerns for artists who amplify these pervasive mythologies. The seemingly transcendental purposes ascribed to art, buoyed by a misplaced enthusiasm, ultimately misled artists into losing track of what art should be for.

29. Gao, *Total Modernity and the Avant-Garde,* 170. Gao tracks the specificity of the term "humanism" *(renwen)* during the '85 Art New Wave in contradistinction to the "humanism" *(rendao)* of just a few years prior.

30. Shu Qun, "Wei 'Beifang yishu qunti' chanshi," 39. Translated by Phillip Bloom in Wu, *Contemporary Chinese Art: Primary Documents,* 82.

31. Wang explains this sentiment in an interview: "Under the circumstances of the time, critics and artists departed far from questions of art in the way they tried to explain or introduce their works. Often, much was made of a work's humanist content or other such metaphysical subject matter, which really had little or nothing to do with questions of social reality. To me, this was dangerous. I'm speaking of the art world at the time. Under those circumstances what I meant by ridding ourselves of humanist fervor was that the question of art should be brought back to that of its relationship with social reality." Merewether, "On the Socialist Visual Experience," 257.

32. Wang Guangyi, interview with the author, Beijing, China, July 12, 2017.

33. Wang Guangyi, interview with the author, Beijing, China, October 15, 2007.

34. Wang Guangyi, "Guanyu *Mao Zedong.*"

35. Wang Guangyi, interview with the author, Beijing, China, July 12, 2017.

36. Ibid.

37. Wang Guangyi, "Guanyu *Mao Zedong.*"

38. Lü Peng, "Tuxiang xiuzheng yu wenhua piping," 36. Cited in Huang Zhuan, "The Misread *Great Criticism,*" n.p. Reprinted in Wu, *Contemporary Chinese Art: Primary Documents,* 169.

39. Debevoise, *Between State and Market,* 243.

40. Ni, "Mao Is Their Canvas." See also Wu Hung, *Remaking Beijing.*

41. Wang Guangyi, interview with the author, Beijing, China, July 12, 2017.

42. Ibid.

43. Ibid.

44. Merewether, "On the Socialist Visual Experience," 257.

45. Wang Guangyi, interview with the author, Beijing, China, October 15, 2007.

46. Wang Guangyi, interview with the author, Beijing, China, July 12, 2017.

47. Sans, "A Pop Agitprop Aesthetic, 2009," 357.

48. Huang Zhuan, "The Misread *Great Criticism,*" n.p.

49. Ibid.

50. Taylor, "Trailblazing East and West."

51. Tang, *Visual Culture in Contemporary China,* 143.

52. Wang Guangyi, interview with the author, Beijing, China, July 12, 2017. Wang also touches on this briefly in an interview in Lu, Liu, and Su, *Individual Experience,* 65.

53. Pang, *The Art of Cloning,* 101.

54. *Meishu cankao ziliao 1,* 59.

55. Yan, "Dark Learning, Mysticism and Art," 163.

56. Wang Guangyi, interview with the author, Beijing, China, October 15, 2007.

57. Wang Guangyi, "Zouxiang zhenshi de shenghuo," 6.

58. Wang's ideological references to "the people" show the complicated ways in which self-definition could invoke socialist ideology and still be a far cry from nationalistic. After this full-page feature ran in *Beijing Youth Daily,* the young arts editor Wang Youshen was criticized by Beijing's local propaganda arm. Investigations and reporting on the incident continued for six months. Officials accused Wang Guangyi of critiquing the results of the reform and opening movement. For all of Wang Guangyi's explicit references to art *not* as a tool for self-expression or a tool for aristocratic thinking, but instead for the public, this still deviated considerably from what the government considered art should look like. This return to the power of the people, indeed a recovery of it, still opened up the distinction between political acceptability and cultural advocacy. Wang Youshen, interview with the author, Beijing, China, June 10, 2017.

59. *Meishu cankao ziliao 2,* 48.

60. Ibid., 52.

61. Wang Guangyi, interview with the author, Beijing, China, July 12, 2017.

62. Wang Guangyi, interview with the author, Beijing, China, October 15, 2007.

63. Ibid.

64. Wang Guangyi, "Zouxiang zhenshi de shenghuo," 6.

65. Wang Guangyi, interview with the author, Beijing, China, October 15, 2007.

66. Yan, "Dark Learning, Mysticism and Art," 156.

67. Sans, "A Pop Agitprop Aesthetic," 359.

68. Stephen Bann emphasizes this aspect of Pop in his statement that Pop Art is "the art movement most notoriously concerned with 'everyday life.'" Bann, "Pop Art and Genre," 115.

69. "Beijing bufen lilunjia dui Laoshengbo zuopin de fanyin," 2. Translated by Jiayun Zhuang in Wu, *Contemporary Chinese Art: Primary Documents,* 43.

70. Ikegami, "ROCI East," 183.

71. Liu Kang, "Popular Culture," 120.

72. Yan, "Dark Learning, Mysticism and Art," 165.

73. Wu, *Transience*, 24.

4. SUI JIANGUO

1. Qiu Zhijie, *Gei wo yige mianju*, 1–62.

2. Sui Jianguo, interview with the author, Beijing, China, July 26, 2017.

3. Wu, "A Case of Being 'Contemporary,'" 296.

4. At the time, when addressing the lack of critical attention paid to sculpture, critics were quick to blame the relatively fewer young artists working in sculpture rather than other mediums and formats. Be that as it may, one could also make the case that it was, in fact, critics' own continued lack of interest in sculpture that contributed to its marginalized position. In the conference accompanying *Sculpture in '94,* art critics began to take notice of their complicity in the state of the discourse around sculpture.

5. Sun, "*Dangdai qingnian diaosujia yaoqingzhan* shuping," 4.

6. Yin Shuangxi, "Zhongyao de zhuanzhe," 13.

7. Although it was called a "graduate school" *(yanjiusuo)* or "research center," the Diaosu Chuangzuo Yanjiusuo was not an academic institution. In the early 2000s, however, it was absorbed into the Central Academy of Fine Arts.

8. Liu Kaiqu, "Dui diaosu jiaoyu de xiwang," 5. In 1990, in addition to being in celebration of the fortieth anniversary of the Central Academy of Fine Arts, the timing of this nationalist rhetoric can also be seen as a backlash against June 4, 1989.

9. Sun, "*Dangdai qingnian diaosujia yaoqingzhan* shuping," 5.

10. Mao Xiaolang, "Kaifang de yujing," 24.

11. Wang Lin, *Diaosu yu dangdai wenhua*, 6.

12. Lai, *Nativism and Modernity*, 121.

13. Han, "Wenxue de 'gen,'" 5. Translated in Lai, *Nativism and Modernity,* 122.

14. Huang Zhuan, *Dian Xue*, 467.

15. For more on the *Stars* exhibitions, see Huang Rui, *Huang Rui: The Stars Times.*

16. Sui, "Wo suo renshi de Bao Pao." Bao was incredibly influential and well known through his participation in the second *Stars* exhibition, but has received little scholarly attention. Wang Keping's works, meanwhile, have been reproduced far more, in part due to the overt symbolism of the content. Wang left China soon after the *Stars* exhibition while Bao Pao actually went on to found his own school, the Quyang School of Environmental Art in Hebei Province in 1985.

17. Chen, "1909 nian Bikasuo funü touxiang yilai de xifang diaoke" [Western sculpture since Picasso's 1909 *Woman's Head*].

18. Sullivan, *Art and Artists of Twentieth-Century China*, 300.

19. Sui Jianguo, interview with the author, Beijing, China, July 5, 2016.

20. Capra, *The Tao of Physics*, 24.

21. Ibid., 25.

22. Ibid.

23. At the time, the students were presumably working toward their graduation show,

which was originally slated for July 1989. After June 4, however, they knew it wouldn't be possible to show their work.

24. Tsao, "The Birth of the Goddess of Democracy," 343.

25. Unlike reports in Western media that the figure had a Western face and was a direct imitation of the Statue of Liberty, the students specifically did not want to make it look too much like the American monument. Moreover, they wanted to give it a distinctly Chinese face as the bearer of a Chinese movement. Sui Jianguo, interview with the author, Beijing, China, December 1, 2007.

26. Ibid.

27. Wu, *Transience*, 66.

28. Sui Jianguo, interview with the author, Beijing, China, July 5, 2016.

29. *Hong Lou Meng [Dream of the Red Chamber]* was written by Cao Xueqin and published during the eighteenth century. *Xi You Ji [Journey to the West]* was originally published in the sixteenth century. Its authorship remains contested, but is often attributed to Wu Cheng'en. For more on the mythology of stone in these texts, see Wang, *The Story of Stone*.

30. Hay, "Double Modernity, Para-Modernity," 117.

31. Shi Mo, "Duzi chengdan qi shengming de chenzhong," 8.

32. Ibid., 10.

33. The artists were Fu Baoshi, Sui Jianguo, Jiang Jie, Zhan Wang, and Zhang Yongjian. From March 21 to April 3, 2013, Sun Zhenhua and Ji Shaofeng cocurated an exhibition of the five sculptors at the Guangdong Museum of Art to pay homage to their original exhibition.

34. "Xin Diaosu."

35. Ibid.

36. Ibid.

37. Shi, "Duzi chengdan," 10.

38. Ibid.

39. Ibid.

40. Wu, "A Case of Being 'Contemporary,'" 295.

41. "Diaosu de zijue," 48.

42. Sui Jianguo, interview with the author, Beijing, China, December 1, 2007.

43. Sui Jianguo, interview with the author, Beijing, China, July 11, 2011.

44. Sui, "Shijian weidu neiwai."

5. ZHANG PEILI

1. The title of this work is often translated as *Water: Standard Version from the Cihai Dictionary*. But a more accurate translation aligns "standard" with the dictionary itself, thus *Water: A Standard Edition of the Cihai Dictionary*. This rendering follows Wu Hung's discussion of the original Chinese in Wu, "Television in Contemporary Chinese Art," 79. This chapter considers the artist's use of a "standard edition" of the dictionary as a critical and meaningful aspect of this work. The image caption, however, adheres to the original translation as this is how it is identified by M+ Museum, which has collected the work.

2. Kristof, "Whither China?" Video of the June 4 broadcast is available at https://www.youtube.com/watch?v=iVWMKVNj7tU. While Du Xian and Xue Fei are featured in person, Xing Zhibin's voice can be heard as the voice-over used to announce updates on the army's suppression of so-called anti-revolutionary violence at Tiananmen Square.

3. Wu, "Television in Contemporary Chinese Art," 79.

4. Jane Perlez uses the phrase "meaningless screed" in "Where the Wild Things Are." The M+ Sigg Collection's online description of the work calls the content "a sea of meaningless words." https://www.westkowloon.hk

5. Pi, "Perpetual Antagonism," 29.

6. Hartman, *Lexicography,* 167. See also Altehenger, "On Difficult New Terms."

7. Lee, "Defining Correctness," 427–28.

8. Huang Zhuan, "An Antithesis to the Conceptual," 15.

9. Dal Lago, "The Art of Not Looking Different," 10.

10. Cheng, "*Yishu wenda.*" This interview with Zhang Peili appears as "Yu Cheng Xiaofeng de fangtan" [Interview with Cheng Xiaofeng], in Huang Zhuan, *Artistic Working Manual of Zhang Peili,* 473–74. In this later publication of the interview, which is dated December 1988, the interviewer is listed as Cheng Xiaofeng.

11. *From Jean-Paul Sartre to Teresa Teng: Cantonese Contemporary Art in the 1980s* (Hong Kong: Asia Art Archive, 2010), film, 47:52.

12. Shi Jiu, "Guanyu *Xin kongjian* he 'Chi she,'" 19. Translated by Kela Shang in Wu, *Contemporary Chinese Art: Primary Documents,* 87.

13. Cheng, "*Yishu wenda,*" n.p.

14. Zhang Peili, "*Yishu jihua di er hao* de chufadian," 215.

15. Ibid., 215–16. Translated by Kristen Loring, in Wu, *Contemporary Chinese Art: Primary Documents,* 112.

16. Cheng, "*Yishu wenda,*" n.p.

17. Zhang, "*Yishu jihua di er hao* de chufadian," 216. Translated by Kristen Loring in Wu, *Contemporary Chinese Art: Primary Documents,* 112–13.

18. Peckham and Lau, *Zhang Peili,* 140.

19. Zhang, "*Yishu jihua di er hao* de chufadian," 216. Translated by Kristen Loring in Wu, *Contemporary Chinese Art: Primary Documents,* 112.

20. Zhang Peili, interview with Asia Art Archive, Hangzhou, China, November 23, 2008, video. https://aaa.org.hk

21. Zhang Peili, "You yize xinwen xiangdao de." Part of this essay is translated in Huang Zhuan, "An Antithesis to the Conceptual," 18–19.

22. Zhang Peili, "You yize xinwen xiangdao de," 372.

23. This cyclical development makes "time" the very subject of the work rather than a discernible plot. Karen Smith compares this with Andy Warhol's *Empire State*; Smith, *Nine Lives.* While *30x30* also makes one aware of the passage of time, it differs from a single extended shot of a building in its activation of circularity through Zhang's repeated actions.

24. Pi, "Perpetual Antagonism," 28.

25. Zhang Peili, interview with the author, Hangzhou, China, July 20, 2017. The Chinese Artists' Association is the national professional organization run by the Chinese Communist Party. For more on its founding, see Andrews, *Painters and Politics.*

26. Zhang Peili, interview with the author, Hangzhou, China, July 20, 2017.

27. Zhang Peili, interview with the author, Hangzhou, China, July 26, 2011.

28. Andrews and Gao, "The Avant-Garde's Challenge to Official Art."

29. Zhang Peili, interview with the author, Hangzhou, China, July 26, 2011.

30. Zhang Peili, interview with the author, Hangzhou, China, July 20, 2017. On June 4,

1989, Zhang Peili was in Hangzhou. Shortly after, he noticed flyers posted all around the city that featured an image of student bodies from Tiananmen with the characters *Tucheng xuezheng* (massacre). Zhang suspects that the image had been faxed from Hong Kong to local students, who then circulated flyers anonymously throughout the city. Zhang took one of the flyers for himself as he and fellow artist and friend Geng Jianyi contemplated what to do with it. They decided to enlarge the image onto a banner stretching as wide as a street. Geng's college students spent an evening collectively enlarging the image and characters onto the banner. On June 8, they participated in the last large-scale protest march in Hangzhou. At the time, Zhang was working as a teacher; he was later questioned by officers of the Public Security Bureau and forced to write a detailed account of events for his supervisor at the school. Zhang, interview with the author, Hangzhou, China, July 20, 2017.

31. Zhang Peili, interview with the author, Hangzhou, China, July 26, 2011.

32. Brownell, *Training the Body for China*, 268.

33. Schell, *Discos and Democracy*, 78.

34. Zhang Peili, interview with the author, Hangzhou, China, July 20, 2017.

35. See Hinton, *Fanshen*.

36. Zhang Peili, interview with the author, Hangzhou, China, July 20, 2017.

37. Huang Zhuan, *Artistic Working Manual of Zhang Peili*, 434–44. This is from an interview dated January 25, 2007, between the artist and Xu Tan and Wang Jing.

38. Zhang Peili to Hans van Dijk, December 30, 1990, Hans van Dijk Archive, Asia Art Archive, Hong Kong.

39. Zhang Peili, interview with the author, Hangzhou, China, July 20, 2017.

40. Zhang Peili, interview with the author, Hangzhou, China, July 26, 2011.

41. Ibid.

42. For more on the appearance of numerical graffiti and the state's cleanup campaigns, see Parke, "Migrant Workers," 240–41.

43. For more on this phenomenon, see Schell, *Discos and Democracy*.

44. Zhang Peili, interview with the author, Hangzhou, China, July 26, 2011.

45. Ibid.

46. "Shenhua," 17–18.

47. Zhang, "Yu xifang zuozhan?"

48. Ibid., 375.

49. Dal Lago, "The Art of Not Looking Different," 10. See also Cachionne, "Related Rhythms."

50. Zhang Peili, "Yu xifang zuozhan?," 376. While he still frames the discussion within power dynamics, Zhang interestingly introduces the term "standard" *(biaozhun)* not only as the standardization of one meaning but also how double standards exist in how many Western people view themselves versus viewing China.

51. Krischer, *Zhang Peili: From Painting to Video*.

6. LIN TIANMIAO

1. Smith, "Lin Tianmiao," 21.

2. Lin Tianmiao's work *The Proliferation of Thread Winding* was installed at the *Century—Woman* exhibition. But at the opening, officials—citing a fire code violation—demanded that she dismantle it. Lin then took a photograph of the installation and displayed this instead. Alongside the photograph, she placed two fire hydrants and a note

stating that fire prevention was more important than art. This was only on display for an hour before officials saw it and became even more alarmed. Lin had to then remove the fire hydrants and sign, leaving only the photograph. Lin and Wang, "Art in Their Own Backyard," pt. 2, 2:29–3:42.

3. Jia, "Preface," 11.

4. Liao, *Women's Approach to Chinese Contemporary Art,* 1–4.

5. Although Lin Tianmiao wasn't among the twenty-two Asian women exhibited in curator Binghui Huangfu's 2000 exhibition *Text & Subtext* at the Earl Lu Gallery in Singapore, her work is repeatedly mentioned in the catalog essays by Huang Zhuan and Jiang Mei. See Huangfu, *Text and Subtext.*

6. Gao, *Inside Out: New Chinese Art,* 162.

7. Chambers, *Threads of Vision,* 46.

8. Erickson, "The Rise of a Feminist Spirit in Contemporary Chinese Art," 67.

9. Welland, *Experimental Beijing,* 172.

10. Chambers, *Threads of Vision,* 10.

11. Cavaluzzo, "Can Lin Tianmiao Break Free of Gender?"

12. Kee, "What Is Feminist about Contemporary Asian Women's Art?" 349.

13. Smith, "Lin Tianmiao," 21.

14. Lin and Wang, "Art in Their Own Backyard," pt. 1, 14:12.

15. Wang, "Subversion, Culture Shock, and 'Women's Art,'" 23.

16. Ibid.

17. Lin, "Wrapping and Severing," 87. Translated by Peggy Wang in Wu, *Contemporary Chinese Art: Primary Documents,* 197.

18. Ibid.

19. Liao, *Women's Approach to Chinese Contemporary Art,* 1–4.

20. Jia, "Preface," 11.

21. Qian, *Chan de kuosan,* 53.

22. Wang, "Subversion, Culture Shock, and 'Women's Art,'" 27.

23. Lin Tianmiao, interview with the author, Beijing, China, August 5, 2011.

24. Smith, "Lin Tianmiao," 21.

25. Lin Tianmiao, interview with the author, Shanghai, China, July 22, 2017.

26. Ibid.

27. Huang Zhuan, "Gazing Back: New Aesthetics of Gender," n.p.

28. Lin Tianmiao, interview with the author, July 22, 2017.

29. Ibid.

30. Lin, "Lin Tianmiao with Kang Kang."

31. Lin, "Lin Tianmiao." This is an interview with Monica Merlin, Beijing, China, November 4, 2013.

32. Lin, "Lin Tianmiao with Kang Kang."

CONCLUSION

1. Hou, "Entropy," 57.

2. Beam, "Beyond Ai Weiwei."

3. Lu, "The Missing Front Line."

4. Kee, *Contemporary Korean Art,* 28–29.

5. Clarke, "Contemporary Asian Art and the West," 247–48.

6. Ibid.

7. Ibid., 246.

8. Weibel, "Globalization and Contemporary Art," 21.

9. Hay, "Double Modernity, Para-Modernity," 113–14.

10. Vine, *New China, New Art*, 9.

11. Sasha Su-Ling Welland points out that one of the differences in using the term "Chinese contemporary art" rather than "contemporary Chinese art" is that the latter can be seen as reifying Chineseness. Welland, *Experimental Beijing*, 22. But it is important to point out that there are dangers in the former as well, if "Chinese" is considered an adaptation of established "contemporary art" conventions. In either case, it is necessary to allow for difference and multiplicity in their applications while confronting interpretative models that seek to calcify either within cultural hierarchies.

12. For more on the deconstruction of the terms "contemporary" and "Chinese," see Silbergeld and Ching, *ARTiculations*.

13. Ash, "Why Young Chinese Artists Are Avoiding Political Art"; Beam, "Beyond Ai Weiwei."

14. Tinari, "Between Palimpsest and Teleology," 66.

15. Ibid.

16. This is argued in Cheah, *What Is a World?*, 5, and Welland, *Experimental Beijing*, 29. See also Khullar, *Worldly Affiliations*.

17. "The Global Issue," 89.

18. Kesner, "Is a Truly Global Art History Possible?" 84.

Bibliography

Alexander, Darsie, and Bartholomew Ryan, eds. *International Pop*. Minneapolis: Walker Art Center, 2015.

Altehenger, Jennifer. "On Difficult New Terms: The Business of Lexicography in Mao Era China." *Modern Asian Studies* 51 (2017): 652–53.

Andrews, Julia F. *Painters and Politics in the People's Republic of China, 1949–1979*. Berkeley: University of California Press, 1995.

Andrews, Julia F., and Gao Minglu. "The Avant-Garde's Challenge to Official Art." In *Urban Spaces in Contemporary China*, edited by Deborah Davis et al., 221–78. Cambridge: Cambridge University Press, 1995.

Andrews, Julia F., and Kuiyi Shen. *A Century in Crisis: Tradition and Modernity in the Art of Twentieth-Century China*. New York: Guggenheim Museum, 1998.

Appadurai, Arjun. *Modernity at Large: Cultural Dimensions of Globalization*. Minneapolis: University of Minnesota Press, 1996.

Antoinette, Michelle, and Caroline Turner, eds. *Contemporary Asian Art and Exhibitions: Connectivities and World-Making*. Canberra: Australia National University Press, 2014.

Ash, Alec. "Why Young Chinese Artists Are Avoiding Political Art." *Atlantic*, July 26, 2018. https://www.theatlantic.com

Bann, Stephen. "Pop Art and Genre." *New Literary History* 24, no. 1 (1993): 115–24.

Beam, Christopher. "Beyond Ai Weiwei: How China's Artists Handle Politics (or Avoid Them)." *New Yorker*, March 27, 2015. https://www.newyorker.com

"Beijing bufen lilunjia dui Laoshengbo zuopin de fanyin" [Beijing theorists' reactions to the art of Robert Rauschenberg]. *Zhongguo meishubao* [Fine arts in China], December 21, 1985, 2.

Belting, Hans, Andrea Buddensieg, and Peter Weibel, eds. *The Global Contemporary and the Rise of New Art Worlds*. Cambridge, Mass.: MIT Press, 2013.

Bourdieu, Pierre. *Un art moyen: Essai sur les usages sociaux de la photographie*. Paris: Éditions de Minuit, 1965.

Brownell, Susan. *Training the Body for China: Sports in the Moral Order of the People's Republic*. Chicago: University of Chicago Press, 1995.

Buchloh, Benjamin. "The Whole Earth Show: An Interview with Jean-Hubert Martin." *Art in America* (May 1989): 150–60, 213.

Cacchione, Orianna. "Related Rhythms: Situating Zhang Peili and Contemporary Chinese Video Art in the Globalizing Art World." *Journal of Contemporary Chinese Art* 5, no. 1 (2018): 21–39.

———. *"To Enter Art History*—Reading and Writing Art History in China during the Reform Era." *Journal of Art Historiography* 10 (June 2014): 1–22.

Cai Guo-Qiang. *What about the Art? Contemporary Art from China.* Doha, Qatar: Qatar Museums, 2016.

Capra, Fritjof. *The Tao of Physics: An Exploration of the Parallels between Modern Physics and Eastern Mysticism.* 3rd ed. Boston: Shambhala, 1991.

Cavaluzzo, Alexander. "Can Lin Tianmiao Break Free of Gender?" *Hyperallergic,* November 14, 2012. http://hyperallergic.com/60151/lin-tianmiao-bound-unbound-asia-society

Chambers, Kristin. *Threads of Vision: Toward a New Feminine Poetics.* Cleveland, Ohio: Cleveland Center for Contemporary Art, 2001.

Chang, Johnson, ed. *China's New Art, Post-1989.* Hong Kong: Hanart TZ Gallery, 1993.

Chen Yingde, "1909 nian Bikasuo funü touxiang yilai de xifang diaoke" [Western sculpture since Picasso's 1909 *Woman's Head*]. Part 1, *Lion Art* 133 (1982): 72–85; part 2, *Lion Art* 134 (1982): 46–63; part 3, *Lion Art* 135 (1982): 125–33; part 4, 136 (1982): 117–28.

Cheah, Pheng. *What Is a World? On Postcolonial Literature as World Literature.* Durham, N.C.: Duke University Press, 2016.

Cheng, Zhidi. "Xuyao fenxi" [Necessary to analyze]. *Meishu* 274, no. 10 (1990): 8–9.

Cheng Xiaoping. "Yishu wenda" [Q&A on art]. *Zhejiang Huabao,* no. 2 (1989), n.p.

Chumley, Lily. *Creativity Class: Art School and Culture Work in Postsocialist China.* Princeton, N.J.: Princeton University Press, 2016.

Clark, John. "The Worlding of the Asian Modern." In Antoinette and Turner, *Contemporary Asian Art and Exhibitions,* 67–88.

Clarke, David. "Contemporary Asian Art and the West." In Harris, *Globalization and Contemporary Art,* 245–52.

———. "Reframing Mao: Aspects of Recent Chinese Art, Popular Culture and Politics." In *Art and Place: Essays on Art from a Hong Kong Perspective,* 236–49. Hong Kong: Hong Kong University Press, 1996.

Cochran, Sherman. "Marketing Medicine and Advertising Dreams in China, 1900–1950." In *Becoming Chinese: Passages to Modernity and Beyond,* edited by Wen-hsin Yeh, 62–97. Berkeley: University of California Press, 2000.

"Cong Weinisi dao Shenbaoluo" [From Venice to São Paulo]. *Hualang* 47, no. 4 (1994): 3–5, 63.

Cotter, Holland. "Art That's a Dragon with Two Heads." *New York Times,* December 13, 1998.

———. "A Great Chinese Leap into a New Sort of Cultural Revolution." *New York Times,* September 18, 1998.

Crossley, Pamela Kyle. "Thinking about Ethnicity in Early Modern China." *Late Imperial China* 11, no. 1 (1990): 1–35.

Dai Hanzhi: 5000 Artists exhibition pamphlet. Beijing: Ullens Center for Contemporary Art, 2014.

Dal Lago, Francesca. "The Art of Not Looking Different." In Peckham and Lau, *Zhang Peili,* 9–13.

———. "How 'Modern' Was the Modern Woman? Crossed Legs and Modernity in 1930s Shanghai Calendar Posters, Pictorial Magazines, and Cartoons." In *Visualizing*

Beauty, edited by Aida Yuen Wong, 45–61. Hong Kong: Hong Kong University Press, 2012.

———. "Personal Mao: Reshaping an Icon in Contemporary Chinese Art." *Art Journal* 58, no. 2 (1999): 46–59.

Debevoise, Jane. *Between State and Market: Chinese Contemporary Art in the Post-Mao Era.* Leiden: Brill, 2014.

"Diaosu de zijue: Sui Jianguo, Fu Zhongwang, Zhang Yongjian, Zhan Wang, Jiang Jie, zuoping zhan xilie duihua" [The self-awareness of sculpture: A conversation among Sui Jianguo, Fu Zhongwang, Zhang Yongjian, Zhan Wang, and Jiang Jie]. *Jinri Xianfeng,* no. 3 (1995): 37–52.

Du, Weihong. "A Turning Point for *Guohua*? Xu Beihong and Transformative Encounters with the Socialist Spirit, 1933–1953." *Twentieth-Century China* 39, no. 3 (2014): 216–44.

Enwezor, Okwui, Nancy Condee, and Terry Smith, eds. *Antinomies of Art and Culture: Modernity, Postmodernity, Contemporaneity.* Durham, N.C.: Duke University Press, 2009.

Erickson, Britta. "The Rise of a Feminist Spirit in Contemporary Chinese Art." *Art Asia Pacific* 31 (July 2001): 64–71.

Fan Di'an. "Liu Xiaodong huo zhenshi de chenshi" [Liu Xiaodong's realistic expression]. *Meishu* 266, no. 2 (1990): 62–64.

Fei Dawei, ed. *'85 Xinchao dang'an* [Archives of the '85 New Wave]. 2 vols. Shanghai: Shanghai People's Publishing House, 2007.

Fibicher, Bernard, and Matthias Frehner, eds. *Mahjong: Contemporary Chinese Art from the Sigg Collection.* Berlin: Hatje Cantz, 2005.

Flath, James. "'It's a Wonderful Life': 'Nianhua' and 'Yuefenpai' at the Dawn of the People's Republic." *Modern Chinese Literature and Culture* 16, no. 2 (2004): 123–59.

Fineberg, Jonathan, and Gary G. Xu. *Zhang Xiaogang: Disquieting Memories.* New York: Phaidon, 2015.

Gao Minglu. "85 Meishu yundong" [The '85 Art Movement]. *Meishu tongxun* 4 (1986): 107–25.

———, ed. *Inside Out: New Chinese Art.* Berkeley: University of California Press, 1999.

———. *Total Modernity and the Avant-Garde in Twentieth-Century Chinese Art.* Cambridge, Mass.: MIT Press, 2011.

Ginzburg, Carlo. "Microhistory: Two or Three Things That I Know about It." Translated by John and Anne C. Tedeschi. *Critical Inquiry* 20, no. 1 (Autumn 1993): 10–35.

———. "Microhistory and World History." In *The Cambridge World History,* edited by Jerry H. Bentley, Sanjay Subrahmanyam, and Merry E. Wiesner-Hanks, 446–73. Cambridge: Cambridge University Press, 2015.

Gladston, Paul. *Contemporary Chinese Art: A Critical History.* London: Reaktion Books, 2014.

———. "Somewhere (and Nowhere) between Modernity and Tradition: Towards a Critique of International and Indigenous Perspectives on the Significance of Contemporary Chinese Art." *Tate Papers no. 21* (Spring 2014). https://www.tate.org.uk/research/publications/tate-papers/21

"The Global Issue: A Symposium; James Clifford, Boris Groys, Craig Owens, Martha Rosler, Robert Storr, Michelle Wallace." *Art in America,* no. 7 (July 1989): 86–89, 151–53.

Goldstein, Andrew. "The Guggenheim's Alexandra Munroe on Why 'The Theater of the World' Was Intended to Be Brutal." artnet news, September 26, 2017. https://news.artnet.com

Gu Chengfeng. "Zhongguo Bopu qingxiang" [Tendencies in Chinese Pop]. In *Jiushi niandai Zhongguo meishu 1990–1992*, edited by Zhang Qing, 90–97. Urumqi: Xinjiang Fine Arts and Photography Publishing House, 1996.

Gu, Yi. *Chinese Ways of Seeing and Open-Air Painting.* Cambridge, Mass.: Harvard University Asia Center, 2020.

Gu Yuan. "Renmin shi wenyi gongzuozhe de muqin" [People are the mother of art and literature workers]. *Meishu* 274, no. 10 (1990): 8–9.

Han Shaogong. "Wenxue de 'gen'" [The 'roots' of literature]. *Zuojia,* no. 4 (1985): 2–5.

Harris, Jonathan. *Globalization and Contemporary Art.* Oxford: Wiley-Blackwell, 2011.

Hartman, R. R. K., ed. *Lexicography: Critical Concepts.* Vol. 2. New York: Routledge, 2003.

Hay, Jonathan. "Double Modernity, Para-Modernity." In Enwezor, Condee, and Smith, *Antinomies of Art and Culture,* 113–32.

Hinton, William H. *Fanshen: A Documentary of Revolution in a Chinese Village.* New York: Monthly Review Press, 1966.

Hou Hanru. "Entropy, Chinese Artists, Western Art Institutions: A New Internationalism." In *On the Mid-Ground,* 54–63. Hong Kong: Timezone 8, 2002.

———. "Théâtre du monde: To Be Unthought." In Munroe, Tinari, and Hou, *Art and China after 1989,* 69–77.

———. "Towards an 'Un-Unofficial Art': De-ideologicalisation of China's Contemporary Art in the 1990s." *Third Text* 10, no. 34 (1996): 37–52.

Hsia Li. "Art Education in New China." *China Weekly Review,* June 3, 1950, 7–8.

Huang, Nicole. "Locating Family Portraits: Everyday Images from 1970s China." *positions: east asia cultures critique* 18, no. 3 (Winter 2010): 671–93.

Huang, Philip C. C. "Rural Class Struggle in the Chinese Revolution: Representational and Objective Realities from the Land Reform to the Cultural Revolution." *Modern China* 21, no. 1 (1995): 105–43.

Huang Rui, ed. *Huang Rui: The Stars Times, 1977–1984.* Beijing: Guanyi Contemporary Art Archive, 2007.

Huang Zhuan. "An Antithesis to the Conceptual: On Zhang Peili." In Peckham and Lau, *Zhang Peili,* 14–29.

———, ed. *Artistic Working Manual of Zhang Peili.* Guangzhou: Lingnan Meishu Chubanshe, 2008.

———, ed. *Dian Xue: Sui Jianguo de yishu* [Dian Xue: Sui Jianguo's art]. Guangzhou: Lingnan Meishu Chubanshe, 2007.

———. "Gazing Back: New Aesthetics of Gender." In *Gazing Back: The Art of Lin Tianmiao.* Shanghai: OCT-Shanghai, 2009.

———. "The Misread *Great Criticism.*" Translated by Jeff Crosby. In *Visual Polity: Another Wang Guangyi,* n.p. Guangzhou: Lingnan Meishu Chubanshe, 2008.

———. *Politics and Theology in Chinese Contemporary Art: Reflections on the Work of Wang Guangyi.* Milan: Skira, 2014.

———. "Report from the Artist's Studio." *Hualang* 58/59, no. 5/6 (1996): 8–11.

————, ed. *Thing-in-Itself: Utopia, Pop, and Personal Theology*. Guangzhou: Lingnan Meishu Chubanshe, 2012.

————, and Pi Li. *Image Is Power: The Art of Wang Guangyi, Zhang Xiaogang, and Fang Lijun*. Hunan: Hunan Meishu Chubanshe, 2002.

Huangfu, Binghui. *Text and Subtext*. Singapore: Earl Lu Gallery, 2000.

Ikegami, Hiroko. "ROCI East: Rauschenberg's Encounters in China." In *East-West Interchanges in American Art: A Long and Tumultuous Relationship*, edited by Cynthia Mills, Lee Glazer, and Amelia Goerlitz, 177–89. Washington, D.C.: Smithsonian Scholarly Press, 2011.

Jia Fangzhou. Preface to *Century—Woman*, 8–11. Translated by Chen Yang and Karen Smith. Hong Kong: Shijie Huaren Yishu Chubanshe, 1998.

Jiang Jiehong. Introduction. *Journal of Contemporary Chinese Art* 4, no. 2–3 (2017): 121–24.

Jones, Caroline A. *The Global Work of Art: World's Fairs, Biennials, and the Aesthetics of Experience*. Chicago: University of Chicago Press, 2017.

Kee, Joan. "What Is Feminist about Contemporary Asian Women's Art?" In *Contemporary Art in Asia: A Critical Reader*, edited by Melissa Chiu and Benjamin Genocchio, 347–69. Cambridge, Mass.: MIT Press, 2011.

————. *Contemporary Korean Art: Tansaekhwa and the Urgency of Method*. Minneapolis: University of Minnesota Press, 2013.

Kesner, Ladislav. "Is a Truly Global Art History Possible?" In *Is Art History Global?*, edited by James Elkins, 81–111. New York: Routledge, 2007.

Khullar, Sonal. *Worldly Affiliations: Artistic Practice, National Identity, and Modernism in India, 1930–1990*. Oakland: University of California Press, 2015.

Köppel-Yang, Martina. *Semiotic Warfare*. Hong Kong: Timezone 8, 2003.

Kraus, Richard Curt. *The Party and the Arty: The New Politics of Culture*. New York: Rowman & Littlefield, 2004.

Krauss, Rosalind. "A Note on Photography and the Simulacral." *October* 31 (Winter 1984): 49–68.

Krischer, Olivier, ed. *Zhang Peili: From Painting to Video*. Sydney: ANU Press, 2019.

Kristof, Nicholas D. "Whither China? Back to the Era of 'Comrade.'" *New York Times*, November 18, 1990.

Lai, Ming-yan. *Nativism and Modernity: Cultural Contestations in China and Taiwan under Global Capitalism*. New York: State University of New York Press, 2009.

Laing, Ellen Johnston. *Selling Happiness: Calendar Posters and Visual Culture in Early Twentieth-Century Shanghai*. Honolulu: University of Hawai'i Press, 2004.

Lang Shaojun. "Chongjian Zhongguo de jingying yishu: Dui 20 shiji Zhongguo meishu geju bianqian de zirenshi" [Rebuilding elite art: Reconsidering changes in the structure of twentieth-century Chinese art]. *Meishu yanjiu*, no. 2 (1989).

Lee, Young Ji Victoria. "Recoding Capital: Socialist Realism and Maoist Images (1949–1976)." PhD diss., Duke University, 2014.

Lee, Siu-yau. "Defining Correctness: The Tale of the *Contemporary Chinese Dictionary*." *Modern China* 40 (2014): 426–50.

Li Hanzhong. "Shehuizhuyi meishu fazhan wenti zuotanhui" [A discussion of problems in the development of socialist art]. *Meishu* 280, no. 4 (1991): 9.

Li Qi. "Zhuxuanlü suixiang" [Caprice of the main melody]. *Meishu* 280, no. 4 (1991): 11.

Li Xianting. "'Hou bajiu' yishu zhong de wuliaogan he jiegou yishi—'Wanshi xieshizhuyi'
yu 'Zhengzhi bopu' chaoliu xi" [Apathy and deconstruction in post-'89 art: Analyzing
the trends of "Cynical Realism" and "Political Pop"]. *Yishu chaoliu* 1 (1992).

———. "Major Trends in the Development of Contemporary Chinese Art." Translated by
Valerie Doran. In *China's New Art, Post-1989*, edited by Johnson Chang, xx–xxii. Hong
Kong: Hanart TZ Gallery, 1992.

———. "Yishu de 'minzu dangdaizhuyi'" [The "national contemporarization" of art].
Jiangsu Huakan 155, no. 11 (1993): 22–24.

———. "Zhang Xiaogang's Epitome Portraits of the Chinese and Chinese Contemporary
Art." In *Umbilical Cord of History: Paintings by Zhang Xiaogang*, 35–37. Hong Kong:
Hanart TZ Gallery, 2004.

——— [Li Jiatun, pseud.]. "Zhongyao de bushi yishu" [The significance is not the art].
Zhongguo meishubao 28 (1986): 1–2.

Liao Wen. *Women's Approach to Chinese Contemporary Art*. Translated by Isolda Morillo.
Beijing: Beijing Yishu Bowuguan, 1995.

Lin Tianmiao. "Lin Tianmiao." Interview with Monica Merlin. *Tate*, February 21, 2018.
https://www.tate.org.uk

———. "Lin Tianmiao with Kang Kang." Interview with Kang Kang. *The Brooklyn
Rail: Critical Perspectives on Arts, Politics, and Culture,* October 5, 2017. https://
brooklynrail.org/2017/10/art/Lin-Tianmiao-with-Kang-Kang

———. "Wrapping and Severing." In *Grey Cover Book*, 87. Beijing: privately published,
1997.

———, and Wang Gongxin. "Art in Their Own Backyard: A Conversation with Lin
Tianmiao and Wang Gongxin." Interview by Yu-Chieh Li. Translated by Shumay
Lin and Yu-Chieh Li. Filmed May 19, 2014, Museum of Modern Art, New York. Part 1,
https://www.youtube.com/watch?v=UCtYd3fY_LQ, 25:47; part 2, https://www.youtube
.com/watch?v=BeHEHwd_DMk, 18:56.

Lipman, Jonathan N. "How Many *Minzu* in a Nation? Modern Travellers Meet China's
Frontier Peoples." *Inner Asia* 4, no. 1 (2002): 113–30.

Liu Kaiqu. "Dui diaosu jiaoyu de xiwang" [Hopes for sculpture education]. *Meishu* 268,
no. 4 (1990): 5.

Liu Kang. "Popular Culture and the Culture of the Masses in Contemporary China."
boundary 2 24, no. 3 (1997): 99–122.

Lovell, Julia. "The Cultural Revolution and Its Legacies in International Perspective."
China Quarterly 227 (September 2016): 632–52.

Lu, Carol. "The Missing Front Line." *e-flux* 80 (March 2017). https://www.e-flux.com
/journal/80/102559/the-missing-front-line

———, Liu Ding, and Su Wei, eds. *Individual Experience: Conversations and Narratives
of Contemporary Art Practice in China from 1989 to 2000.* [In Chinese.] Guangzhou:
Lingnan Meishu Chubanshe, 2013.

Lu Hong. "Zouchu 'xifang zhongxin' zhuyi de yinying" [Walking out of the shadow of
"Western-centrism"]. *Hualang* 48, no. 1 (1995): 32.

Lü Peng. *Bloodlines: The Zhang Xiaogang Story.* Milan: Skira, 2016.

———. "Qianwei yishu 'xiake'" ["Class is over" for avant-garde art]. *Jiangsu Huakan* 154,
no. 10 (1993): 34–35.

———. "Tuxiang xiuzheng yu wenhua piping" [Image alteration and cultural criticism]. In *Dangdai yishu chaoliu zhong de Wang Guangyi* [Wang Guangyi within the trends of contemporary art]. Sichuan: Sichuan Meishu Chubanshe, 1992.

Mao Tse-tung [Mao Zedong]. "Talks at the Yenan [Yan'an] Forum on Literature and Art" (1942). In *Selected Works of Mao Tse-tung.* Vol. 3. Peking [Beijing]: Foreign Languages Press, 1965.

———. "Mao Zedong: Speeches at the 1957 'Moscow Conference.'" Translated by Michael Schoenhals. *Journal of Communist Studies* 2, no. 2 (1986): 109–26.

Mao Xiaolang. "Kaifang de yujing: Bufen dangdai yishjia, pipingjia fangtanlu" [Open context: Record of discussion between contemporary artists and critics]. *Hualang* 54, no. 1 (1996): 22–25.

Meishu cankao ziliao 1: Baotou xuanji [Art reference materials 1: Selections of mastheads]. Beijing: Renmin Meishu Chubanshe, 1971.

Meishu cankao ziliao 2: Baotou xuanji [Art reference materials 2: Selections of mastheads]. Beijing: Renmin Meishu Chubanshe, 1972.

Merewether, Charles. "On the Socialist Visual Experience." In Huang and Pi, *Image Is Power,* 253–60.

Mitchell, W. J. T. *Picture Theory.* Chicago: University of Chicago Press, 1994.

———. "World Pictures: Globalization and Visual Culture." In Harris, *Globalization and Contemporary Art,* 253–64.

Mittler, Barbara. "Popular Propaganda? Art and Culture in Revolutionary China." *Proceedings of the American Philosophical Society* 152, no. 4 (December 2008): 466–89.

Mosquero, Gerardo. "Some Problems in Transcultural Curating." Translated by Jaime Flórez. In *Global Visions: Towards a New Internationalism in the Visual Arts,* edited by Jean Fisher, 133–39. London: Institute of International Visual Arts, 1994.

Mullaney, Thomas S. *Coming to Terms with the Nation: Ethnic Classification in Modern China.* Berkeley: University of California Press, 2010.

Munroe, Alexandra. "A Test Site." In Munroe, Tinari, and Hou, *Art and China after 1989,* 20–49.

———, Philip Tinari, and Hou Hanru, eds. *Art and China after 1989: Theater of the World.* New York: Guggenheim Museum, 2017.

Ni, Ching-Ching. "Mao Is Their Canvas." *Los Angeles Times,* September 14, 2006.

Oliva, Achille Bonito. *XLV International Art Exhibition: Cardinal Points of Art Theoretical Essays.* Venice: Ulisse e Calipso edizioni mediterranee, 1994.

PaceWildenstein. *Revision: Zhang Xiaogang.* New York: PaceWildenstein, 2008.

Pang, Laikwan. *The Art of Cloning: Creative Production during China's Cultural Revolution.* New York: Verso, 2017.

Paparoni, Demetrio. *Wang Guangyi: Works and Thoughts, 1985–2012.* Milan: Skira, 2013.

Parke, Elizabeth. "Migrant Workers and the Imaging of Human Infrastructure in Chinese Contemporary Art." *China Information* 29, no. 2 (July 2015): 226–52.

Peckham, Robin, and Venus Lau, eds. *Zhang Peili: Certain Pleasures.* Hong Kong: Blue Kingfisher Limited, 2011.

Peng De. "Miandui xinchao de zhongjie" [Facing the end of the New Wave: An Interview with *Fine Arts in China*]. *Zhongguo meishubao,* May 8, 1989, 1.

Perlez, Jane. "Where the Wild Things Are: China's Art Dreamers at the Guggenheim," *New York Times,* September 29, 2017.

Pi Li. "Perpetual Antagonism: Tracing Zhang Peili's Practice." In *Zhang Peili: Record. Repeat,* edited by Orianna Cacchione, Pi Li, et al., 24–32. Chicago: Art Institute of Chicago, 2017.

Qian Zhijian. *Chan de kuosan [The Proliferation of Thread Winding].* In *Zhongguo dangdai meishu tujian: Guannian yishu fence, 1979–1999* [Illustrated handbook for Chinese contemporary art: Volume on conceptual art, 1979–1999], edited by Lu Hong and Huang Zhuan, 53. Hubei: Hubei Jiaoyu Chubanshe, 2001.

Qiu Zhijie. *Gei wo yige mianju* [Give me a mask]. Beijing: China Renmin Daxue Chubanshe, 2003.

Rojas, Carlos. *Homesickness: Culture, Contagion, and National Transformation in Modern China.* Cambridge, Mass.: Harvard University Press, 2015.

Sans, Jérôme. "A Pop Agitprop Aesthetic, 2009." In Paparoni, *Wang Guangyi,* 355–60.

Schell, Orville. *Discos and Democracy: China in the Throes of Reform.* New York: Anchor Books, 1988.

Shao Dazhen. "Zhongguo dangdai youhua san tiyi" [Three proposals for Chinese contemporary oil painting]. In *Meishu pipingjia niandu timingzhan* [Annual exhibition of works of the artists nominated by art critics], edited by Wang Lin and Yin Shuangxi, 4–6. Chengdu: Sichuan Meishu Chubanshe, 1994.

Shao Yiyang. "The International Identity of Chinese Art: Theoretical Debates on Chinese Contemporary Art in the 1990s." In *Contemporary Chinese Art and Film, Theory Applied and Resisted,* edited by Jason Kuo, 49–64. Washington, D.C.: New Academia Press, 2013.

Shen Guanghan. "Yazhou de shili he fangwei: Hancheng jiancheng 600 zhounian guoji yishujie zongshu" [The place and power of Asia: Summary of *600 Seoul International Art Festival*]. *Hualang* 48, no. 1 (1995): 33–34.

"Shenhua: Xifang yu Zhongguo" [Myth: The West and China]. *Jinri Xianfeng* 2 (1994): 6–28.

Shi Jiu. "Guanyu *Xin kongjian* he 'Chi she'" [On *New Space* and the "Pond Society"]. *Meishu sichao,* no. 1 (1987): 16–21.

Shi Mo. "Duzi chengdan qi shengming de chenzhong: Yu Sui Jianguo de duihua" [Bearing the weight of life by oneself: A conversation with Sui Jianguo]. *Hualang* 50, no. 3 (1995): 8–13.

Shu Kewen. "Ba yishu zuocheng pinpai" [Create brands for art]. In Huang and Pi, *Image Is Power,* 238–39.

Shu Qun. "Wei 'Beifang yishu qunti' chanshi" [An explanation of the Northern Art Group]. *Meishu sichao* 1 (1987): 36–39.

Shui Tianzhong. "'Xishan huiyi'—huiyi yu sikao" [Memories and reflections on the Xishan symposium]. Artron.net, September 9, 2007. news.artron.net/20070912/n34268.html

Silbergeld, Jerome, and Dora C. Y. Ching, eds. *ARTiculations: Undefining Chinese Contemporary Art.* Princeton, N.J.: Princeton University Press, 2010.

Smith, Karen. "Lin Tianmiao." In *Lin Tianmiao: Non Zero,* 5–21. Hong Kong: Timezone 8, 2004.

———. *Nine Lives: The Birth of Avant-Garde Art in New China.* Updated ed. Hong Kong: Blue Kingfisher Limited, 2008.

Smith, Terry. "Currents of Worldmaking in Contemporary Art." In *The Visual Culture Reader,* 3rd ed., edited by Nicholas Mirzoeff, 109–17. New York: Routledge, 2013.

Solomon, Andrew. "Their Irony, Humor (and Art) Can Save China." *New York Times Magazine,* December 19, 1993, 42–51, 66, 70–72.

Stevens, Mark. "Is Ai Weiwei China's Most Dangerous Man?" *Smithsonian Magazine,* September 2012. https://www.smithsonianmag.com

Sui Jianguo. "Shijian weidu neiwai" [Dimensions of time]. July 16, 2011. https://linggu.org/2011/07/22

———. "Wo suo renshi de Bao Pao" [The Bao Pao that I know]. *China Sculpture* 2 (2008): 28–29.

Sullivan, Michael. *Art and Artists of Twentieth-Century China.* Berkeley: University of California Press, 1996.

Sun Zhenhua. "*Dangdai qingnian diaosujia yaoqingzhan* shuping" [Commentary on the *Contemporary Young Sculptors Invitational*]. *Jiangsu Huakan* 145, no. 1 (1993): 4–6.

Tang, Xiaobing. *Visual Culture in Contemporary China: Paradigms and Shifts.* Cambridge: Cambridge University Press, 2015.

Tang Xin. *Huajiadi . . . 1979–2004 Zhongguo dangdai yishu fazhan qinglizhe tanhualu* [Huajiadi . . . Dialogues on the development of Chinese contemporary art, 1979–2004]. Beijing, China: Zhongguo Yingcai Chuban Youxian Gongsi, 2005.

Taylor, John Russell. "Trailblazing East and West." *Times* (U.K.), March 8, 1993.

Thea, Carolee. "The Extreme Situation Is Beautiful: An Interview with Hou Hanru." *Sculpture* 18, no. 9 (November 1999): 30–37.

Tinari, Philip. "Between Palimpsest and Teleology: The Problem of 'Chinese Contemporary Art.'" In Munroe, Tinari, and Hou, *Art and China after 1989,* 51–67.

Tomii, Reiko. *Radicalism in the Wilderness.* Cambridge, Mass.: MIT Press, 2016.

Tsao, Hsingyuan. "The Birth of the Goddess of Democracy." In *Cries for Democracy: Writings and Speeches from the 1989 Democracy Movement,* edited by Minzhu Han and Sheng Hua, 342–48. Princeton, N.J.: Princeton University Press, 1990.

Vine, Richard. *New China, New Art.* Rev. and expanded ed. London: Prestel, 2011.

Visser, Robin. *Cities Surround the Countryside: Urban Aesthetics in Postsocialist China.* Durham, N.C.: Duke University Press, 2010.

Wang, Cheng-hua. "Rediscovering Song Painting for the Nation: Artistic Discursive Practices in Early Twentieth-Century China." *Artibus Asiae* 71, no. 2 (2011): 221–46.

Wang Chunchen. "Realism Is a Kind of Ideology in China." In *A New Thoughtfulness in Contemporary China: Critical Voices in Art and Aesthetics,* edited by Jörg Huber and Zhao Chuan, 71–78. Bielefeld, Germany: Transcript-Verlag, 2011.

Wang Guangyi. "Guanyu *Mao Zedong*" [Concerning *Mao Zedong*]. *Zhongguo meishubao* 11, March 13, 1989, 2.

———. "Guanyu 'qingli renwen reqing'" [On "cleansing humanist enthusiasm"]. *Jiangsu Huakan* 10 (1990): 17–18.

———. "Zouxiang zhenshi de shenghuo" [Walking toward real life]. *Beijing Youth Daily,* March 22, 1991, 6.

Wang, Jing. Guest Editor's Introduction. *positions: east asia cultures critique* 9, no. 1 (2001): 1–27.

———. *High Culture Fever: Politics, Aesthetics, and Ideology in Deng's China.* Berkeley: University of California Press, 1996.

———. *The Story of Stone: Intertextuality, Ancient Chinese Stone Lore, and the Stone Symbolism in "Dream of the Red Chamber," "Water Margin," and "The Journey to the West."* Durham, N.C.: Duke University Press, 1991.

Wang Lin. "Aoliwa bushi Zhongguo yishu de jiuxing" [Oliva is not the savior of Chinese art]. *Dushu* 10 (1993).

———, ed. *China—Art of Post 89.* [In Chinese.] Hong Kong: Yishu chaoliu zazhi she, 1997.

———, ed. *Chinese Fine Arts in 1990s: Experiences in Fine Arts of China.* [In Chinese.] Chengdu: Chengdu dadi wenhua fazhan gongsi, 1993.

———, ed. *Diaosu yu dangdai wenhua* [Sculpture and modern culture]. Hong Kong: Yishu chaoliu zazhi she, 1997.

———, ed. *Yishujia Wenzhai* [Artists digest]. Hong Kong: Yishu chaoliu zazhi she, 1994.

Wang Luyan. "Shijiexing, shangpinhua, qiantu" [Worldliness, commercialization, the future]. *Meishu* 9 (1988): 18–19.

Wang, Meiqing. "Officializing the Unofficial: Presenting Chinese Art to the World." *Modern Chinese Literature and Culture* 21, no. 1 (Spring 2009): 102–40.

Wang Nanming. "Xifang shuangchong biaozhun yu dangdai yishu piping de qitu" [Double standards of the West and the wrong path of contemporary art criticism]. *Jiangsu Huakan* 209, no. 5 (1998): 2.

Wang, Peggy. "China's Emerging Art Market: Debates on Art, Criticism, and Commodity in the Early 1990s." In *Negotiating Difference: Contemporary Chinese Art in the Global Context,* edited by Juliane Noth et al., 189–98. Weimar: VDG Weimar, 2012.

———. "Subversion, Culture Shock, and 'Women's Art': An Interview with Lin Tianmiao." *n. paradoxa* 29 (January 2012): 22–31.

Wang Youshen. "Laizi Weinisi de yishu 'da hechang'" [An art chorus from Venice]. *Jiangsu Huakan* 11 (1993): 3–8.

Weibel, Peter. "Globalization and Contemporary Art." In Belting, Buddensieg, and Weibel, *The Global Contemporary and the Rise of New Art Worlds,* 20–27.

Welland, Sasha Su-Ling. *Experimental Beijing: Gender and Globalization in Chinese Contemporary Art.* Durham, N.C.: Duke University Press, 2018.

Wolbert, Barbara, "World Art, Framed Wall." *Antropologia Portuguesa* 14 (1997): 63–78.

Wu Hung. "A Case of Being 'Contemporary': Conditions, Spheres, and Narratives of Contemporary Chinese Art." In Enwezor, Condee, and Smith, *Antinomies of Art and Culture,* 290–306.

———. *Contemporary Chinese Art: A History (1970s–2000s).* New York: Thames & Hudson, 2014.

———, ed. *Contemporary Chinese Art: Primary Documents.* New York: Museum of Modern Art, 2010.

———. *Remaking Beijing.* Chicago: University of Chicago Press, 2005.

———. "Television in Contemporary Chinese Art." *October* 125 (Summer 2008): 65–90.

———. *Transience: Experimental Chinese Art at the End of the Twentieth Century.* Chicago: David and Alfred Smart Museum of Art, University of Chicago, 1999.

———, Wang Huangsheng, and Feng Boyi, eds. *Reinterpretation: A Decade of Experimental Chinese Art: 1990–2000*. Guangzhou: Guangdong Museum of Art, 2002.

"Xin Diaosu: *Diaosu 1994* xilie geren zuopin zhan lilun yantaohui fayan jiyao" [New sculpture: Summary of the speeches delivered at the conference in conjunction with the exhibition series *Sculpture in '94*]. Artron.net, November 21, 2012. https://news.artron.net/20121119/n283418_1.html

Xu Guoqi. *Olympic Dreams: China and Sports, 1895–2000*. Cambridge, Mass.: Harvard University Press, 2008.

Yan Shanchun. "Dark Learning, Mysticism and Art—Wang Guangyi Interview Transcript." Translated by Jeff Crosby. In Huang, *Thing-in-Itself*, 138–93.

Yan, Yunxiang. "Managed Globalization: State Power and Cultural Transition in China." In *Many Globalizations: Cultural Diversity in the Contemporary World,* edited by Peter L. Berger and Samuel P. Huntington, 19–47. New York: Oxford University Press, 2002.

Yang Jingsong. "Zouxiang bentu" [Walk toward one's native land]. *Jiangsu Huakan* 132, no. 12 (1991): 27–28.

Yee, Herbert S. "The Three World Theory and Post-Mao China's Global Strategy." *International Affairs* 59, no. 2 (Spring 1983): 239–49.

Yi Ying. "Xiandai zhuyi de kunjing yu women de xuanze" [The modernist dilemma and our options]. *Meishu* 256, no. 4 (1989): 10–13.

———. "Criticism on Chinese Experimental Art in the 1990s." In Wu, Wang, and Feng, *Reinterpretation*, 98–104.

———. "Political Pop and the Crisis of Originality." In *Subversive Strategies in Contemporary Chinese Art*, edited by Mary Bittner Wiseman and Liu Yuedi, 21–34. Leiden: Brill, 2011.

Yin Jinan. "Xianzhuang guanhuai: Hou xinchao yu xin shengdai" [Concern for the current situation: Post–New Wave and the new generation]. *Yishu Guangjiao* 2 (1992): 60–62.

———. "Xin shengdai yu jin jüli" [New generation and close-up artists]. *Jiangsu Huakan* 133, no. 1 (1992): 16–17.

Yin Shuangxi. "Zhongyao de zhuanzhe: Guanyu diaosujia 1994 xilie geren zuopinzhan" [An important turning point: On 1994 individual sculpture series exhibition]. *Jiangsu Huakan* 170, no. 2 (1995): 13–16.

Yu, George T. "China and the Third World." *Asian Survey* 17, no. 11 (November 1977): 1036–48.

Peckham, Robin, and Venus Lau, eds. *Zhang Peili: Certain Pleasures*. Hong Kong: Blue Kingfisher, 2011.

Zhang Peili. "*Yishu jihua di er hao* de chufadian" [Point of departure for *Art Project. No. 2*]. In *The '85 Movement*. Vol. 2, *An Anthology of Historical Sources*, edited by Gao Minglu, 214–16. Guilin: Guangxi Normal University Press, 2007.

———. "You yize xinwen xiangdao de" [Thoughts on a piece of news]. In Huang, *Artistic Working Manual of Zhang Peili*, 371–73.

———. "Yu xifang zuozhan?" [Doing battle with the West?]. In Huang, *Artistic Working Manual of Zhang Peili*, 374–77.

Zhang Qun, and Meng Luding. "Xinshidai de qishi: *Zai xinshidai* chuangzuo tan" [Enlightenment of a new era: On *In the New Era*]. *Meishu* 211, no. 7 (1985): 47–48.

Zhang Xiaogang. "Wo de zhiyi—Magelite" [My soul mate Magritte]. *Yishu Shijie,* no. 5 (2001): 72–73.

Zhang Xueyan. "Meishu zenyang zouxiang shijie? Jige shiji wenti de sikao" [How can art head toward the world? Some thoughts on a few actual problems]. *Meishu* 259, no. 7 (1989): 18–19.

Zheng, Bo. "From *Gongren* to *Gongmin:* A Comparative Analysis of Ai Weiwei's *Sunflower Seeds* and *Nian.*" *Journal of Visual Art Practice* 11, no. 2–3 (2012): 117–33.

Zheng Shengtian. "Looking Back at Thirty Years." In *Art and China's Revolution,* edited by Melissa Chiu and Zheng Shengtian, 19–39. New Haven, Conn.: Yale University Press, 2008.

———. "Waves Lashed the Bund from the West: Shanghai's Art Scene in the 1930s." In *Shanghai Modern, 1919–1945,* edited by Jo-Anne Birnie Danzker, Ken Lum, and Zheng Shengtian, 174–98. Berlin: Hatje Cantz Verlag, 2005.

"Zhongguo youhua de fangxiang: Zhongguo meixie youhua yiweihui zuotanhui zhaiyao" [The direction of Chinese oil painting: Summary of conference proceedings of the Chinese Artists' Association Oil Painting Art Advisory Committee]. *Meishu* 273, no. 9 (1990): 25–28.

Zhou Yan. "Jinqi tansuoxing meishu zhuizong" [Tracing recent exploratory art]. *Jiangsu Huakan* 133, no. 1 (1992): 3–4.

———. "Writing an English-Version History of Chinese Contemporary Art from Chinese Contemporary Perspective." In *Shenme shi Zhongguo dangdai yishu* [What is Chinese contemporary art?], edited by Zhang Xiuzhu. Chengdu: Sichuan Meishu Chubanshe, 2010.

Index

PEGGY WANG is associate professor of art history and Asian studies at Bowdoin College.